MEDIEVAL ART

MARILYN STOKSTAD

MEDIEVAL ART

SECOND EDITION

Westview PRESS
An Icon Edition

A Member of the Perseus Books Group

Copyright © 2004 by Marilyn Stokstad

Published in the United States of America by Westview Press, 5500 Central Avenue, Boulder, Colorado 80301-2877, and in the United Kingdom by Westview Press, 12 Hid's Copse Road, Cumnor Hill, Oxford OX2 9JJ.

Find us on the world wide web at www.westviewpress.com

Westview Press books are available at special discounts for bulk purchases in the United States by corporations, institutions, and other organizations. For more information, please contact the Special Markets Department at the Perseus Books Group, 11 Cambridge Center, Cambridge, MA 02142, or call (617) 252-5298, (800) 255-1514 or email specialmarkets@perseusbooks.com.

Text design by Brent Wilcox
Set in 11-point Adobe Garamond by the Perseus Books Group

Library of Congress Cataloging-in-Publication Data
Stokstad, Marilyn, 1929–
 Medieval art / Marilyn Stokstad.—2nd ed.
 p. cm.
 Includes bibliographical references and index.
 ISBN 0-8133-4114-0 (pbk. : alk. paper)—ISBN 0-8133-3681-3 (hardcover : alk. paper)
 1. Art, Medieval—History. I. Title.
N5970.S75 2004
709'.02—dc21

 2003006643

The paper used in this publication meets the requirements of the American National Standard for Permanence of Paper for Printed Library Materials Z39.48-1984.

10 9 8 7 6 5 4 3 2 1
Printed in Canada

CONTENTS

10|14

10|21

EXAM

10/28 191-208
11/4 208-226

PREFACE

Like those Celtic saints who confidently set sail for parts unknown on ships of millstones or cabbage leaves, I once accepted a strange mission and a challenge—to write a survey of over a thousand years in the history of western art and architecture, from ancient Rome to the modern age of exploration. The Celtic sailor-saints, beset by flying fish, giant cats, and deep-sea monsters, made their way to new lands, to the very mouth of Hell, to the Blessed Isles, and back home again to tell their stories. This book, subject to a closer scrutiny than those ancient tales, suggests an intellectual voyage no less challenging and certainly just as enlightening.

Medieval Art, like most books by college professors, began as a set of lecture notes that changed over the years in response to the interests of students and the critiques of colleagues. My purpose in writing *Medieval Art* then as now was to introduce the reader, the museum visitor, and the student to extraordinarily complex and beautiful art and architecture. The diverse arts of painting (from tiny manuscript illustrations to huge stained glass windows), architecture, and sculpture are presented within the religious, political, and intellectual framework of lands as varied as France and Denmark, Spain and Germany—countries that did not even exist as political entities in the Middle Ages. Over a thousand years of art had to be summarized within the constraints of a limited number of pages and illustrations.

Medieval Art includes the art and building of what is now Western Europe from the second to the fifteenth centuries. Although to Renaissance scholars the Middle Ages was a single dark period, a vast black hole in the triumphant development of western philosophy and science from the Greeks and Romans to their own enlightened days, the period is in fact extremely diverse. What do the painters of catacomb images have in common with artists of the imperial Byzantine court, or indeed with stone carvers in Ireland or builders of Gothic cathedrals? One would first say: a devotion to and sponsorship by the Christian church, whether the Latin church led by the Pope in Rome or the Orthodox church led by the Patriarch in Constantinople. However, one should note that religious art has survived, while secular art and architecture has largely vanished. Christianity, of course, was subject to constant interpretation and development, and the impact of non-Christian cultures influenced the form, if not the content, of the art.

The great cultures of Eastern Europe, of the Orthodox Church, of Judaism, and of Islam have been given far less attention that they deserve. These great arts, worthy of independent studies, have been presented primarily as sources of influence and inspiration

for the art of the West. Late Medieval art has also been given a more cursory treatment than I would wish. This material, however, has been included in books on northern Renaissance art or, in the case of Italian art, as a prelude to the Renaissance. In a limited and highly selective text many favorite monuments—be they cathedrals or jewels—have been omitted. I have often chosen my own favorites to discuss and illustrate. When possible I have used works now in American museums, hoping to encourage the study of local collections. The reader will also note the inclusion of some less traditional work. This probably stems from my interest in the art of northern Europe, an interest that led me, as a student, back in time from the paintings of Edvard Munch to the art of the Vikings. I have continued to follow those Viking hordes, exploring coasts and rivers of Western Europe, thus giving this book a slightly peninsular and insular focus. The inclusion of Scandinavian, British, or Spanish art may sometimes be at the expense of a more traditional focus on France, Italy, and Germany. Even the added attention paid to the so-called cloister crafts or decorative arts might be attributed by the fanciful reader to my admiration for the brilliant, sparkling, and exquisite work of northern goldsmiths.

The book has gone through many transformations, and the present text bears little resemblance to the one read by colleagues many years ago. The original project—to summarize and define the styles found in over a thousand years of art and architecture—was twice abandoned, but finally, with the encouragement of family and friends and the enthusiastic support of Cass Canfield Jr., creator of the Icon Editions, the book was finally completed. When the Icon Editions became part of Westview Press, Sarah Warner took over the vital managing role of Senior Editor for this new edition of *Medieval Art*.

In the beginning, before there was a first edition of *Medieval Art*, three medievalists worked very hard with me on the project: the late Franklin Ludden and the ever-optimistic William Clark and Ann Zielinski. My heartfelt thanks to them and to all those other friends and colleagues, some of whom know parts of the original manuscript only too well and others who offered advice, criticism, and encouragement. Among the many who have tried to save me from egregious error are Santiago Alcolea, Peter Barnet, Janetta Benton, Sara Blick, Jonathan Bloom, Robert Bork, Katherine Reynolds Brown, Walter Cahn, Robert Calkins, Annemarie Weyl Carr, Madeline Caviness, John Clark, Robert Cohon, Walter Denny, William Diebold, Jerrilynn Dodds, Lois Drewer, Marvin Eisenberg, James D'Emilio, Helen Evans, Ilene Forsyth, Paula Gerson, Dorothy Gillerman, Dorothy Glass, Stephen Goddard, Oleg Grabar, Cynthia Hahn, M. F. Hearn, Ruth Kolarik, Charles Little, Janice Mann, Serafin Moralejo, Karl Morrison, Lawrence Nees, Judith Oliver, Virginia Raguin, Paul Rehak, Richard Ring, Lucy Freeman Sandler, Elizabeth Sears, Pamela Sheingorn, Mary Shepard, David Simon, Anne Ruddoff Stanton, Roger Stalley, Neil Stratford, Thomas Sullivan, Elizabeth Valdez del Alamo, Amy Vandersal, Otto Karl Werckmeister, John Williams, William Wixom, and John Younger. Graduate Research and teaching assistants who have helped me include Ted Meadows, Martha Mundes, Donald Sloan, and Jill Vessely. Reed Anderson revised the bibliography for this new edition. The words of others still ring in my ears: Harold Wethey, Jane Hayward, Thomas Lyman, George Forsyth, Robert Van Nice, Marie-Madeleine Gauthier, Jose Gudiol Ricart, and Juan Ainaud de Lasarte.

Anna Leider and Nancy Dinneen gave me benefit of the intelligent layperson's view, and students at the University of Kansas and Colorado College have read and criticized the text. For help in assembling photographs and checking references I would like to thank vi-

sual resources librarians Sara Jane Pearman, Ruth Philbrick and Monserrat Blanch, and librarians Susan Craig, William Crowe, Richard Clements, and my sister Karen Leider. Thanks, too to the staff members of the Instituto Amattler in Barcelona, the National Gallery in Washington, the Victoria and Albert Museum in London, Dumbarton Oaks in Washington, the American Academy in Rome, and the Kenneth Spencer Research Library in Lawrence, Kansas, where much of this book was written and rewritten. The Kress Department of History of Art at the University of Kansas, where I have been privileged to be the Judith Harris Murphy Professor of the History of Art, and the Endowment Association of the University of Kansas assisted me as I prepared the Manuscript.

Special thanks go to my editor at Westview Press, Sarah Warner, and her able assistants Jessica McConlogue, Lisa Molinelli and Jim Ahern (who took on the arduous task of assembling the illustrations and permissions), copy editor Norman MacAfee in New York, Senior Project Editor Rebecca Marks, designer Brent Wilcox, proofreader Alexandra Eddy, Philip Schwartzberg for his work on the maps, and researcher Reed Anderson. They truly know what it means to labor in the vineyards.

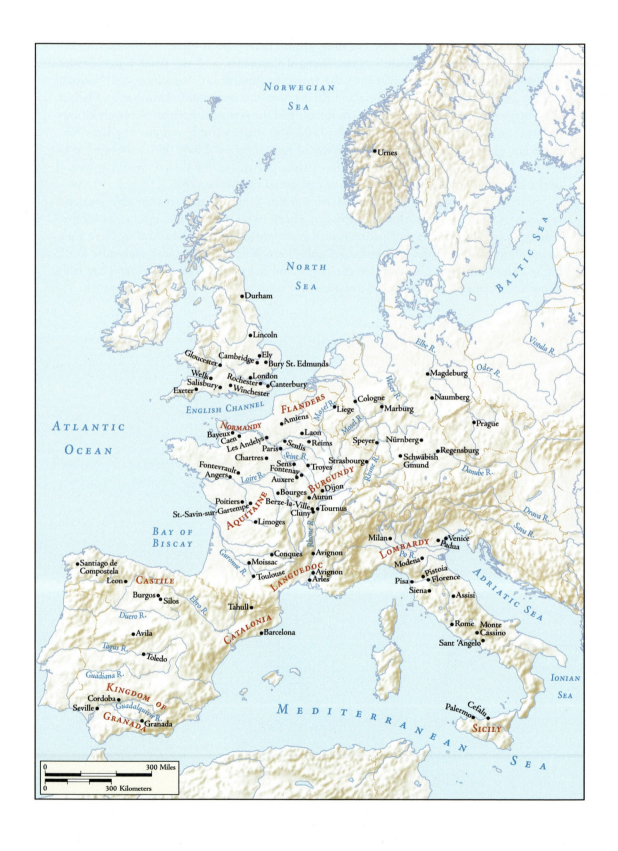

NORWEGIAN
SEA

BALTIC SEA

• Urnes

NORTH
SEA

Elbe R.

Vistula R.

Oder R.

• Durham

• Lincoln

Gloucester• •Cambridge •Ely
 •Bury St. Edmunds
Wells• •Rochester •London
Salisbury• •Winchester •Canterbury
Exeter•

• Magdeburg

• Naumberg

ENGLISH CHANNEL

FLANDERS •Cologne
 •Amiens •Liege •Marburg
NORMANDY Laon • Prague
Bayeux• •Caen •Senlis •Reims •Nürnberg
Les Andelys• •Paris Seine R. Speyer• • Regensburg
Chartres• •Sens •Troyes •Strasbourg
Fontevrault• Fontenay •Schwäbish
Angers• Loire R. Auxere Gmund Danube R.
 •Bourges •Dijon BURGUNDY
Poitiers• Berze-la-Ville• •Autun
St.-Savin-sur-Gartempe• •Cluny •Tournus
 •Limoges Drava R.
AQUITAINE

ATLANTIC
OCEAN

Mosel R.

Mosel R.

Weser R.

Rhine R.

Sava R.

BAY OF
BISCUS BISCAY

Garome R.

Rhone R.

•Milan LOMBARDY •Venice
 •Padua
•Conques •Avignon •Modena Po R.
Santiago de •Toulouse LANGUEDOC •Arles Pisa• •Pistoia
Compostela• •Avignon •Florence
Leon• CASTILE •Siena
Burgos• •Silos •Assisi
 Ebro R. ADRIATIC
 •Tahull •Rome •Monte
Duero R. CATALONIA Cassino
•Avila •Barcelona Sant 'Angelo•
Tagus R.

•Toledo

Guadiana R.

KINGDOM OF
•Cordoba Guadalquivir R.
Seville• GRANADA •Granada

MEDITERRANEAN

•Cefalu
Palermo•

SICILY

IONIAN
SEA

SEA

0 300 Miles

0 300 Kilometers

FAROE
ISLANDS

● Urnes

SHETLAND
ISLANDS
ORKNEY
ISLANDS

● Oseberg

NORTH
SEA

GOTLAND

BALTIC SEA

IONA ●

● Lindisfarne

Monasterboice ●
Durrow ●
Kells ●

NORTHUMBRIA
● Durham

ATLANTIC

OCEAN

Sutton Hoo ●
Winchester ●
Rochester ●
● Canterbury

FLANDERS
● Hildesheim
● Brunswick
● Magdeburg

Elbe R.

Oder R.

Vistula R.

Bug R.

● Kiev

NORMANDY
Bayeux ●
Caen ●
St.-Denis ●

Aachen ●
Centula ●
Reims ●
Jouarre ●
Metz ●

● Essen
● Cologne
● Fulda
● Trier
● Speyer

SAXONY

Dnieper R.

Tours ●

Auxerre ●

● Richenau

● Regensburg

Danube R.

Drava R.

SEA OF
AZOV

AQUITAINE
BURGUNDY
Cluny ●
● Tournus

Loire R.

Santiago de
Compostela ●

Naranco ●
ASTURIAS
Leon ●
Tabara ●
Avila ●

Roncesvalles
Conques ●
Toulouse ●
● Moissac
LANGUEDOC
Canigou ●
● Cardona
● Barcelona
CATALONIA
CAROLINGIAN
MARCHES
Tahull ●

Douro R.

Tagus R.

Ebro R.

Rhône R.

A L P S

Milan ●

LOMBARDY

Po R.

● Venice

● Ravenna

Sava R.

Danube R.

B Y Z A N T I N E

BLACK SEA

CORSICA

● Rome

● Monte
Cassino

SARDINIA

● Bari

E M P I R E

Toledo ●

Seville ●
CALIPHATE OF CORDOBA
Cordoba ●
Granada ●

STRAITS OF
GIBRALTAR

M E D I T E R R A

Palermo ●
● Cefalu
SICILY

N E A N

● Constantinople

● Thessalonika

● Hosios Loukas
● Daphni

S E A

CRETE

RHODES

CYPRUS

Jerusalem ●

Mt. Sinai ▲

- - - - Byzantine Empire (c. 1050)
······· Ottonian Empire (c. 1050)
▲▲▲▲▲ Islamic Territory (c. 1000)

0 ————————— 500 Miles

0 ————————— 500 Kilometers

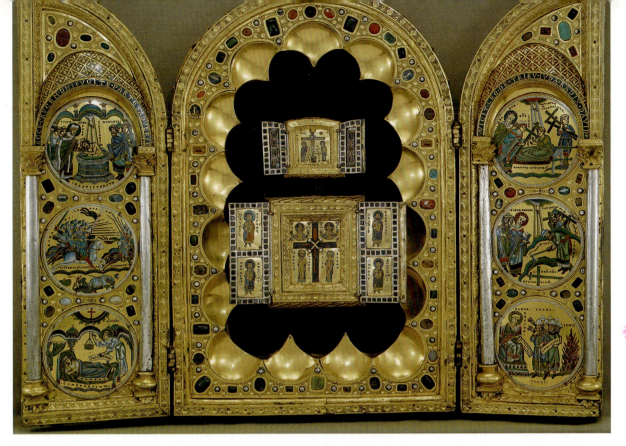

1.1 Stavelot Triptych, Reliquary of the True Cross, Mosan, Belgium, mid-12th century, The Pierpont Morgan Library.

AN INTRODUCTION TO MEDIEVAL ART

THE TRUE CROSS

A strange but hauntingly beautiful object greets visitors to the Pierpont Morgan Library in New York [1.1]. Drawn by the glitter of gold and jewels, we move closer and discover that we are looking at a three-part winged shrine, a triptych. The piece displays and protects two small enameled triptychs, which in style and technique are quite different from it. The label information—that this is the Stavelot Triptych made in the Mosan region of Belgium in the twelfth century—fails to satisfy our curiosity. The glowing colorful figures in their golden world have lured us back into the Middle Ages where works of art often frustrate our modern desire for information. We do not know who the artists were or even the location of the workshops where they mastered their craft. We do not know with certainty who ordered the work or provided the semi-precious stones, the enamels, and the relics assembled here. We have theories, suppositions—guesses, if you will—combined with some hard evidence from the works of art themselves and from a few documents. The study of history, literature, philosophy, religion, and folklore, as well as other works of art may help us to understand. Of one thing we are sure, the makers of the Stavelot Triptych believed that they had enshrined relics associated with Christ, including the Cross on which he was crucified. In contrast to the large triptych, the two small reliquaries exemplify the art of the Eastern, Byzantine Church.

Originally the Mosan artists placed them on a golden field enriched with semi-precious stones. (The velvet background seen today is modern.) In the wings, the Mosan artists added their own enamels to tell the story of the True Cross as it was known in the Middle Ages.

In the enamel medallions on the wings, the Mosan artists capture the drama of the legends and miracles of the Cross. According to the collection of saints' lives written by the thirteenth-century bishop of Genoa Jacob of Voragine, the *Golden Legend,* Constantine, during the night before fighting his rival Maxentius for control of the Roman Empire, dreamed he saw the Cross of Christ in the sky. Angels told him that the sign of the Cross would ensure victory. Constantine ordered his troops to place the cross-monogram of Christ (Chi Rho) on their shields. In the ensuing battle at the Milvian Bridge outside Rome, Constantine won a decisive victory, killed Maxentius, and entered Rome in triumph. In the last scene, Constantine accepts Christianity and is baptized by Pope Silvester. In fact, Constantine granted toleration to all the unofficial religions in his empire, and he put off Christian baptism until the end of his life, in 337.

In the right-hand wing of the triptych, Empress Helena, Constantine's mother and a Christian, has traveled to Jerusalem seeking the True Cross. In the first scene, she interrogates the Jews. They lead her to Golgotha and dig up the crosses of Jesus and the two thieves who were crucified with him. The True Cross reveals itself when it brings a dead youth back to life. In the medallion, a servant carries off the two false crosses. The empress brought pieces of wood and the nails from the Cross, along with the other relics, back to the imperial court.

The larger of the two Byzantine reliquaries in the central panel houses a fragment of the wood of the True Cross, which on the enamel cover is

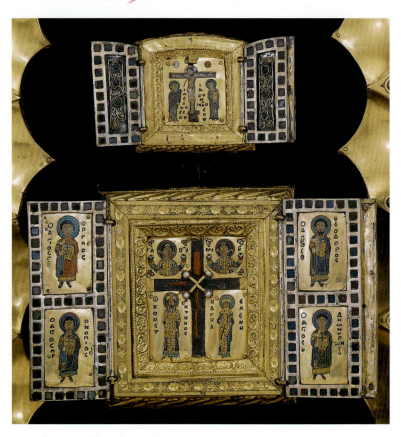

1.2 Stavelot Triptych, detail.

flanked by angels, Eastern saints, and Constantine and Helena [1.2]. The Eastern Orthodox Church revered Constantine and Helena as saints, but Constantine was not considered a saint in the West. The smaller reliquary held relics of the True Cross, the Holy Sepulchre, and the robe of the Virgin Mary, all of which were identified on a strip of parchment. In the enamels, St. Mary and St. John witness Christ's death on the Cross. The twelfth-century text in the arches above the narrative roundels celebrates the Discovery and Exaltation of the Cross. It reads, "Behold the Cross of the Lord. Flee you hostile powers. The Lion of the Tribe of Judah, the Root of David has conquered." The medieval artists succeed in giving the essence of Christian belief tangible form, both in the Western narratives and the static symbolic icons of the Eastern Church.

What else can we learn from these enamels? First, they are technically different, following the

preferences of the Eastern and Western churches. The small rectangular plaques are cloisonné enamel, and the larger medallions are in the champlevé technique. Both use fine colored glass enamel, but in cloisonné the individual cells that divide the colors are formed by tiny gold strips soldered to the surface of the panel, whereas in the champlevé technique, the cells are gouged out of the metal plate. Cloisonné enamel is typical of Byzantine art (the art of the Eastern Orthodox Church), and champlevé enamel is the preferred technique among Western artists. Eastern artists created two-dimensional patterns in translucent jewel-like colors with enamels that reflect light like rubies and emeralds. Mosan artists, working in the champlevé technique, try to suggest rounded, three-dimensional forms in space by using two or more colors in the cells. The two very different enamel techniques represent two very different views of the world.

Medieval art is essentially Christian art, but the Stavelot Triptych focuses our attention on an East-West dichotomy in Christianity, which continues to this day in the Catholic and Orthodox churches. Not only do we see two different enamel techniques but also two different modes of representation. The Eastern Byzantine artists use a symbolic mode: static hieratic compositions in which figures, seemingly almost frozen in place, quietly adore the Cross. In contrast, the Westerners work in a narrative mode, creating lively energetic figures acting out dramatic stories of visions, battles, confrontations, and miracles. Finally, even the conception of Emperor Constantine differs—in the Byzantine Church, he was venerated as a saint; in the Western Catholic Church, he was never canonized, although his mother, Helena, was.

In the twelfth century when the Mosan enamels were made, Abbot Wibald led the imperial Benedictine monastery of Stavelot (1130–1158). The abbot was an important diplomat and adviser to three Holy Roman Emperors—Lothair II, Conrad III, and Frederick Barbarossa. In 1154, Frederick Barbarossa sent him on a mission to Constantinople. The Byzantine Emperor Manuel Komnenus may have given Abbot Wibald the two small

Byzantine reliquaries as a diplomatic gift. The abbot traveled to the Byzantine court again in 1157, and he died in 1158 on the way home. In the period between the abbot's two trips, the Western shrine for the Byzantine reliquaries could have been made in Stavelot. Of the artists who made the triptych, we know nothing.

The Idea of the Middle Ages

The Middle Ages—exuberantly self-confident Renaissance scholars looked back on this period of a thousand years as an interlude. They considered the centuries after the fall of Rome as a dark "middle" age because the period fell between the time of Classical Greece and Rome and the revival of learning in their own day. Today, these centuries appear to us as a brilliant period out of which emerged our own modern world with its rival nations, its different philosophical, political, and economic systems, and its varied forms of art and architecture. The medieval period extends from the fourth-century battle of the Milvian Bridge—when Constantine's troops, bearing the monogram of Christ on their shields, conquered Rome—to the fifteenth-century discovery of the Americas by navigators from Portugal sailing the uncharted ocean with the Cross of the Order of the Knights of Christ on their sails. Thus, two powerful visual images will begin and end our study—the Chi Rho and the Knights' Cross.

CHRISTIANITY AND THE EARLY CHRISTIAN CHURCH

We have been looking at an image made for a triumphant Christian Church. Christianity did not begin as an imperially sponsored religion. In the first century, Octavian, who was made Roman emperor by the Senate with the title Augustus, formed a united empire. Far from Rome, in Palestine, where Herod ruled as Roman governor, a woman called Mary gave birth to a child she named Jesus. The Gospels tell of angelic messengers announcing the coming of the Messiah and wise men traveling to Bethlehem to recognize him

as the Christ, the Son of God. Later his followers declared his birth to be the beginning of a new era, year one of the time of our Lord, Anno Domini, A.D., today more ecumenically referred to as the Common Era, C.E.

At first, few people would have been aware of Jesus of Nazareth, a Jewish carpenter who performed miracles of healing and who claimed to be the Son of God and the Messiah of the Jews. Jesus urged his followers to love all humankind and to consider life on earth merely a preparation for life everlasting in Heaven. By his death on the Cross, Jesus offered himself as a sacrifice to atone for the sins of all humanity. The Christians said that Jesus arose from the tomb and returned to God, his Father in Heaven, but he would return to judge the world and take those people deemed worthy back with him to paradise. This message of faith and hope soon gained followers, especially among the poor.

The central body of Christian belief is contained in the New Testament, which together with the Jewish scriptures, called by the Christians the Old Testament, form the Bible. The New Testament consists of four Gospels (meaning the good news), attributed to Matthew, Mark, Luke, and John. These four Evangelists provide four versions of the life and teachings of Jesus. St. Paul's letters to the new Christian communities (the Epistles) and the Acts of the Apostles record the establishment of Christianity as an organized religion. The New Testament concludes with St. John's Revelation of the end of earthly time in the Apocalypse. The sacred texts of the Jews provided the Christians with the historical context for their belief. Christians saw Old Testament events as prefigurations of Christianity; for example, the deliverance of Jonah from the sea monster became a prototype for the Resurrection of Christ, and the shepherd of the 23rd Psalm could be identified with Christ the Good Shepherd. At the end of the fourth century, St. Jerome edited and translated the Bible into Latin, the vulgar or people's language, and his edition is known as the Vulgate.

The form of Christian worship was at first very simple. When Christ gathered with the apostles

The Christian Story and Liturgical Cycles

Christians use two kinds of time—historical and liturgical. Events in the Life of Christ may be represented as a narrative in historical sequence or grouped and organized according to the order in which they were celebrated by the church. The Western Christian liturgical year is based on Christmas (fixed on December 25th, the Roman solstice) and begins with the first Sunday in Advent, four Sundays before Christmas. A second set of calendrical calculations establishes the date of Easter, which is set by the Jewish Passover, and consequently based on the lunar year. The eastern Christian Orthodox calendar is based on Easter.

Events in the Gospels are usually organized into three "cycles."

The Marian (or Nativity) Cycle: Annunciation, Visitation, Nativity, Annunciation to the Shepherds, Adoration of the Magi, Presentation in the Temple, Massacre of the Innocents, Flight into Egypt, Jesus among the Doctors.

The Public Ministry Cycle: Baptism, Calling of the Apostles, Calling of Matthew, Jesus and the Samaritan Woman, Jesus Walking on the Water (Storm on Galilee), Marriage at Canaan, Raising of Lazarus, Delivery of the Keys to Peter, Transfiguration, Cleansing of the Temple.

The Passion Cycle: Entry into Jerusalem, Last Supper, Washing the Apostles' Feet, Agony in the Garden, Betrayal (Kiss of Judas), Denial of Peter, Trial of Jesus, Pilate Washing His Hands, Flagellation, Crowning with Thorns, Bearing the Cross, Crucifixion, Deposition, Lamentation (Pietà), Entombment, Descent into Limbo (Harrowing of Hell), Resurrection, Marys at the Tomb, Noli Me Tangere (Jesus and Mary Magdalene), Supper at Emmaus, Doubting Thomas, Ascension, Pentecost.

Other themes used in Christian art include:

The Last Judgment, or Second Coming.

The Fathers of the Church (Scholars and teachers of the early Church).

The Latin Fathers: St. Jerome, St. Ambrose, St. Augustine, and St. Gregory.

The Greek Fathers: St. John Chrysostom, St. Basil, St. Athanasius, and St. Gregory Nazianzus.

Lives and miracles of the Saints.

for the Jewish Feast of the Passover and defined the bread and wine as his own body and blood, he established the sacrament of Holy Communion. "And he took bread, and gave thanks, broke it, and gave unto them, saying, This is my body which is given for you: this do in remembrance of me. Likewise also the cup after supper, saying, This cup is the New Testament in my blood, which is shed for you." (Luke 22:19–20) The new concept of Christian commemoration, added to the original Jewish rite of thanksgiving for divine intervention and salvation, has remained the core of Christian worship.

At first the Christians gathered in the homes of members of the congregation to reenact the Last Supper by taking a full meal together. Twenty-five officially Christian houses *(tituli)* are known to have existed in Rome, and there must have been many more. The communal meal became formalized into a ritual (the Mass, or Eucharistic rite) performed by a priest, in which bread and wine miraculously became the flesh and blood of Christ (transubstantiation). Eventually, the supper table became an altar; and the house where the Last Supper was reenacted became known as the House of the Lord—Domus Dei, the Church.

As a more elaborate service developed in the fourth century, elements of Jewish worship—reading from sacred books, collective prayer, and song—were incorporated into the Christian ritual. The service was divided into two parts—one open to all, and a second part reserved for initiates. In the public part of the service—the liturgy of the Word—the clergy and people invoked the saints and praised the Lord with hymns. Then, in the liturgy of the Eucharist, the initiates alone celebrated the Lord's Supper [1.3]. The priest consecrated the bread and wine, asking God to transform the bread and wine into the body and blood of Christ. A complicated ceremony of the breaking of bread and taking of wine followed. The service ended with collective prayers of thanksgiving and a formal dismissal, "Ite, missa est" (Go, you are sent forth), from which the term for the service, the Mass, is derived.

The second important rite in the early Church was the initiation ceremony called baptism. The

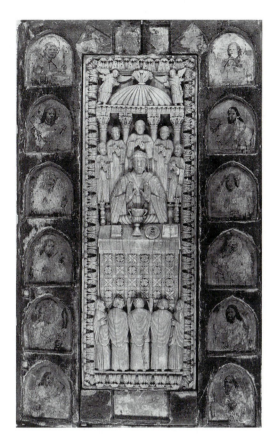

1.3 The Mass. Northern France, c. 875 or Germany, c. 1000. Ivory. Universitätsbibliothek, Frankfurt.

simple washing away of sins and the gift of the Holy Spirit by the laying on of hands mentioned in the New Testament became an elaborate and formal ritual presided over by the head of the Christian community, the bishop. In baptism the initiates "died" and were reborn in Christ. The participation of large numbers of people in the Mass and baptism required special buildings. The ritual death and rebirth suggested the architectural symbolism of the tomb for the baptistery, just as the Lord's Supper could appropriately be taken in a house-church.

In the early years, rival religions influenced the development of Christianity. Many of the religious cults in the Eastern part of the empire evolved around the concept of death and rebirth, for example, the Egyptian cult of Isis and Osiris. The Roman cult of the Earth Mother Demeter and the

Greek cults of Dionysus (Bacchus) or the Great Goddess Cybele were also ecstatic in tone and highly individual in their appeal. These "mystery religions" had elaborate, secret rites in which music, incense, lights, and sacred images created a sense of dramatic urgency among the believers. Christians incorporated some of these elements into their liturgy to enhance the emotional intensity and immediacy of their worship. The idea of powerful secrets open only to the initiate, ensuring eternal life through union with a Man-God-Savior, was powerful indeed.

Monotheistic cults and religions, such as the Neoplatonic One, Zoroastrianism, Mithraism, and Sol Invictus (triumphant sun), also spread through the empire by the third century. The army favored Mithras, and Sol Invictus had a cult associated with the Roman emperors. Even Constantine, for all his support of the Christian cause, continued his devotion to the sun and was baptized only on his deathbed, a common practice among adult men, especially those active in politics and government, who thus avoided the problem of having to live sin-free lives after baptism. The designation of Sunday rather than the Jewish Sabbath (Saturday) as the Christian sacred day and the choice by the Christians of December 25 (both the festival of Sol and the birth of Mithras) to celebrate the birth of Christ suggest the influence of these other beliefs on Christian practice.

As Christianity became a major religion within the Roman Empire, it needed an organized administrative structure and a coherent philosophy. The first it took from the Romans and the second from the Greeks. As a political and economic institution, Christianity adopted the Roman imperial model—provincial governments under a central ruler (bishops, and especially the bishop of Rome, the Pope), a system of taxation (tithes), and even elaborate records and archives. To create a rational system for the justification of intuitive belief—essential in order to appeal to the educated classes—Christians turned to Greek philosophy. However, the Greek belief in man as a rational being contrasted vividly with the Christian acceptance of the power of faith.

St. Augustine (354–430) in the West and St. Gregory of Nazianzus (329–389) in the East sought to adapt elements of Greek Platonic philosophy to Christianity. The Platonic cosmology, later refined by Plotinus and the Neoplatonists, conceived of a Universal Soul that radiated through the universe and animated the world of matter. Human beings participated in both the world of the soul and the world of matter but their ultimate goal was the reunion with the Universal Soul, the One. The educated Greek or Roman could understand the Universal Soul as another way of describing the Christian God.

For more than a thousand years the ideals and precepts of Christianity dominated European thought and its visual expression in art and architecture. At the same time early Christian art can be seen as a phase of Late Roman art, distinguishable as Christian only by its subject matter.

TRADITIONAL ROMAN ART

Roman art is fascinating in itself, but it cannot be treated here with the care and depth it deserves. The examination of a few examples must suffice to establish a context for the earliest Christian art. Typical of Roman imperial art is the Arch of Titus, erected in 81, commemorating the Roman Palestine campaign and conquest of Jerusalem [1.4]. Such tangible records of specific historical events, represented with well-observed detail, are an important contribution by the Romans to the history of art. On the Arch of Titus, the historical situation depicted is as follows: A rebellion in Judea (66–70) ended disastrously for the Jews when the Roman general Titus captured Jerusalem. Titus brought the Ark of the Covenant, the temple lampholder known as the Menorah, and other treasures back to Rome as trophies. He and his troops paraded through the heart of the city to the Temple of Jupiter, the customary triumph awarded a victorious general. Titus later ruled as emperor (79–81) and on his death joined the official state gods of the empire.

Relief sculpture, on the inner faces of the piers of the commemorative arch, depicts the triumphal

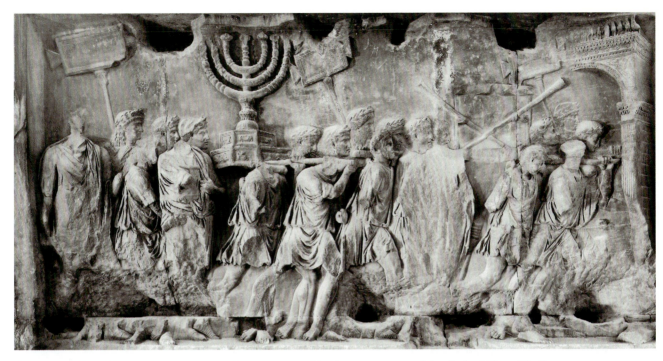

1.4 Spoils from the Temple of Solomon, Jerusalem, relief in the passageway of the Arch of Titus, 81. Rome.

procession. On one side is the emperor, and on the other soldiers march through an arch carrying the spoils from the Temple including the Ark of the Covenant and the menorah. Not only have the artists carefully reproduced marching men and their loot, but they have also achieved a sense of space. By the remarkable device of the curved background plane, they eliminate the cast shadows of the frame and so produce an illusion of atmosphere. The sculptors also varied the height of the relief, carving figures in the foreground in high relief and those farther away progressively lower. The artists have tried to create the illusion of a window through which a spectator looks out on the world.

During the second century, artists continued to depict specific events in a sensible, rational world, but new techniques undermined the subtle realism seen in first-century art. In the Hadrianic reliefs on the Arch of Constantine, the sculptors began to compress space and action by tilting the ground upward and by reducing the architecture or landscape to a few well-chosen elements [1.5]. They modeled the individual figures as subtly as had the sculptors of the Arch of Titus, but to make the

images more visible at a distance, they sharpened outlines by undercutting the edges of the forms to create shadows. Gradually the sculptors began to think in terms of light and shade rather than of solid figures in a defined space, a change in focus that naturally led to a change in style and an increasing abstraction of form.

By the third century, the Roman Empire, and its art, changed. The Christians had been given limited official status in the empire, first by Emperor Septimius Severus in 202, who made it permissible to be a Christian but not to try to convert others, and later by Gallienus (253–268), who made Christianity a "permitted religion" *(religio licite)*. This easy situation changed under Diocletian. In an attempt to bring religious as well as political stability to the empire, in 303 Diocletian issued an edict requiring sacrifices to Jupiter, the Roman gods, and the deified emperors as proof of allegiance. Christians and Jews who worshipped no God but their own were imprisoned and sometimes executed, becoming martyrs for their faith.

Emperor Diocletian reorganized the Roman Empire into workable administrative units by

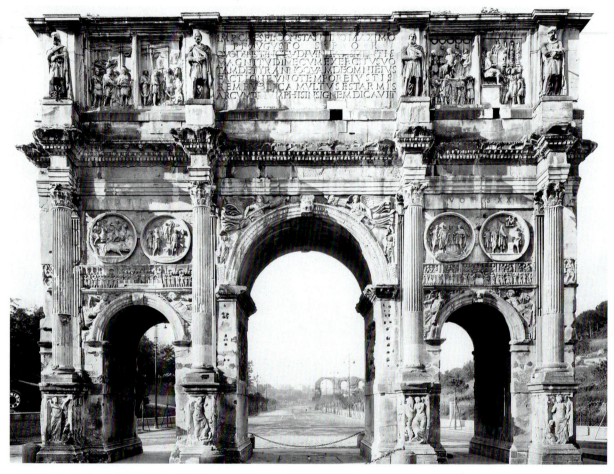

1.5 Arch of Constantine, 312–315. Rome.

From Idealism and Realism to Abstraction

Greek artists observed nature and then tried to create typical but perfect forms—the ideal. They focused on moments of perfect harmony and on the idealized representation of human beings. Roman artists recorded the world of everyday existence, that is, they worked in a realistic or naturalistic style. They interpreted nature with great skill and imagination. They achieved an illusion of material reality in sculpture, painting, and mosaic through subtle modeling, varied textures, and the effects of light.

In contrast to the ideal or realistic art of the ancient classical world, an abstract and expressionistic mode unrelated to visual appearances characterizes medieval art. The change in style began as part of the technical and visual changes seen in the second century. The two styles—realistic and abstract—existed side by side by the end of the third century. Sometimes one, sometimes the other gained ascendance depending on political, social, and economic as well as religious factors. Patrons and artists came to prefer abstract styles as the appropriate means to express the visionary character of their belief. By denying the importance of the material world they also denied the relevance of an art that recorded surface appearances.

An ideal style is often called "classical." Greek and Roman art, whether idealized or realistic in style, is often referred to as classical. But the term "classical" has other meanings. Any peak of achievement has come to be referred to as "classic," hence classic cars, screen classics, or a classic Gothic cathedral.

establishing a four-man rule, known as a tetrarchy. Two emperors (Augusti) each had a junior emperor (Caesar) as an assistant and heir. Diocletian became Augustus of the East, and his old friend Maximian was Augustus of the West. When Diocletian and Maximian retired as planned in 305, the tetrarchy failed, and the empire was again split by contending factions as the Caesars and their heirs fought for supremacy. Constantine (ruled 306/312–337) and Maxentius (ruled 306–312) both claimed the Western Empire. In the bitter struggle that ensued, Constantine defeated Maxentius in 312 [see 1.1]) and re-established a strong central government. Having secured his authority in the West, Constantine sought absolute supremacy in the Eastern Empire as well. The struggle with Licinius lasted until Constantine finally emerged victorious in 324.

OFFICIAL ART UNDER CONSTANTINE

Contemporary sources record that Constantine commissioned many colossal statues of himself and appropriated sculpture made for his predecessors. Portraits served as symbols of the imperial presence. Constantine's portraits radiate heaven-sent sovereignty through aggrandized, abstracted features [1.6]. The geometric forms of the face, his massive jaw, hawk nose, and distinctive haircut suggest his individual characteristics, while rigid frontality and absolute immobility create a superhuman appearance. Although his deeply set eyes look upward, the regular, repeated arcs of his eyelids and eyebrows seem to deny even this slight sense of movement. These immense staring eyes seem to fix on the spiritual source of the emperor's rule, for Constantine directs his sight upward to the gods acknowledged by his reign, be they Christian or Roman. No longer the portrait of a mortal man, Constantine personifies ordained majesty in eternal communion with the heavens.

A magnificent triple arch erected by the Roman Senate to celebrate his victory over Maxentius recalls Constantine's imperial triumph. As if to assert Constantine's place in the succession of great Roman emperors, the builders incorporated fragments of sculpture from monuments honoring

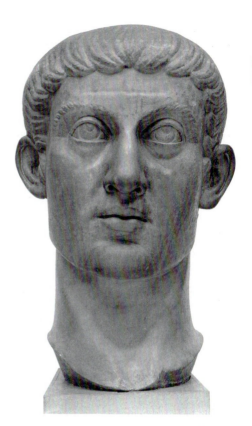

1.6 Head of Constantine, c. 325. Marble. Height 3ft., 1.5in. (95.3 cm). The Metropolitan Museum of Art.

his greatest predecessors—Trajan, Hadrian, and Marcus Aurelius. Figures and reliefs carved especially for the arch break decisively with the Roman realistic style [1.5, lower relief]. Instead of carefully modeling three-dimensional figures and settings, the sculptors outlined forms by drilling a series of holes or continuous grooves to produce deep shadows and strong highlights. At a distance the images are strikingly dramatic, but when seen close at hand, the two-dimensional pattern of drill work tends to destroy the organic unity of forms. This change in technique signaled a change in attitude toward the representation of the material world, as artists sought to create an illusion of substance rather than a tangible form. The complete work of art began to depend on elements that are outside the image—that is, on the effects of light and on the imagination and vision of the spectator. The rational, self-reliant, and anthropocentric classical

Greek and Roman world gave way to times requiring a new style, an art focused on intangible concepts expressed through geometric forms abstracted from nature, symbolizing intellectual and spiritual ideals.

On the Arch of Constantine every part of the new reliefs—not only the composition but also the carving of individual figures—reflects the artists' will to depict the emperor as benign yet all-powerful, an imperial presence dispensing wisdom, justice, and alms. Constantine appears at the precise center of the composition, the only figure unconfined by the horizontal registers. His frontal position removes him from the active world, since the frontality isolates him physically and psychologically from his petitioners and retainers, who are consistently rendered as short, dumpy figures with enormous heads. Whether the figures dispense charity or petition for it, their repeated forms and gestures and their round, heavy-jawed heads produce a symmetrical pattern. Four identical galleries house indistinguishable officials, all bestowing the emperor's gifts to similar recipients. Alms giving is represented as a permanent feature of Constantine's rule rather than as a pictorial recollection of a specific act of generosity.

In the Constantinian reliefs, the illusionistic space of earlier Roman art has given way to a flat background aligned parallel to the relief surface. The architecture does not establish any illusion of three-dimensional space, yet we can identify the individual buildings. Crowds are represented by the ancient convention of superimposed registers. Compounding this lack of implied depth is the actual overall flatness of the modeling. A transparent plane seems to press against the figures, cutting off any projection into the spectator's space. Figures are simplified to geometric essentials: Drapery folds are reduced to patterned linearity; legs are like a row of tree stumps. Extensive drill work produces sharp contours and patterns of light and shadow. Finally, the composition is dominated by the strict rectangularity of the panel's shape—a "sovereignty of the frame." If we regard this new symbolic mode not from the point of view of

Roman art but from that of the Middle Ages, it emerges, like most Constantinian art, as an omen for the future.

Roman architects and engineers as well as sculptors and painters provided models. Later Christian builders learned from Roman practicality and efficiency, functional planning, excellent engineering, and creative use of strong, inexpensive materials. Throughout the Middle Ages, great brick and concrete walls and vaults towered over the columns and friezes of temples and basilicas, a constant demonstration of engineering skill to be emulated when Western builders tried again to cover large spaces with vaults. Roman secular basilicas, audience halls, and peristyles provided models for Christian churches. Roman imperial tombs and the Roman Pantheon, rededicated to the Virgin Mary and all the martyrs in 609, reinforced the idea of using centrally planned, domed buildings as martyrs' churches and baptisteries.

CONSTANTINE AND THE CHRISTIANS

As emperor, Constantine immediately began to undo the wrongs that his predecessors had visited upon the Christians. First he issued a decree whereby Christians would be tolerated and their confiscated property restored, then he recognized Christianity as a lawful religion. In a crucial pronouncement known as the Edict of Milan, issued in 313 in concert with the Eastern ruler, Licinius, Constantine formalized his earlier decrees. The text of the edict, a model of religious toleration, allowed not only to Christians but to the adherents of every other religion the choice of following whatever form of worship they pleased.

Giving religious freedom to both Christians and pagans should have assured the empire internal peace. But if Constantine expected the Christians to unite behind his government as a pious, harmonious people, he was disappointed. Christian theologians attacked each other with the same vigor that they directed toward unbelievers. A critical problem in the fourth century was the very definition of the nature of Christ. To most Christians the

indivisible equality of Christ's human and divine nature was essential. All the time he lived and died on the Cross as a man, Jesus remained the divine Son of God. Nevertheless Arius (d. 336), a Libyan priest in Alexandria, Egypt, argued that the Father, Son, and Holy Spirit were not one substance and that Christ, being a creation of the Father, was not identical with God. The Arian position was challenged by Athanasius (d. 373), who claimed that the three persons of the Trinity were of one substance. In 325 Constantine called a church council at Nicaea in an effort to establish a uniform Christian doctrine for the empire. The council accepted the Trinitarianism of Athanasius as the basis for the Nicaean Creed and declared Arius' doctrine heretical. Nevertheless, Arianism continued to flourish and to plague the Christian world.

As Persians and others living outside the frontiers challenged the Roman Empire, Constantine, ever the pragmatist, decided to move from Rome to a new headquarters nearer the troublesome East. After his defeat of Licinius in 324, he chose a superbly defensible site, Byzantium, a Greek port on the Bosporus at the eastern end of the Mediterranean. There, in 330, he dedicated a magnificent imperial residence. The city was called Constantinople, the city of Constantine, and throughout the empire it came to be considered the New Rome (see Chapter 3).

Until his death in 337, Constantine commissioned works of art and architecture for his new city, for he recognized the propaganda value of great public works. Pervading these monuments is an ecumenical spirit that reflects the emperor's calculated willingness to be all things to all people, and the universal toleration explicitly stated in the Edict of Milan. For his forum in Constantinople, he ordered a colossal statue of himself—a full-length portrait incorporating objects revered by his people. Now lost, it was said to have combined Jewish, Christian, and pagan elements in a monument that enabled every citizen to regard Constantine as the defender of his or her own faith. A bronze figure of Apollo was turned into an image of Constantine by replacing the pagan god's head

with a portrait of the emperor. Crowning the imperial brow was a diadem, which had in it one of the Crucifixion nails discovered by St. Helena. The base of the statue was believed to contain a marvelous collection of sacred objects: for Jews, an adz used by Noah to build the Ark and the rock from which Moses struck water in the desert; for Christians, crumbs from the loaves of bread with which Christ miraculously satisfied five thousand faithful, fragments from the crosses of the two thieves whom the Romans crucified with Jesus, and the jar of spices and ointment used by the Holy Women to prepare Christ's body for the tomb; for tradition-loving Roman citizens, the standard that had been carried to Rome from Troy by its mythical founder Aeneas. The monument typified Constantine's cosmopolitan, syncretic vision.

THEODOSIUS AND OFFICIAL ART IN THE LATER FOURTH CENTURY

The Pax Romana envisioned by Constantine faded with his passing. Not until the accession of Theodosius I in 379 were decisive steps taken to stabilize the empire. With external threats more ominous than ever, Theodosius determined to unify his subjects through religion. In a series of momentous edicts, he proclaimed Christianity for the first time to be the sole religion of the empire. By the time he died in 395, Theodosius had irrevocably transformed the Roman Empire into a thoroughly Christian state.

Theodosius, while condemning paganism, did not repudiate the imperial glorification of the emperor that paganism fostered. Official art in the second half of the fourth century continued to portray the emperor as a superhuman being. His artists intensified the formal principles developed earlier in the century—abstraction of natural forms, insistent frontality, rigid symmetry, and hieratic scale. In a stark and uncompromisingly symbolic manner they depicted the emperor as an omnipotent, divinely inspired sovereign.

A silver plate (*missorium*) made in 388 to mark the tenth anniversary of Theodosius' accession por-

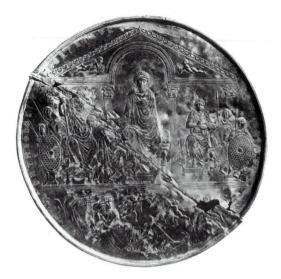

1.7 *Missorium* of Theodosius, found in Estremadura, Spain, 388. Diameter, 29 1/8in (74cm), silver. Academy of History, Madrid.

trays the emperor looming over an official to whom he presents a commission [1.7]. The artist has made hierarchic distinctions visible and explicit.

The emperor—rigid, frontal, and twice the size of any other man—is flanked by his co-rulers, his nephew Valentinian (d. 392) and his son Arcadius. They hold scepter and orb, and haloes circle their heads to indicate imperial majesty. The guards are smaller still and shown in the more informal three-quarter view. The emperor's achievements and the prosperity of his reign are symbolized by a person-ification of Earth, who reclines at his feet, bearing the cornucopia of abundance and surrounded by plants and putti bearing offerings. Theodosius is majestically enthroned in a symbolic palace, an arched lintel and gable that also serve to isolate him and emphasize his position. The material vestiges of the classical heritage—idealized faces, personifications, and architectural forms—appear

in a space made immeasurable and irrational by the flatness of the relief. Bodies disappear beneath stiff ceremonial robes or behind decorative shield patterns, while mask-like boyish faces with stylized hair and jeweled headdresses seem to exist only to frame immense staring eyes. Not surprisingly, the style of such secular imperial work provided a fitting model for Christian artists when they began to represent Jesus as the Divine King with a court of apostles and saints.

Theodosius, like Constantine, made Constan-tinople his capital. Meanwhile, the city of Rome suffered political and economic decline although the city remained the administrative center of the Western Church (Alexandria, Antioch, and Jerusalem, as well as Constantinople were also major centers). To meet the threat posed by peo-ples such as the Goths, the government in the West moved northward first to Milan, which flourished under its great bishop, St. Ambrose, and then, at the beginning of the fifth century, to the safer retreat of Ravenna on the Adriatic coast (see Chap-ter 3). In 410 the Visigothic chieftain Alaric lay siege to Rome and finally entered its gates. The fall of Rome sent shock waves through the empire.

The idea of Roman unity and imperial grandeur, as expressed in Roman architecture and sculpture, remained an ideal and a model throughout the Middle Ages. Roman buildings, even in ruins, helped to keep alive the concept of international dominion, a concept adopted by the Christian Church and emulated time and again by later polit-ical leaders. Imperial capital cities—Constantinople in the East and Rome in the West—became Christian capitals. As the emperor and his family became patrons of Christian art, imperial Roman art became Christian art. Ultimately the Christian Church supplanted the Roman Empire as the unifying force in the Western world.

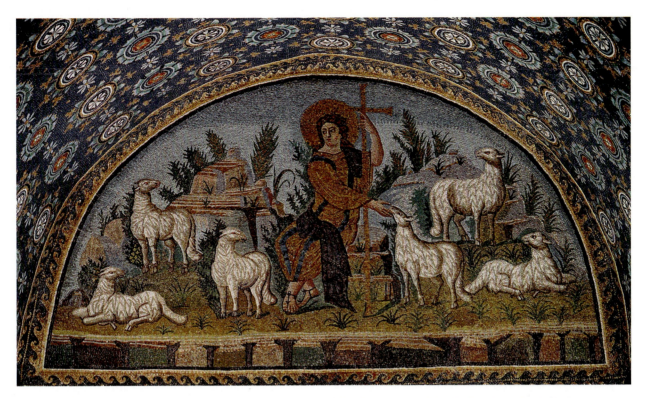

2.1 The Good Shepherd. Lunette mosaic over the entrance to the Mausoleum of Galla Placidia. 425–450. Ravenna.

THE EARLY CHRISTIAN PERIOD

A beautiful landscape, a handsome young shepherd, a flock of gentle sheep—even an urban dweller with no personal experience of country life can feel the sense of peace and security pervading the image placed over the door into the so-called Mausoleum of Galla Placidia [2.1]. The artists have tried to portray ideas and feelings rather than events. They communicate through symbols and metaphors, and they depend on the spectator to understand their meaning. The curly-headed youthful Christ reflects a type established centuries earlier for Apollo, the healer, and adopted by Alexander the Great to express his association with the divine sun. Christ sits in a mountain landscape and turns to comfort a lamb.

Everyone could interpret the image of the Good Shepherd according to his or her own tradition: A pagan could see the god Hermes or the shepherd Orpheus, and a Jew, the Good Shepherd of the Psalms; the Christian knew that the image symbolized Christ and the parable of the lost sheep (Luke 15:3–7). Churchmen might argue passionately over the nature of Christ, but artists followed the words recorded by St. John: "I am the Good Shepherd, the Good Shepherd lays down his life for the Sheep. . . " (John 10:11–16).

As the viewer's eyes wander over the mosaic surface, they are drawn to the glittering gold of Christ's robes and the imperial purple of his mantle. This is no ordinary shepherd but Christ, the

| 13

supreme ruler. The symmetry of the composition focuses attention on the golden cross. Christ's twisting movement and right arm also lead the eyes not only to the lamb but also to the tall, stemmed cross. The imperial staff joined to the Christian cross replaces the Constantinian Chi Rho monogram as the imperial standard and the symbol of the combined earthly and heavenly empires. The golden cross proclaims Christ's victory over death. That victory brings the hope of salvation for all faithful believers.

As they gaze at the lunette, the spectators are sheltered by a vault as splendid as any secular palace. A deep blue mosaic is spangled with stars—or are they flowers? The sumptuous pattern creates a twofold effect—it becomes the starry vault of heaven and recalls the flowering meadows of Paradise. The image of the Good Shepherd appeared in every medium—in paintings and mosaics, gold glass, and sculpture. It is found in tombs, catacombs, and baptisteries. What better image for the believers than Christ with his promise of new life?

JEWISH AND CHRISTIAN ART BEFORE CONSTANTINE

Social factors worked against the creation of significant Jewish and Christian art in the second and third centuries. Christians and Jews emphatically disassociated themselves from official Roman religious practices, including the veneration of images of many gods. Both religions expressed serious reservations about the representation of divinity. Sometimes the Biblical prohibition against graven images was interpreted as referring only to three-dimensional images, and sometimes representational arts of all kinds were forbidden. Among the earliest Christians the austerity of actual poverty as well as the denial of worldly goods as irrelevant, if not downright evil, also played a part in the rejection of art by some communities. Nevertheless, a vibrant artistic tradition existed in some Jewish communities and soon developed among the Christians as well.

The study of early Jewish and Christian art depends on chance survivals and especially on funerary art. In the twentieth century, remarkable religious art of many faiths came to light in Dura-Europos, a Roman city on the Euphrates River in Mesopotamia, which was destroyed in 256. Buried in the hastily erected city wall were a Jewish synagogue and a Christian house-church. Archaeologists also found temples dedicated to Zeus, Bel, Mithras, and many other gods. The Jewish community at Dura-Europos remodeled a private house into a large and splendidly decorated synagogue [2.2]. The hall with the niche for the Torah (the first five books of the Old Testament) was painted with scenes from the life of Isaac, Jacob, and Moses. Within decorative frames dividing the

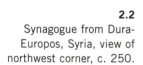

2.2
Synagogue from Dura-Europos, Syria, view of northwest corner, c. 250.

walls into rectangular panels, the stories unfold with quiet dignity. The painters worked in an abstract style that reduced the forms of people, animals, and architecture to simplified geometric shapes with strong outlines and flat, bright colors. The frontal figures engage the viewers' attention by looking out with huge staring eyes. The painters follow a visual convention known as hieratic scale in which size depends on importance rather than on relationships in space. Either a sharply rising plane or superimposed registers indicate distance. This abstract and decorative style, known throughout the Near East and Egypt, seems appropriate for the representation of anti-material religious beliefs. If painting of such clarity and vigor flourished in a border city like Dura-Europos, then surely a fully developed Jewish pictorial tradition must have been widespread.

The Christians also remodeled a house. Their house-church is an ordinary, modest home with rooms arranged around a courtyard. Except for one room, the baptistery, which had a rectangular font set in a niche framed by columns at one end of the hall, none of the rooms had any special architectural features. The date 231 was scratched in the plaster of one of the walls.

Paintings in the baptistery depict the fall of man and salvation through Christ, a recurrent theme in Christian art [2.3]. Behind the font the artist drew figures of Adam and Eve and the Good Shepherd, and on the side walls he depicted Christ's miracles and the Holy Women at the Tomb. The paintings are mere sketches with crude figures scattered irregularly over a light, neutral background. The painter ignored the physical beauty of human beings and their world in the attempt to communicate an important message. The Good Shepherd combined with Adam and Eve reminded the newly baptized Christians of their sins and at the same time the promise of salvation affirmed by St. Paul in a letter to the Corinthians: "For just as in Adam

2.3 The Good Shepherd, baptistery in the Christian House, Dura-Europos, before 256. Drawing by Henry Pearson. The Yale University Art Gallery.

all die, so in Christ shall all be made to live" (I Cor. 15:22). Even this earliest Christian art is an art of stories and allegories intended to state and reinforce Christian doctrine.

In Rome, funerary art provides evidence for Jewish and Early Christian art. Paintings and some sculpture are found in the underground cemeteries known as catacombs. Catacombs consisted of narrow streetlike tunnels with niches in the walls *(loculi)* to hold the dead. Chambers *(cubicula)* provided additional space for loculi and for simple funeral rites. With increasing demand for space, a catacomb became a complex maze of passages and chambers on many levels, a veritable necropolis, or city of the dead. Catacombs were not secret places (an idea spread by nineteenth-century Romantic writers). Commemorative services and funeral banquets took place openly in large halls and churches built above ground in the cemeteries.

Pictures appropriate for the beliefs of the owners covered the walls of the catacomb chambers. Jewish catacombs might have the Ark of the

2.4 Ark of the Covenant, flanked by candelabra. Painting at the back of the arcosolium. Catacomb in the Villa Torlonia, 3ʳᵈ–4ᵗʰ century. Rome.

Covenant, the menorah, and other symbols painted on the walls [2.4]. Traditional Romans might decorate walls with the vines of Bacchus, or with Orpheus or Hermes.

In the decoration of the underground chambers, the painters worked in the current illusionistic style, modeling forms with loose, fluid brushwork and subtle colors. Although the final effect of illusionistic painting is one of spontaneous ease, the technique actually required great control, care in execution, and thoughtful composition. In the hands of lesser artists, it could all too easily become sketchy shorthand, as is apparent in the painting of the baptistery at Dura-Europos and in many catacombs. The distinction between imperial and popular art is all too often one of quality and in the case of Christian or Jewish art, one of iconography—that is, subject matter and its interpretation. The abstract quality inherent in Roman illusionism, developed in late imperial art and characteristic of Near Eastern art (such as the Dura Synagogue paintings) became an effective instrument for the expression of a new anti-materialistic vision of the world.

Sometimes only the context identifies the work as Christian. As we have seen, a shepherd in a land-scape could be Christ but might be Orpheus or Hermes. A harvest scene with putti did not necessarily convey the image of the vineyard of the Lord and the wine of the Eucharist but might also be interpreted as the wine of Bacchus. A fisherman, a flock of sheep, an anchor, a praying soul (hands upraised and known as an orant), a shepherd, or a seated philosopher—none of these figures has overtly Christian meaning. Yet when they are found in a clearly Christian context they can be identified with the Fisher of Souls, the Good Shepherd, Christ the teacher, the congregation of faithful Christians, and symbols of hope and prayer.

The Catacomb of Priscilla has some of the finest surviving Early Christian painting. The Cubiculum of the Veiled Lady illustrates the typical arrangement of the paintings and the adaptation of themes by the Christians [2.5]. Black, red, and green lines divided the creamy white ceiling into symmetrical fields. Four lunettes surround a central medallion and create a shape that suggests the canopy of the heavens with a vision of paradise through a central opening. This central medallion frames the Good Shepherd, an idealized youth effortlessly bearing a sheep on his shoulders and standing in a landscape

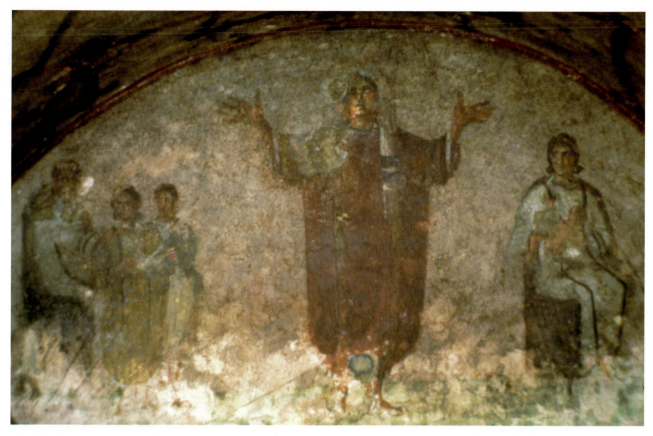

2.5 Teacher and Pupils, Orant, and Woman and Child, wall painting in a lunette. Cubiculum of the Veiled Lady, Catacomb of Priscilla, 3rd century. Rome.

between two more sheep. Doves stand among flowers, and leaves fill the lunettes on the ceiling and rectangular panels on the walls. The artist has copied the typical secular wall decoration of foliage, birds, and flowers set in fanciful painted architectural frames found in fine Roman houses; however, in the context of the catacomb the painting suggests the Christian soul in the gardens of paradise.

The Catacomb of Priscilla is a veritable painting gallery filled with images of salvation [2.6]. The artist could have been inspired by Jewish and Christian prayers, which enumerated examples of God's intervention on behalf of His people. "Deliver, O Lord, the soul of thy servant as thou didst deliver Noah in the flood . . . Isaac from the sacrificing hand of his father . . . Daniel from the lion's den . . . the three children from the fiery furnace. . . ."

The Hebrew youths condemned to the fiery furnace (Daniel 3), wearing the Persian dress associated with Mithras or Zoroaster, stand with their hands raised in the ancient gesture of prayer as the flames whip around them. The figures are merely green shapes touched by yellow; hands, faces, and flames are sketched in with a few strokes of red and orange. Yet, in spite of the simplification of the forms and the economy of the brushwork, the story and its message would have been clear to Jews and Christians alike. The presence of the Holy Spirit, in the form of a dove bearing foliage that could be either the palm of victory or the olive branch of peace, indicates that the flames were powerless to harm the believers. The mood of the catacomb paintings remains hopeful and even joyous. Believers waited confidently for the release of death, for salvation, and for the eternal bliss of paradise.

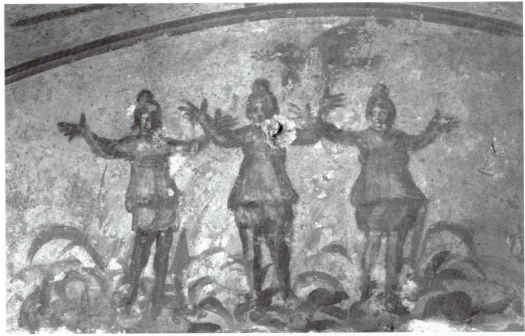

2.6
Three Children in the Furnace, Catacomb of Priscilla, 3rd century. Rome.

Single images, as well as narratives, conveyed Christian messages. The palm was an emblem of victory whether given to a victorious athlete or to a Christian martyr (one who died for his faith) who triumphed over death as an "athlete of God." A dove indicated the presence of the Holy Spirit. The anchor became a symbol of hope. The cross, however, was usually disguised as the mast of Jonah's ship, a T-shaped *(tau)* cross, or an Egyptian looped cross (the *ankh,* symbol of life). Only in the fourth century, after Constantine's vision and Empress Helena's discovery of the True Cross, did the cross become the principal Christian symbol.

At first, the most common and important early Christian symbol was the fish. The fish had many meanings. It signified Christ, for the word "fish," as a cryptogram on the Greek word *ichthus,* spelled out the first letters of the phrase "Jesus Christ, Son of God, Savior." Christ had called on his disciples to be "fishers of men," and thus the fish stood for the Christian soul swimming in the water of baptism, to be caught and saved by the Fisher of Souls. Christ fed the multitude with fish (baptism) and loaves (the Eucharist). In such ways

2.7 Mother and Child, Catacomb of Priscilla, 3rd century. Rome.

did the Christians give multiple interpretations to apparently simple subjects.

Some images seem perfectly clear even today. In the Catacomb of Priscilla, the nurturing theme of mother and child has been interpreted as the earliest representation of Mary and Jesus [2.7]. The man pointing to a star may be the Prophet Isaiah

2.8 The Story of Jonah, 3ʳᵈ century. Asia Minor. Marble 12–21in. high (30.5–53.3cm). The Cleveland Museum of Art.

foretelling the birth of Christ (Isa. 7:14) or the priest-diviner Balaam (Numbers 24:17), who prophesied, "A star shall come out of Jacob, and a scepter shall rise out of Israel." A skillful artist has captured the image of a squirming child and protective mother. The reduction of illusionistic modeling to flashes of color touched with brilliant highlights suggests the dematerialization of form typical of late Roman art.

In Early Christian sculpture, like painting, subjects are often ambiguous. The carvers adapted pagan and Old Testament themes for their new Christian patrons. The Jonah story, for example, is told in a remarkable series of statuettes now in the Cleveland Museum of Art [2.8]. Freestanding sculpture from the Early Christian period is rare, and these figures illustrate the difficulty of assigning a date and place of origin for many works of art. Scholars now suggest that they are the product of a workshop active in the third quarter of the third century somewhere in Asia Minor where classical Hellenistic influence remained strong. Even the function of the figures is unclear. Who ordered them, and why? They could have come from a tomb or a baptistery. They might have been fountain ornaments in a private Christian home. In two of the statuettes, the sea monster swallows and spews forth Jonah with a vigor that recalls the

intricate compositions of Hellenistic Greek sculpture. A third statue illustrates Jonah reclining under a vine like the classical shepherd Endymion. The Cleveland group also includes a Good Shepherd, a praying Jonah, and six portrait busts. The figures are highly finished, and the details of head, hair, and anatomy are skillfully treated. The sculptor had clearly not lost contact with his classical heritage and could, when called upon, create remarkably expressive idealized figures.

Christian sculpture in the round was rare in the third century, but mosaic—the monumental and expensive medium that was to become one of the glories of Early Christian and Byzantine art—is even more unusual. One of the earliest Christian mosaics known today was found in the Mausoleum of the Julii in the cemetery under St. Peter's Basilica in Rome and is dated to the end of the third century [2.9]. Like so much Early Christian art, the mosaic at first appears to have a pagan subject: the vineyard of Bacchus and a charioteer. Like Helios crossing the sky in his chariot, the man has beams of light streaming from his head. The walls of the mausoleum, however, were painted with Jonah, the Fisher of Souls, and the Good Shepherd. Consequently, in the mosaic the vine symbolizes the Eucharistic wine, making the charioteer none other than Christ ascending to Heaven. The

2.9 Christ/Helios. Mausoleum of the Julii, 3rd century. Mosaic, 78 x 64in. (198.1 x 162.6cm). Vatican.

image of the charioteer has a long history in art. In the Near East he symbolized astral bodies and the cosmic power of the ruler. In pagan Rome the heavenly charioteer carried a deceased emperor into the heavens at the moment of apotheosis. The charioteer could also represent the Victorious Sun, Sol Invictus. The triumphant visual equation of Christ as Light of the World with Helios and cosmic power, and Christ's Resurrection with an imperial apotheosis, indicates the growing strength and confidence of the Christian community. In this mausoleum, at least, the Christian owners and the artist adopted the most imposing imperial symbolism for their image of Christ.

If Christ/Helios appears brilliantly simplified, the effect is due in part to mosaic as the medium.

Mosaic lends itself to simplification and abstraction, for repeated geometric patterns, such as the vine leaves, are easy to set, and they produce handsome decorative effects. A skilled artist working with small tesserae of many shades can imitate the illusionistic effects of painting, and Roman mosaicists had learned to reproduce natural forms, usually in strong colors against a light background. But in the modeling of the charioteer's cloak and tunic or in the horses, for example, shadows and highlights are exaggerated and repeated so that they begin to form independent patterns, almost like drill work in sculpture. Through repetition and misunderstanding, techniques that began as rapid, easy ways to achieve an illusionistic effect eventually led to a new style. When this abstract mode also served to express a new definition of reality—when abstract form and spiritual content coincided—a new medieval style emerged.

Christian art flourished when people from a level of society accustomed by wealth and education to patronize the arts began to enter the Church in large numbers. These cultured Romans commissioned painting and sculpture in the current local style, changing only the interpretation of the subject matter. The development of a style is not a self-conscious act. The earliest artists working for Jewish and Christian patrons represented new subjects, but obviously it did not occur to anyone that they should create a new style in order to do so appropriately. The Late Antique style current throughout the Roman Empire, combined with increasingly strong influence from the Near East and the north—the people outside the borders of the empire—gradually produced an art in which the physical appearance of material objects and their spatial relationships were unimportant. Artists denied the physical world and conveyed the essence of the scene through expressive glances and gestures. Late Roman art had become abstract and expressionistic in style before it became Christian in content, but artists working for Christians enhanced and consciously developed these tendencies until painting, sculpture, and mosaic approached the ideal described by the philosopher

Plotinus, "an appropriate receptacle . . . seeming like a mirror to catch an image of [the Soul]."

CHRISTIAN ART IN THE AGE OF CONSTANTINE

A reluctance to raise the visual arts to a position of prominence persisted among many Christians. Nevertheless, the practical value of art as an instrument of instruction and the desire for monumental commemoration encouraged the creation of images and buildings that might otherwise have been considered too worldly, too ostentatious, and too reminiscent of pagan idolatry. Sculpture in the round was particularly vulnerable to the charge of idol worship. Except for portrait busts or small figures of the Good Shepherd, Christianity encouraged figurative sculpture only on sarcophagi.

When the Roman prefect Junius Bassus died on August 25, 359, at the age of 42 years and two months, he held one of the two highest official positions in the city government. Aristocratic, wealthy, and politically powerful, he was baptized on his deathbed. All funerals were ceremonial moments for the family, and the sarcophagus becomes a central focal point, replacing the deceased and emphasizing family ties and aspirations. Junius Bassus was interred in a splendid sarcophagus displaying a complex narrative program [2.10].

The sarcophagus of Junius Bassus was carved on three sides as if it was intended to stand in a mausoleum or in a garden cemetery. Instead the family placed it as near as possible to the tomb of St. Peter in the Vatican. The patrons and carvers of the sarcophagus seem to have been concerned with two themes—the guarantee of salvation and the triumph of the Roman Christian Church. Ten scenes from the Old and New Testaments occupy two horizontal registers and are set forth as if in tabernacles, framed by freestanding ornamental columns supporting an architrave of alternating shells and gables. The sculpture is the work of an iconogra-

2.10 Sarcophagus of Junius Bassus, Rome, c. 359. Marble, approximately 4 x 8ft. (1.22 x 2.44m). Vatican.

Types and Typology

In Christian art and thought Typology refers to the foreshadowing of persons and events in the New Testament by events in the Old Testament. The word "type" comes from a Greek word meaning figure or example. Christ himself used Jonah's three days in the belly of the sea monster as an example—the type—of his own resurrection. Moses and the brazen serpent prefigure the crucifixion; Abraham's preparation to sacrifice his son Isaac, prefigures God's sacrifice of His son, Jesus.

Typology was never a fixed system of correspondences, and individual scholars, patrons, and artists devised increasingly complex systems in the eleventh and twelfth centuries. In enamels that are now assembled as an altarpiece (see Ch. 9) Nicholas of Verdun divided the Old Testament types into events occurring before and after Moses received the Law. Nicholas set up a three-part system in which the New Testament antitype was flanked by Old Testament types; for example, on the theme of betrayal, the Pre-law type is Cain slaying his brother Abel; the New Testament antitype is the Kiss of Judas, the betrayal of Christ; the Post-law type is Joab slaying Abner, whom King David had granted safe conduct.

In another system medieval scholars recognized four levels of interpretation: the literal, the allegorical, the moral (tropological), and the spiritual (the consideration of divine reality or anagogical interpretation).

pher or master sculptor who knew the conventions of the Passion cycle so well that he felt free to use traditional images and to improvise new ones. He may have invented the image of Christ enthroned in majesty above the personified heavens, an image traditionally associated with Jupiter. To combine the image with "the handing down of the law" *(tradio legis),* the moment when Christ designates Sts. Peter and Paul as his successors, was ingenious. Next to this image is the martyrdom of Peter (a rare image thought to have been used first in the apse mosaic of St. Peter's). Below is the Entry into Jerusalem, which begins the Passion cycle.

At the right Christ stands in front of Pontius Pilate, who, washing his hands, initiates the sacrifice that will lead to Salvation. All around are Old Testament prefigurations (types)—Adam and Eve, whose sin made necessary the sacrifice of Christ, Abraham and Isaac, Daniel and the lions (a toga-clad figure replaces the original nude), and Job and his wife. Peter and Paul, the first saints in the Canon of the Mass, frame the image of Christ with their own martyrdoms. The emphasis on these saints affirms the second major theme on the sarcophagus—the triumph of the Roman Catholic Church through the local saints, Peter and Paul.

Architectural elements break up the surface into evenly measured units. The evenly disposed columns, gables, and entablature impose a sym-

metrical composition. Stage-like settings and figures completely fill the neutral background, and tiny trees and buildings further suppress the illusion of measurable space. The figures are short, muscular actors who move beneath form-revealing drapery, and their gestures are both dramatic and convincing. The conflict between the human images and their unreal, stagelike environment testifies to the lingering appeal that classical forms still held for wealthy Christian Romans.

The sarcophagus of Junius Bassus had an imperial size and proportions. Typical of Christian sarcophagi is the Passion Sarcophagus [2.11] from the Catacomb of Domitilla. Here symbol and narrative have been harmoniously merged. Again a few figures suggest a larger story, that is, each panel functions like an abstract emblem. Christ is arrested and brought before Pilate, who by his symbolic washing of hands leaves the Lord's fate to the will of the multitude. At the left a Roman soldier mockingly crowns Christ with a wreath of thorns, and then Simon of Cyrene seeks to lighten Jesus' burden by carrying the Cross, an act indicating the obligation of every Christian metaphorically to bear the Cross after Christ. The Crucifixion and Resurrection are implied, not represented. In the central panel, doves, symbols of peace and purity, perch on the arms of the Cross while overhead hangs the laurel-wreathed Chi Rho seen by Con-

2.11 Passion Sarcophagus, Catacomb of Domitilla, second half of 4th century. Rome.

stantine and thus understandable as an allusion to the triumph of the Church. However, the most striking innovation, combining symbol and narrative as never before, is the inclusion of the two sleeping figures. Sent to guard Jesus' tomb, they are the soldiers who watched in vain, unaware of the miracle of the Resurrection. Their presence reminds us that the Chi Rho stands not only for Christ's monogram and Constantine's victory, but also for Christ's own victory over death—the moment when the Lord triumphantly rose from the sealed tomb. With Jesus appearing not in human guise but under the sign of His Holy Name, we enter the symbolic world of the Middle Ages.

ARCHITECTURE

The modest buildings and houses adequate for the simple Early Christian service became inappropriate once Constantine recognized Christianity as one of the state religions. Christian architects had new problems to solve. The ever-present symbolic focus of Christianity demanded that the Church signify both the house of God and the tomb of Christ. The building had to be majestic, worthy of the Ruler of Heaven. Furthermore, this heavenly mansion on earth had to house the entire Christian community. In their efforts to create an imposing architecture, Early Christian builders rejected Roman temples and turned to the civil basilica and the tomb for inspiration.

Roman secular basilicas were large, rectangular halls that served as places for public gatherings, such as law courts, markets, and palace reception rooms. A basilica could be a simple hall with a trussed timber roof, or it might be extended by colonnades and aisles. Lower levels with shed roofs over the aisles allow the upper wall of the central aisle to be pierced with windows (the clerestory). In addition, a basilica had one or more semicircular apses projecting beyond the walls. The apse of a civil basilica provided an imposing site for a judge's seat, an emperor's throne, or the *image* of the emperor. In a church it housed the clergy and altar.

In their churches, Christians adapted the basilican form to their own purposes. At the end of the hall a single apse housed the clergy and the altar, while the hall served the congregation. The entrance was placed opposite the apse so that, on entering, the worshipper's attention was immediately focused on the sanctuary. This longitudinal orientation of the building also provided space for processions. Thus, both conceptually and functionally, the basilica fulfilled the congregational needs of the Early Christian Church.

Constantine and his successors built splendid churches to vie with pagan temples and to dignify Christianity as an official religion of the empire. Although he commissioned huge buildings for the Christians and lavished riches on their interiors, Constantine built churches with simple exteriors and placed them in the outskirts of Rome,

The Christian Basilica: Sta. Sabina

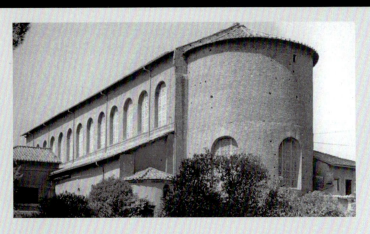

2.12
Sta. Sabina, Rome.
Exterior of apse. 422–432.

The Church of Sta. Sabina in Rome, built between 422 and 432 (and carefully restored in the 1930s) gives us a good idea of the appearance of the Christian basilica. Like the pagan secular basilica, the church consisted of a rectangular hall with a high central nave flanked by lower side aisles. A colonnade divides the nave and aisles. Sta. Sabina's nave had long, tall proportions (length 148 feet or 48 m., width 48 feet or 13.50 m., height 61 feet or 19 m.). Clerestory windows pierced the upper nave wall. Between the nave colonnade and the clerestory, a wall (the triforium) covered the blind space formed by the sloping roofs over the aisles. A raftered roof covered the nave. The nave ended in a semicircular apse covered by a half-dome vault. The juncture of apse and nave wall was called the triumphal arch. Mural decoration in painting or mosaic covered the apse and triumphal arch, and colorful marbles were used on the triforium, outer wall, and floors.

The church was oriented, with the altar at the east, except in Constantinian churches like St. Peter's. The altar stood at the front of the apse under a canopy supported by four columns (the baldachino or ciborium). In the apse, curving benches for the clergy followed the line of the outer wall. The choir, defined by low walls or the choir screen, stood in the nave in front of the altar.

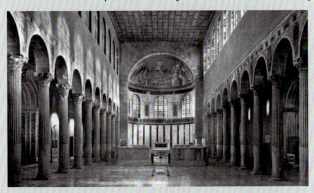

2.13 Sta. Sabina, Interior of nave.

An entrance porch (narthex) and usually a colonnaded open courtyard (the atrium) stood in front of the church at the west. The doorway into the nave might be decorated, but generally the exterior of the church was unadorned. Sta. Sabina had carved wooden doors, parts of which have survived. Additional features (not seen in Sta. Sabina) might include galleries over the aisles for women (the matroneum), a crypt under the apse, a separate bell tower, and in Constantine's buildings sometimes cross aisles or a transept. Additional rooms might be added to accommodate special requirements such as the prothesis, where the wine and bread for the Eucharist were prepared and stored, and the diaconicum, where the deacons kept archives, books, vestments, and other church treasures.

2.14
Sta. Sabina, Plan. This is a good example of the small, basilica-plan Christian churches built throughout the city once Christianity became established as the state religion.

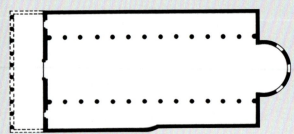

often on imperial property. Of course, cemeteries with their martyrs' shrines lay outside the city walls. The emperor may have wanted to avoid offending the pagan Romans who still held political and economic power. It is estimated that in Constantine's time the city of Rome had a population of almost 800,000 (down from a high of a million or a million and a half) of whom one third were Christians or had Christian sympathies. The wealthy, politically powerful classes remained pagan, with a few exceptions like the prefect Junius Bassus.

The Church of St. John Lateran is Constantine's first imperial Christian building. As early as 312 Constantine donated the Palace of the Laterani and the imperial horseguard to the Christians to serve as a residence for their bishop (the administrative head of the church). The bishop's church, consecrated on November 9, 318, is still the Cathedral of Rome—that is, the church in which the Pope presides as the bishop and has his throne *(cathedra)*. Early descriptions of the Lateran Basilica, originally dedicated to Christ but now to St. John (S. Giovanni in Laterano), enable us to imagine the appearance of the Constantinian church [2.15]. The original building is hidden by Francesco Borromini's seventeenth-century structure.

The ciborium and altar provided the focal point of the church [see 1.3]. The basilica, entered now from the narrow gable end, was a vast rectangular space divided by four rows of columns into a wide nave flanked by double side aisles. The colonnade and entablature accentuated the longitudinal focus of the nave, directing the viewer's eye to the sanctuary, a ceremonial path illuminated by clerestory windows at the end of the nave. The triumphal arch signified the triumph of Christ about to take place symbolically at the altar. In this sense the arch marked a dividing line between the worldly nave and aisles and the sanctified space in the apse.

Passing through the portals, the worshippers entered a light- and color-filled space. No ex-

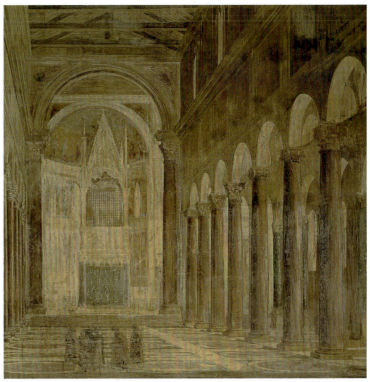

2.15 Interior of the Lateran Basilica before its reconstruction in the 17th century. S. Martino ai Monti, Fresco, Rome.

pense was spared on glittering veneers and fine furnishings. Gold foil covered the timber roof, picking up the color of the red, green, and yellow veined marble columns. More than a hundred chandeliers and 60 candlesticks, all of gold and silver, produced a shimmering light that was reflected off seven golden altars and silver statues of Christ and the apostles. Although inspired by the pomp of the imperial court, the magnificence of the church was justified as an attempt to re-create on earth the splendor of the House of the Lord in Paradise.

If the church building had been oriented solely around a congregation assembled to participate in the Mass, the basilica would have provided a model wholly satisfactory to later architects, but the organization and devotional character of Christianity had grown remarkably complex. Just as the Mass had developed from a simple commemorative meal shared in a private home to an

intricate ritual performed within the sanctified space of a church, so too Christian devotions came to encompass the saints and martyrs who sacrificed their lives as witnesses to their faith.

To aid them in their prayers for intercession, Christians wanted to associate themselves with a martyr (from the Greek for "witness"), to possess a relic of the saint, or, if a relic was not available, a strip of linen (called a brandea) animated by a relic. Eventually the inclusion of relics transformed every altar into a symbolic tomb as well as into the sacred table of the Mass. Whereas an altar or a small shrine initially marked a martyr's burial or an especially holy place, when thousands of pilgrims began to visit, buildings known as martyria had to be erected to accommodate the crowds and to protect the relics. Cemeteries became crowded not only with tombs but with facilities for funeral and commemorative banquets and shrines of the martyrs—that is, funeral basilicas and martyria.

Such a complex with a basilica, funeral basilica, and catacomb arose on imperial lands outside Rome around the burial place of St. Agnes (S. Agnese) beside the Via Nomentana [2.16]. A funeral basilica combined the features of a covered cemetery, a banquet hall, and a church where commemorative banquets ended with the celebration of the Mass. Graves filled the building, and tomb slabs paved the floor. To enable the congregation to approach the altar and to pass by the relics in the shrine under the altar, the builders projected the side aisles into an aisle encircling the apse (an ambulatory), making a U-shaped plan. This ambulatory permitted people to walk around the altar, at the same time protecting the relics from the possibility of desecration. Thus, a new type of church developed in response to the practical requirements of the veneration of martyrs and the dead.

Tombs joined basilicas in the expanding repertory of Christian architectural types. The typical pagan mausoleum was a tall chamber, square, polygonal, or circular in plan, and often covered by a dome, symbolic of the Dome of Heaven. The mausoleum of Constantine's daughter (dated some-

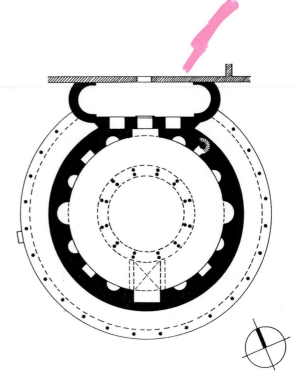

2.16 Plan, Church of Sta. Costanza, c. 350. Rome.

time between the death of Constantine in 337 and of the princess about 351) is a typical circular central domed structure extended with an encircling ambulatory [2.17]. The exterior is unadorned, but inside, twelve pairs of columns support the dome on an arcade and clerestory wall. A barrel vault covers the circular ambulatory. Four niches (one of which includes the entrance and one, the space for Constantina's sarcophagus) suggest the form of a cross. Twelve windows lighting the central space may symbolize the twelve apostles. Today the tomb is the Church of Sta. Costanza, another form of the princess's name.

Constantina was a Christian but the aggressive paganism of her two husbands may have influenced the decoration of her tomb. The decoration of the dome (lost), the ring vault of the aisle, and the niches combined religious and secular themes [2.18]. A host of cupids, libation vessels, assorted birds, foliage, and the ever-present grapevine come together in a celebration that could be interpreted as either Bacchic or Christian. Clearly the artists came from the syncretic milieu of the Constantinian court. The mosaics, with their pagan motifs

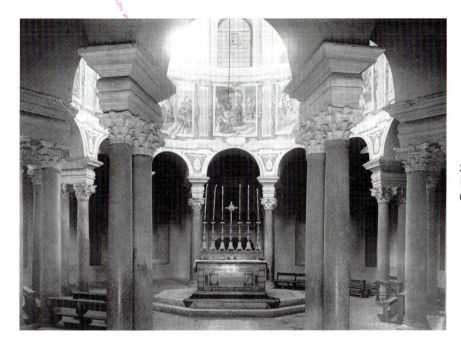

2.17
Interior, Church of Sta. Costanza, c. 350. Rome.

2.18
Vintaging putti, Church of Sta. Costanza, Mosaic in ring vault, c. 350. Rome.

and late Roman style, are related to floor mosaics in both theme and technique and to decorated ceilings in composition. Fully modeled objects and figures are depicted against a light background laced with ornamental frames and foliage. In some panels cupids and nymph-like females fill medallions formed by a continuous circular interlace, while in two panels putti work enthusiastically in a vineyard. Although Christians had appropriated the popular images of grape vines to allude to the wine of the Eucharist, any overt sign for Christ is absent. The mosaics at Sta. Costanza exemplify the coexistence of Christianity and paganism found in fourth-century Rome.

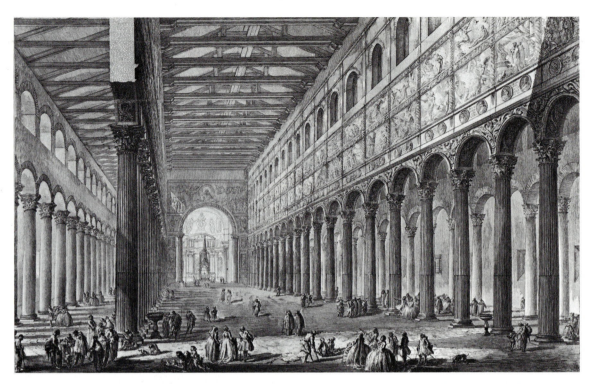

2.24 Interior of the Church of St. Paul Outside the Walls in the 18th century. Etching, 1749. G. B. Piranesi.

the eighteenth century [2.24] before a fire in 1823 destroyed much of it (but left the sanctuary and right wall standing). In the spring of 384 or 386, Theodosius I began a basilica, which copied old St. Peter's. It was finished about 400. The builders made a few changes from St. Peter's: They oriented the plan, placing the altar at the east; the transept was as high as the nave and projected only slightly beyond the line of the walls; and the nave colonnade supported arches, not entablatures. Ample supplies of expensive materials were available from disused pagan temples. Columns came from pagan buildings, but new capitals were carved for the church. The mosaics and painted decorations of the church were part of the restoration work carried on by Pope Leo I (440–461) with the financial help of the Empress Galla Placidia.

THE FIFTH CENTURY

Rome remained the spiritual center of the Western Empire and the home of the Pope, but the city lost its political power after Constantine moved the imperial capital to his New Rome, Constantinople (see Chapter 3). Later in the fourth century Milan developed into the administrative and commercial capital of the Western Empire. St. Ambrose (340–397), who became bishop of Milan in 373/374, transformed that city, for a short time, into the foremost ecclesiastical center of the West. The sack of Rome by the Goths in 410 and Vandals in 455 shocked the world.

At the beginning of the fifth century, Honorius, emperor of the west, moved the capital again, this time to Ravenna, a port on the Adriatic Sea. In Rome, in the course of the fifth century, the Popes grew ever more powerful under the leadership of Sixtus III (432–440) and Leo I (440–461). But by the end of the century the population of the city had fallen to about 100,000; Christianity was the only permitted religion; and the Pope was the de facto ruler of the city.

Even Ravenna was not a safe haven for the Western government, and at the end of the century the Arian Goths captured the city. Theodoric the Great, king of the Ostrogoths, made Ravenna his

Galla Placidia

Galla Placidia—daughter, sister, wife, mother, and grandmother of kings and emperors and Augusta herself—led the kind of life only imagined today by romantic novelists. The princess was born in Constantinople about 388/89 to Theodosius I the Great and his wife Galla. She was sent to Milan (the seat of government in the west) to be educated by St. Ambrose in 394. When Theodosius died in 395, the divided empire was ruled by her half-brothers Honorius in the west (395–423) and Arcadius in the east (395–408).

During the fourth century the Goths and other barbarian peoples moved into the Roman Empire. Galla Placidia had the misfortune to be living in Rome at the time that the Visigothic King Alaric laid siege and sacked the city, 408–410. (At the time Honorius and the Pope were both living safely in Ravenna). Carried off as a hostage, she moved with the Visigoths through Italy, southern Gaul, and into Spain. In 414 she married the Visigothic King Athaulf. Within a year she had a son; the baby died; her husband was murdered; and her own existence became precarious. Finally the Goths allowed Galla Placidia to return to the Romans. In 417 Honorius forced her to marry his general, Constantius.

Galla Placidia had a daughter, Justa Grata Honoria, and then in 419 a son, Valentinian. Honorius, having no heir, appointed Constantius his co-ruler and his sister Augusta in 421. When Constantius died a few months later, Galla Placidia was suspected of abetting conspiracy. She fled with her children to Constantinople, where Theodosius II had ruled since the death of Arcadius.

When Honorius died in 423 still without an heir, Theodosius should have ruled both East and West, but the Roman Senate elected a new emperor. Theodosius II declared Valentinian to be the rightful ruler, made Galla Placidia Augusta (Empress of the West), and sent his army to defeat and execute the usurper. Galla Placidia assumed the regency for her six-year-old son, who was proclaimed Emperor as Valentinian III and crowned in Rome on October 23, 425. The story does not end happily with this victory, however, for both the Huns and the Vandals continued to threaten the slowly disintegrating empire. Galla Placidia found an implacable and clever rival in the general Aetius, who was in league with the Huns. When Valentinian came of age in 437, Aetius made his move, and in 438 Galla Placidia had to retire from active politics.

Galla Placidia's influence continued as a staunch defender of the Pope and as a patron of the arts. In Rome, she added mosaic decorations to the Church of St. Paul's Outside the Walls, and in Ravenna she built churches including the Church of the Holy Cross (Sta. Croce). Attached to Sta. Croce's narthex, she built a chapel dedicated to St. Lawrence. Galla Placidia may have intended the building to be her mausoleum, but she died in Rome on November 27, 450. Her burial place is unknown. As a postscript to her life, we must note that Valentinian murdered Aetius in 454 and was himself murdered by Aetius' allies in 455. In 455 the Vandals occupied and looted Rome, and in 476 the empire in the West came to an end.

capital and ruled there from 497 until his death in 526, nominally as vice-regent for the Byzantine emperor, but in fact as an independent king.

The Eastern Roman Empire, meanwhile, was ruled from Constantinople, where Arcadius and his son Theodosius II (b. 401, ruled 408–450) created an effective bureaucracy and stable government. They ushered in a period of internal civil peace and prosperity, although Persians and the Goths remained a threat and the Huns had to be bought off with large amounts of gold. The Eastern Church, however, was not at peace, for debates over the nature of Christ and the role of the Virgin Mary in-

tensified. Heresies spread throughout the East. Nestorianism denied Mary the title "Mother of God" (*Theotokos*, or God-bearer) by claiming that while Jesus' divine nature came from the God the Father, the Virgin bore him solely as a human. In 431 a church council at Ephesus attempted to settle the controversy and decreed that Christ had two distinct natures, human and divine, inseparably joined in his one person. Another heresy developed out of a reaction to Nestorianism. Monophysitism, or belief in a single nature, held that Jesus was wholly divine. The Council of Chalcedon in 451 attempted to destroy Monophysitism, but as

before, the bishops' decisions only clarified theological issues, doing little to end the strife. Syria and Egypt remained bastions of Monophysitism, and as the century progressed the controversy persisted. The Coptic church is still Monophysite.

The historical overview of the fifth century reveals the empire beset by dangers from within and from without. The West remained spiritually unified under the Pope but fragmented by military invasions. Meanwhile the East, although politically unified under the emperor at Constantinople, found itself rent by religious wars. As if to escape the turmoil of their own time, people looked nostalgically back at the fourth century when architects and artists evolved new forms befitting the special requirements of Christianity. The fifth century, particularly in Rome and Constantinople, became an era of consolidation and retrospection, while in outlying regions artists adapted Roman Christian art to suit local needs.

ROME IN THE FIFTH CENTURY

In Rome especially during the reign of Pope Sixtus III, the purest form of the classical revival flourished. Although partly the product of the Pope's own refined taste, the invocation of ancient Rome also lent an aura of stability and grandeur to Christian art. Christian artists underplayed the materialistic aspects of pagan classicism, as though they sensed that a style proper to one kind of image might be incongruous when applied to another. The result, however, was that the classical revival simply appeared in a more veiled manner in work such as the ivory representing the Ascension and the Holy Women at Christ's Tomb seen earlier [see 2.18]. The image is based on the apocryphal (unauthorized) Gospel of James rather than the brief account of the Ascension in Acts 1:9–12. Compared to the Passion Sarcophagus [see 2.11], the figures have more natural proportions, and they move dramatically within an illusionistic environment. Legs and feet extend beyond the frame to thrust the figures forward into the viewer's space. Space within the frame is also indicated, for the figures are foreshortened, and the lumpy hillside provides a continuous landscape setting. Christ triumphantly strides up to grasp the hand of God, represented in an art that remains richly evocative of ancient Rome.

This classical heritage appears in ever-changing guises [2.25]. In an ivory with a Crucifixion scene, probably carved in Rome about 420–430, the

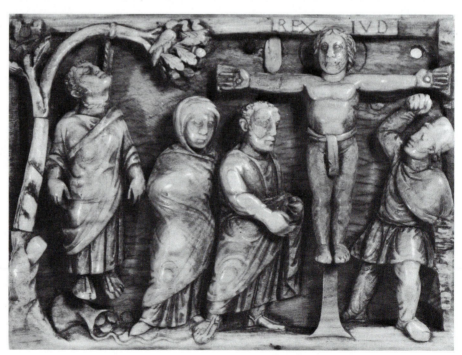

2.25
The Crucifixion and the suicide of Judas, Rome or southern Gaul, 420-30. Ivory, 3 x 4in. (7.6 x 10.2cm). The British Museum, London.

proportions of the figures have become stocky, the heads large, and the musculature stylized. At the left, a tree, instead of gracefully receding through a gradual lowering of the height of relief, as in the Ascension ivory, stands isolated against a flat ground—so much so that it describes not a real space but a symbolic one.

The classical heritage surfaces, however, here in the narrative concept. At the right, the Roman centurion Longinus shields his eyes in reference to the miracle of his sight. On the other side of the cross stand Mary and either St. John or—because the figure is bearded—Joseph of Arimathaea, the pious Christian who would later place the body of the Savior in his own tomb. In the tree above, a bird feeds its young, a reference to the eternal life promised by Christ. In contrast to these positive images of salvation, Judas swings lifelessly from the tree as telltale silver coins spill out of a bag at his feet. By representing two separate moments with a single frame, instead of dividing events by columns or other confining devices, the artist imitated the tradition of continuous narrative used in imperial Roman reliefs. The portrayal of the protagonists also establishes the dramatic element. The erect posture, open eyes, and idealized anatomy of Christ on the Cross characterize his sacrifice as triumphant. The letters above his head read REX IUD, "King of the Jews." The heroic image of Christ contrasts with Judas, whose body dangles limply from the tree. This concern for narration and drama belongs to the ancient tradition of Roman realism.

The most monumental evidence of the classical revival appears in Roman churches. Churches had been spared during the fifth-century pillaging of Rome, thanks in part to the Goths' and Vandals' own Arian Christianity. The heretics' presence in Rome, however briefly, provided another reason for the assertion of pontifical authority. The Popes had not only claimed primacy over the patriarchs of Constantinople but also had to prove that their condemnation of Arianism was binding throughout the empire. The building of churches like Sta. Sabina on the Aventine Hill (see Box: *The Christian Basilica of Sta. Sabina*) and Sta. Maria Maggiore on the

Esquiline and the decoration of the basilicas of St. Peter and St. Paul outside the Walls became important projects for Popes Sixtus III and Leo the Great, who enjoyed the support of the imperial family.

The decoration of the majestic basilica of Sta. Maria Maggiore [2.26] became Pope Sixtus' single most important project. New research suggests that the church had been begun about 30 years before Sixtus' reign and that it had an unusual plan. Like the funeral basilicas of the fourth century, the side aisles of the nave continued around the apse to form an ambulatory. An Ionic colonnade, continuous with the nave colonnade, defined the sanctuary. The builders faithfully copied classical architecture, so the columns carry an entablature whose frieze is ornamented with a classical foliage scroll. Pilasters divide the upper wall into panels framing mosaics under clerestory windows. The building has been altered many times over the centuries, and photographs do not do it justice. The splendid ceiling we see today was given by Ferdinand and Isabella of Spain and is covered with gold brought from the Americas.

Early Christian mosaics survive in small panels on the triforium wall of the nave and the triumphal arch. The nave mosaics have the oldest surviving narrative cycle from Christian Rome. They illustrate the Old Testament stories of Abraham, Jacob, Moses, and Joshua, but the Old Testament patriarchs are also interpreted as prefigurations of Christ. Although late antique in style, the dramatic imagery of the narratives may have been inspired by Jewish illustrated manuscripts. Uniquely Christian is the emphasis on allegorical and miraculous happenings [2.27].

The rebellion of the Jews against Moses focuses on God's intervention to save Moses. Having wandered through the desert seeking the Promised Land, the people began to lose faith in their leaders. As interpreted in the mosaics, when the spies returned from Canaan with their report, the rebellious people angrily stoned Moses, Joshua, and Caleb. Just as the Old Testament describes (Numbers 13:25–31 and 14:10), the people throw stones at the men to no avail. In the center of the composition the stones literally bounce off "the glory of

2.26
19th Century reconstruction drawing of nave, Church of Sta. Maria Maggiore, 432–440. Ceiling after 1492. Rome.

2.27
Rebellion Against Moses, Church of Sta. Maria Maggiore, 432–440. Mosaic in the nave. Rome.

the Lord" that surrounds Moses and his lieutenants. The indescribable presence of God is represented by His hand above and the mandorla, an almond-shaped aureole of light.

The Roman illusionistic style lingers on in the solid modeling of the figures and in their energetic gestures, in the landscape background of rolling hills and blue sky, and in the perspective rendering of the city walls and tabernacle. On the other hand, strong outlines encompassing shoulders, arms, and much of the architecture tend to flatten the forms. The artists carefully graduate the colors to suggest rounded forms; at the same time they introduce space-denying gold tesserae. Their use of gold marks a shift from the classical Roman style to the intentional immateriality of medieval art.

In the New Testament mosaics of the triumphal arch, the symbolic mode grows noticeably stronger [2.28]. The figures have lost that lively mobility of gesture that gave dramatic force to the nave mosaics. Instead, they stand erect and immobile. Since their heads nearly touch the top of each register, they block any illusionistic view into the background. This hieratic presentation suits the location on the triumphal arch and the message contained in the subject matter. Underlying the New Testament images is the reminder of the de-

crees of the Council of Ephesus. The mosaics proclaim both natures of Christ—his eternal divinity and his humanity. The role of Mary as *Theotokos,* the Mother of God, and her lofty position as Queen of Heaven and receptacle of divinity are emphasized by her enthronement, her regal costume, and the attentive presence of guardian angels. Moreover, Jesus appears not as a baby in his mother's lap, as in the early catacomb paintings [see 2.7], but as a miniature adult. The youthful Savior sits isolated on a throne and reigns as King of Heaven with his angelic court. The Magi approach bearing gifts; they appear as Zoroastrian priests and symbolize the Gentiles. At the crest of the arch, all the implicit references to Christ's divinity converge upon a single symbol: In a medallion flanked by Sts. Peter and Paul and the emblems of the four Evangelists, an imperial throne supports a cross, a crown, and the apocalyptic lamb—all three together symbolizing Christ's triumphant Second Coming. Beyond the arch, the original apse mosaic had an image of the Virgin, as Queen of Heaven. Thus, at the visual climax of the church, she was raised to an exalted state suitable only for the Theotokos.

Through the affirmation of Mary as Theotokos in the Church of Sta. Maria Maggiore, Pope Sixtus

2.28
Infancy of Christ, Church of Sta. Maria Maggiore, 432–440. Mosaic on the triumphal arch. Rome.

refuted Nestorianism and defended the Roman prerogatives. His successor, Leo the Great, made a similar claim for absolute authority at mid-century when the Council of Chalcedon met to condemn Monophysitism. Pope Leo supported his claim by glorifying St. Peter and St. Paul in a campaign of church decoration. The Pope's efforts can only be imagined, for little remains of the work completed during his pontificate. Drawings, watercolors, and prints made before the destruction show the paintings ordered for St. Peter's, St. Paul's, and the Lateran basilica by Pope Leo.

In contrast to its austere exterior, the interior decoration of St. Peter's was light and colorful, shimmering with polished marble and mosaic. The columns with Corinthian capitals were *spolia* (spoils taken from pagan buildings). In figural imagery, the artists and patrons were both followers and innovators. Since an image of the emperor had been placed in the apse of a basilican civil court, it followed that an image of Christ, the King of Kings, should be located in the apse of a basilican church. But the apse mosaic also has a new theme—the dramatic moment when Jesus singled out St. Peter—and consequently the bishopric of Rome—to be the foundation of the Christian Church. The *traditio legis,* or the handing down of the law, had its most monumental expression here. In the transept, illustrations of the life of St. Peter attested to his importance as the chosen Apostle. In the nave, Pope Leo commissioned a double row of Old and New Testament scenes and, below them, resting on the architrave, roundels with portraits of all his predecessors, beginning with St. Peter. The Popes form a symbolic progression down the nave to the apse, where Christ ordains their illustrious founder.

Pope Leo with the backing of Empress Galla Placidia also ordered the decoration of the Basilica of St. Paul Outside the Walls. In paying homage to the two founders of Christian Rome by enriching their churches, Pope Leo gave moving testimony to the divinely prescribed heritage of the Roman bishops, whose mortal remains lay under the great funeral church, and to the primacy of Rome as the apostolic See.

FIFTH-CENTURY ARCHITECTURE AND DECORATION OUTSIDE ROME

Patrons and their architects outside Rome adapted traditional architecture and visual arts to regional traditions. In response to local materials and methods of construction, as well as to slightly differing ceremonial practices, patrons might order builders to add towers or elaborate the atrium courtyard and narthex or entrance porch to the familiar basilica. They might rethink the design of the transept area or add galleries over the aisles. Because of the requirements of the Eastern Orthodox rite, they might add rooms to the narthex or the apse where the clergy prepared and stored the consecrated Host (the prothesis) and housed the archives, treasury, and clerical vestments (diaconicon, or sacristy).

In Ravenna, Galla Placidia embarked on a building campaign while ruling as regent (425–437) for her young son Valentinian III. One of her first buildings was the Church of Sta. Croce, now partly destroyed but known for the small mausoleum and martyr's chapel that adjoined its narthex [2.29]. The cruciform chapels stood at each end of the narthex; the one at the right was probably dedicated to St. Lawrence. The present-day appearance of the chapel is deceptive, for the ground level of Ravenna has risen, reducing the building's tall proportions. For the building the architects adopted the cross plan in which the four wings abut the sides of a higher central block [see the Church of the Holy Apostles, 2.16]. Blind arcades strengthen and enliven these outer walls, and alabaster panels fill the narrow windows. The arms are capped by pediments and tiled roofs. Even the fabric of the mausoleum—not stone or thin Roman bricks but thick bricks with narrow mortar joints—denotes the participation of craftsmen from northern Italy.

On the interior the original vertical proportions of the chapel are apparent [2.30]. Rising over the lower, barrel-vaulted arms and giving the effect of a soaring space within the tiny building, the tall crossing bay is covered by a pendentive dome. An atmosphere of luxury pervades the dark interior. The lower walls are veneered in veined marble; and ornamental and figurative mosaics glisten on the

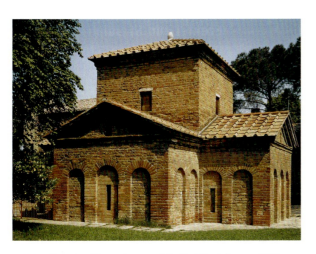

2.29 Exterior Mausoleum of Galla Placidia, c. 425. Ravenna.

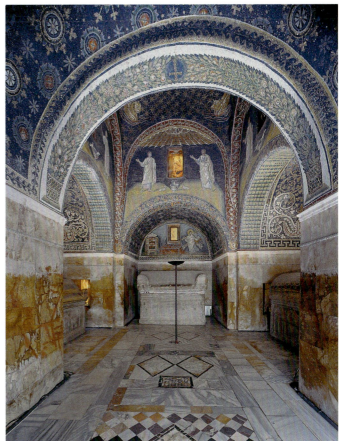

2.30
Interior, Mausoleum of Galla Placidia,
Ravenna, c. 425–450.

walls and vaults. White and gold stars or flowers turn the blue vaults into a vision of paradise while the dome of Heaven covers the crossing. This allusion to the celestial realm accords with the iconographic program of the mosaics, since each of the four lunettes at the terminals of the cross arms contains a scene that alludes to salvation through Christ: the Good Shepherd [2.1], stags symbolizing Christian souls drinking the waters of paradise, and the martyr St. Lawrence (d. 258).

In the mosaic depicting St. Lawrence, the saint strides eagerly forward to his martyrdom on a flaming grill. (The Romans executed Lawrence for refusing to turn over the Church's money.) The Word of the Lord is symbolized by the four Gospels resting on the shelves of the cupboard at the left. Read together, the elements of the composition represent two possible vehicles of deliverance available to the pious Christian. The gridiron on

which the saint was tortured and the Cross he carries signify redemption through the intercession of martyred saints. The images do not, then, unfold in narrative fashion, as do those in Roman churches, but rather stand as separate emblems to be contemplated.

The central crossing rises above the barrel vaults of the four arms. Silhouetted against the blue of the walls are pairs of apostles [2.31]. They gesture upward, acclaiming the Cross in the star-studded blue and gold sky. The four mystical creatures described by Ezekiel appear in clouds. In the center of the dome, positioned in relation to the door, a golden cross symbolizes the divinity of Christ, in contrast to Christ as the Good Shepherd in the lunette below. Here, the idea of the Second Coming is bound up in the divine light of the golden cross. In Neoplatonic fashion, the decorative program moves from earthly references in the lunettes

to Holy Wisdom (Hagia Sophia) faced the palace across a square. Beside the palace stood a racecourse (Hippodrome) with its loggia, a place where the emperor and the court made official appearances. Defensive walls protected the city from land attacks and the navy guarded the waterways.

The great age of Byzantine architecture began with a military project in the fifth century—the building of a new city wall [3.2]. Early in his reign

3.2 Land walls of Constantinople, built by Theodosius II, 412–413.

(408–450), Theodosius II expanded the city by constructing a second wall about a mile beyond the fourth-century defenses. The new fortifications were necessary in order to secure the city from the barbarians in the west and Persians in the east. These Theodosian defenses—double walls and a moat—provided the city with effective protection for more than a thousand years. They held back in-

vaders until 1453, when elite troops of the Turkish sultan, using cannon for which no fifth-century builder could have prepared, finally broke through the fortifications.

That the ramparts stood firm for a millennium was due to the inventiveness of the imperial engineers. (Their work provided a model for builders of fortifications throughout the Middle Ages.) Sea walls and the navy defended the city against attacks from the sea, and the Golden Horn (the harbor) could be closed to ships by drawing a giant iron chain across its entrance. Danger lay on the land side of the peninsula, and here the engineers created a whole defensive system rather than a single wall. This system, four and a half miles long and about 180 feet (54.9m) wide, was composed of alternating walls and terraces and a moat. An enemy first encountered a 60-foot (18.3m) stone-lined moat, reinforced with additional earth embankments, then a terrace and a massive towered wall. A second terrace led to a mighty inner wall, 36 feet (11m) high and 16 feet (4.9m) thick. These inner fortifications commanded and protected the outer. The inner wall was strengthened by battlements, fortified gates, and 96 huge towers, which stood 80 feet (24.4m) high. The towers projected beyond the wall and served as firing platforms. The defenders could unleash a raking crossfire against intruders along any part of the wall. Finally, since every tower was physically independent of its neighbor, the enemy had to try to take them one by one.

The only inherent weaknesses in the walls were the gateways leading into the city, but to reduce this liability the defenders flanked each of the openings with a pair of towers. The principal entrance was the so-called Golden Gate, an impressive structure covered with marble revetment and closed with gilded bronze doors. The outer gate opened only into a courtyard in front of the main gate. This space was surrounded by walls and towers so that an invading party, breaching the outer defenses, would find itself trapped under a barrage of fire from soldiers in the inner towers.

The builders of the Theodosian walls adopted an ancient eastern Mediterranean masonry system in which alternating courses of stones and bricks

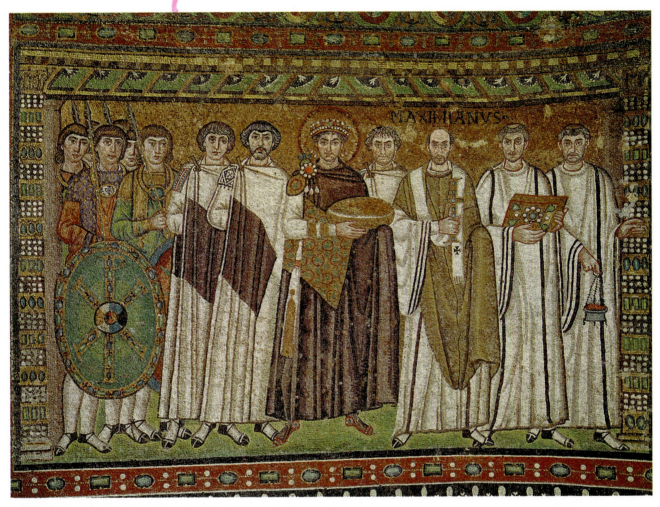

3.3 Emperor Justinian and his attendants, mosaic on north wall of the apse, Church of San Vitale, c. 547. 8ft. 8in. x 12ft. (2.64 x 3.65m). Ravenna.

faced a solid core of concrete and rubble. In the tower rooms thin bricks set in thick mortar formed light, strong vaults. Here engineers and masons gained practical experience, which was to stand them in good stead when the emperors ordered them to build elaborate churches and palaces.

In the sixth century, Justinian (ruled 527–565), a man as remarkable in his own way as Constantine, ruled the Eastern Empire [3.3]. With the help of brilliant advisers he achieved the imperial goal of a revitalized, unified Empire. His closest adviser may have been his strong-minded wife, Theodora. Justinian appointed the generals Belisarius and Narses to turn back barbarian threats and

win new territories for the empire. Justinian called upon John of Cappadocia, an administrative genius, to help reorganize the government, revise its tax structure, and set up an efficient civil service. He ordered the scholar Tribonianus to sort out the complex, contradictory, and often unjust laws and to direct the writing of a new code, or "body of civil law" *(corpus jurus civilis),* now known as the Justinianic Code. Byzantine law became the basis of many modern legal systems in the West.

With an exceptionally fine bureaucracy to administer clear and just laws, Justinian would seem, in the words of his biographer, Procopius, to have "wedded the whole state to a life of prosperity," but

in reality Justinian's reign was neither as prosperous nor as benevolent as Procopius would have us believe. Constantinople had its poor and sick, its immigrants as well as artisans and merchants. The revised taxation system permitted the emperor to increase assessments until taxes became an intolerable burden on the populace. Meanwhile, the Monophysites, a formidable sect in the Eastern Empire, grew ever more discontent with Justinian's orthodoxy. And like all medieval cities Constantinople suffered fires, plagues, and urban discontent.

In 532 the citizenry rose up against Justinian in the Nika rebellion, so called from the rioters' cheer of Nika (Victory). Within a few days the insurgents destroyed half the city, including the old Church of Hagia Sophia. Justinian panicked and his ministers begged him to flee. Theodora alone stood firm, saying that she preferred death as the empress to flight and life as a fugitive. "Purple," she is reported to have said, referring to the imperial color, "makes a fine shroud." Taking courage from the empress, Justinian remained in Constantinople and, with the aid of Belisarius, put down the rebellion. The rebuilding of the city and of the churches began at once. So did a campaign of reconquest throughout the Mediterranean. Justinian extended the empire as far as Spain, recaptured Italy from the Goths, and made Ravenna his western capital.

Justinian tried to unify the empire further by enforcing the pronouncements of the fifth-century church councils of Ephesus and Chalcedon. Of the five great patriarchies, Rome, under the Pope, became the spiritual capital of Christendom, while at the same time the patriarch of Constantinople became the senior bishop in the east. The patriarchies of Antioch, Alexandria, and Jerusalem gradually lost power. Like Constantine and Theodosius before him, Justinian convened church councils in an attempt to reconcile the quarreling Christian factions. Although the Second Council of Constantinople (553) was only marginally successful, the emperor emerged as the political head of the Church. Such an exercise of temporal and religious authority is called "caesaropapism." The term is especially applicable to Justinian, a secular emperor who nevertheless ruled as a sacred monarch, living in a sacred palace, and surrounded by elaborate rituals.

ARCHITECTURE

Secure from barbarians and Persians behind the Theodosian walls, and in full control of the city after the Nika rebellion, Justinian embarked on a building campaign that not only changed the city but demonstrated his generosity throughout the state. The court historian Procopius devoted an entire book, *On Buildings,* to Justinian's works. According to Procopius, the emperor sponsored more secular architecture than he did religious building; however, the secular buildings have been destroyed or remodeled. Churches, on the other hand, were often preserved out of respect for tradition; consequently, the accomplishments of Byzantine architects can be viewed today primarily in religious buildings. Hagia Sophia as well as churches in the western capital of Ravenna attest to the brilliance of the Byzantine court and the lasting achievement of its artists.

The Nika rebellion had left the city center in ruins. No sooner had Justinian subdued the rebellious citizens in 532 than he set out to erect a new Church of Hagia Sophia [3.4]. Construction progressed so rapidly that the project was completed in the short space of five years—clear testimony to the emperor's overriding concern for the project. Surely Justinian's personal interest spurred the builders on to create one of the most original monuments in the history of architecture, a church that fulfilled all the aesthetic, symbolic, and functional needs of the Byzantine Church. Hagia Sophia was known simply as "the Great Church."

That the finest structure in the long history of Byzantine architecture was created at the very outset of Justinian's reign rather than after generations of experimentation may seem remarkable, but Justinian was a patron of unusual energy and sophistication. Only a daring and discerning patron would have been inspired to select as architects two theoretical scientists who had never confronted the problems of erecting an actual building. An-

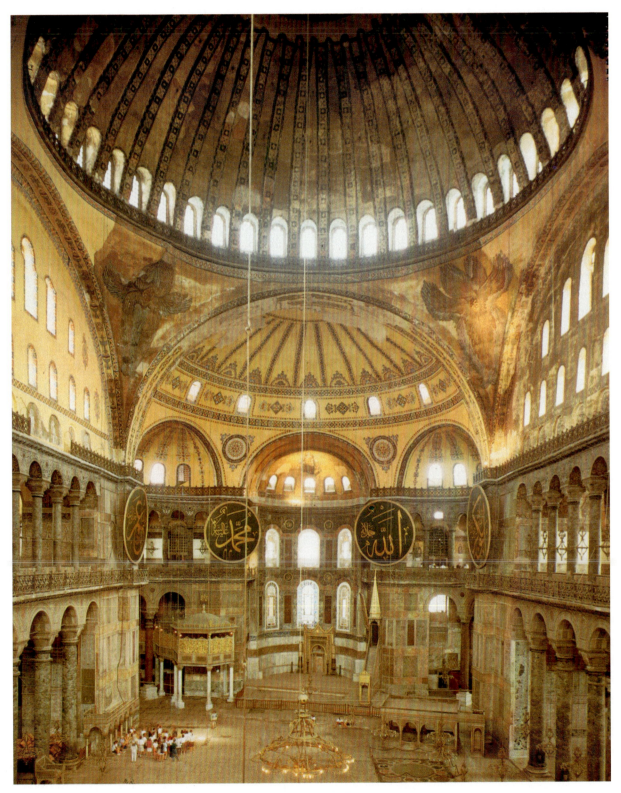

3.4 The Church of Hagia Sophia, (modern Istanbul) 532–537. Constantinople.

themius of Tralles, a Greek mathematician, specialized in geometry and optics. To complement Anthemius' abstract talents, Justinian chose Isidorus of Miletus, a professor of physics at the universities of Alexandria and Constantinople, who was an academic expert in the mechanics of thrust and support and the author of a scholarly commentary on vaulting. In his extraordinary perceptiveness, the emperor foresaw that the Church of Hagia Sophia, in order to rise as the perfect embodiment of imperial power and Christian aspirations, had to be designed by men whose theoretical knowledge could transcend the limits of contemporary architectural practice.

Justinian's architects succeeded magnificently. They captured the spiritual and ceremonial needs of the Orthodox Church by integrating the longitudinal and centralized schemes of early Christian buildings in a manner inconceivable to Constantinian architects [3.5]. Fourth- and fifth-century architects simply built basilicas and rotundas next to each other and linked them by colonnades, as we have seen at the Holy Sepulchre in Jerusalem. The extraordinary Byzantine achievement was to consolidate the basilican plan and elevation with the central domed martyrium into one logical and indivisible whole. The inspiration to fuse the disparate types seems to have come from the liturgical and symbolic requirements of Byzantine ritual. In the Byzantine rite, the Gospel and the Host remained in or near the sanctuary. (In the Middle Byzantine period, about which we have more information [see Chapter 6], the Eucharistic proces-

sion no longer followed the longitudinal direction of the nave but formed a circuit moving around the apse and its adjoining rooms—the diaconicon and the prothesis—into the nave, and back again.) In order to make the structure at one with ceremony, Byzantine architects turned to the dome, the hemispherical symbol of the canopy of Heaven. Indeed, the very word "Byzantine" today conjures up visions of rising domes and vaults covered with shimmering mosaics. The dome is a shape that encourages the eye to circle upward, seeking the crown of the vault. In marked contrast to the driving horizontal movement down the nave to the apse in a basilica, the movement in a domed building revolves around a central vertical axis. One can even draw a striking parallel between the two structural types and their characteristic decorations. In architectural terms, the basilica is to the narrative scheme what the dome is to the symbolic image, in that the first suggests an active succession of events while the second induces a static contemplative state.

In order to vault the enormous spaces demanded by the imperial ceremonies, Justinian's builders gave the dome on pendentives its definitive form. Pendentives had appeared as early as the second century, and we have seen a pendentive dome over the central crossing in Galla Placidia's chapel, but the Byzantine architects were the first to make extensive use of the forms. Moreover, they reduced the weight on the load-bearing walls by substituting a brick and mortar construction, similar to that found in the towers of the land walls, for the traditional stone or concrete fabric. In so doing, the architects could build very large domes and half-domes, and support them with fewer and lighter piers and abutments.

Such was the structural and visual adaptability of the dome on pendentives that it could be applied to several different plans—domed basilicas, domed octagons, and domed Greek-cross churches. Even the number of domes employed remained variable, so that in the course of the sixth century two major types of domed architecture evolved. In one, a single dome covered a central area usually expanded by aisles and galleries. In an-

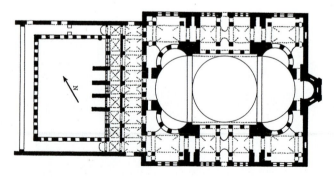

3.5 Plan, Hagia Sophia. Body of building, 226ft. 7in. x 244ft. x 8in. (69.1 x 74.6m).

The Dome

A dome, like the vault, is an extension of the arch (imagine an arch pivoted on its axis). Just like an arch, the dome exerts a dynamic thrust outward with the greatest movement occurring at the curving haunch. The steeper the profile of the dome, the less outward thrust it exerts and the more stable the structure becomes. A pendentive is a spherical triangular section of masonry that makes a structural transition from the square of the bay to the circular rim of the dome. The walls, piers, and pendentives carry the sheer weight of the dome while the thrust is countered by galleries and half-domes abutting the dome. Since the dome needs continuous support at the rim, sometimes it is literally tied with chains or timbers. One of the most spectacular domes on pendentives is that of Hagia Sophia [3.6 and 3.7].

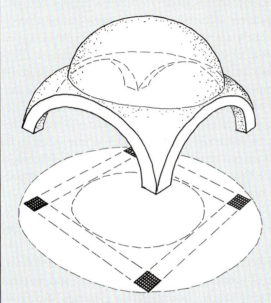

3.6 Diagram of pendentives.

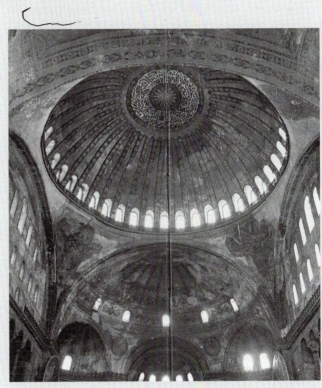

3.7
Hagia Sophia, interior of dome.
Height of dome 184ft. (56.1m).

other, several domes covered the nave and transept or the arms of a Greek cross (seen in the Church of the Holy Apostles). Although the multidomed building had a wider and more lasting influence than did buildings roofed with only one dome, it was the single-domed church, developed by Justinian's architects and perfected at Hagia Sophia under his special patronage, that generated the most imaginative aesthetic and structural forms. The designers converted the dome on pendentives into a canopy that not only covered an extensive space and mirrored the circular path of the Eucharistic ceremony but also served to integrate the forms and spaces of the entire fabric into an indissoluble whole.

The greatness of Anthemius and Isidorus lay in their ability to reconcile the inherent conflict in Christian church architecture between the desire for a symbolic, upward-soaring space and the need for a directional focus on the altar. From afar, Hagia Sophia commands the whole skyline of Constantinople. If we block out the four minarets—those slender towers added by the Muslim Turks—Hagia Sophia ascends from an earth-hugging mass into a man-made mountain. The dome that crowns the upward-surging exterior also dominates the inte-

rior. Through a series of large niches (exedrae) and half domes rising to the main dome, the architects infused the inevitable horizontal movement from entrance to altar with a dramatic upward sweep of 180 feet (54.9 meters), a unique integration of the basilica and the central-domed building.

In theory (not in actual construction), the architects began with the gigantic dome, measuring 100 Byzantine feet in diameter (102 feet or 31.1 meters), supported on four enormous piers and pendentives. Then, in order to expand the church's longitudinal dimensions while accentuating the all-important rising effect of the central canopy, the architects added half domes at the eastern and western sides (creating a vaulted nave). These half domes were in turn supported by conch-covered niches. The sanctuary with an apse at the east, an atrium and double narthex at the west, and vaulted side aisles on the north and south further extended the basilica-like plan. Galleries extended over the aisles and narthex. Nevertheless, the dome remained the unifying, form-giving element in the design, drawing together sanctuary and nave into a centralized space known in Byzantine architecture as the naos (Greek, meaning "interior"). Anthemius and Isidorus defined the longitudinal space of the nave primarily with circular shapes: from the relatively low level of the narthex, the rising movement leads the eye from vaulted aisle to conch to half dome to dome and on down again to the altar. This slow rising and falling movement was originally even more fluid and continuous than it appears today, since the original dome had a shallower curve than the present one. The architects defied gravity by building a dome so low in curvature that it exerted a powerful outward thrust, and then by piercing its rim with windows.

Building techniques could not match the architects' bold imagination. They used narrow bricks and very thick mortar, building so rapidly that the mortar did not have time to set properly. In 558, part of the dome collapsed. The builders replaced it with a ribbed dome 20 feet (6.1m) higher than the first, but this second, steeper dome was balanced precariously, and it required extensive repairs—in 989, when the western section fell, and again in 1346, when the eastern half had to be strengthened. (The dome has survived recent earthquakes.) Apart from the decorations added after 1453 by the Turkish conquerors of Constantinople, the vault still retains its sixth-century appearance.

The central dome, even with its steeper profile, is an amazing achievement. The brick and mortar structure seems to levitate, as if it were truly the visionary Dome of Heaven [see 3.8]. This floating sensation results from a dramatic passage of light. Byzantine architects designed their churches with as much attention to illumination and visual effects as to structural or functional necessities. Forty windows pierce the entire rim of the dome. By opening the circumference of the dome to the sky, the architects created a luminous aureole that dematerializes the real substance of the support. Procopius remarked that the golden dome seems to be "suspended from Heaven." Even today spectators share Procopius' amazement at the dome's apparent hovering suspension.

The wonder of Hagia Sophia's physical fabric was more than equaled by the spectacle of its decoration, for Byzantine planners understood the architectural interior as an arena for a splendid display of precious materials, vivid colors, and patterns of light. Hagia Sophia's dome glistened with gold mosaic while the columns were of purple porphyry and green marble. A lustrous veneer of green, white, yellow, and purple marble covered the walls, and the windows transmitted light through panes of colored glass. The columns and architrave of the sanctuary screen were sheathed in silver and hung with red silk. Against such a background, the effects of the constantly shifting shafts of illumination must have elevated worshippers to a state of spiritual exaltation in which they felt themselves truly to be in the presence of the divine. Justinian was devoutly moved by the magnificence of his new church. Upon entering Hagia Sophia for the dedication on Christmas day, 537, he is said to have exclaimed, "Solomon, I have surpassed thee!"

Hagia Sophia, as the palace church, was a testament of unending praise to the emperor as well as to God, and Justinian took full advantage of the symbolic possibilities of the liturgical ceremony

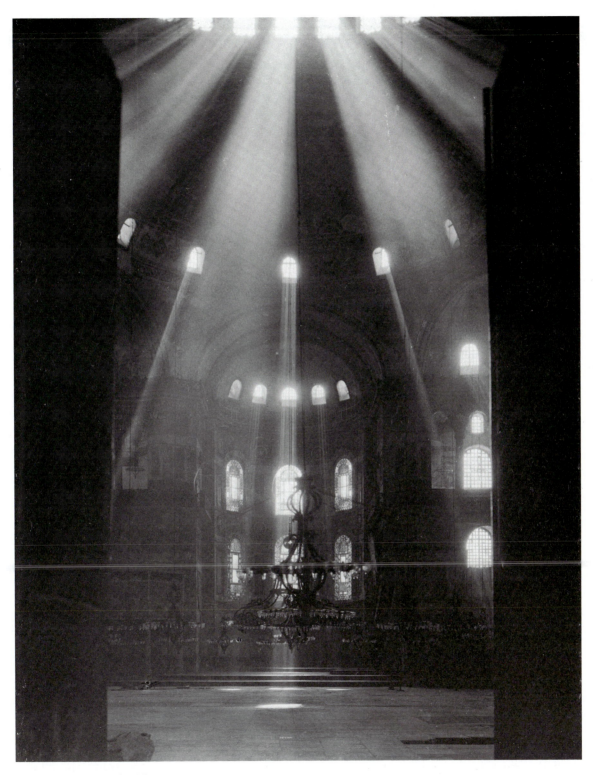

3.8 Interior, Hagia Sophia.

Neoplatonism and the Aesthetics of Light

The theoretical formulations underlying Neoplatonic aesthetics derived from the third-century Greek philosopher Plotinus, whose writings, *The Enneads,* were familiar to the Byzantine world through the interpretations of his fifth-century disciple Proclus. Plotinus developed a cosmology of creation and divinity based on a hierarchical order. At the pinnacle of the hierarchy is the incomprehensible One, a unity perfect in truth, beauty, and goodness. Through a process known as emanation, the One is reflected in Divine Reason, an intelligence then made manifest in the Universal Soul, which in turn animates the material world. Matter lies at the bottom of Plotinus' scale. Since the One is the only reality, all else being an ever weakened reflection of unknowable perfection, material things have no existence except as they are given spiritual life by the Universal Soul. Earthly objects and beings appear as faint echoes of the One.

Although humans belong to the world of matter, they also participate in higher realms because they have intellect. Each person, theoretically, can achieve a mystical union with the One through meditation. Contemplation of beauty in the visual arts assists this union. In the words of the philosophers, then, art becomes a mirror to catch an image of the Universal Soul. The artist must try to represent the essence of the thing depicted rather than superficial, outward appearances. Only by capturing this essence can art transmit the knowledge of infinite beauty to humanity's imperfect intelligence.

None of these metaphysical speculations would have influenced Byzantine imagery had not Neoplatonism found adherents among Christian thinkers. In the late fifth century, the anonymous Greek theologian known as Dionysius the Pseudo-Areopagite, reinterpreted Plotinus' theories in Christian terms. The Pseudo-Dionysius saw the One of Plotinus as the Christian God. He justified the use of images as a step toward mystical communion with the Divine. Like Plotinus, the Pseudo-Dionysius believed that light and the colors that transmit light play an essential part in the contemplative process. As the immaterial element in material things, light links the world of matter with the higher realm of the spirit. Neoplatonic aesthetics required that art glow with light and color in order to make the perfect beauty of the invisible world intelligible and visible to the ordinary person.

Hypatius of Ephesus, writing in the mid-6th century, justified decorating churches as a means to inspire piety in the congregation. He wrote: "We, too, permit material adornment in the sanctuaries, not because God considers gold and silver, silken vestments and vessels encrusted with gems to be precious and holy, but because we allow every order of the faithful to be guided in a suitable manner and to be led up to the Godhead, inasmuch as some men are guided even by such things towards the intelligible beauty, and from the abundant light of the sanctuaries to the intelligible and immaterial light."

enacted within its walls. Indeed, the Eucharistic service is telling evidence of the Byzantine emperor's caesaropapism, for among laymen only Justinian had the privilege of participating directly in the lengthy and elaborate ritual. The solemnities were partially screened from the congregation by railings and curtains. The ceremony began with a double entrance as the patriarch and his clergy moved into the sanctuary and the emperor arrived with his court. The courtiers watching from the aisles and the empress and ladies from the galleries saw only a series of processions moving out from and into the sanctuary: the Great Entrance, a procession of the clergy bringing the bread and wine from the prothesis to the altar, the appearance of the emperor and patriarch to exchange the kiss of peace, and finally the emperor's entrance to receive communion. Justinian had a special relationship to God and the Church; he was an equal of the patriarch. Throughout the ceremony the emperor and the patriarch were sheltered by the "Dome of Heaven," where as an eighth-century patriarch wrote, "The church is an earthly heaven in which the super-celestial God dwells and walks about."

Hagia Sophia was never copied by Christian builders, although it inspired Islamic mosques after the Turks captured the city. Neither its un-

usual structure nor its perfect fusion of architecture and symbolic ritual suited a church where the emperor was not in attendance. Nor, given the high cost of such perfection, could an imperial patron again risk bankrupting the empire for his personal glorification of God. Nevertheless, Hagia Sophia set a standard of architectural excellence throughout the Byzantine world.

Although Hagia Sophia was the architectural marvel of Byzantium's Golden Age, its design was too sophisticated and too closely allied with the ceremony of the imperial court to remain a workable model for other buildings. To satisfy symbolic and devotional needs, Byzantine planners turned to such multidomed buildings as the Church of the Holy Apostles. By the sixth century, the Constantinian Church of the Holy Apostles needed repair, and in 536 Justinian rebuilt the martyrium and vaulted its Greek cross form with five domes [3.9]. The new church, dedicated in 550, was so easily imitated and so well suited to the needs of the Eastern Orthodox Church that it became a model for later Byzantine architecture.

3.9 Typical multidomed Greek-cross plan (Church of St. Mark, Venice), inspired by the 6ᵗʰ-century Church of the Holy Apostles, Constantinople (destroyed 1469).

Although the sixth-century church was razed in 1469 to make room for the Turkish conquerors' mosque, we can reconstruct its appearance from Procopius' description and from churches inspired by the plan, such as St. Mark's in Venice. The emperor's architects chose not to alter significantly the symbolic Greek-cross plan, but they transformed the roofing system by building a central dome over the crossing, surrounded by four lower domes over the arms of the cross. Furthermore, they inserted a ring of windows around the rim of the main dome, thereby creating an emphatic vertical accent by flooding the crossing with light. The upward-surging spaces inside the church reflected the ancient symbolism of the martyrium. Moreover, the renovated church was easy to build, because of its modular composition of repeating units, each one of which was a square surmounted by a dome on pendentives. The very simplicity of the design facilitated both imitation and endless variation.

A view of St. Mark's Church in Venice enables us to compare the relative success of single-domed and multidomed buildings [6.19]. The single, though expanded, dome of Hagia Sophia creates a sense of flowing, interpenetrating spaces. In contrast, the spatial development of the multidomed church is the product of individual units. This breakup of spaces seems unsatisfactory if measured against Hagia Sophia, since the very repetition of the dome reduces and diffuses its dramatic effect. Also, the series of vertical axes in a multidomed structure creates a conflict with the horizontal movement of space down the long arm of the nave. This negative comparison is unjustified, however, because the single-domed church evolved out of the special needs of the imperial court. When we consider the multidomed building as an independent architectural conception, its organization of spaces merges as a rich and complex scheme of unending fascination.

In spite of the challenging possibilities offered by domed buildings, the traditional basilica with its trussed roof continued to be popular. In Ravenna, the capital of the Byzantine Empire in the West after 540, builders adopted aspects of the Byzantine aesthetics even while they perpetuated the venerable

3.10 Exterior, Church of S. Apollinare in Classe, the former sea port of Ravenna (Classis), 533–549.

Western tradition of the basilican hall. The Church of S. Apollinare Nuovo, originally the Arian cathedral dedicated to Christ, was built at the end of the fifth century by the Arian Gothic ruler Theodoric (493–526) as his palace church [3.10]. In the sixth century, the victorious Byzantine conquerors rededicated the basilica to St. Martin. (Later the relics of St. Apollinaris—the first bishop of Ravenna—were transferred to the church, which became the "new" Church of St. Apollinaris—S. Apollinare Nuovo.)

The relics of St. Apollinaris originally lay in a church in Ravenna's seaport, Classe. The church was built by a Byzantine official, Julianus Argentarius, and completed in 549. Both S. Apollinare in Classe (532/536–544) and S. Apollinare Nuovo are three-aisled basilicas, but they differ from Roman basilicas in their proportions and other details. The naves are wider and shorter than in typical Roman basilicas. Side rooms flanking the apse reflect the architects' Eastern heritage, although these rooms may have served simply as chapels rather than as the Byzantine diaconicon and prothesis. Furthermore, the apse has an Eastern form, polygonal on the exterior and semicircular on the interior. (The apse at S. Apollinare Nuovo was destroyed by an earthquake.) Large windows in the outer walls flood the aisles and lower part of the nave with light, which emphasizes the lateral extension of the space [3.11]. Thus the directional emphasis so characteristic of the Western basilica gives way to a feeling of expansiveness in the Ravennate type.

The finest surviving church in Ravenna, the Church of S. Vitale, was founded by Bishop Ecclesius (521–532) while that city was still the capital of the Ostrogothic Empire [3.12]. Probably soon after 540, when Justinian's armies under Belisarius

3.11 Nave, Church of S. Apollinare Nuovo, 6th century, Ravenna.

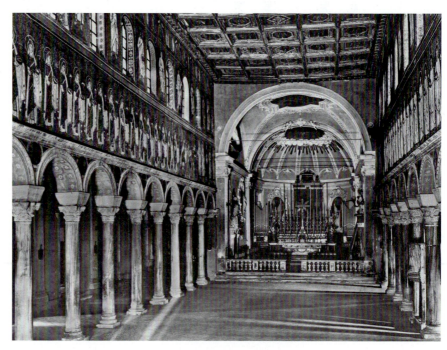

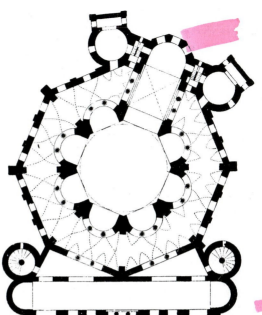

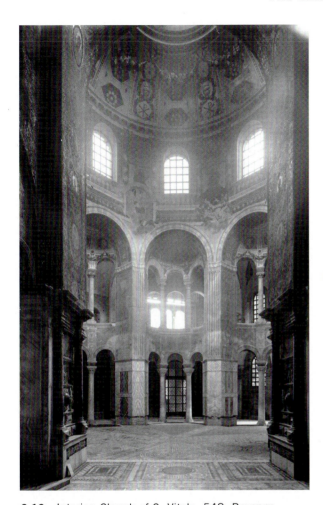

3.13
Church of S.
Vitale. Plan.
Diameter
about 111ft.
(33.8m).

3.12 Interior, Church of S. Vitale, 548, Ravenna.

recaptured Ravenna and again turned the Adriatic port town into the Western Byzantine capital, Julianus Argentarius gave 26,000 gold solidi for the present church's construction. On May 17, 548, the Orthodox Archbishop Maximianus (546–556) dedicated the church to the city's patron St. Vitalis, who had been martyred on the site. The Church of S. Vitale had a central octagonal plan, perhaps inspired by the Constantinian Golden Octagon in Antioch or by martyria. The designers gave the familiar plan new complexity and sophistication.

At S. Vitale, the central domed octagon is surrounded by an ambulatory and gallery [3.13]. The eight piers that support the dome also define the galleried niches, which seem to press out from this central core. A rectangular choir, apse, and flanking rooms project from the eastern face. Even so,

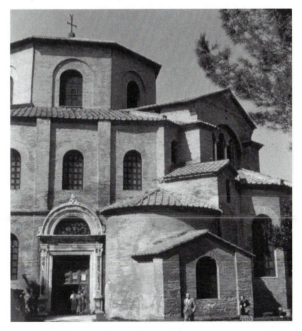

3.14 Exterior, Church of S. Vitale. Consecrated 548.

an exterior view of the building discloses a clarity uncommon in Constantinopolitan buildings but characteristic of the West [3.14]. The apse, the choir, and the gallery roofs all ascend to the roof over the dome in a series of distinct yet interlocking polygonal forms. Such a lucid disposition of

exterior shapes contrasts with the complexity of spaces within the church.

The church was connected to the palace by a shallow narthex placed at an angle to the main axis. A stair tower at each end of the narthex led to the gallery (one tower was later made into a bell tower). The offset narthex created two entirely different vistas for the worshipper, and neither view carries the eye directly to the sanctuary. This spatial ambiguity extends throughout the building, since the semicircular exedrae, opened as they are by arcades at two levels, cause space to seem to flow unbroken between the naos and the outer aisles. The arcades create identical semicircular figures and rise into half-domed niches. The architects provided additional structural stability to the slender columns by inserting downward-tapered impost blocks between the column capitals and the arcade above, thereby concentrating the weight at the center of the column. A lighter wall was made possible by constructing the dome of ceramic tubes and mortar, a device first used in ancient Rome. The steep dome and its attenuated supporting structures created an effect of rising space. (The church became part of a Benedictine monastery in the eighteenth century. The dome and upper walls were frescoed with a scene of the glory of St. Vitalis and St. Bernard.) In the worshipper's experience of the building even today, such verticality helps to bind all the parts into a single, soaring whole. As light pours in from the large windows of the ambulatory, galleries, and dome, it forms a halo of illumination around the tall central core. In its own way S. Vitale is as remarkable a building as Hagia Sophia.

BYZANTINE MOSAICS

In the churches built to honor the Sts. Apollinaris and Vitalis, the most noticeable features are the mosaics. The Ravenna mosaic cycles give us precious information about the lavish programs that once decorated the churches built under imperial patronage in Constantinople and elsewhere. They reveal that artists combined high standards of craftsmanship with an extraordinary spirit of innovation. Byzantine mosaicists had to create sumptuous interiors worthy of both the imperial and the heavenly courts. To achieve this awesome goal, artists augmented naturally colored stones with glass tesserae, and because glass could be manufactured in almost any hue, the variety and intensity of colors could be increased. For the gold so vital to Byzantine sensibilities, dazzling tesserae were created by encasing a layer of gold leaf in clear glass. Ultimately, artists and patrons came to prefer color schemes composed of brilliant gold, deep blue, green, and purple, all enhanced by touches of red, yellow, and white. With these imperial colors they turned each wall into a light-refracting plane. Craftsmen spaced tesserae widely and often colored the exposed plaster bed with red, thereby achieving a rich yet subdued background color. The mosaicists also tilted the tesserae at irregular angles to heighten the play of glittering reflections from candles and lamps. Finally, Byzantine designers created mosaics that seemed truly to float over walls and vaults, as if with a separate reality independent of the supporting structural framework. No longer were images conceived of as windows opening into the world of matter. On the contrary, a Byzantine mosaic aimed to transcend matter and capture the intangible world of the spirit.

Justinian's artists worked within a well-formulated aesthetic theory, grounded in the Greek philosophy of Neoplatonism. By the sixth century, the Neoplatonic ideal had so pervaded the Eastern Empire that it became the intellectual basis for the entire scheme of pictorial arts. Neoplatonism emphasized a hierarchical order of the universe; thus, in devising the iconographical program, the most sacred figures were placed in the upper zones, and the earthly scenes in the lower registers. Byzantine artists and viewers, in effect, agreed to a series of conventions—that is, an artistic language that communicated unseeable mystic reality. The most important artistic convention evolved from the Neoplatonic theories of light and vision. Since all objects, Plotinus contended, interrelate and interpenetrate as they share in the oneness of Divine Reason, they are, ideally, transparent. To eliminate matter and attempt to evoke the diaphanous nature of material presences, the artist concentrated on light and color, while

ignoring aspects of darkness and shadow—those features, in other words, that lent three-dimensionality to forms. With the image thus separated from mundane appearances, the viewer could meditate on art not with the physical but with the "inner eye." In so doing, the viewer intuitively grasped the reflections of beauty and perfect goodness emanating from the One through the Universal Soul.

Byzantine artists employed another device to deny traditional illusionism. They rendered objects in reverse perspective, that is, the lines diverge from each other as they recede, and objects appear to tip up and grow larger in the distance. In the mosaic of Theodora's court in S. Vitale, for example, the fountain is drawn in reverse perspective [3.15]. Two factors, both grounded in Neoplatonic philosophy, are responsible for the use of this method of representing space. First, the object had to be presented as completely as possible in order to permit the viewer's eyes to wander over its surface. Second, the zone between the observer and the work of art is the active space. The spectator did not look through the wall to the image but was confronted by it. Any space depicted had to extend forward, toward the

3.15 Detail of [3.18] Theodora's court, mosaic in Church of S. Vitale.

viewer, not backward beyond the wall. The artists accepted the notion that material objects exist in space, but they inverted the "illusionism" of the setting to imply that things project forward into the atmosphere between the image and the observer. In short, they abandoned the Roman idea that the picture is a window on the world.

Byzantine artists had to satisfy both societal and imperial needs. The Eastern emperors wanted to rule in the glorious tradition of imperial Rome. Assisted by the educated taste of the court advisers, they encouraged a revival of classical culture, ceremonial etiquette, and art. In reconciling the earthy realism of ancient art with the spiritual goals of Neoplatonism and Christianity, sixth-century artists developed the first truly medieval style. In order to capture the intangible reflection of divinity or supreme power, be it Christ or the emperor, court artists adapted a hieratic, abstract style. Thus two different but equally respected modes of perception—naturalistic illusionism and hieratic abstraction—underlie the Byzantine style.

The shift from illusionistic vision to thoroughly abstract imagery is nowhere more evident than in the mosaics covering the interiors of Byzantine churches. This is not surprising since religious art was regarded as an aid to meditation and had to be rendered so that the worshipper could suspend belief in sensory experience, the better to partake of the spiritual world. For this purpose, the static, timeless quality of an image took precedence over any narrative element. Furthermore, if the required emphasis on light and color permitted an intellectual ascent to immaterial beauty, it also served to glorify Church and state by creating a brilliant environment for the celebration of the Mass. Hagia Sophia must have offered the most splendid setting of all. Unfortunately, the church's original decorations have been damaged or destroyed, but in Ravenna, despite changing political fortunes and religious controversies, sixth-century mosaics survive in remarkable numbers.

At S. Apollinare Nuovo, the mosaics show a conscious effort to reject narrative development in favor of abstract, hieratic imagery [3.16]. The panels above the clerestory windows, part of the Arian dec-

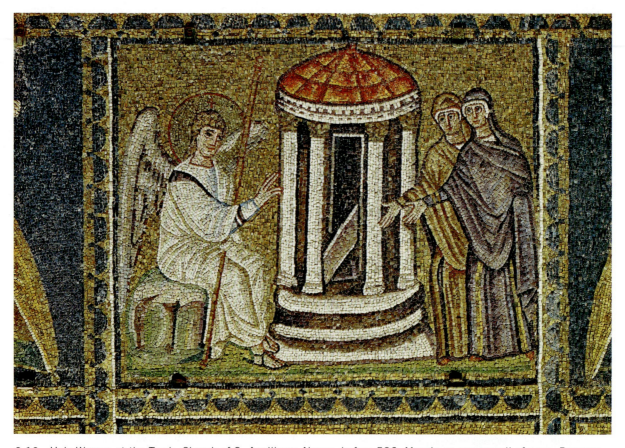

3.16 Holy Women at the Tomb, Church of S. Apollinare Nuovo, before 526. Mosaic on upper wall of nave. Ravenna.

oration of the church, and probably completed before Theodoric's death in 526, form the earliest surviving mosaic cycle illustrating the miracles and the Passion of Christ (appropriately since the church was dedicated to Christ). Strong contours and bright, flat colors make the images easily visible from the nave floor. That the sixth-century mosaicists carefully considered the worshipper's relationship to the artwork is further demonstrated by the simplification of the design. Gone are the genre details and the profusion of small figures that gave many earlier mosaics an anecdotal character. Instead, the Arian artists have reduced the number and enlarged the size of the remaining figures. Still, making the image visible to the spectator was not the only motivation behind the artist's simplified design. The individual image is no longer understood as part of a lively narrative, but rather as an eternal symbol. When looking at the picture, the worship-

per had to grasp its symbolic content in order to see and understand the reflection of divinity mystically present in the material substance of the mosaic.

The designers ordered each composition symmetrically and eliminated all landscape and architectural details, except for the few elements essential to the identification of the subject. Thus, a rock and some green lines establish the garden site of Christ's tomb. These vestiges of nature appear against a glimmering golden background rather than against the blue sky found, for example, in the Good Shepherd lunette in the nearby oratory [see 2.1]. The use of gold at S. Apollinare Nuovo disassociates the scene from a tangible environment and forces the viewer to focus attention on the dominant, central sepulchre. Unlike the Early Christian ivory that represented the same moment [see 2.22], the Byzantine mosaic only suggests a story. In the ivory sculpture, sleeping soldiers and the confrontation between the Holy Women

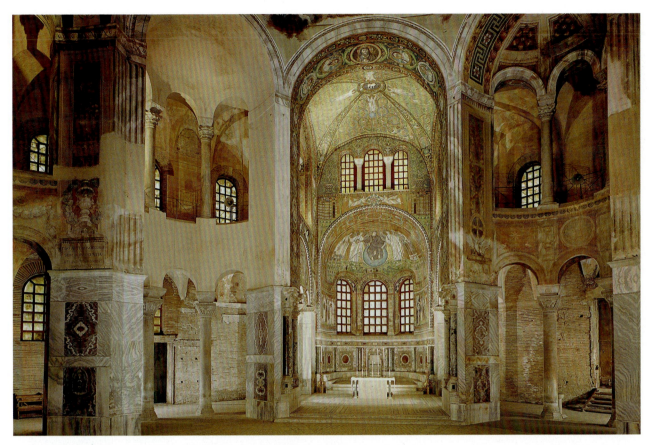

3.17 Sanctuary of the Church of S. Vitale, before 548. Ravenna.

and the angel lend drama to the depiction of a specific moment. Here the soldiers have disappeared. The divine messenger and the pious witnesses, rigid in posture and staring outward, simply gesture toward the tomb between them, where the open door reveals the raised lid of the empty sarcophagus. By means of this pictorial abbreviation, the artists present, not the temporal narrative of Christ's ascent from the tomb, but the miracle of the Resurrection.

Although created for the decoration of an Arian church, the scenes from the life of Christ showed no heretical views, and the later Orthodox conquerors left them untouched. Below the clerestory windows, however, Theodoric's Arian artists had placed a procession of men and women and views of the palace and seaport of Ravenna. The Byzantines transformed these secular figures to a gathering of saints. On the left side of the nave, the three Magi lead a procession of female martyrs toward the

Virgin and Child. On the right, male martyrs leave the palace to follow St. Martin, the new patron of the church, to the enthroned Christ. The figures repeat the verticality and regular rhythm of the nave columns and enhance the directional movement toward the sanctuary. Barely distinguished from one another in physiognomy, and in no way individualized by dress or gesture, the toga-clad men become patterns—white shapes overlaid with blue and green lines. The S. Apollinare Nuovo martyrs cast no shadows; they stand in an aureole of bright yellow tesserae. The Ravenna mosaicists have willfully inverted the natural order of the material world as they exclude the material world from pictorial representation.

In the Church of S. Vitale, we find a more highly developed version of these ideas. The mosaics of the sanctuary survive, still surrounded by elegant columns, carved capitals, intricate moldings,

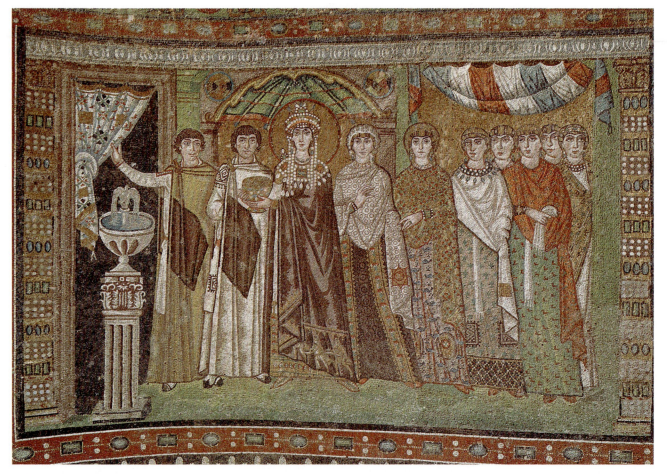

3.18 Empress Theodora and her attendants, mosaic on the south wall of the apse, Church of S. Vitale. Ravenna.

and a rich encrustation of marble veneer imported from the imperial quarries near Constantinople [3.17]. Sheer splendor, however, is only one aspect of the decorative program, for in the hallowed space of the apse, the artists finally rejected continuous narration in favor of symbolic images related to the function of the sanctuary.

In the apse, Christ sits enthroned on a celestial orb and offers a crown of martyrdom to St. Vitalis, at the same time that he accepts a model of the church from Bishop Ecclesius, its founder. On the wall below, Justinian rules the material world as Christ's vicar. The emperor, attended by courtiers and Archbishop Maximian, holds his gift to the church, a Eucharistic plate (paten) [see 3.3]. Across the sanctuary, but represented as if in the narthex, Empress Theodora with her guards and ladies com-

plements Justinian's action by offering a chalice [3.18]. Although neither Justinian nor Theodora ever visited Ravenna, they participate eternally in the celebration of Mass at the altar. Theodora died of cancer in June 548, shortly after the dedication of the church.

In the lunettes of the choir, just in front of the apse, Old Testament scenes refer to the sacrifice of Christ. The patriarch Abraham entertains three angels, symbols of the Trinity, with round loaves incised with crosses, prefigurations of the Host. At the right, the hand of God reaches out to stop Abraham's obedient sacrifice of his son Isaac, an event symbolizing the Crucifixion of Christ. As if to make explicit the analogy between the Old and the New Testaments—between the sacrifice of Isaac and of Jesus—two angels hovering above the

lunette support a cross wreathed by a victor's laurel.

The dedicatory mosaics of Justinian and Theodora provide an instance of the union of styles found in the best Byzantine art of the period. Pictorial abstraction has made the imperial presences a timeless reflection of the celestial order. Justinian, Theodora, and their entourage stand in a yellow glow rather than shadows, a space-denying device appropriate to their ethereal bodies. Indeed, the men's garments, like those at S. Apollinare Nuovo, are arranged as flat white rectangles articulated by tubular folds and interrupted by patterns of black lines. Meanwhile, the multicolored, bejeweled robes and headdresses of the female figures and soldiers create an even more dazzling effect. In contrast, all the faces—especially those of the imperial couple and their closest attendants—are rendered as lifelike portraits, thereby evoking the Roman tradition of realism. The images may have been based on official portraits made in Constantinople and sent to Ravenna to be copied. Ultimately, the combination of two distinct pictorial modes in the S. Vitale dedicatory panels suggests that at the very moment the mosaicists sought to represent the exalted nature of emperor and empress, they also wanted to leave future generations in no doubt about the monarchs' identity.

In the Theodora mosaic many individual elements recall the classical heritage—the shell-like niche denoting prestige, the fluted pedestal and fountain, the open door, and the knotted draperies of the natural world. But since Theodora and her companions neither stand in a rational space nor have material substance, the architecture and the curtains cannot function, as they had in the Greco-

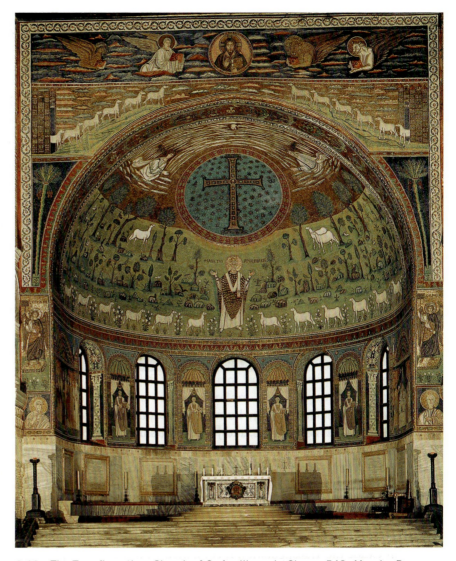

3.19 The Transfiguration, Church of S. Apollinare in Classe, 549. Mosaic. Ravenna.

Roman world, as space-creating elements. Instead, they simply allude to a bygone visual tradition.

The substitution of symbolic images for narrative or visual realism, so pervasive at S. Vitale, reaches a climax in the two great apse mosaics, in the Church of S. Apollinare in Classe [3.19] and the Monastery of St. Catherine at the foot of Mount Sinai, where Moses received the Ten Commandments [3.20]. Although geographically distant, both works probably reflect aspects of the court style in Constantinople in the second half of the sixth century. Both depict the Transfiguration of Christ—the moment, that is, when Jesus tem-

3.21 Beth Alpha Synagogue. Plan showing mosaic pavement. c. 518.

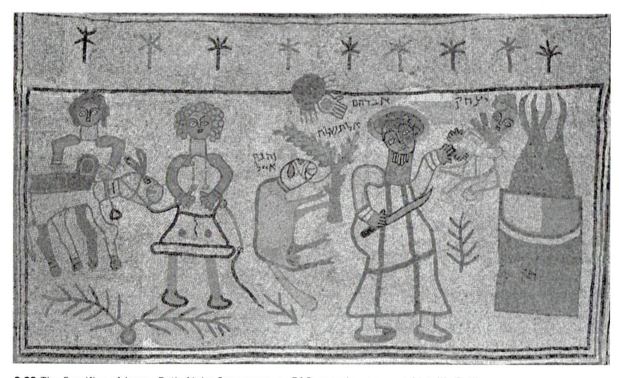

3.22 The Sacrifice of Isaac, Beth Alpha Synagogue, c. 518, mosaic pavement (detail). Galilee.

545 Justinian banned the building of synagogues. Then in the seventh century, Arabs under the banner of Islam conquered the Near East. In 638 Jerusalem fell to Islam, and in 661 Damascus became the capital of the new Umayyad Dynasty.

IVORIES AND MANUSCRIPTS

When we turn from architecture and monumental decoration to the sumptuary arts, we are at once reminded that objects and images fashioned from precious materials delighted the wealthy, cultivated, intellectual elite. Goldsmiths worked and lived in the imperial palace and even enjoyed favored seating at festivals and in the hippodrome. Artists excelled in working with ivory, silver, gold, and semiprecious stones. Panel painting and manuscript illuminations, too, took on a jeweled, highly wrought character, although some paintings also reflect the style of large-scale mosaic cycles.

Ivory sculpture illustrates the debt of the Byzantine artists to their classical heritage; however, not unexpectedly, classical forms are imbued with symbolic content. Superb examples of this Byzantine classicizing style are two ivories made in Constantinople: one of the archangel Michael [3.23] and another of an emperor, probably Justinian. In churches throughout the East, ivory diptychs (panels joined in pairs) served as memorial tablets, on which were inscribed the names of people for whom prayers were to be said during the Mass. On one such panel, St. Michael appears as a divine messenger holding an imperial orb with a cross. His youthful face conforms to a classical ideal, and his well-proportioned figure is revealed by clinging tunic and pallium. The archangel seems more like a young Greek hero or a Roman orator than an invisible messenger of God.

The Byzantine sculptor's debt to classical art is nowhere more striking than in this relief; nevertheless, features of the panel disclose its Byzantine character. The architectural framework, for example, does not create a rational space; St. Michael's feet rest on the back steps of a staircase that recedes from the pedestals and columns in the foreground, while

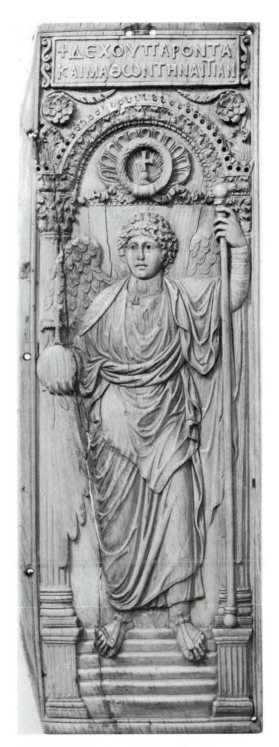

3.23 St. Michael, early 6th century. Ivory diptych, right leaf, 16 7/8 x 5 5/8in. (42.9 x 14.3cm). The British Museum, London.

his arms and wings project in front of the columns, bringing the upper part of his body into the foremost plane. This spatial ambiguity between figure and setting denies the careful realism of the individual details. The Byzantine artist has suspended the physical world's laws of optics and gravity, and, in the process, created a fitting environment for a Heaven-sent messenger. The Greek inscription reads, "Receive these gifts, and having learned the cause. . . ." The quality of the sculpture suggests that the ivory was made in the imperial workshop, and the right-hand leaf of the diptych might have had a representation of the emperor and a continuation of the inscription.

In the fifth and sixth centuries, complex imperial ivories, composed of several panels, were made. Four of the five panels of such a relief makes up the so-called Barberini ivory [3.24]. An idealized emperor clad in Roman armor sits astride a rearing horse. The image may echo the towering equestrian statue of Justinian once set up on a column in Constantinople. In the ivory, antique emblems mingle comfortably with religious allusions in

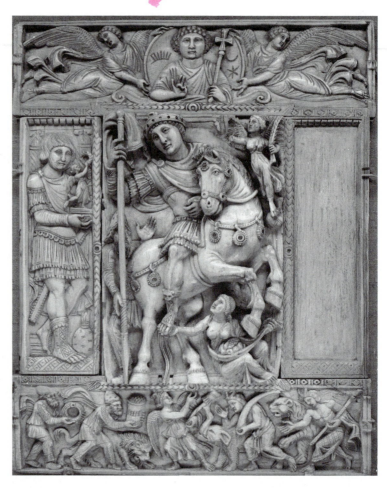

3.24 The Emperor Victorious: the Barberini ivory, 6th century. The Louvre, Paris.

that mixture of pagan and Christian iconography familiar in Constantinian art. A personification of earth supports Justinian's foot, while a winged Victory bearing a palm cheers the emperor on. To the left (and originally to the right as well), a general offers a statue of Victory bearing a wreath. Still another flying Victory, surrounded by tribute-bearing representatives of the subjugated territories, reaches up to Justinian from the center of the lower frieze. The full, rounded modeling and the complex poses of conquered Persians and barbarians and wild animals suggest that the sculptor turned to Roman battle scenes for inspiration. The emperor himself, although seated on a rearing horse, appears as an ideal, superhuman ruler. His impassive, masklike face seems to look beyond the earthly realm. So

that the source of Justinian's authority does not go unnoticed, Christ blesses him from the heavens above (represented by a sphere engraved with sun, moon, and stars). In a thoroughgoing combination of pagan and Christian motifs, two winged angels holding the celestial image are indistinguishable from classical Victories.

The late Roman style seems to have lingered tenaciously into the sixth century in Byzantine painting as well as ivory carving [3.25]. Manuscript illumination can be studied only through isolated examples. An encyclopedia of medicinal herbs compiled in the first century by the Greek physician Dioscorides, and known as the *Materia Medica,* has survived in a sixth-century copy made in Constantinople for the Princess Anicia Juliana

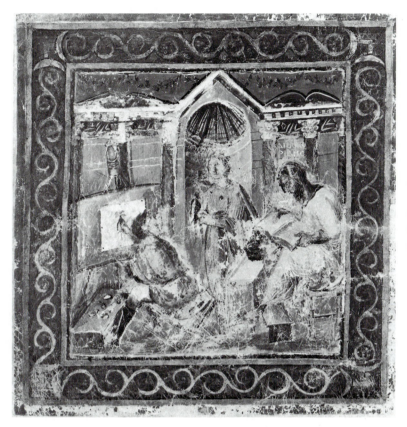

3.25
Portrait of the author at work with an assistant, and Inspiration, Dioscorides, *Materia Medica,* Constantinople, 512. 15 x 13in. (38.1 x 33cm). Österreichischen Nationalbibliothek, Vienna.

(it is now in Vienna and therefore is known as the Vienna Dioscorides). Since in a scientific treatise the illustrations were intended to clarify the text, not merely to ornament it, the artists naturally copied the late Roman painting style along with the text. The illustrations demonstrate a careful observation of nature.

The scene with Dioscorides and his assistant at work not only follows the established tradition of including a portrait of the author of the book but makes abundantly clear the artist's intention to record nature faithfully. Dioscorides is represented as a scholar seated with an open book on his lap. He is inspired by Epinoia, the Power of Thought, who holds a mandrake root. An assistant studies the plant as he records it on a large sheet of vellum fastened to his easel. (In the first century, long papyrus rolls began to be replaced by codices made up of individual leaves, as in a modern book. By the fourth century, the codex had become the usual form of a book.) Such realistic details contrast with the ideal-

ized background of colonnade and niche. The complex poses of the figures, the refined modeling in light and dark tones, and the perspective rendering of the setting suggest that the Vienna Dioscorides is a skillful rendering of its classical model.

The antique pictorial style also influenced the illustration of religious texts with Christian subjects. Artists who worked in the imperial workshops for the production of books (scriptoria) created luxurious manuscripts worthy of their patrons. First, they dyed the light-colored vellum a deep purple, the color reserved for the use of the imperial court. Then the scribes wrote out the texts in silver or gold. Finally the painters illustrated the narrative, often turning to classical sources as they worked.

One of the most sumptuous manuscripts to survive from the sixth century is part of the Book of Genesis, now in the National Library in Vienna, and consequently known as the Vienna Genesis [3.26]. Twenty-four folios survive, each page with a half-page illustration. The artists did not fully

3.26
Rebecca at the Well,
Vienna Genesis,
Constantinople, sixth
century. Purple vellum,
13 1/4 x 9 7/8in.
(33.7 x 25.1cm).
Österreichischen
Nationalbibliothek,
Vienna.

adapt to the modern codex arrangement, for they often illustrated the events as a continuous narrative as they would in a scroll. In the story of Rebecca (Genesis 24), the heroine, carrying a jug on her shoulder, journeys out of the walled city and down to a stream. A lightly draped classical nymph leaning on a jar appears as a personification of water. The narrative then turns to the right where Rebecca appears again, charitably offering water to Eliezar and his camels. This shift in pictorial direction suggests that the illuminator was self-consciously following the scroll format. The figures themselves are equally reminiscent of an earlier, classical style. Even though the flat purple ground removes the scene from the material world, the individual figures are full-bodied and seem to move easily and naturally in their limited space.

Not all Byzantine manuscripts were imperial purple codices. Many were made for private patrons and for churches and monasteries in the provinces. Such a book is a Gospel copied in 586 by a calligrapher named Rabbula at the Monastery of St. John in Zagba, Syria [3.27 and 3.28]. Here the artists worked in brilliant colors on the natural light vellum, using a sketchy illusionistic painting technique for the background although they retained strong outline drawings for the well-modeled figures. The accurate proportions, expressive poses and gestures, and illusionistic setting suggest that they, too, used classical models.

Some of the full-page paintings in the codex may have been inspired by monumental apse decorations in the churches of the Holy Land. The scene of Christ's Ascension is combined with apocalyptic imagery described by Ezekiel (see Box: *Ezekiel and St. John*). The depiction of the four beasts emerging with eye-studded wings from wheels of fire follows the scriptural source. As he is borne heavenward in a mandorla by the creatures and angels, Christ raises his hand in blessing and steps forward like an ancient orator. Below the celestial apparition, angels direct the apostles' wondering gaze to the miracle of the Ascension. Yet, the focus of attention also falls on the Virgin. The Mother of the Lord does not share in the apostles' excitement. Instead, she stretches out her arms like an orant, as if praying for the faithful who will come before her Son on the Day of Judgment, on that awesome day already alluded to in Ezekiel's vision.

3.27
The Ascension, Rabbula Gospels,
Zagba, Syria, c. 586. 13 1/4 x
10 1/2in. (33.7 x 26.7cm).
Biblioteca Medicea Laurenziana,
Florence.

3.28
Crucifixion and Holy Women at the
Tomb, Rabbula Gospels, Zagba, Syria,
c. 586. 13 1/4ft. x 10 1/2in.
(33.7 x 26.7cm). Biblioteca Medicea
Laurenziana, Florence.

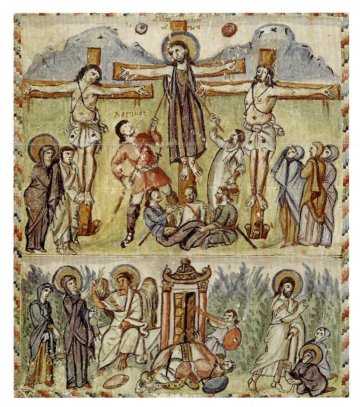

In another illustration, the many episodes at the end of the Passion cycle have been organized into a symmetrical composition in two registers (perhaps inspired by the apse at Golgotha). Christ is a mature, regal figure represented as alive and triumphant on the Cross. He wears a colobium, or long, sleeveless, purple robe, in the modest and dignified tradition of the Byzantine Church. Good and bad thieves, the centurion Longinus and Stephaton with the sponge, the mourning Virgin, St. John, and the Holy Women surround the Savior. Below the Cross, indifferent Romans fulfill the prophecy (Matthew 27:35) by casting dice for Jesus' clothes. In the lower register the artist depicted later episodes: the Holy Women at the empty, guarded tomb and the appearance of Jesus to the two Marys to reaffirm His Resurrection (Matthew 28:9–10). In contrast to the Arian mosaics in Ravenna, this wealth of narrative detail gave historical validity to Christ's sacrifice and presented in visual terms the Orthodox answer to the heretical Monophysites, who, believing the Lord to be totally divine, denied the reality and the necessity of the Crucifixion.

ICONS AND ICONOCLASM

The very heresy that the artists of the Rabbula Gospels may have sought to counter indirectly caused one of the greatest traumas of Byzantine civilization. If Christ was an exclusively divine manifestation, the Monophysites argued, then no anthropomorphic form could describe him. Pictures that attempted to represent the godhead were blasphemous. This position, also advocated by those Christians who upheld the Old Testament ban on imagery, diametrically opposed the popular use of art as an aid to instruction and meditation. In the sixth and seventh centuries, the condemnation of religious images increasingly focused on icons—hence the designation of the resulting crisis as iconoclasm, or "image-breaking."

Icons (Greek: eikon, image) were small portraits of Christ, the Virgin, or the saints, designed, like the pagan imperial portraits, to serve as proxies for the divine presences. In order to avert charges of idolatry, theologians carefully pointed out that in

venerating an icon one paid respect not to the image but to the person depicted. Thus, St. Basil explained that "the honor rendered to the image passes to the prototype." By this process the icon provided a channel of communication between the worshipper and the divinity.

An important distinction between icons and secular portraits was that the original Christian images were believed to have been fabricated under miraculous circumstances, often without human intervention. The column of the flagellation, for example, bore traces of Christ's form, and the Mandyleon of Edessa, believed to have been given to King Abgar by Christ himself, had the face of Christ on a cloth. The Empress Eudokia, wife of Theodosius II, discovered a portrait of the Virgin Mary painted from life by St. Luke, or so it was believed. Because of these supernatural origins, the faithful often credited the icon itself with marvelous powers. At the time of Persian invasions, in 626 and 717, icons of Christ and the Virgin were taken to the gates of Constantinople and were believed to have saved the city.

Naturally, the number of miraculously wrought images was limited. Consequently, ordinary mortals began to copy the sacred icons, in the hope that even a facsimile of the holy form would in some way partake of its sanctity. Monasteries became important centers for the manufacture and sale of these reproductions because they kept most of the existent icons in protective custody. Icons could be fashioned in mosaic, ivory, or precious metals, but the monks preferred painted images, using either encaustic (colored wax) or tempera on wood panels, which enabled them to avoid that three-dimensional likeness so uncomfortably reminiscent of pagan idols.

Very few icons survived the victory of the iconoclasts in the eighth century. The movement resulted in the destruction of countless works of art. In the Monastery of St. Catherine, however, far away in the deserts of the Sinai Peninsula, an unusually large collection of icons has been preserved. Among the earliest is a sixth-century encaustic image of the Virgin and Child [3.29]. The Byzantine preference for abstract form determines the severely frontal

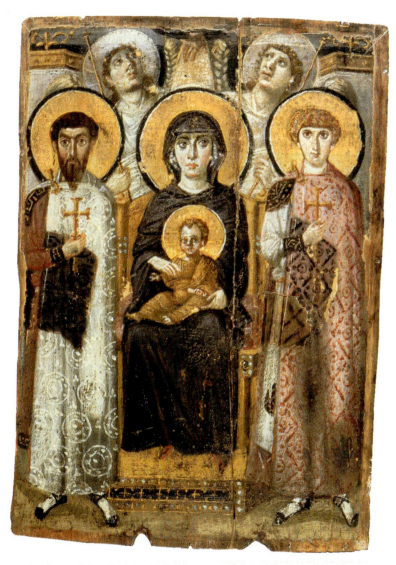

3.29 Icon of the Virgin and Child with saints and angels. Encaustic painting, 27 x 19 6/16in. (68.6 x 49.2cm). Constantinople, 6th century. Monastery of St. Catherine, Mount Sinai, Egypt.

figures of the enthroned Virgin and Child and the attendant saints. The Virgin herself becomes a throne for the Christ Child through her hieratic posture, while rich brocades transform the bodies of St. Theodore and St. George into flat, attenuated and equally architectonic designs. Moreover, the ovoid shape of the faces of Mary and the saints, along with the repetition and the sheer size of the heavy halos, also reduces their tangibility. Nevertheless, the two angels behind the throne, and to

some extent the Infant himself, seem inspired by classical art, revealing yet again the two stylistic worlds that constitute the universe of Byzantine art. The saints stare directly into the viewer's eyes seemingly to communicate and intensify the devotional experience, but the Virgin disconcerts by looking to the right. "The eyes encourage deep thoughts," wrote the poet Agathies in the sixth century.

By the eighth century, the opposition to icons had grown formidable. Because the images were

A BRIEF HISTORY

Even as the Roman Empire reached the apogee of its power and grandeur, the ever restless outsiders began to cross imperial frontiers, lured there by the attractiveness of Roman civilization—its relative security, its cultivated land, and its stable life. At first they claimed only territories that had not originally belonged to Rome. The Romans, after all, had extended their empire across Celtic lands to the Rhine and Danube Rivers. The Romans often turned the indigenous population into *foederatii,* allies or federates, and charged them with the defense of the newly established borders. The people in return received military aid and lands, as well as the privilege of associating with the mighty empire. Eventually the Roman army was largely composed of Germanic troops. Most of the men who fought for Constantine in 312 were Germans.

The transplanting of Mediterranean art and architecture beyond imperial borders by the Roman conquerors and settlers introduced the indigenous populations to a new repertory of visual forms and materials. Imperial architects, following on the heels of victorious battalions, introduced masonry construction to a people accustomed to building in wood. Moreover, Roman sculpture, paintings, and mosaics displayed a classical simplicity and a formal regularity that must have seemed strange to the people who based their art on the sheer energy of nature as expressed by the animal world and in geometric forms such as spirals and interlaces.

Christianity did not at first provide a unifying force. Unfortunately for the stability of the Roman Empire, in 345 the Goths abandoned their old gods for heretical Arian Christianity. Other tribes followed their lead. In the eyes of Rome and Byzantium, therefore, many barbarians had simply renounced paganism for heresy.

Increasing violence marked the fifth century as the tempo of migration accelerated under new pressure from the Huns, who swept into Europe from Central Asia. They forced the Goths to cross Rome's Danube frontier. The eastern Goths, or Ostrogoths, established a kingdom in northern Italy, while the Visigoths, or western Goths, led by

Barbarian Imagery

The Celtic and Germanic artists' and patrons' love of abstraction and patterns was conceptually akin to the dematerializing tendencies of Early Christian and Byzantine art; however, their abstract style stemmed from vastly different spiritual sources. Even after they accepted Christianity, these people did not forget their ancestors' veneration of the forces of nature and creation—of the life-giving power of the sun, of the earth as a fertile mother goddess, and of the physical strength and energy of wild animals. They continued to use solar disks, trefoils, swastikas, and spirals—motifs that had been inspired by their forebears' pantheistic religion. The spiral winding in and out of itself remained a sign of the ever-recurring seasons, a life cycle encompassing death and regeneration. The soaring eagle with an upturned head and disk-like body remained an ancient reference to the sun, and the slithering serpent represented evil, darkness, and death. Hawks, boars, stags—the strongest and most ferocious beasts in the animal kingdom—once employed as tribal totems, became personal insignia. When the time came to transfer allegiance to the Christian god and to fashion objects whose themes did not offend the new spiritual masters, artists simply adapted the primal motifs to a changed context. In so doing, they laid the foundation for that extraordinary fusion of Northern, Eastern, and Mediterranean styles, which resulted in Western medieval art.

Alaric (B. C. 370–410), captured and sacked Rome itself before moving on into France (see Box: *Galla Placidia*). Other Germanic tribes, which had already pushed the Celts to the western fringes of the continent, were themselves displaced. The Burgundians settled in Switzerland and eastern France; and the Franks occupied Germany, France, and Belgium. Meanwhile the Vandals (whose name has come to mean senseless destruction—vandalism) swept through France and Spain, crossed over into Africa, where they established a kingdom around Carthage. In 455 they returned to sack Rome.

On the move again under their ruthless leader Attila—known to Christians as the "scourge of God"—the Huns raided western Europe. Before he died in 453, Attila devastated parts of France and Germany. The Visigoths escaped to Spain and other displaced Germanic tribes migrated to Italy. In 476 the last Western Roman emperor was deposed, and the Ostrogoth Odovacar (B. C. 433–493, also spelled Odoacer) ruled Italy under the nominal authority of the Eastern emperor in Constantinople. His successor, Theodoric the Great (B. C. 454–526, vice-regent of the Western empire from 497), established his court in Ravenna and made the former Roman city an Arian stronghold.

Meanwhile in 496 Clovis (ruled 481–511), the king of the Franks, accepted Roman Christianity on behalf of all his people. His wife, Clotilda, a Burgundian princess, was already a Christian. Across the Channel, the British outposts of the Roman Empire were left undefended in 408/409 by the recall of the imperial troops. The Picts and Scots breached the old Roman walls in the north, and the Angles, Saxons, and Jutes crossed the seas to settle southeastern Britain. The Celts finally took refuge along the western coast of Europe.

Bewildering as this migration period seems, Europe as we know it began to take shape out of this confusion. One more major political shift occurred in the sixth century, when Justinian reconquered some of the Mediterranean territories for the Byzantine Empire. Yet such victories proved to be ephemeral, for the pagan Langobards (later called Lombards) invaded Italy in 568 and settled in northern Italy, thereafter called Lombardy. Nevertheless during the next century almost everyone accepted Christianity and acknowledged the spiritual authority of the Pope in Rome.

THE ART OF THE GOTHS AND LANGOBARDS

While Theodoric's architects sought to emulate and adapt Christianized classical forms, as we have seen in the mosaic decorations in the royal Church of the Savior (rededicated as S. Apollinare Nuovo) at Ravenna [see 3.11], the Visigoths, who had moved from Italy to southern France and on into the Iberian Peninsula, continued their pagan heritage in fine weapons and jewelry. In a magnificent pair of eagle brooches [4.6] that combine polychrome and animal styles, the artist rendered the bird in flight with outspread wings and tail, and profile head with curved beak and large round eyes. The fibulae also display a rich assortment of gems. Besides the red garnets interspersed with blue and green stones, the circles that represent the eagles' bodies have cabochon (polished but unfaceted) crystals at the center. Round amethysts in a meerschaum frame form the eyes. Pendant jewels originally hung from the birds' tails, accentuating the lavish polychrome effect. The eagle remained one of the more popular motifs in Western art, owing in part to its significance as an ancient sun symbol, a symbol of imperial Rome, and later as the emblem of St. John.

The Visigothic ruler King Reccared converted from Arianism to Roman Christianity in 587. He

4.6 Eagle-shaped fibulae, Spain, 6th century. Gilt, bronze, crystal, garnets, and other gems. Height 5 5/8in. (14.3cm). The Walters Art Museum.

Visigothic Scholar

St. Isidore (560–636), who became the Bishop of Seville in 599, exemplifies the extraordinary scholarly energy of the Visigothic clergy. St. Isidore attempted to preserve all human knowledge, which he collected and organized into a huge encyclopedia. He called his work *Etymologies* because he attempted to explain things by analyzing words and names and tracing their histories. Many of his derivations are quite fantastic, and Isidore clearly loved to record a fabulous story. Nevertheless, so comprehensive and learned was his study that it became the most frequently consulted source book for the next three hundred years. Carolingian scholars based their work on his. Every great library had a copy of *Etymologies,* and it continued to be used as a reference book throughout the Middle Ages.

St. Isidore also wrote on church history, doctrine, and liturgy, including the Mozarabic liturgy. He wrote a history of the world beginning with the Creation and ending with his own time (615). His *History of the Goths, Vandals, and Suevi* is an invaluable resource today. Not surprisingly, St. Isidore is the patron saint of historians—and art historians.

4.7 Recceswinth Crown. Toledo, 653–672. Museo Arqueológico Nacional, Madrid.

and his successors consciously copied imperial ceremonies. Justinian had presented votive crowns to Hagia Sophia—that is, crowns designed to hang over the altar in testament to the emperor's piety and ecclesiastical authority—so the Visigothic monarchs also ordered jeweled crowns and crosses as royal offerings [4.7]. A crown, given by King Recceswinth (ruled 649–672), is the most magnificent example of these donations. In a wide band of gold, three rows of 30 large polished sapphires alternate with pearls over an openwork surface punched with palm-like motifs. The narrow strips girding the upper and lower edges are decorated with interlaced tangent circles, a late Roman design often called "Constantinian." From the base of the crown hang inlaid letters spelling out the Latin phrase "Reccesvinthis rex offeret" (offered by King Recceswinth). From each letter hangs a sapphire and a pearl. Four golden chains of pierced, heart-shaped palmettes suspend the crown from an exquisite floral terminal of gold and rock crystal. The jeweler enhanced the borders of these palmettes with granulation, a process whereby beads of gold are fixed to the golden ground. The formal setting of precious stones and pearls within the gold frame recalls Byzantine design, while the exquisite craftsmanship harks back to traditional barbarian metalwork. The crown marks both the end of the classical tradition and the beginning of a new Western style.

Artists in Italy did not enjoy the relatively peaceful existence permitted their Visigothic counterparts. The violence that marked the Langobards' invasion of 568 continued unabated even after the conquerors had settled the region. Paul the Deacon, an eighth-century scholar whose *History of the Langobard People* recounts their wanderings, described with horror the devastation wrought by the armies: "The churches have been reduced to rubble and the priests murdered; the cities have become deserts and the people destroyed. Where once were the homes of people, today is the domain of wild beasts."

At the beginning of the seventh century, the kingdom, ruled by Queen Theodelinda and her

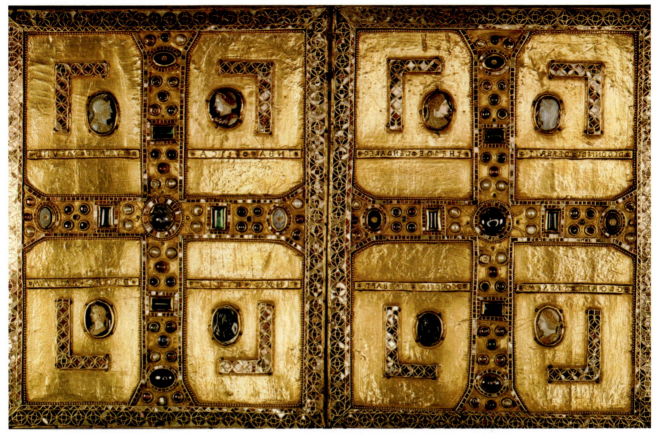

4.8 Cover of the Gospels of Theodelinda. Basilica of St. John the Baptist, Monza, Italy. Gold, gems, and pearls on a wood base. 13 2/5in. (34cm) high, 6th–7th century. Museo del Duomo, Monza.

consort, King Agilulf, had become a microcosm of the religious beliefs dividing the Western world. Although the majority of the Langobards were Arian Christians, some had remained pagan. The queen herself was a loyal follower of Pope Gregory the Great and the Roman church; nevertheless, she permitted rival Celtic monks to establish a monastery at Bobbio. St. Columban (c. 543–615) founded this monastery, which not only served as a link between the Celtic and the Langobard peoples but became one of the foremost centers of scholarship and book production in the early Middle Ages. Books made splendid gifts of state. In 616 Queen Theodelinda presented Pope Gregory with a gold and jeweled case, or cover, which combines the formal symmetry of classical art with the refined metalworking skills traditional among her barbarian Langobard ancestors [4.8]. Like the Goths, the Langobard rulers sought to emulate the art of Rome and Byzantium.

The Langobards attained the height of their power during the reign of King Luitprand (ruled 712–744), who restored and endowed churches, monasteries, and palaces. So skilled were the masons that the term "Lombard" was adopted in the Middle Ages to designate the building technique used throughout northern Italy. While few of Luitprand's projects still stand, the skills developed by his masons became forever part of the local tradition, with the result that the Lombard masters profoundly influenced the formation of the Romanesque style.

Luitprand commissioned many buildings for Cividale del Friuli, in the political and religious heart of his kingdom. Of those that survive, the Oratory of Sta. Maria in Valle, known as the Tem-

4.9
Sta. Maria-in-Valle,
Cividale, Italy,
8th century. Stucco,
relief sculpture.

pietto, or little temple, is the most remarkable for its splendid interior display of six over-life-sized stucco figures [4.9]. The decoration of the entrance wall echoes the Byzantine style. Indeed, the standing female saints and the ornamental moldings may even have been carved by itinerant Eastern artists rather than local craftsmen. In either case, the floral patterns across the wall re-create Byzantine designs in a somewhat stylized fashion. The figures—five crowned saints in richly embroidered cloaks and one dressed in a nun's habit—show their Byzantine ancestry. Static in pose, elongated in proportion, with small heads on slender bodies, the Cividale women could be granddaughters of the Empress Theodora and her retinue in the mosaic in San Vitale. Here the sculptor has intensified the regularity of the faces and the parallel lines that indicate the garment folds. Nevertheless, in the context of eighth-century Italy, this conservative version of the Byzantine style remains unique in its bold three-dimensional modeling.

The creative potential underlying Sta. Maria in Valle was never to be realized, because the Langobard kingdom did not endure long after Luitprand's death. Although he had maintained relatively cordial relations with the Franks, later Langobard rulers were not so astute. In 751 the Langobards conquered Rome, but this action forced the Pope to appeal to the Franks for aid. The two armies battled for control of Italy until 774, when the Franks, under Charlemagne (see Chapter 5), decisively defeated the Langobards and ushered in a new phase of medieval art.

THE ART OF THE MEROVINGIAN FRANKS

During the fifth and sixth centuries, the Salian Franks of the Merovingian dynasty—so called after their semi-legendary founder, Merovech—occupied Gaul and successfully vanquished or incorporated all others into their kingdom. If we are to believe the unsympathetic account of Bishop Gregory of Tours (d. 594), the Merovingians achieved these victories because, although they had adopted Christianity, they remained ruthless and greedy.

The Franks had converted to Christianity (496) during the reign of Clovis partly through the efforts of Queen Clotilda. According to legend, in the midst of battle, the king called on the Christian God for help, and his troops immediately carried the day. Thus Clovis, like Constantine,

4.10 A massive Burgundian buckle and belt plate in iron overlaid with silver and decorated with interlace partially gilded, the bosses covered with gold. 13 3/4in. (35cm): The Walters Art Museum.

adopted Christianity in order to ensure military victory. The conversion immediately put the Franks on the side of the Roman Church. In the process of successfully defending the papacy in the eighth century, the Franks emerged as the prevailing military force in continental Europe.

Understandably, early Frankish art reflects its Germanic tribal origins, with jewelry and weapons in both the polychrome and animal styles being the principal objects. The magnificent Burgundian belt buckle decorated with silver and interlacing serpents is typical [4.10]. The craftsmen had ample opportunity to study the art of other migratory people, partly as a result of trade and the exchange of gifts, but primarily because hoards of precious jewelry and armor constantly circulated throughout Europe as booty taken and given by people forever at war with one another.

The skills of the metalworkers soon were employed in the service of Christianity. Frankish artists copying the objects and themes favored by Rome and Byzantium satisfied their patrons' love of brilliant display and their own taste for abstract design. A medallion with Christ holding the Bible, placed above the arc of the heavens, flanked by alpha and omega (the first and last letters of the Greek alphabet, therefore signifying "the beginning and the end") and mysterious heads (the winds?), suggests that the Christian artists had adapted the early polychromatic gem style [4.11]. Like the Byzantine reliquaries of the Stavelot Trip-

tych [see 1.1, 1.2], the image is cloisonné enamel. Since the colored glass forms a brilliant, nearly luminous surface, the artist could work with dazzling colors and glittering surfaces without incurring the expense of precious stones. Furthermore, the medium lends itself to the abstract style preferred by the Franks. In early Western enamels, forms are simplified and colors limited to emerald green, dark and light blues, red, yellow, and white.

When the Merovingians began to build churches, they necessarily adopted late Roman architectural

4.11 Medallion with bust of Christ, Frankish, second half of 8th century. Cloisonné enamel on copper. Diameter about 2in. (5.1cm). The Cleveland Museum of Art.

4.12 Crypt of St. Paul, Abbey of Notre-Dame, 7th century. Left: Sarcophagus of Agilbert; right: Sarcophagus of Theodochilde. Jouarre.

techniques and structural forms. Gregory of Tours wrote of large and lavishly decorated basilicas and baptisteries such as the Church of St. Martin at Tours, erected in 466–470 to house the relics of the fourth-century apostle to Gaul. The Merovingians added towers to the horizontal basilican hall and, according to Gregory of Tours, decorated their churches with paintings, marble panels, and rich ornaments.

Interesting masonry walls, columns, and capitals can be seen in the Crypt of St. Paul, Jouarre, in France [4.12]. In 630 Celtic missionaries had established a monastery at Jouarre in northern France. About 50 years later, the bishop of Paris,

Agilbert, erected a church on the site, intending the foundation to serve as his family's mausoleum. The crypt dedicated to the fourth-century saint known as Paul the Hermit survived untouched during later restorations. The Frankish architects used indigenous structural techniques in patterned masonry walls, and they pilfered columns from local Gallo-Roman buildings. To fit these shafts, they imported capitals from workshops in southern Aquitaine, where marble carvers still used classical compositions and techniques.

Capitals that so carefully adapt Roman designs lead us to presume a Late Antique Style in other sculpture. Such expectations are confirmed by the

reliefs on the sarcophagus of St. Theodochilde (d. 662), the sister of Bishop Agilbert and the first abbess of Jouarre [seen at the right in 4.12]. Only a firsthand knowledge of Mediterranean art could have inspired the vine scroll with leaves and grapes adorning the cover and the rows of scallop shells and the precise letters of the inscription decorating the side of the marble tomb. The austere simplicity of the design, with its delicate carving and finely adjusted proportions, suggests contact with Byzantine art.

Merovingian monasteries such as Jouarre were missionary outposts and educational establishments. An important duty of the monks was to copy books, since missionaries needed the Bible and the writings of the Church Fathers. From the seventh century onward, the writing and decoration of manuscripts was a flourishing enterprise in Merovingian scriptoria. The natural desire of an expert scribe to glorify the text with art caused words and letters themselves to be so elaborated that words often took on the semblance of jewelry. It was but a step from decorated words to the addition of pictures. Inspired by Early Christian and Byzantine manuscripts, Frankish illuminators inserted author portraits at the beginning of the Gospels and frequently turned concordances of the four Gospels (canon tables), cross pages, and the introductory words of the text (incipits) into full-page designs.

Scribes delighted in adopting traditional motifs for their manuscripts, just as craftsmen employed the decorative patterns invented for swords and fibulae to adorn church treasures. One popular conceit was derived from the Roman practice of converting birds and fish into readable letters. Knowledge of this custom was surely acquired through the Celtic monasteries that developed close contacts with Italy. Nowhere did a Merovingian artist more beautifully interpret the animal alphabet than in the Sacramentary of Gelasius, probably made in a monastery at Corbie about 750 [4.13]. Named for the fifth-century Pope Gelasius, the Sacramentary is a liturgical service book containing the celebrant's part of the Mass. Each section has a decorated opening. The second section begins with

a portal, followed by a cross that introduces the words "Incipit liber secundus" (Here begins Book Two). Roundels inhabited by animals form the arms of the cross, and the Lamb of God appears instead of a human at the center. The lamb was an up-to-date feature, since Pope Sergius (687–701) had introduced the Agnus Dei into the Mass only 50 years earlier. Two birds hovering below the alpha and the omega nibble at the pendent letters, and the last words on the page are made up entirely of small fish and birds. These creatures, although at first glance rendered in natural proportions, are ingeniously composed of compass-drawn arcs. Their distinctive Merovingian eyes—round and white with a black dot exactly in the center for the pupil—repeat the circular motif. The cross, the roundels, the foliate motifs are laid out with geometric precision, for the traditional love of ornament still dominates the Merovingian style.

4.13 Sacramentary of Gelasius, France, mid-8th century. Manuscript illumination, 10 1/4 x 6 7/8in. (26 x 17.3cm). Vatican Library.

and added engraved crosses and symbols. The Papil Stone from Shetland, dating from the late seventh or early eighth century, has a compass-drawn cross flanked by figures in hooded cloaks carrying crosiers [4.23]. Below stands a lion (the symbol of St. Mark) having the distinctive Pictish emphasis on spiral joints and long curling tongue and tail. At the bottom of the stone, strange bird-headed men holding axes either peck at or hold an object, sometimes identified as a human head, sometimes as the Host. Pictish symbol stones pose fascinating problems of interpretation.

The scribes, faithful to the legacy of pagan styles, although respectful of Mediterranean models, created a distinctive style of painting in their books. (Works produced in Ireland, Scotland, and northern England have so many features in common that the style is called Hiberno-Saxon. "Hibernia" was the ancient name for Ireland.) Luxurious Gospel Books, among the glories of Christian art, document the development of this style.

The Book of Durrow was made between 664 and 675, in Iona or Northumbria. An Evangelist's emblem precedes each Gospel. The lion introduces the Gospel of John (following an early convention that reverses the usual symbols of Mark and John). The beast is far more ferocious than his Pictish cousin and strides forward framed by interlaces whose colors [4.24] change from red to yellow to green, and red stippling (seen in the Cathach) enriches interlacing ribbons. Stippling also covers the lion's head, and red and green diamond shapes resembling enamel inlay form his fur. Typical Pictish bands in yellow mark the muscles, tail, eye, and claws.

The man, symbol of St. Matthew, recalls even more emphatically the art of the enamel workers [4.25]. His body is a solid block of pattern resembling the millefiori inlay of the Sutton Hoo clasps. Only his head and tiny feet add a human element. Although his head with its staring eyes and simple arcs for nose, brows, and mouth seems more pattern than human face, the artist has observed the monks' appearance. St. Matthew wears his hair cut in the fashion of the Celtic church with high shaved forehead and straight cut hair hanging behind his ears. The cut of the tonsure was one of the many points

4.23 Papil Stone, late 7th or early 8th century, Shetland. National Museum of Scotland.

4.24 Lion of John. Book of Durrow. Probably northern England, second half of the 7th century. The Board of Trinity College, Dublin.

4.25 Man of Matthew, Book of Durrow. Probably northern England, second half of 7th century. The Board of Trinity College, Dublin.

of difference between the Celtic and Roman Churches resolved at the Synod of Whitby.

The tradition of fine goldsmithing continued in works for the Church. With generations of craftsmen behind him, the artist of the eighth-century Ardagh Chalice [4.26] was understandably adept at fashioning liturgical vessels. Such metalwork required no representational elements and therefore allowed free rein to the artist's inherent love of intricate abstract patterns. The clean, unbroken lines of the chalice and its smooth silver surface, inscribed with the apos-

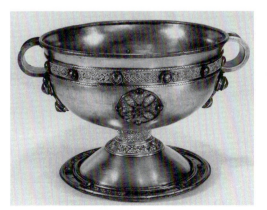

4.26 Ardagh Chalice. c. 800. National Museum of Ireland, Dublin.

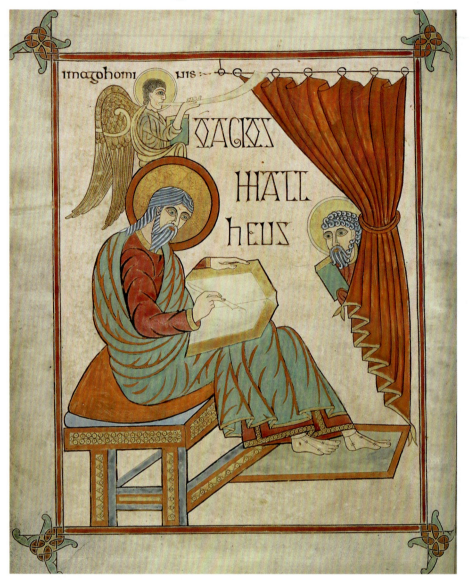

4.27 St. Matthew, Lindisfarne Gospels, Lindisfarne, Northumbria, early 8th century. Manuscript illumination, 13 1/2 x 9 3/4in. (34.2 x 24.8cm). The British Library, London.

tiny circles framed by a notched border in low relief. With such remarkable displays of technical virtuosity, the artists sought to honor their God. They created equally remarkable illustrated books to place with the chalice on the altar.

In the Lindisfarne Gospels and the Book of Kells decorative invention reaches its height. In the colophon, or end notes, the Lindisfarne Gospels provides us with an unusual record of the history of a medieval book. In the tenth century, Aldred, then prior of Lindisfarne, documented the efforts of his predecessors. He wrote that the book was written and drawn by Eadfrith, bishop of Lindisfarne (698–721) in honor of St. Cuthbert (d. 689), the founder of the community. Ethelwald bound the book, which was adorned with ornaments of gold and jewels by Billfrith, and glossed in English by himself, Aldred. The Lindisfarne Gospels has lost its jeweled cover, but the text is almost complete, with prefaces, canon tables, and commentaries. Each Gospel is preceded by the author's portrait and a cruciform carpet page.

tles' names, are enhanced by a subtle application of gold and enamel ornament. The artists did not permit their skill to overwhelm the massive, simple contours of the vessel, and they limited filigree and enamel to panels around the circumference of the chalice and on the handles. In some filigree panels, the master formed a thread out of twisted wires and then ran a beaded strand over it, while in others he hammered a beaded wire flat and soldered a second thin ribbon on top, thereby generating a string of

For the image of the evangelist Matthew [4.27], Eadfrith adopted a Byzantine author portrait [4.28], probably using a Bible brought to Northumbria from Italy. St. Matthew closely resembles the portrait of the scribe Ezra from the Codex Amiatinus, one of three giant Bibles copied by Northumbrian scribes about 700. The two figures are similar in posture, hand positions, and even chairs and footstools. The differences are also significant. While the Ezra painter captured his model's illu-

4.28
The scribe Ezra, Codex Amiatinus, Northumbria, early 8th century. Manuscript illumination. Biblioteca Medicea Laurenziana, Florence.

CODICIBVS SACRIS HOSTILI CLADE PERVSTIS
ESDRA DO FERVENS HOC REPARAVIT OPVS

sionistic modeling and perspective drawing in the furniture, the artist of St. Matthew emphasized two-dimensional linear patterns. He must have copied the Greek inscription, "Hagios Mattheus," from his model, but he returned to Latin, "Imago hominis" (the image of man), when he added Matthew's symbol, an angel, hovering over the author's head. Ultimately the two images are so different in conception that it has been suggested that the Lindisfarne artist may have been copying a flatter and more linear model than the Cassiodoran Bible. The northern artist maintains the flat colorful patterns to which he was accustomed. What better way for the artist to signal his indifference to naturalistic representation than by completely eliminating the legs of the stool, so that the solid footrest becomes a levitating rug.

The artist's inherently abstract aesthetic assumes full command in the cross carpet page [4.29]. Here, with stunning complexity yet total control, the painter displays an extensive repertory of motifs, as if the painted page were really a bejeweled plaque spread with golden filigree and enameled interlace. Within the spiral and trumpet patterns derived from earlier insular art, the illuminator set pairs of hounds who snap at long necked birds, traditionally symbolizing the immortal soul. This tangle of creatures remains subservient to the cross, filling the arms with twisting quadrupeds whose ribbon-like bodies and interlacing legs surround small, white-framed crosses. Since this inner ornament is as dense as the knots of birds and dogs, the cross and the field appear to be a single surface. The artist, in other words, like the Scandinavian and Anglo-Saxon goldsmiths, denied the concept of foreground and background and substituted pure geometry—a method revealed by the still visible ruler lines and compass pinpricks. A series of

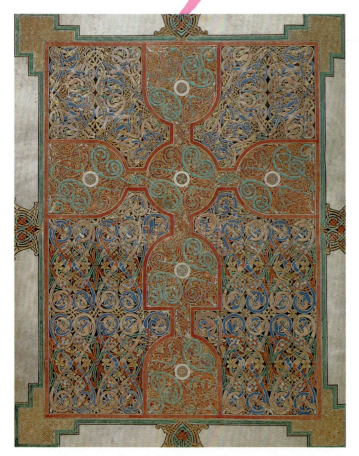

4.29 Carpet page preceding Matthew's gospel. Lindisfarne Gospels. Lindisfarne, early 8th century. The British Library, London.

parallel and diagonal lines and circles orders the layout of the page, and once this underlying logic is perceived, the potentially frantic and wild energy of the elements falls into satisfying rhythms, moving with the precision of clockwork. The Lindisfarne Gospels, the work of a scholarly monk captivated by complex visual abstractions, marks the classic moment of the style, a moment when intellectual control and decorative lavishness are held in perfect balance.

The Book of Kells is larger and even more richly illuminated than the Lindisfarne Gospels. "The chief relic of the Western world," as the Book of Kells was described as early as the eleventh century, was begun by Connachtach, a scribe and the abbot of Iona. When he died in the Viking attacks of 802, the fleeing monks carried the unfinished book to the Irish monastery of Kells, where at least four

other artists and a number of assistants finished it. The Chi Rho monogram is perhaps the most celebrated of the illuminations [4.30]. The three Greek letters, XPI, both represent the sacred monogram of Christ and introduce the text of the Nativity story: "Christi autem generatio" ("Now the birth of Jesus Christ took place in this way."—Matthew 1:18). So elaborate is the ornament that only three words could fit on the page.

The Book of Kells is distinguished by the sheer variety of its design components. The painter subdivided letters into panels filled with interlaced animals, snakes, spirals and knots, then filled the spaces between the letters with equally complex ornamental fields. Despite this profusion of ornament, every line can be traced as a single thread, and the individual parts of every beast are easily discovered. The Kells illuminator also used human figures as shapes in the overall pattern; for exam-

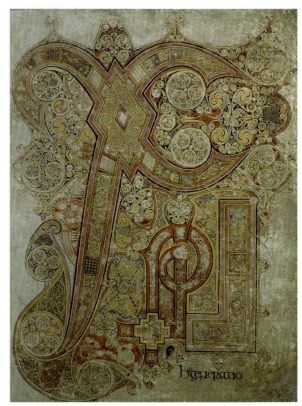

4.30 Monogram of Christ, Book of Kells, Iona and Kells, late 8th or early 9th century. 13 x 9 1/2in. (33 x 24.1cm). Trinity College Library, Dublin.

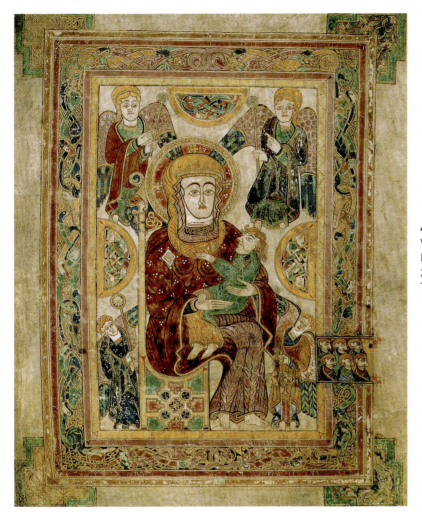

4.31
Virgin and Child. Illustration in the Book of Kells. 13 x 9 1/2in. (33 x 24.1cm). Late 8th or 9th centuries. Trinity College Library, Dublin.

ple, a male head terminates the under curve of the rho and at the same time it "dots" the iota. Angels spring from the downward stroke of the Chi.

In the midst of these abstractions the artist inserted astute pictorial observation and commentary. Near the bottom of the page, just above and to the left of the word "generatio," he painted an otter holding a fish in its jaws. Has this image symbolic meaning, or is it merely observation of the natural world? To the right of the Chi's tail, two cats pounce on a pair of mice as the tiny rodents nibble a Eucharistic wafer. Is this scene an allegory on good and evil with noble cats and demonic rats? Or does it simply record the monastery's cats at work?

The Kells painters may have seen Byzantine icons like the ones Benedict Biscop brought from Rome, or perhaps they looked at illustrated books. Only Mediterranean models would account for the painting of the Virgin and Child with their broadly draped mantle folds, hieratic immobility, and truly monumental, almost hypnotically impressive, faces [4.31]. The Virgin's inlaid throne suggests the classical world, but it occupies no space and it sprouts interlace and animal heads. The illuminators seem to reaffirm their Celtic ancestry, not merely by an abundance of geometric and animal decoration irrepressibly bursting forth in the border and intruding as half discs on the images, but in the drawing and ambiguous disposition of the figures. They achieve the colorful heraldic character of monarchs in a deck of playing cards.

cessors of that great sixth-century leader, challenged by intriguing, aggressive enemies and further immobilized by their own sloth and incompetence, turned over more and more administrative duties to court officials. Consequently, the official known as the mayor of the palace assumed responsibility for the day-to-day management of the kingdom, its finances, and its army. By the time a man named Pepin rose to the office at 697, the mayor of the palace was the virtual ruler of France, and the office had become a hereditary position. In 717, the succession passed to Pepin's illegitimate son, Charles Martel, called The Hammer (d. 741). Charles not only brought the Merovingian nobility under his sway, but, by defeating the invading Muslim forces at the battle of Tours in 732, he also made western Europe safe for Christianity.

Charles Martel's son, Pepin the Short, overthrew the last of the Merovingians in 751. To obtain sanction for his act, Pepin called upon the Pope, and in return for political assistance Pope Stephen II anointed Pepin as king of the Franks in 754 at the Abbey of St. Denis in France. This act initiated the close association between the Frankish monarchs and Rome and also emphasized the importance of the Abbey of St. Denis. When Pepin died in 768, his sons, Carloman and Charles, divided the kingdom, but Carloman died in 771, leaving Charles—Charlemagne—the sole ruler of the Franks.

Charlemagne (768–814) deserved to be called "the Great." He was exceptionally skilled as a warrior and an administrator, and he proved to be a remarkably intelligent ruler. He gathered around him the most learned people of western Europe, and within a few short years he transformed his court at Aachen into one of the foremost intellectual centers of the Middle Ages. Alcuin of York (c. 730–804), a great Anglo-Saxon scholar, led Charlemagne's educational efforts emphasizing not merely literacy but good grammar, accurate texts, and extensive libraries. Carolingian scribes created a clear readable script based on Roman letter forms, which was used throughout the empire. Paul the Deacon, the historian of the Langobards, came from Italy; Theodulf, a Visigothic theologian and poet from Spain, joined the court circle as bishop of Orleans. Einhard

(d. 840), a scholar and artist from Fulda [see 5.4], was a pupil of Alcuin and succeeded his master as the "minister of culture" in Aachen. In his *Life of Charlemagne,* Einhard gives us a vivid description of the Carolingian court. Charles was likened to the Old Testament kings David and Solomon, the patriarch Joseph, and the Roman Caesar.

To cement relations with the papacy, in 789, Charlemagne ordered that the Roman liturgy rather than the native Gallican service be used in all churches—an astute move designed to unify the people through their worship services. Charlemagne also supported a revitalized Benedictine monasticism, promulgated by another former member of the court, St. Benedict of Aniane (d. 821). Charlemagne transformed the Church into an administrative arm of his empire by appointing his children, relatives, and friends to positions of ecclesiastical authority, from which vantage they organized an elite civil service to rule the far-flung territories. Drogo (bishop, the archbishop of Metz), along with Ebbo (bishop of Reims), and Angilbert (a son-in-law and lay abbot of Centula) carried the culture of the court throughout the empire.

Side by side with the ecclesiastical administration was the equally well-organized secular government. Charlemagne established a unified monetary system for the empire, the silver penny. He laid the foundations for the medieval state by formalizing the ancient barbarian tradition of loyalties and oaths. He divided the empire into counties, ruled by loyal officials, the counts, who had followers of their own. Such a system created a ready supply of soldiers for the emperor's military campaigns. The booty from these campaigns gave the victors the enormous wealth needed to support their building programs and patronage of the arts. Charlemagne personally led at least 53 expeditions, and because he always fought in the name of Christianity, it can be said that he, like Constantine before him, used religion to enhance his political goals.

Following his father's precedent, Charlemagne defended Rome against the Langobards and finally destroyed their kingdom in 774. He waged successful wars against the pagan Saxons in northeastern Germany and the nomadic Avars from the

The Value of Art

St. Gregory the Great (Pope, 590–604), writing to the iconoclastic Bishop Serenus of Marseille, argued that images had an educational value in the church as long as they were used to "instruct the minds of the ignorant" and not adored for their own sake. He wrote, "To adore images is one thing: to teach with their help what should be adored is another. What Scripture is to the educated, images are to the ignorant, who see through them what they must accept; they read in them what they cannot read in books." (Epistle 13, translated by Davis-Weyer, *Early Medieval Art, 300–1150*) The Pope's letter was often quoted in the arguments over the value of art.

The debate over the presence of images in the church broke out anew in the ninth century at the end of the iconoclastic controversy. In response to what the Carolingians learned about the position of the Eastern Church, Bishop Theodulf of Orleans, as spokesman for Charlemagne's court, wrote a lengthy and impassioned reply—"The Carolingian Books" *(Libri Carolini)*. Theodulf distinguished between things made by God, such as the relics of saints, and things made by artists, which were not in themselves holy. Those who made images were craftsmen who learned their trade like anyone else. Art had its principal use as an educational tool in the church and its value depended on the quality of materials and workmanship. Both images and words could tell stories, but the image remained inferior to the word. This point of view represents a common attitude toward art and artists during the Middle Ages.

Hungarian plain (and incidentally acquiring an enormous amount of gold and silver). Around the borders of his realm Charlemagne established special frontier districts known as the Marches (German: *Mark,* boundary district) governed by powerful warriors. The most famous was the Spanish March. Here Charlemagne, accompanied by his vassal Count Roland of Brittany, fought against the Moors (as Muslims in Spain were called). The death of Count Roland during the massacre of the emperor's rear guard in 778 provided the inspiration for the later epic poem, *The Song of Roland.* In this masterpiece of French medieval literature, Charlemagne and his knights exemplify the heroic ideal of Christian chivalry.

Charlemagne's seal read "renovatio Romani imperii" (the revival of the Roman Empire). Whatever the political and religious ramifications of the Frankish dream, it also generated a respect for classical art and learning in its Early Christian guise to such an extent that the period is often referred to as the Carolingian Renaissance.

CAROLINGIAN ARCHITECTURE

During the last 20 years of his reign, from about 794, Charlemagne maintained a fixed capital at Aachen. Not only did the city have a geographically advantageous location, it also boasted vast game preserves and natural hot springs, where the emperor could indulge his fondness for riding, hunting, and swimming. Consequently, although he had other residences, it was at Aachen that Charlemagne built a palace complex with a judicial hall and chapel for the imperial court. As models for this endeavor the emperor turned to the imperial cities he knew—Rome and Ravenna.

Charlemagne's architects, led by Odo of Metz, designed the Aachen complex on a classical grid plan, typical of Roman frontier towns [5.2] and [5.3]. Buildings housing the law court, the guards' barracks, and the administrative offices were crossed by two major axes, one running east-west and the other extending from north to south, with a monumental gateway at the point of intersection. The gateway opened into a large forum in the center of which Charlemagne placed an equestrian statue of Theodoric the Great (see Chapter 4), which he brought from Ravenna. Dominating the Aachen complex were Charlemagne's palace chapel on one side of the forum and his residence and audience hall on the other. The audience hall was a large, two-story structure with apses on three sides and a stair tower on the fourth. The imperial re-

790s, a campaign to enlarge the building resulted in an aisled basilica, again with an apse and crypt for the saint's remains at the eastern end. In 802 Abbot Ratger (802–817) evidently decided that the relics of St. Boniface should have as splendid a setting as the tomb of St. Peter's in Rome. The building was to be as nearly identical to the Constantinian church as differing construction methods, the influence of local style, and the already existent basilica would allow. Abbot Ratger's men added a western transept and apse in order to duplicate St. Peter's tau-cross plan and orientation. The abbot even requested that the dimensions of St. Peter's be sent from Rome, with the result that, when completed, the Abbey Church of Fulda was the largest of all northern churches. Three years after the Fulda abbey church was consecrated in 819, monks, again following the model of St. Peter's, built a new cloister on the east instead of the south side. This atrium, however, fronted the earlier semicircular apse, because they had left the eastern apse of the original church untouched. (The church no longer exists, since it was rebuilt at the beginning of the eighteenth century.)

5.4 Abbely Church of Fulda, 802–819. Plan.

Buildings such as the Abbey Church of Fulda demonstrate that Carolingian planners never produced slavish copies of Constantinian monuments, even when they claimed to be doing so. Consequently, it is more accurate to describe the Carolingian revival of Early Christian architecture as a reinterpretation of the older forms—a reinterpretation that integrated classical designs with the northern requirements and so laid the foundation for later medieval structures.

The originality of Charlemagne's architects stands out most clearly in those churches that were not designed as overt imitations of Roman buildings. The Abbey of St.-Riquier at Centula in northern France attests to the inventive character of Carolingian architecture [5.5]. Built by Angilbert, its lay abbot, between about 790 and 799, Centula illustrates the Carolingian builders' interest in geometric planning. Excavations reveal that a cloister joined three churches in a roughly triangular layout. Perhaps this three-sided figure gave visual presence to the three-part, indivisible Trinity to which the monastery was dedicated. Carolingian architects seem to combine their ancestors' delight in geometric designs with the Christian interpretation of architecture as symbolic form—an interpretation already encountered in cross-plan churches and eight-sided baptisteries. The church consecrated to the Virgin and the Apostles also demonstrates the architects' concern for symbolism. Modern excavations have shown that this chapel was a 12-sided structure, surrounded by an aisle that housed 12 altars—one for each of the apostles.

St. Riquier, the major church at Centula, illustrates an innovative Carolingian church design that was to have a long life in Germanic countries. The silhouette of St. Riquier was remarkable for the verticality produced by the tall crossing towers (towers over the juncture of transept and nave) with flanking stair turrets rising from both the eastern and western ends. The towers were composed of round or square drums (the evidence is not clear) supporting three stages of open arcades surmounted by spires. These structures must have been built of timber, perhaps around a central mast. The desire for soaring heights seems to have far outweighed

5.5 Abbey Church of St. Riquier, Monastery of Centula, France, dedicated in 799. Engraving, dated 1612, copy of an 11th century drawing.

space for altars or a choir. It could have a private room for emperor or king, as we have seen at Aachen. Westworks served as reliquary chapels and even as independent parish churches for laymen when the church served a monastic community. Although precedents for the westwork exist in other Carolingian churches, St. Riquier provides the first fully developed example of what was to become a characteristic element in medieval German architecture. Towers and westworks mark a building as important.

Chapels in Carolingian westworks could not house the growing number of relics arriving in France and Germany. In gratitude to Pepin and Charlemagne, the popes had allowed Frankish churchmen to extract relics from Roman catacombs for their own churches. Altars dedicated to the martyrs began to fill the naves as well as the chapels of Carolingian churches. When pilgrims began to visit the shrines, new interior arrangements were required to create additional space. At the same time, in order to accommodate an increasingly large clergy, architects found it necessary to expand the overall size of the sanctuary. Inspired by the early Christian martyrs' churches in Rome, builders found a way to provide for both the relics and the people who came to venerate them. Underneath the sanctuary they built substructures, or crypts, accessible from the main level of the church. Because crypts had to support the weight of the church above, the builders relied on Roman masonry construction techniques of groin and barrel vaults.

The Carolingian monastery, however, was far more than a pilgrimage station. It was designed to be a religious center where people sworn to obedience and poverty lived in a self-sufficient community according to the rule of St. Benedict and worshipped together in a regular sequence of church services, the Divine Office. Just as services in the church formed the heart of the community's spiritual life, so the cloister and scriptorium, where the monks and nuns studied and created books, became the nucleus of its

the need for the kind of permanence afforded by masonry construction. St. Riquier was essentially a timber-roofed basilica with an eastern transept and apse in the Early Christian manner to which a second transverse hall and towers were added at the west. The final building double ended and symmetrically balanced east and west.

The western complex, called a "tower" by the Carolingians, is now known as a "westwork." The westwork was a monumental entrance complex with an upper chapel designed to create additional

5.11 St. Mark, Ada Gospels, Palace School, Aachen, c. 800. 14 1/2 x 9 5/8in. (36.8 x 24.4cm). Stadtbibliothek, Trier.

5.12 St. John, Coronation Gospels, Palace School, Aachen, early 9th century. Purple vellum, 12 3/4 x 9 7/8in. (32.3 x 25cm). Kunsthistorisches Museum, Vienna.

When Alcuin retired to Tours in 796, Charlemagne's biographer, Einhard, became chief of the palace scriptorium. Under Einhard, Carolingian artists rediscovered the illusionistic painting of imperial Rome as it had been preserved by the Byzantines. Indeed, one or more Greek illuminators may actually have come to Aachen to work. The Greek name "Demetrius Presbyter" appears on the first page of the Gospel of Luke in the Coronation Gospels [5.12]. What part he played in the execution of the manuscript is not known, but the inscription does document the presence of a Greek at the court.

The extraordinary new style that developed out of the revival of ancient Roman art, no less than from the assistance of Eastern-trained artists, is nowhere more striking than in these Coronation Gospels. (When Emperor Otto III opened Charlemagne's tomb, in the year 1000, he found the Gospel book on his predecessor's knees, and he took it for himself. Thereafter German emperors swore their coronation oaths on this book). Written in gold on purple vellum, the book is dated late in the eighth century or at least before Charlemagne's death in 814. The painter has created portraits of the Evangelists that rival the illusionistic painting of ancient Rome. St. John, a full-bodied, white-robed figure, is seated on a crimson-cushioned golden throne isolated against a hilly landscape. This concentration of solid human forms in an impressionistic landscape suggests antique illusionism. The artist achieved the effect of chiaroscuro modeling by building up forms with a thick application of paint (some of which has flaked off over the centuries). One need only compare the Coronation Gospels' St. John to St. Mark in the Ada Gospels to see the increase in substance and monumentality of the figures. A second comparison, with such Byzantine works as the Rabbula Gospels, reveals the Carolingian painter's source for the lush forest and pale blue sky behind St. John's throne [see 3.27, 3.28]. The wide golden frame is yet another classicizing element, for by creating a picture-window view, it enhances the illusionistic quality of the painting. Nevertheless, the footstool in reverse perspective projects out over the frame into the spectator's space, in accord with Byzantine aesthetic theory.

With Byzantine painting playing such a vital role in manuscript illumination, it is not surprising to find that ivory carving also fell under the influence of Byzantine art. When a Carolingian artist carved ivory reliefs for the cover of a Gospel book at the Abbey of Lorsch, about 810, he must have seen some ivories from Justinian's court [5.13]. (So well did Charlemagne's artists understand their models that this Carolingian book cover was once identified as sixth-century Byzantine work.) The Lorsch cover consists of five panels: the enthroned Virgin and Child, flanked by Zacharias and St. John the Baptist, in the center; a medallion held by hovering angels in the upper section; and the birth of Christ and Annunciation to the Shepherds in the lower panel. The architectural setting of the full-length figures recalls the Byzantine Archangel Michael ivory [see 3.23].

5.13 Virgin and Child with John the Baptist and Zacharias. Book cover of the Lorsch Gospels (back). Nativity and annunciation to the shepherds below. Ivory, 14 7/8 x 10 3/4in. (37.8 x 27.3cm). C. 810. Victoria and Albert Museum, London.

The sculptor of the Lorsch book cover, like the painter of the Ada Gospels, exploited the two-dimensional decorative possibilities of line rather than its form-defining function. Although the architectural setting is convincingly rendered, the figures themselves occupy little tangible space. Their corporeal substance is denied by rich ornamental drapery patterns. Looped and hooked folds suggest the roundness of shoulders, thighs, belly, and breasts, but lower legs are hidden by an array of straight sharp lines. The figures seem to disappear behind these linear patterns. The sculptor must have worked from a model having measurable volumes; however, his attempt to express these volumes by linear means has resulted in a markedly different style. The true classical style, even as translated by the Byzantines, always eluded Charlemagne's artists.

LATER CAROLINGIAN ART

The Carolingian Empire did not last long after the death of the man whose vision created it. Trouble began almost at once, during the reign of the new emperor, Louis the Pious (ruled 814–840), called "pious" because of his interest in the development of monasteries as the spiritual, artistic, and intellectual centers of Carolingian life. Louis had little political or military ability, however, and he could not control his sons, who attempted to secure for themselves as rich a portion of their father's lands as possible. When Louis died, Lothair I inherited the title of emperor, along with the middle section of the empire from the North Sea through Italy. The two younger heirs, Louis the German and Charles the Bald, received, respectively, the eastern and western parts (modern Germany and France). Even if the brothers had lived in peace with each other, Charlemagne's dream of imperial unity was a hopeless cause. The Treaty of Verdun in 843 confirmed the tripartite organization of the empire.

Territorial wars continued until the map of Europe became a jigsaw puzzle of small, interlocking holdings. The moral authority of the Church also suffered under these anarchical conditions. In 882 assassins struck down the Pope himself. So precarious was the political climate that at the end of the century six different popes reigned within a two-year period.

Adding to the misery of civil wars and the lack of spiritual leadership, the aging Carolingian Empire was threatened from the outside. In the late eighth century the Vikings began their expedi-

tions around Europe. By 881 the Norsemen had destroyed Angilbert's monastery at Centula. Eight years later they leveled Alcuin's abbey at Tours, and in 885–886 they attacked Paris, lifting the siege only when Charles the Fat paid an enormous tribute. As if these incursions from the north were not enough, the Muslims invaded Sicily and then raided the Italian peninsula. They destroyed the famous Benedictine monastery at Monte Cassino in 884 and even attacked Rome. At the close of the ninth century, the savage Magyars swept across Europe from the east and plundered northern Italy. Today we recognize that the Vikings, Muslims, and Magyars had splendid cultural and artistic traditions of their own, but to contemporaries this "dark age" of western Europe seemed terrible indeed. To understand what happened to the Carolingian dynasty, one need only look at the titles of its successive rulers, for such laudatory epithets as Charles the Hammer, Charles the Great, and Louis the Pious gave way in the ninth century to less than flattering nicknames. It is surely a sign of the empire's debilitated state that among the last of the Carolingian monarchs were kings called Charles the Fat, Louis the Stammerer, and Charles the Simple.

When the warring and harassed kingdoms ceased to function, Carolingian art was doomed. It had been a product of imperial patronage and the taste of an educated elite. Nonetheless, for another 50 years, throughout the ninth century, masterpieces continued to be produced. During the reign of Louis the Pious, Reims under Archbishop Ebbo and Metz under Archbishop Drogo, as well as St. Martin's Monastery at Tours, dominated cultural productivity. All three continued on after the Treaty of Verdun—Metz in the kingdom of Lothair, Reims and Tours in that of Charles the Bald. In addition, Charles may have founded a workshop, at the Abbey of St. Denis, where he was titular lay abbot. Since the arts continued to rely on imperial patronage, styles often reflect the individual taste of a patron or the models that happened to be available to the artists.

Louis the Pious appointed Ebbo, who had been the imperial librarian at Aachen, to be Archbishop

of Reims in 816. Shortly thereafter, Ebbo commissioned a Gospel Book for the Abbey of Hautevillers near Reims. The book was made there under the direction of Abbot Peter, probably between 816 and 823 [5.14]. An author portrait precedes each Gospel, followed by an initial page with golden text. The book is one of the great masterpieces of Carolingian art. Although the portrait of St. Mark ultimately derives from sources like the evangelist pages in the Coronation Gospels, in the Ebbo Gospels the classical calm exuded in the early manuscript becomes a vibrating rhythm of brush strokes. Rapid, calligraphic flourishes with an overlay of gold replace illusionistic impasto modeling. The painter focused less on the outward appearance of a man writing than on the inner, spiritual excitement filling the evangelist as he records the Word of God. The consequent expressiveness of face and gestures produces a grotesque result: Mark's head and neck jut awkwardly out of hunched shoulders; his left hand clumsily grasps the book, while the right seeks out the ink bottle. The long diagonal slashes that represent the saint's eyelids lend an almost theatrical character to his inquiring upward glance. Even the furniture serves to accentuate the instability of the composition, for only a single bulging leg supports the lion throne, and the inkstand rests on taffy-like mounts.

The most famous Carolingian manuscript, the Utrecht Psalter [5.15], belongs to this school of painting. In the ink drawings designed to illustrate the Psalms, the scribes captured the linear vitality of the Ebbo Gospels style in a powerful, expressive style—despite the fact that the depiction of buildings and crowds and the integration of picture and text into one field betray a source in antique illuminated manuscripts. The Psalms are metaphorical praises and laments rather than narrative descriptions. Thus, the text of Psalm 88 (89) is a blessing on the kingdom of David and a promise of protection against enemies. God—a youthful Christ in a mandorla—is surrounded by angels and a personified sun and moon. Below on the right hand of God, David, "the anointed one," is enthroned in his palace and receives the gifts of kings who arrive in their ships. On God's left, one sees the evils of the

5.14
St. Mark, Ebbo Gospels,
Hautevillers, 816–823.
10 1/4 x 7 3/4in.
(26 x 19.7cm).
Bibliothèque, Epernay.

world—the destruction of war, the plundering of cities, the individual cruelty of men, and even the Crucifixion of Jesus. The psalmist cries out for God's help: "like the dead who lie in the grave . . . the terrors destroy me: they surround me like water all day long; together they encircle me." Fortresses and palaces, hill, rivers, and the sea provide the setting for the energetic figures of kings, warriors, peasants, seamen, and prophets. One soul alone (at the upper left) receives a robe and crown of glory from three angels. The unrestrained energy of the drawings typifies the northern medieval spirit. Weightless figures, elegant and delicate, stand on tiptoe, gesturing emphatically. The dynamism accorded serpents in Scandinavia or abstract spirals in Ireland is here transferred to human beings and their activities.

FURORTUUS ETOMNESFLUC
TUSTUOSINDUXISTISUPER
ME DIAPSALMA
LONGEFECISTINOTOSMEUS
AME POSUERUNTMEAB
OMINATIONEMSIBI
TRADITUSSUMETNONEGRE
DIEBAR OCULIMEILANGU
ERUNTPRAEINOPIA
CLAMAUIADTEDNE TOTA
DIEEXPANDIADTEMANUS
MEAS
NUMQUIDMORTUISFACIES
MIRABILIA AUTMEDICI
SUSCITABUNTETCONFITE
BUNTURTIBI

NUMQUIDNARRABITALI
QUISINSEPULCHROMISE
RICORDIAMTUAM ETUE
RITATEMTUAMINPER
DITIONE
NUMQUIDCOGNOSCENTUR
INTENEBRISMIRABILIA
TUA ETIUSTITIATUAIN
TERRAOBLIUIONIS
ETEGOADTEDNICLAMAUI
ETMANEORATIOMEAPRAE
UENIETTE
UTQUIDDNEREPELLISORA
TIONEMMEAM AUERTIS
FACIEMTUAMAME

PAUPERSUMEGOETINLABO
RIBUSAIUUENTUTEMEA
EXALTATUSAUTEMHUMILI
ATUSSUMETCONTURBATUS
INMETRANSIERUNTIRAETU
AE ETTERRORISTULCON
TURBAUERUNTME
CIRCUMDEDERUNTMESICUT
AQUATOTADIECIRCUMDE
DERUNTMESIMUL
ELONCASTIIAMEAMICUM
ETPROXIMUS ETNOTOSME
OSAMISERIA

LXXXVIII INTELLEC TUSAETHAN ETZRALLITAE

5.15 Psalm 88, Utrecht Psalter, Hautevillers or Reims, 816-832. Ink on vellum, approximately 13 x 10in. (33 x 25.4cm). University Library, Utrecht.

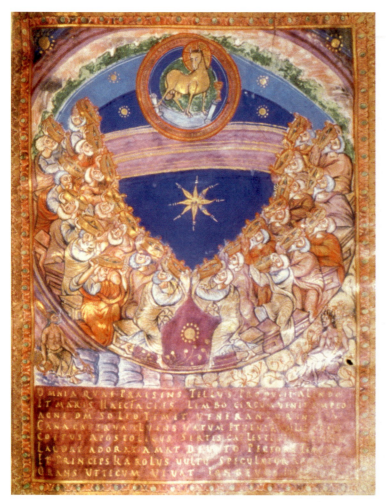

5.22 Adoration of the Lamb of God. Codex Aureus. Court school of Charles the Bald, c. 870. Bayerische Staatsbibliothek, Munich.

that makes it truly a Codex Aureus. The brothers Berengar and Liuthard finished the Gospels in 870. In a depiction of the Apocalypse [5.22], which may have been inspired by the dome mosaics of Charlemagne's palace chapel at Aachen, the 24 elders adore the mystic Lamb who stands in a circle of light above a rainbow. The chalice in front of the Lamb recalls Christ's sacrifice and the celebration of the Eucharist. In pictorial terms, the painters conformed to the Byzantine practice of representing the apocalyptic Christ as the Agnus Dei rather than as the human redeemer known in the Western tradition. Within the great star-studded disk of Heaven, the elders twist and turn, rising from their thrones and offering golden crowns to the radiant golden Lamb. The glorious color and gold lend an ecstatic tone to the awesome vision of glory. The painters capture the drama of the scene by adapting the dynamic linearism and spirited movements used by their colleagues at Reims and Metz while retaining the corporeal solidity and illusionistic modeling of their classical models and the earlier court schools.

The covers of these manuscripts match the sumptuous quality of the illuminations within. On the cover of the Lindau Gospels, made about 870, a jewel-encrusted frame surrounds a jewel-bordered cross bearing the triumphant living Christ [5.23]. Weeping personifications of the sun and moon with fluttering, gesticulating angels fill the upper quadrants of the field. Below, the Virgin, St. John, and two mourners twist in grief around bosses formed of gems and pearls. The small figures with their hunched shoulders, expressive movements, and fluttering draperies contrast with the serene, idealized Christ. In spite of their patrons' pride in emulating Early Christian and Byzantine art, Frankish artists continued to develop the jewelwork and metalwork so beloved by their barbarian ancestors. Delicate arcades on lions' feet support polished gems, and beaded mounts set off pearls from the foliage-encrusted ground. Jewels and pearls attest

earthly goals. If the canons of St. Martin's hoped to capture the king's attention and to educate him, they were to be disappointed. Charles continued to give away church lands to pay off his supporters and was himself lay abbot of St. Denis, one of the most important monasteries of his kingdom.

Charles the Bald, as temporal ruler and lay abbot of St. Denis, was one of the last Carolingian rulers to patronize the arts on a grand scale. The Codex Aureus of St. Emmeran is quite literally a "golden book"—from its bejeweled gold cover to the purple vellum and golden script. Charles not only acknowledges patronage of the book but records his provision of the gold

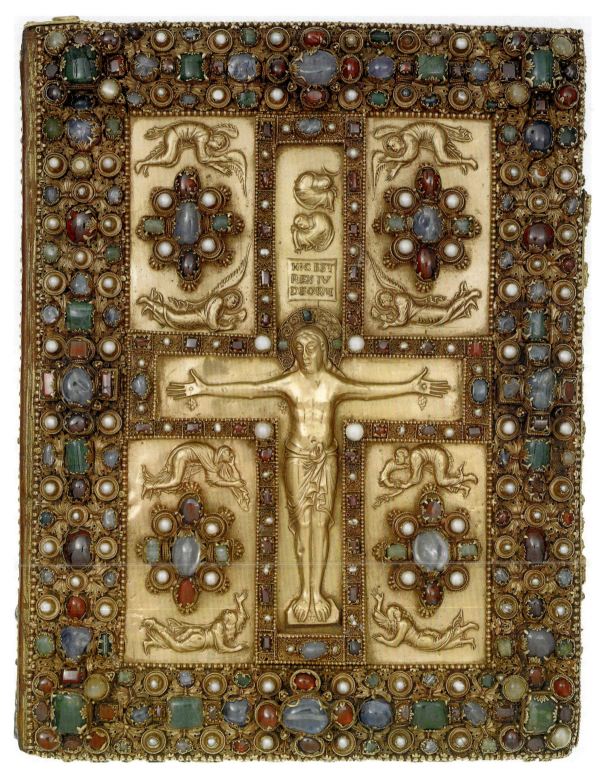

5.23 Christ on the Cross, cover, Lindau Gospels, c. 870, precious stones, pearls, 13 3/8 x 10 3/8in. (34 x 26.4cm). The Pierpont Morgan Library.

6.2 Hagia Sophia, interior view through doorway. Discs with names of God, Muhammad, and early Caliphs, c. 687. Constantinople.

6.3 Hagia Sophia, Virgin and Child, Apse mosaic, c. 867. Constantinople.

Byzantines saw their society as a continuation of the glorious and all-powerful Roman Empire, albeit the Christian Roman Empire of Constantine. For their part, the Muslims had risen to power and greatness suddenly, seemingly out of nowhere in the Arabian peninsula. Yet, within a century of Muhammad's death in 629, they were masters of the Iberian Peninsula and had crossed the Pyrenees into France. The two powers seemed destined to confront each other although in the thirteenth century both suffered temporary defeats from outsiders—the Western Crusaders looted Constantinople in 1204 (and held power there until 1261), and the Mongols conquered Baghdad in 1258.

In the period between the eighth and the thirteenth centuries, few people would have foreseen that in the fifteenth century Islam would prevail, and that Byzantine Constantinople would become Turkish Istanbul, where the Church of Hagia Sophia would serve as the conqueror's mosque. A view through the main ceremonial entrance to the church shows a mosaic of the emperor (probably Leo VI) kneeling before Christ [6.1]. Just visible through the open doors are huge discs hung in the nave by the Turks and bearing the names of Allah [6.2]. Between these masterpieces of Turkish calligraphy, the mosaic images of

Mary and the Christ Child can be seen enthroned in the golden apse [6.3].

THE MIDDLE BYZANTINE PERIOD, 867–1204

When in 843 the Council of Constantinople ended the iconoclastic controversy, the Byzantine emperors embarked on an ambitious program of restoration, rebuilding, and refurbishing the city's palaces and churches. Constantinople again became a city filled with rich treasures and spectacular buildings. Hagia Sophia received new mosaics in the narthex, galleries, and even the apse. The splendor of the court was supported by the military prowess and administrative skill of many of the emperors and court officials. In the ninth century a wily and ruthless player in the game of palace intrigue, Basil (ruled 867–886), established the Macedonian dynasty (867–1056). Basil and some of his successors, such as Leo VI (ruled 886–912) and Constantine VII (ruled 945–959), patronized the arts as an imperial policy. Mosaics, illuminated manuscripts, and silver, ivory, and enameled treasures testify to the enduring glory of the empire. The period became a second "Golden Age" for Byzantine art.

The creation of art and architecture on a grand scale requires political and economic stability. Although the Macedonian dynasty provided these conditions during the first hundred years of its existence, by the latter part of the tenth century, Muslim armies and marauding bands of Slavs and Vikings threatened the empire. In the Mediterranean area, Muslims landed in Sicily in 827 and completed the conquest of the island by 859. Meanwhile on the empire's northern frontier, Slavs moved across the land and Swedish Vikings sailed down the Russian rivers from the Baltic Sea. In the East the Muslims were halted by Nicephoros II Phocas (ruled 963–969), and the Slavs suffered defeat at the hands of Basil II (ruled 976–1025), henceforth known as the "Bulgar Slayer." Meanwhile, the Viking danger in Russia was reduced when the Vikings began to turn their camps into permanent trade centers and cities. In 989

Vladimir II, Prince of Kiev, accepted Christianity and affirmed his decision by marrying Basil's sister. In Constantinople the Vikings formed the Imperial Guard, effectually reducing the danger from the north.

Troubles multiplied for the empire in the second half of the eleventh century, however. In 1054 the long-standing conflict between Byzantine and Latin Christianity on doctrinal issues resulted in the final separation of the Eastern and Western Churches, with the Pope in Rome and the Patriarch in Constantinople excommunicating each other. In the West the Normans moved into southern Italy and soon turned former Byzantine territory into the Duchy of Apulia. In the East the Muslim threat increased when Seljuk Turks rose to power. Sultan Alp Arslan routed the Byzantine army at Manzikert, in Armenia, in 1071 and then conquered most of Asia Minor.

During this period of crisis a new dynasty came to power through the skill of Alexios Komnenos (ruled 1081–1118) and his son John II (ruled 1118–1143). The Komnenian Period lasted for the next hundred years (1081–1185). In spite of the antagonism between the Roman and Byzantine Churches, Emperor Alexios turned to the West for help against the Muslims. His pleas led Pope Urban II to preach the First Crusade in 1095. For the rest of the Middle Ages westerners mounted crusades against the Muslims in an attempt to control the Holy Land.

The city of Constantinople in the tenth and eleventh centuries was not the city built by Justinian, for many of the capital's most magnificent monuments had been severely damaged during the iconoclastic controversy. After the triumph of the iconodules (lovers of images), the artists of the imperial court restored or replaced the obliterated images in Hagia Sophia. In 867 the Patriarch Photios preached a sermon on the restoration of the images, and the monumental apse mosaic of the enthroned Virgin and Child (*Theotokos, Mother of God*) must be dated to this time. The massive figures and the idealized faces of Mary and Jesus demonstrate that neither the sensitivity to classical art nor the craft of mosaic had been lost during the period of iconoclasm.

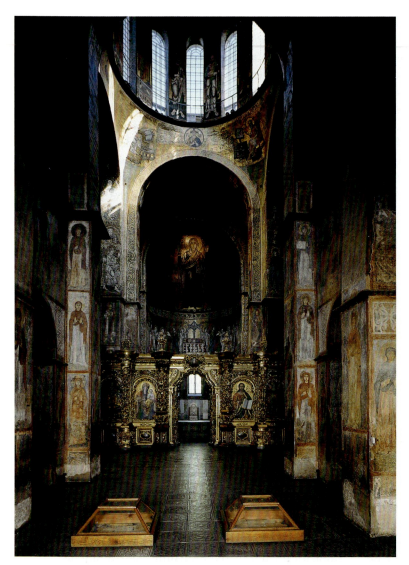

6.16
Interior, Cathedral of St. Sophia,
11th century and later, Kiev.

ceremonies, in both the court and the church, on people only a generation removed from their pagan past. The mosaic emphasizes the role of the new Christian priests, and reaffirmed both religious belief and liturgical practice.

The Orthodox missionaries to the Rus' must have brought icons, and books, as well as crosses, chalices, and other liturgical equipment with them. The new church needed many icons of Christ, the Virgin, and the saints. The earliest surviving icon in Russia is now known as the Virgin of Vladimir [6.18]. Probably made in Constantinople in the twelfth century, the icon was in Kiev by 1131. It was repainted after a fire in the thirteenth century, and today only the faces date from the early period. The Rus' believed the icon to have been painted by St. Luke. The theme of mother and son pressing their faces together is called the Virgin of Compassion. As the center of power shifted from Kiev to Novgorod and Vladimir, so too the icon moved. It was in Vladimir in 1155, and then finally it was taken to Moscow. Recently restored and now in the Tretyakov Museum in Moscow, a true miracle of the icon may well be its survival into the twenty-first century.

BYZANTINE ART IN THE WEST

Byzantine art came into western Europe through Venice and Sicily. The Republic of Venice had maintained close diplomatic and economic relations with Constantinople and other important

6.17
Cathedral of St. Sophia, Kiev, c. 11th century, as interpreted by Aseyev, V. Volkov, and M. Kresalny.

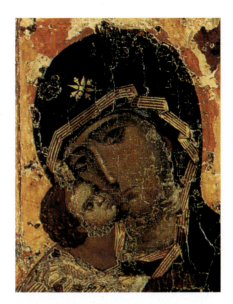

6.18 Virgin of Vladimir, 12th century. Tempera on board, 30 3/4 x 21 1/2in. (78 x 54.6cm). Tretyakov Gallery, Moscow.

cities in the Eastern Empire long after northern Italy had gained independence from Byzantine rule. The prosperity of Venice rested in large measure upon its commerce with the East. When in 1063 the Venetians began to rebuild the church of their patron St. Mark, they copied the Church of the Holy Apostles in Constantinople [see 3.9]. Naturally, they incorporated the changes made during the tenth-century remodeling of that church, a project that had resulted in the raising of the five domes on drums pierced by arched windows. In St. Mark's Church (a cathedral only since 1807), the massive hemispheres of the five great domes and the connecting and abutting barrel vaults produce a space reminiscent of Justinian's buildings [6.19]. Unlike the complex broken views characteristic of many Middle Byzantine churches, St. Mark's repeated vaults and large domes flow one into the next with harmonious grandeur. The mosaics (twelfth century and later) convey the sumptuous effect of the original scheme.

Southern Italy and Sicily also adopted Byzantine art and architecture, but for different reasons. The Byzantines had retaken southern Italy from the Muslims in the tenth century, but Sicily remained in Muslim hands. Then in the eleventh century the Normans under Count Roger (ruled 1061–1101) invaded, and by the twelfth century they controlled the south (Apulia) and Sicily. Roger II (ruled 1101–1154) was crowned King of Sicily, Apulia, and Calabria in 1130 at Palermo. He established a remarkably tolerant state in which Norman, Muslim, and Byzantine cultural and artistic traditions mingled to form a brilliant and exotic art.

THE BYZANTINE CONTRIBUTION TO THE ART OF THE WEST

Byzantine art exerted a profound and continuing influence on the art of the West. Techniques of painting, mosaic, cloisonné enamel, gold work, and ivory carving were transmitted to the West first by artists and later through handbooks. Byzantine iconography, figure style, and decorative motifs were also adopted by Western artists. At certain key moments in the development of Western art, Byzantine art played an important role. Byzantine models changed the direction of Carolingian painting at the end of the eighth century, and the art and artists who came to the Ottonian court reintroduced Byzantine art to the West at the beginning of the eleventh century. A Burgundian interpretation of the Komnenian manuscript painting style was spread through Europe by the monks of Cluny at the end of the eleventh century. Later, as artists in the Île-de-France were experimenting with the new forms, which we now call Gothic, they had another opportunity to study Byzantine art in the reliquaries brought back by Crusaders.

One of the most significant and enduring contributions to the art of the West was the Byzantine concentration on single religious images in icons. In the design of an icon, the artist had to organize a unified composition around a single idea or a single figure. To some degree, the development of the full-page manuscript illustration and eventually that of panel painting in the West were inspired by the icon painters.

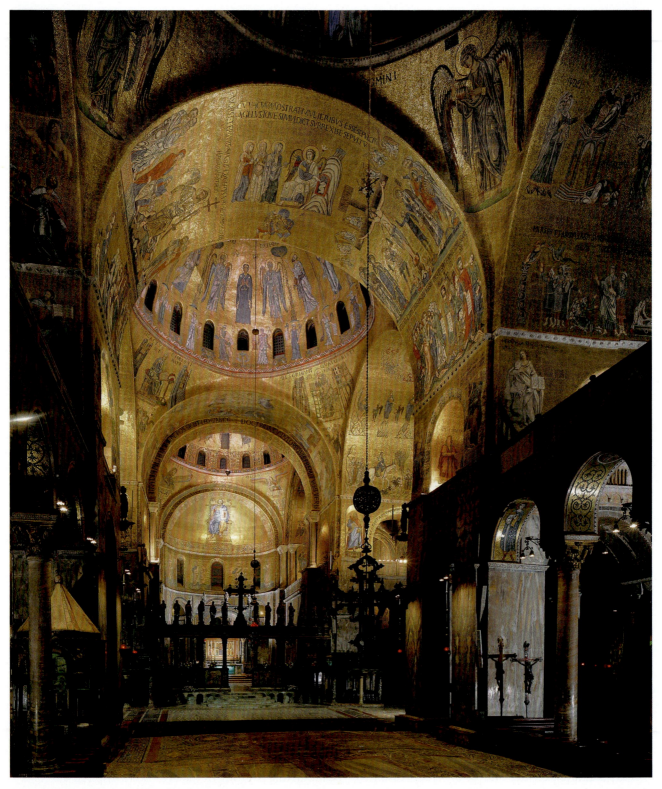

6.19 Cathedral of St. Mark, begun 1063, nave, Venice.

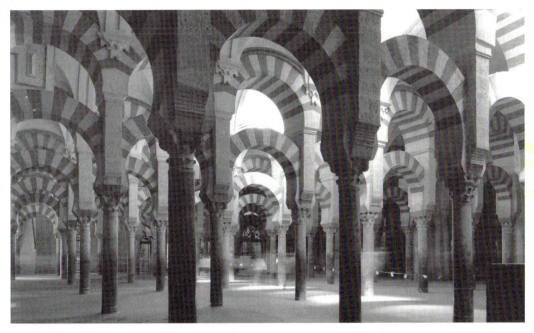

6.20
Great Mosque,
Córdoba, begun 785,
enlarged in the 9th
and 10th centuries.

Constantinople also had the largest collection of ancient Greek sculpture available to the artists of the Middle Ages. The city must have been like a museum, and its artists became the interpreters of the ancient classical heritage for the West. Western artists gradually absorbed more and more of the ancient humanistic style as interpreted by Byzantine artists. The vital message of ancient art, and one not wholly lost in Byzantine art, was an appreciation of the beauty and dignity of the human figure. If in creating human beings God had combined both matter and spirit, then the body should be shown as motivated by an inner will—or so the patrons rationalized. When the artists accepted the challenge of depicting the Word made flesh, they created landscapes and architectural spaces inhabited by spirited figures defined by color and light.

ISLAMIC ART

In the seventh century, a powerful spiritual and political leader, Muhammad (c. 570–632), appeared in Arabia. He founded a new religion, Islam, a word derived from *salam,* meaning the perfect peace that comes when one's life is surrendered to God. Making no claims to divinity, Muhammad called himself the prophet to whom Allah—God—revealed the truth. These revelations, collected in the Koran, became the sacred scripture of the Muslims.

Islam owed its international success to Caliph Omar, a leader who combined military and political skill with religious fervor. The caliph, meaning "successor," continued to be both a religious and a political leader. Omar embarked on a campaign of conquest: Damascus fell in 635, Jerusalem in 638. Among the great Christian cities of the East, only Constantinople remained in Christian hands. By the time of Omar's death in 644, the Islamic conquests spread from Egypt to Iran. Omar's followers established the Umayyad dynasty, which continued his military and spiritual success. When the Abbasids, who claimed the leadership of the Muslim world through Muhammad's uncle Abbas, toppled the Umayyads in 750, one Umayyad prince, Abd al-Rahman, "the flower of Islam," escaped to Spain.

In 756, Abd al-Rahman established a strong centralized government in Spain with a capital at Córdoba [6.20]. He allowed Christians and Jews to practice their religion by paying a tax for the privilege. They made up most of the city population and the artisan and commercial classes, while

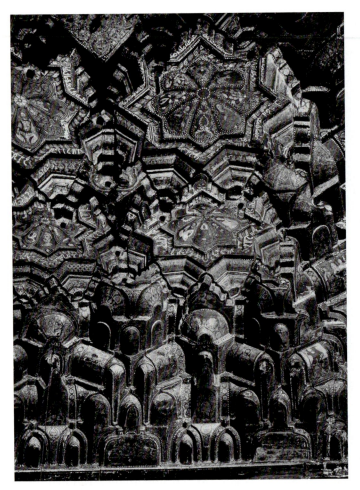

6.23 Cappella Palatina, ceiling of nave, 12th century, wood painted and gilded, Palermo.

mitted defenders to slaughter the trapped invaders almost at will.

A spectacular decorative form invented by Islamic architects in the eleventh and twelfth centuries is the muqarnas, or "stalactite," vault or ceiling [6.23], an ingenious system of corbels and squinches. The vault may be built of masonry or wood and is often purely decorative. Concentric rows of concave cells are corbeled out one above another in an interlocking triple squinch so that the vertical axes of the cells alternate and the upper seem to grow out of the lower. The weight of a muqarnas vault over a square bay does not rest on the corners of the square but on two points along each wall—that is, on the eight points of an octa-

gon inscribed within a square plan. The completed honeycomb-like structure is typically Islamic in its intricate geometric design and its disguise of underlying logic by a dizzying multiplication of forms. Muqarnas could be used structurally in ceilings and vaults and decoratively in marble, plaster, and tile on capitals and wherever architectural decoration was called for.

A wooden muqarnas ceiling covers the Norman Palace Chapel in Palermo. Fatimid artists working for the Normans painted the ceiling with foliate forms, calligraphy, and stylized scenes of court life. Muhammad had promised the faithful eternal bliss in a garden of earthly delights, described in the most sensual, physical terms. Islamic artists lavished attention on secular art and architecture, on material comforts and conveniences, and on worldly display.

THE DECORATIVE ARTS

Muslim artists excelled in the production of luxury objects. They achieved extraordinary effects all the while using inexpensive, impermanent materials—brick, wood, clay, and textiles. The transformation of simple materials into objects of delicate beauty, the concentration on the decorative arts, and the elevation of crafts to a position of honor are characteristic of Muslim art.

Fine writing, that is, calligraphy, became a Muslim specialty [6.24]. As the authentic word of Allah, given to Muhammad by the archangel Gabriel, the Koran inspired a superb nonfigural art. No definite prohibition against images is found in the Koran, but a strong iconoclastic party existed in Islam. Nothing in Islam, however, equals the vehemence of Hebrew prohibitions against images (for example, Isaiah 44:9–20). Muslim scribes focused on fine writing with decoration formed by geometric patterns and the abstract floral interlace known as arabesque. Their work influenced all the arts.

Calligraphy played an important role in the decoration of ceramics [6.25]. One of the most remarkable and characteristic achievements of Muslim artisans in the ninth and tenth centuries was the development of ceramics—the conversion of a

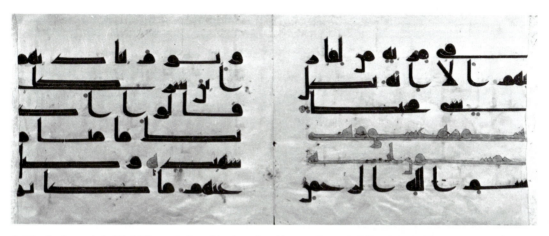

6.24 Kufic script, 9th-10th centuries. Black and gold on vellum, 8 1/2 x 21in. (21.6 x 53.3cm). The Nelson-Atkins Museum of Art.

base material like clay into a work of art. Inspired by Chinese porcelains coming into the Middle East along the trade routes, Muslim artists developed their own distinctive variations. A prohibition against the use of precious metals may have led the patrons to demand a substitute and the potters to invent luster. In luster painted ware, the potters covered a fine white ceramic body with a transparent glaze, and then after firing, painted the decoration of calligraphy, interlaces, foliage, and birds or animals on the surface with metallic glazes. A second firing resulted in a shining metallic surface. Luster painted ware became one of the glories of eleventh- and twelfth-century Muslim art. On an eleventh-century lidded bowl from Syria, decorated with birds, foliage, and calligraphy, the inscription reads "Patience means power; he who is patient is strong. Trust [in God] is what one needs."

Islam required the union of the individual will with a universal, all-pervasive God, achievable through contemplation and the performance of a fixed ritual. Likewise, art expressed Islam through the submergence of individual forms by means of an infinite multiplication of identical elements. This desire for infinite extension in space provides powerful symbolic associations. The geometric basis of forms and ornaments and the subjection of nature to mathematical figures characterizes early Islamic art.

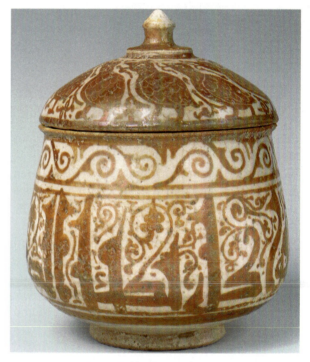

6.25 Lidded Bowl (Pyxis), Syria, second half of the 11th century. Composite body with white slip, glazed and luster-painted. Height 8in. (20.3cm). The Metropolitan Museum of Art.

The decoration of fine metalwork expresses these ideals. Muslim craftsmen perfected techniques of engraving and metal inlay, known today as damascening. Splendid utensils, such as a large silver inlaid brass ewer from Syria [6.26], display

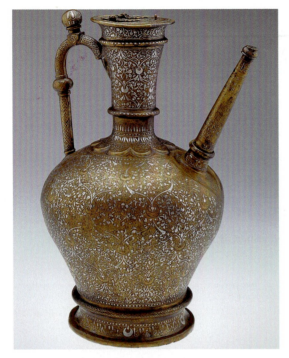

6.26 Inlaid brass ewer, Syria. 1232, Freer Gallery of Art.

this sophisticated technique. The silver forms an all-over pattern, sweeping over the body and neck of the vessel, and forming pointed ovoids framing an intricate abstract floral arabesque. The inscriptions tell the viewer that Qasim ibn Ali made the piece in 1232.

No less splendid are Muslim textiles. Patterned silks were produced by both Byzantine and Muslim weavers working around the eastern Mediterranean. Techniques and patterns are so much alike that experts often cannot agree on the place and date of manufacture [see 6.8]. The silk with roundels of elephants, senmurvs, and winged horses has been attributed to both Byzantine and Muslim weavers and dated between the eleventh and twelfth centuries.

The demand for Eastern textiles in western Europe meant that merchants carried silks and brocades across the continent. An inventory from St. Paul's Cathedral, London, made in 1245 lists Eastern silks with eagles, griffins, elephants, lions, trees, and birds. Sphinxes attacked by lions, slim stylized trees, and eight-pointed stars were also worked into patterns or repeated medallions. Such textiles provided Western artists with a veritable encyclopedia of decorative motifs. Silk weavers continued to use the traditional patterns well into the fourteenth century.

Islamic art often seems to present insoluble contrasts, for it may appear to be at the same time rational and anti-rational, earthbound yet otherworldly. Artists did not aim to re-create the appearance of life; instead they based their aesthetic principles on geometry. The expression of the complexity of growth from within, rather than dependence on the observation of external manifestations in nature, characterizes the Islamic use of forms. Intricacy seems to have been appreciated for its own sake. Artists gave their work symmetry without emphasis. The Islamic attitude toward the arts is perhaps best seen in the decorative arts. In the decorative arts, the ornamentation of the forms converts the simple shape or material into something beyond itself, just as the application of luster glaze transforms humble clay into the illusion of shimmering gold.

No attempt has been made here to trace the history and development of Islamic art, for this history deserves a special study. The buildings and objects discussed here, selected because they are of the kind possibly known to Christian artists, can only hint at the riches of a great culture. The struggle between Islam and Christianity both in the Byzantine East and the Latin West continued throughout the Middle Ages. The contact, although sometimes antagonistic, led to valuable cross-fertilization in art.

THE NORMAN KINGDOM IN SICILY: A UNIQUE CASE STUDY

When Roger established his administrative headquarters in Palermo, he was making a political statement, for Palermo had been the Muslim capital of Sicily. Roger succeeded in uniting the diverse population of Normans, Byzantine Greeks, Latins, and Muslims (300 mosques are reported to have existed in Palermo in Roger's time). Unity in diversity led to unprecedented prosperity for the

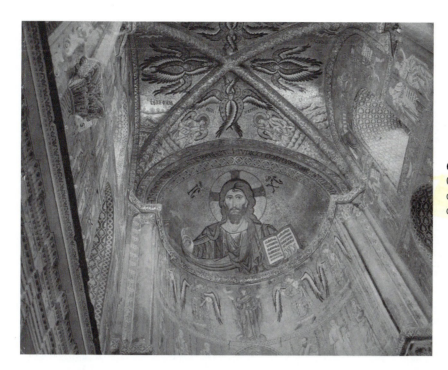

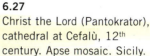

6.27
Christ the Lord (Pantokrator), cathedral at Cefalù, 12th century. Apse mosaic. Sicily.

next three generations. The Kingdom of Sicily enjoyed a measure of peace, stability, and well-being unknown in the rest of Europe.

At Cefalù on the Mediterranean coast east of Palermo, Roger II founded a church to serve as a dynastic pantheon [6.27]. In 1132 he commissioned mosaics for the church and imported materials and artists from Constantinople. Artists had to adapt the iconographical scheme developed for domed buildings to the apse of a basilica. With the ceremonial and aesthetic focal point in the apse rather than a central dome, the designers moved the image of the Pantokrator to the semi-dome of the apse and the angels to the vault of the sanctuary. Still adhering to the principle that the larger and higher the figures, the greater their sanctity, the mosaicists placed Mary and the archangels under Christ but above rows of apostles—all in superimposed registers on the curving wall.

In decorating the sanctuary, the artists compensated for the large surfaces to be covered and the distance of the images from the spectator by increasing the figure size. They simplified shapes and modeled in broad zones of flat color intensifying the colors of the mosaic. With tonal modeling almost abandoned, faces and draperies became a stylized network of color bands. Extravagant use of gold glass tesserae meant that the radiance of gold spread over architecture and figures alike—from the acanthus capitals of the framing colonnettes to the gold-shot robe of Christ. The final effect is of static figures, whose very stillness creates a serene spirituality. The Cefalù Christ has a kindly dignity, in contrast to the terrifying Pantokrator of Daphni. Even His blessing seems more welcoming, and His open book proclaims in Greek and Latin, "I am the light of the World" (John 8:12).

While Cefalù Cathedral was still under construction, King Roger commissioned a palace and chapel in Palermo [6.28]. The Norman palace has continued in use as the center of government to our own day, housing the Sicilian Parliament. In spite of over 800 years of remodeling to meet new needs, parts of the Norman palace survive.

The Norman chapel was consecrated in 1140, although the craftsmen only finished their work during the reign of William II, the Good (1166–1189). The architecture and decoration of the Palace Chapel captures the spirit of the ecumenical Norman rule. Architecturally it combines

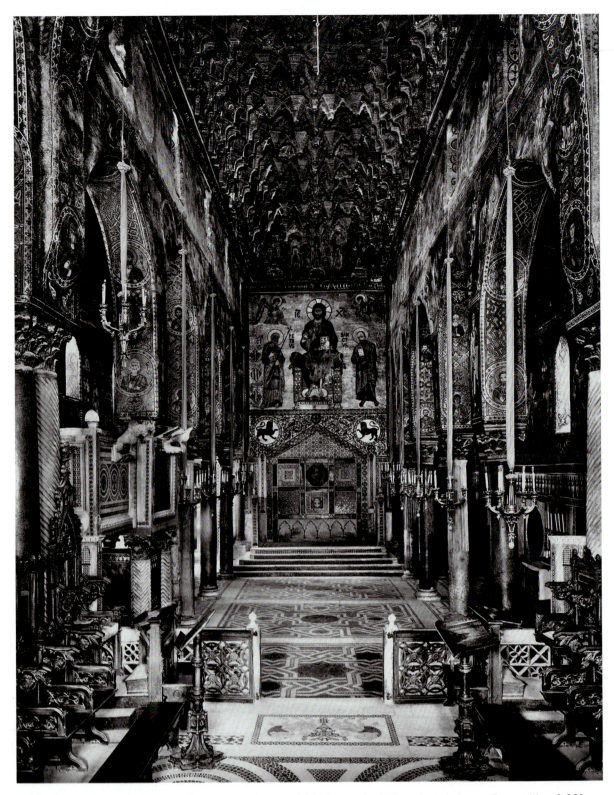

6.28 Palace Chapel, interior, 12ᵗʰ century, consecrated 1140, mosaic 12ᵗʰ century, Palermo. [see ceiling 6.23].

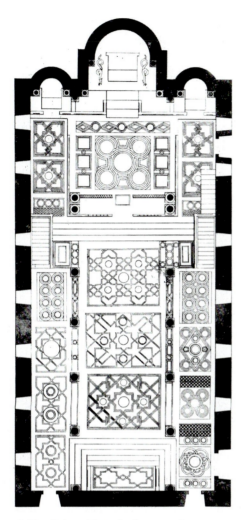

6.29 Palace Chapel, diagram of pavement after Serradifalco, Del duomo di Monreale, Palermo.

a Middle Byzantine domed sanctuary with a Western Latin aisled basilica whose nave is covered by an Islamic wooden muqarnas ceiling. On the walls of these diverse structures are both Byzantine and Western mosaics. Fatimid painting covers the wooden ceiling of the nave, and Roman-style colored stone inlay, the floor.

Recently, William Tronzo has solved some of the mysteries of this unique building. He proposed two distinct and very different building phases, one under Roger II and one under the two Williams. Roger's architects built two distinct, but joined, buildings [6.29]. A Middle Byzantine

church centralized under a dome, having a sanctuary with royal box (a private balcony) at the north, gave the structure a north-south orientation. But to this Byzantine scheme, the builders attached a basilica with an east-west orientation focused on the sanctuary at its east end but also having a platform for the royal throne at the west. This portion of the chapel served as a royal audience hall. The basilica plan, the muqarnas ceiling painted with scenes of court life, and wall hangings woven with colored silk and gold thread were all appropriate for this royal hall.

The chapel stood in the center of the palace, with courtyards to the north and south. A monumental stair led to the public entrance on the southwest. The king had private access from his residence on the north either into chapel or into the royal box where he could privately participate in the Mass. Some evidence suggests that the queen and her ladies also had a private area in an upper room.

In the chapel, the sanctuary mosaics followed the typical Middle Byzantine scheme—the Pantokrator in the dome supported by angels, the four Evangelists in the squinches, and the Feasts of the Church represented on the vaults and walls. The mosaics on the south wall, which King Roger would have faced, emphasized themes of power and glory—Christ's triumphant entry into Jerusalem and his Transfiguration [6.30]. Here a second image of the Pantokrator fills the space under the vault and a complex Nativity scene covers the wall. The two scenes are united by the metaphor of light, for the open book with its message "I am the Light of the World" is joined to the Christ Child. It is placed directly over the huge star, whose beams lead straight to the altar-like manger crib. Emphasizing the theme in words as well as pictures is a poetic inscription; the star leads the world to the divine light, which appears on earth as the newborn child of Mary.

A Western love of narrative detail pervades the scene of the Nativity. All action revolves around Mary and Jesus with Joseph observing pensively from the lower left hand corner. Mary reclines on a large mattress in a cave—a Byzantine conven-

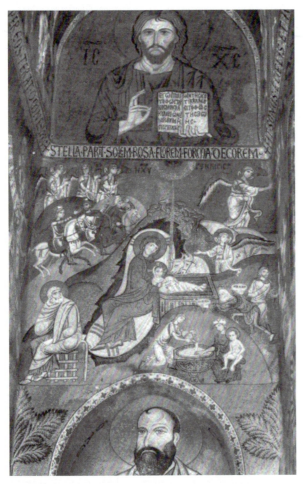

6.30 Palace Chapel, mosaics of east wall of southern transept arm: St. Paul, Nativity, and Pantokrator. Palermo.

tion—and the ox and ass (symbolizing the Jews and Gentiles) adore the child. Below, the two midwives prepare to bathe the baby (Jesus appears for the second time), and the withered hand of the woman who doubted the virginity of Mary is miraculously restored. The three magi gallop through a mountainous landscape led by gesturing angels and the huge star. The magi appear a second time delivering their gifts. Angels in the upper right corner direct the spectator's gaze to the adjoining south wall where the shepherds are tending

flocks of sheep. The sheer exuberance of the figures energizes the surrounding space and draws the viewer into the drama.

This very elaborate mosaic decoration would have been nearly invisible except to people in the south aisle. Tronzo proposes that it played a part in the ritual of homage to the king. The courtiers or ambassadors mounted the stairs from the courtyard and entered the chapel through the door in the south aisle where they turned and walked up the south aisle—at which time the Pantokrator and Nativity mosaics would have been their visual focal point. They turned again to move into the nave, where they would see the king enthroned against the west wall of the chapel. The patterns of the magnificent colored stone floor reinforce the idea of this processional path.

Roger's son William I (ruled 1154–1166) and grandson William II (ruled 1166–1189) turned the royal hall into the nave of the church we see today. They added mosaics in the nave that were Western in style and subject—Old Testament narratives on the clerestory walls and the lives of Sts. Peter and Paul on the aisle walls. They also elaborated the throne and added the church furniture, including a notable sculptured Easter candelabrum. They left untouched the muqarnas ceiling [see 6.22], perhaps because its star patterns suited the theme of heavenly light and the promise of paradise—or perhaps they simply respected Roger's taste—and did not look too closely at the imagery.

The Norman rulers of Sicily brought together the diverse streams in medieval art. Their architecture is both western European and Byzantine. Their mosaics provide a splendid record of late Komnenian art and also illustrate Western interpretations of the style. The muqarnas ceiling of the palace chapel provides evidence of Muslim woodworking and painting. The floors, church furniture, and Easter candlestick exemplify the Romanesque style (see Chapter 8) in southern Italy.

A Royal Palace

Rarely can one experience the ambience of a medieval royal hall. Bare stone walls may suggest the size and arrangement of spaces, but without paintings, textile hangings, and furniture, and without courtiers resplendent in brocades and jewels, the rooms are merely dingy shells. In the Norman palace in Palermo, the mosaics in the vault and on the upper walls of a royal chamber remind us of the exuberant imagery and brilliant color that once surrounded the king and court. According to a letter written during the reign of William II, this room was used for relaxation and receptions.

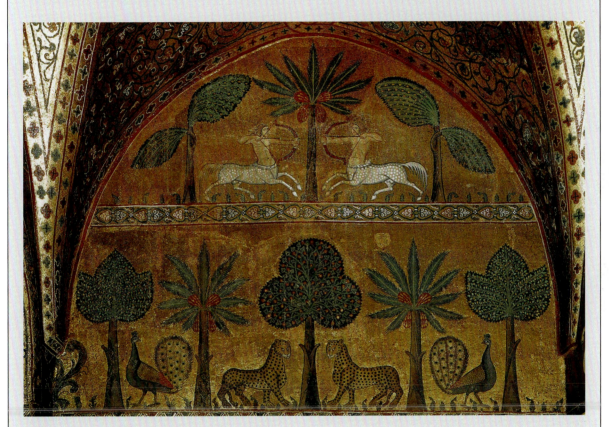

6.31 Norman Palace, Norman Stanzam, Palermo.

Like the Palace Chapel, the room was probably built by Roger II but decorated by William I. Centaurs, animals, and trees turn it into an imaginary royal hunting park, literally a paradise (the word "paradise" comes from the Persian word for such a park). The symmetry, simplified geometric forms, and flat bright colors of the figures are all associated with Near Eastern taste. Clipped trees and palms, regal lions, leopards, and peacocks, and hunting centaurs are silhouetted against a gold ground. Symmetrically arranged in confronted pairs, the images seem frozen in time and place. [6.31]

The Imperial Ideal: Early Medieval Reactions to Ancient Rome

All around the Mediterranean Sea— not only in Rome itself but from the provinces of the Near East to the mountains of the Iberian peninsula, even north to the bleak moors of Britain— massive walls and collapsing vaults rising above the ever encroaching wilderness proclaimed the might of the once great Roman empire. The pagan world had come to an inglorious end, to be replaced by a new Christian era, or so many thought. Earlier, the Jewish people had fought the Romans for the right to worship one God; and later, Muslims proclaimed their faith in Allah throughout lands once held by Rome. Christian rulers in Western Europe, who were themselves not far removed from their barbarian pagan ancestors, believed that they could establish a new Rome. Crowned by the Pope, Charlemagne in 800 and later Otto, in 1000, claimed to follow the first Christian emperor Constantine with an imperial authority approved by God.

While Charlemagne and Otto might intend to revive the Empire, the Byzantine emperors thought themselves to be the heirs of Rome. Was not their great city Constantinople the New Rome, established by Constantine? Did not their court ceremony and the liturgy of their worship hark back to the earliest Christian empire? Under Justinian and Theodora's patronage, their great church dedicated to the Holy Wisdom of God, Hagia Sophia, rivaled any ancient imperial building. Constantinople was the seat of classical learning and art, as well as government. At the end of the Middle Ages the city and the Byzantine Empire fell at last to the Muslims and Hagia Sophia became a Muslim prayer hall, a mosque. But during the Middle Ages, the East – first as the Byzantine Empire, and later as part of the Islamic world – stood as a model for luxury arts and splendid architecture, and of lavish enlightened patronage.

The distinctive quality of early medieval art in the West was more than a blend of the imperial styles of ancient Rome and Byzantium. Motivating artists and patrons was a powerful tradition in the visual arts going back to the original Celts as well as the incoming migrating peoples from the north and east. The fertile mix of styles brought an entirely different visual tradition in which geometric patterns and fantastic beasts rather than humans cover small precious intricately worked objects. When they looked at the surviving Roman walls, they imagined them to have been built by giants and magicians. The sophistication of their carpentry is demonstrated by the design and construction of their ocean going ships. By the 9th and 10th centuries Vikings challenged the continental empires, and when Otto was crowned in Rome they were crossing the north Atlantic to North America – their Newfoundland.

Earlier Charles the Great – Charlemagne – had begun a self-conscious revival of Roman culture. Charlemagne himself looked to Theodosius and Constantine, to King David and other Old Testament heroes. From his court at Aachen he ordered monumental masonry architecture, basilican churches, bronze sculpture, mosaics, and mural paintings. Books were to be written in a legible script based on Roman inscriptions, and the desire to communicate visually as well as verbally meant a revival of narrative art with human actors. Charlemagne's empire did not survive, but by the year 1000 another empire had been established in the Germanic lands. Centered first in the Rhineland but soon extending east into today's Germany and also south over the Alps into Italy. In Rome the German imperial palace stood on the Aventine Hill next to the Early Christian Basilica of Sta. Sabina, whose carved wooden doors inspired Abbot Bernward to create doors with Old and New Testament scenes for his church in Hildesheim.

Rome, the city of the Caesars, was replaced by the City of God and the House of the Lord – Paradise – whose glory was suggested by the buildings of the Church. The highest quality art and architecture came to be made for Christian service. The Church became the focus of the people's aspirations and the recipient of their treasure, their energy and skill, their imagination even while Rome survived as an inspiration and perhaps a cautionary tale.

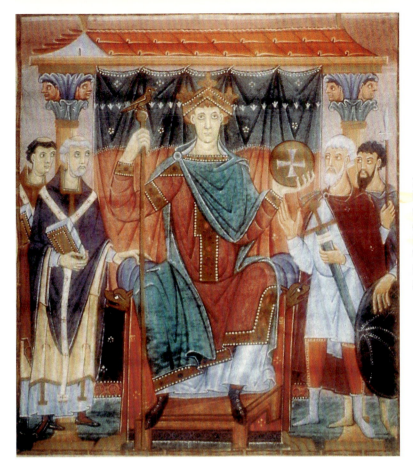

7.1
Otto III between
representations of Church
and State. Gospel of Otto
III. Richenau?, c. 1000.
Vellum, 13 1/8 x 11 1/8in.
(33.4 x 28.3cm). Bayerische
Staatsbibliothek, Munich.

ART AT THE MILLENNIUM
The Imperial Tradition Continues

Emperor Otto III, enthroned between representatives of ecclesiastical and lay authority—Bibles at his left and swords and lances at his right—wears the huge jeweled crown of the empire and holds the eagle-topped staff of command and the cross-inscribed orb symbolizing the Christian world [7.1]. Otto commands the loyalty of the people of the empire he inherited from his father, Otto II, and grandfather, Otto the Great. Dressed in imperial purple and seated in a royal hall in front of a magnificent cloth of honor, Otto recalls in this portrait earlier images of power, such as the Missorium of Theodosius. Like Theodosius, the emperor looms over both elderly advisers and youthful supporters, his importance emphasized by the painter's use of hieratic scale. Even more than external symbols, the abstract style of the painting—severe, monumental, with simplified contour drawing, schematized forms, and brilliant color and gold—creates an aura of power. Otto was leading a new Christian empire.

The Carolingian Empire had disintegrated in the second half of the ninth century, leaving two rivals competing for world domination—the Orthodox Byzantines and the Muslims [7.2]. By mid-tenth century a revitalized Western Catholic Europe again challenged the East, as religious and political leaders began to gather power and territory, inspired by the dream of re-creating imperial Rome. They stopped the Muslim advance into continental Europe and

walls and vaults. Barrel vaults reinforced by transverse arches cover both upper and lower rooms. Exterior strip buttresses reinforce the thin ashlar walls and support the vault of the hall.

Although sculpture at Naranco lacks the finesse of the architecture, its presence reveals the patron's desire for monumental decoration. Bands in low relief punctuate the face of the loggia and terminate in roundels set within the spandrels of the arches, a decorative device known in late Roman architecture. But in the hands of local craftsmen, the spiral columns of the loggias become flaccid and rope-like, denying their supporting and stiffening functions. In a reference to Roman decoration, the flat, spatula-like leaves of the capitals retain a distant resemblance to Corinthian capitals, and the strip buttresses are grooved to suggest pilasters. In spite of the simplicity of the forms, Asturian architecture and sculpture suggest that a wide network of artistic connections existed in the ninth century.

MOZARABIC ART IN NORTHERN SPAIN

Christian warriors rapidly pushed southward into Muslim territory. In 930, they established their headquarters at Burgos in Castile. By 1085, Alfonso VI of Castile captured the former Visigothic and later Muslim stronghold of Toledo, which he made his new capital. The constant interchange between people, even though often unfriendly, created a taste for sophisticated Moorish art among the Christians; furthermore, as Christians from the south moved into conquered lands in León and Castile, they brought with them a knowledge of Moorish arts and crafts. They created a distinctive blend of Christian and Muslim art known as the Mozarabic style, from the Arabic *must'arib,* Arabicized.

At the beginning of the tenth century, Alfonso the Great invited Christians living under Muslim rule to move north and resettle newly conquered lands in León. One of these refugee groups, a Benedictine community from Córdoba, founded a monastery at Escalada [7.4]. The church, dedicated in 913 to St. Michael, is a typical basilica; however, the Mozarabic builders used the Cór-

Mozarabic and Mudejar Art

Mozarabs were Christians living in Moorish Spain. They adopted some characteristics of Muslim art: in architecture they used horseshoe arches and colorful ceramic tiles (azulejos); in painting and the decorative arts they emphasized colorful abstract patterns. The Beatus manuscripts are typical—the painters use a Muslim style to express Christian content. Even when the Mozarabs moved to lands under Christian rule, they continued this distinctive style. Mozarabic art usually dates from the tenth and eleventh centuries. In Mudejar art, the situation is reversed; here Muslims or Muslim-trained artists are working for Christian or Jewish patrons. Mudejar architecture is characterized by elaborate decorative brickwork, colorful tiles, ribbed vaults, and pointed horseshoe arches. Mudejar art can be found in the fourteenth and fifteenth centuries, especially in the Kingdom of Aragón and in the formerly Muslim lands of southern Spain. Jewish artists in Spain often worked in the Mudejar style [see 11.26].

doban horseshoe arch in both the plan and the elevation of the building. Not only are the nave arcade, the sanctuary screen, and the exterior porch built with horseshoe arches, the three rooms of the tripartite sanctuary are horseshoe in plan. The timber roof permitted a light, open nave; and slender columns support rubble and mortar walls pierced by large clerestory windows.

The present austere appearance of S. Miguel de Escalada results from modern restorations. Originally the interior was painted, hung with rich, patterned textiles, and filled with hanging lamps and patterned screens. The sanctuary screen, hung with curtains, functioned like a Byzantine iconostasis, hiding the altar and officiating priests from view. (The Mozarabic liturgy resembled the Byzantine in its emphasis on the mystery of the sacraments.) *Azulejos,* the glazed tiles popular in Muslim architectural decoration, may also have been used by the Christian builders on the walls.

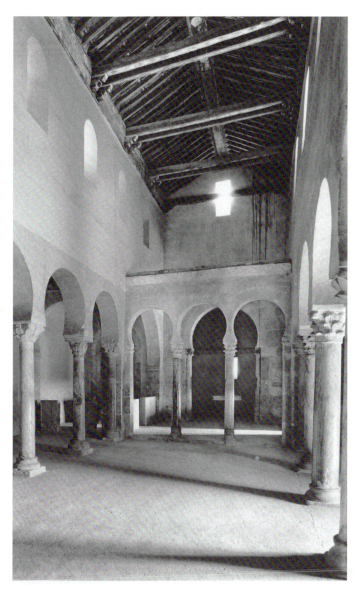

7.4 Interior, S. Miguel de Escalada, circa 913.

The view of the scriptorium at Tábara bears witness to the importance of book production in Mozarabic monasteries. In the tenth and eleventh centuries an extraordinary school of painting arose, centered in the province of León. Mozarabic scribes not only signed their works but also included the names of patrons and painters, the date of completion, and even brief notes, prayers, and appeals for appreciation in endnotes, called colophons. According to its colophon, the Tábara Apocalypse was begun by "the worthy master painter" Maius from Escalade. When Maius died in 968, his student Emeterius completed the book in three months, in era 1008, that is, 970 A.D. (the Spanish calendar ran 38 years ahead of the calendar in use today). Working with Emeterius and other artists at Tábara was a woman named Ende. She is identified as a

The colorful effect of tenth-century structures is recorded in contemporary manuscripts. In the Tábara Apocalypse, Emeterius and Senior represented themselves and their parchment cutter at work in a scriptorium adjacent to a five-story tower [7.5]. Emeterius renders the interior and exterior of the buildings simultaneously, the better to reveal the bustle of activity—the bell ringers, climbing men, and busy scribes—as well as the brilliantly colored tiles affixed to the walls. Emeterius also tells us that the tower was of stone.

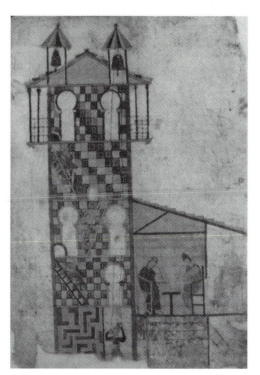

7.5 Emeterius and Senior at work, tower of Tábara, Tábara Apocalypse, 970. 14 1/4 x 10 1/8in. (36.2 x 25.7cm). Archivo Histórico Nacional, Madrid.

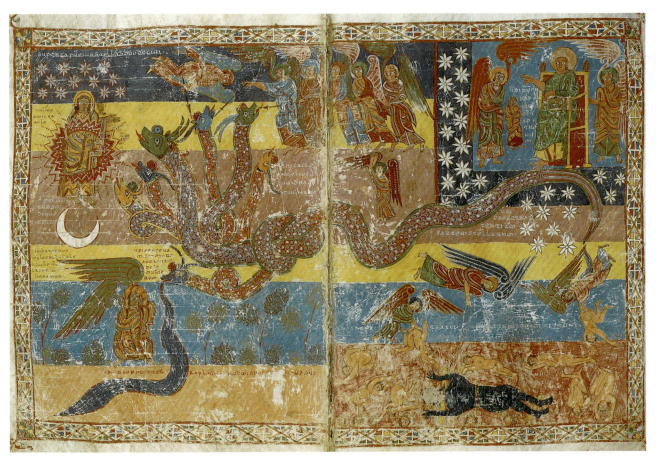

7.6 Maius, Woman clothed with the sun escaping from the dragon, Morgan Beatus, c. 940–945. 15 x 11in. (38.1 x 27.9cm). The Pierpont Morgan Library.

"painter and servant of God," one of the first women painters whose name we know. Ende signed no individual paintings; however, according to the colophon of a manuscript now in the Cathedral of Girona, she and Emeterius illuminated the manuscript and finished the work in 975.

Beatus manuscripts are distinctive products of northern Spain. Christians in Spain remained out of the mainstream of western European art. They continued to use the Visigothic liturgy, and they seemed prone to heretical beliefs. In 782, they revived an Early Christian heresy known as Adoptionism—the belief that Christ was born a man and subsequently adopted by God as His Son. The monk Beatus of Liebana (d. 798) dedicated himself to counteracting both the adoptionist heresy

and Islam. His commentaries on the Apocalypse were widely copied and magnificently illustrated.

In the tenth and eleventh centuries, Beatus' commentaries were often combined with St. Jerome's commentary on the Old Testament Book of Daniel (but now referred to as "Beatus manuscripts"). In the imagery of the end of the world—destruction, suffering, and final deliverance—and the trials of Daniel, Christians evidently saw a direct analogy with the struggle to preserve the Church from heresy and to free their co-religionists from the Moors. At the monastery of Tábara, Maius finished a copy of Beatus' commentary about 940–945. An allegory of the triumph of the Church over its enemies introduces chapter 12 [7.6]. In the upper left is "a woman clothed with

the sun, and the moon under her feet, and upon her head a crown of twelve stars," an image associated with Mary and the Christ child. She is threatened by "a great red dragon, having seven heads and ten horns, and seven crowns upon his heads. And his tail drew the third part of the stars of heaven, and did cast them to the earth. . . . And there was war in heaven: Michael and his angels fought against the dragon; and the dragon fought his angels, and prevailed not; neither was their place found any more in heaven and the great dragon was cast out, that old serpent, called the Devil. . . . And the serpent cast out of his mouth water as a flood after the woman . . . and the earth helped the woman, and the earth opened her mouth and swallowed up the flood which the dragon cast out of his mouth."

In the hands of a master like Maius, the stylized, ornamental Mozarabic style accentuates the dramatic, nightmarish quality of the text. Such flights of imagination enhance the explicitness of the narration. Maius transformed the background into horizontal bands of brilliant colors and suggested landscape with a few foliage patterns. Curving, brightly hued stripes make up figures that are little more than bundles of drapery. Each face, moreover, dominated by white, staring eyes, is encircled by a colored halo. So thoroughly does the decorative system destroy an illusionistic vision that even the star-covered field of Heaven becomes a frame for frozen activity. In this way, by reducing the momentous, apocalyptic events to exotic abstractions, Maius rendered a pictorial counterpart to the visionary description of the Last Days. Nevertheless, for all its dazzling beauty, Mozarabic painting exists as an elegant and exotic style outside the mainstream of Western European art.

THE LOMBARD-CATALAN STYLE IN ITALY, FRANCE, AND CATALONIA (CATALUNYA)

Meanwhile, in the eastern Pyrenees, the Muslim incursion had been short-lived. Catalonia (Catalunya)—Charlemagne's Spanish March—had close ties to western Europe—politically to the Carolingian dy-

nasty and ecclesiastically to southern France and Italy through the Benedictine Order. The mountains became more bridge than barrier—the backbone, so to speak, of a rugged kingdom lying in both Spain and France. By 840 Catalan rulers replaced the Visigothic liturgy and script with the Roman rite and Carolingian minuscule. In the tenth century, an art and architecture developed under the patronage of the counts of Catalonia, which played an important part in the origin of Europe's mature Romanesque style [7.7].

A powerful Catalan ruler, Count Oliba of Besalu (known as Oliba Cabreto), had traveled in France and Italy. He spent a year in St. Benedict's monastery at Monte Cassino, and on his return he introduced the Benedictine order into Catalonia. His son Bishop Oliba (971–1046) kept up this contact with Monte Cassino, with the reformed Benedictines of Cluny (installed in Catalonia in 962), and with the papal court in Rome. The monk Gerbert of Aurillac exemplifies the continent-wide network of relationships at this time. Gerbert began his career in Aurillac, studied in the monastery at Ripoll in Catalonia (c. 967), moved on to Reims in northern France as head of the cathedral school, became the archbishop of Reims, then the archbishop of Ravenna, joined the Italo-German court of Otto III, and ended his days in Rome as Pope Sylvester II (999–1003).

The travels of rulers and churchmen were only partly responsible for the wide spread of the Lombard-Catalan style. Equally important were the builders themselves, masons who journeyed from project to project. They created an international brotherhood of masons and a common method of building and decoration. Lombard-Catalan architecture is clearly a mason's style, in which the primary concern was for practical, sturdy construction of walls and vaults. The building technique, in other words, determined the style. Wherever they worked, Lombard-Catalan masons built fine masonry using the most readily available materials—in the finest buildings, ashlar blocks or small split stones, but also bricks and even irregular stones or river pebbles. They developed an efficient

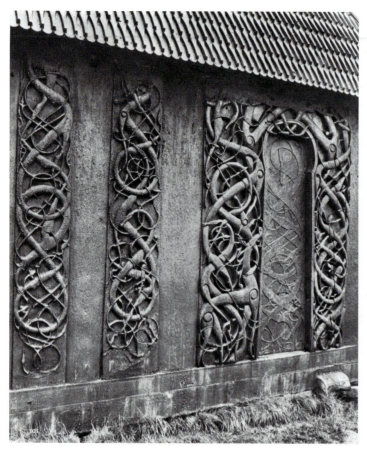

7.17 Stave church, Urnes. Carved portal and wall planks. 11th century.

the finest examples appear in wood carvings of c. 1050–1070 that were incorporated into the twelfth-century church. The beauty of the Urnes style in Scandinavia, no less than in the British Isles, where it was transported, lies in its aesthetic control—the elegance of drawing and the harmonious balance of thick and thin elements arranged in a series of figure-eight patterns, like the carpet pages in Hiberno-Saxon manuscripts but with far greater freedom and vitality.

After the Viking invasions of the British Isles, Danes ruled the north and east in a region known as the Danelaw, while Anglo-Saxons continued to control the south and west. The glory of Anglo-Saxon art lies not in architecture or sculpture but in manuscripts. St. Dunstan's revival of Benedictine monasticism brought the insular monasteries

into close contact with the Continent. St. Ethelwold, Bishop of Winchester (963–984), established a scriptorium in Winchester, the Anglo-Saxon capital. The painters, profoundly affected by Carolingian art but at the same time the heirs of the strikingly different Hiberno-Saxon pictorial tradition, created two kinds of illustrated manuscripts: those with fully painted illuminations and those with colored drawings based on the Utrecht Psalter style. The New Minster Charter exemplifies the first type and shows that combination of Hiberno-Saxon and Carolingian art that marks the Winchester style [7.18]. These illuminations are characterized by exuberant use of curling acanthus foliage and expressive drawing, perhaps inspired by Carolingian art.

In 966 King Edgar granted a charter to St. Ethelwold's abbey (minster) at Winchester. St. Ethelwold commissioned a luxurious copy of the charter to be displayed on the altar as thanks to the king and a testament to the importance of the Benedictines in England. Written in gold, the New Minster Charter rivaled Carolingian imperial manuscripts. In the dedication, King Edgar presents the charter to Christ, who is enthroned in a mandorla supported by angels. St. Mary and St. Peter, patrons of the abbey, look on. The composition recalls presentation scenes in Carolingian painting, but the figure of King Edgar is an original Anglo-Saxon creation. He twists and his head turns back over his shoulder in order to simultaneously look up at Christ and confront the spectator. The other figures, while not subject to such contortions, also move energetically, creating animated draperies pulled tightly across the thighs but ending in crinkly edges or flying folds.

Acanthus leaves winding around golden trellises frame the images. The variegated curling leaves seem to grow from a stem located in the center of each side. In contrast to Carolingian artists, who filled golden letters with acanthus shoots or enclosed the foliage within a geometric border, Anglo-Saxon illuminators followed their Hiberno-Saxon predecessors and let the ornament burst out beyond the frame. Ultimately foliage and trellis frames dominated the page.

the Resurrection. The frame, whose enclosing function is already challenged if not destroyed by foliage, becomes a mere foil for actors in a religious drama, as the actors in turn become visual adjuncts to the border rosettes. In the best tradition of Hiberno-Saxon decoration, Godoman and his assistants combine the frame, text, and narrative into a single ornamental composition.

The visually dynamic appearance of the Benedictional owes much to its calligraphic drawing. Indeed, artists in the British Isles had always shown unusual skill in drawing. Faster and cheaper than painting and gilding, drawing suited active monastic scriptoria that were not sustained by an imperial court. Also, books had to be produced rapidly in the tenth and eleventh centuries, for the libraries devastated by Viking raids had to be replenished. This preference for drawing was reinforced when the Utrecht Psalter was brought to

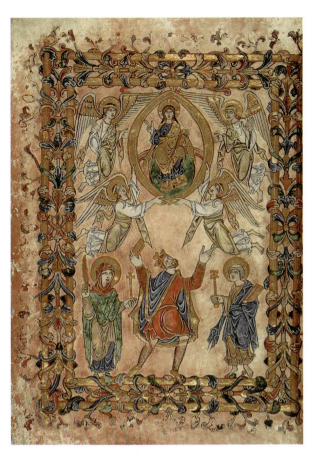

7.18 King Edgar presenting the charter to Christ, New Minister Charter, Winchester, 966. The British Library.

Magnificent frames for full-page illustrations characterize the finest manuscript of the Winchester group, the Benedictional of St. Ethelwold [7.19]. (A benedictional is a prayer book used by the bishop during Mass.) The book was made at Winchester about 980 and signed by the scribe Godoman. The foliage that crept beyond the trellis in the New Minster Charter here commands the entire decorative system. Gold, double-banded trellises support a luxuriant growth of acanthus foliage and four outsized rosettes. As the leaves wind around the frame or each other, they seem permeated with energy. More important, however, is the fact that figures also move into and over the frame. Three women in the right border face the angel seated on Christ's empty tomb, while at the left the Roman soldiers gaze awestruck at the miracle of

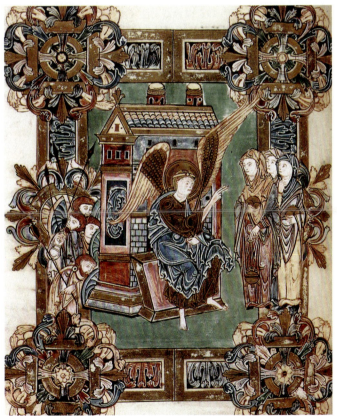

7.19 The Marys at the Tomb, Benedictional of St. Ethelwold, Winchester, c. 980. The British Library.

Anglo-Saxon Painting

An unfinished page in the Benedictional provides an opportunity to study the tenth-century Anglo-Saxon artist's method. The illuminator first rendered the outlines in red, and then filled them in with broad areas of color, over which he applied both light and dark tones. Godoman drew with quick, staccato strokes, especially when representing drapery and foliage. He created heads, with their broad low brows, square jaws, and jutting necks, like those of the Reims school, although the stockiness of his figures bears more relation to the Metz type. Unlike that of the Carolingian models, his drapery becomes so elaborate and excited that the bodies almost disappear. Through the swirling pattern of rippling drapery with fluttering, ragged edges, even a rather static figure gains a nervous energy. When the undulating lines of clouds, hills, or water are added to the scene, individual elements and sometimes the very narrative are virtually lost.

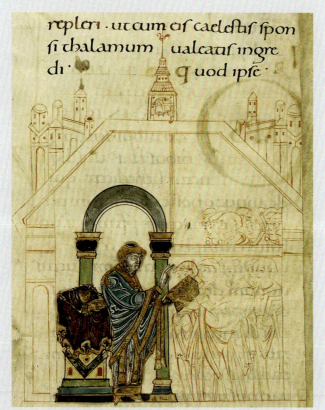

7.20 Bishop Blessing the Congregation. The British Library.

Canterbury about 1000, and a copy was made in colors. How and why the manuscript came to England remains a mystery.

The Anglo-Saxon version of Carolingian drawing as well as the Anglo-Saxon artist's narrative skills is impressively displayed in the Liber Vitae of New Minster (a list of benefactors, for whom prayers were to be said, kept on the altar) [7.21]. In the upper register of a highly theatrical version of the Last Judgment, a spirited St. Peter welcomes the blessed into paradise. Below, assisted by an angel holding the book of good deeds, Peter fights for a soul by smashing the devil's face with his huge keys. An angel triumphantly locks the gate against an enormous demon that pulls the damned by their hair into the gaping mouth of hell. The interest in human reactions, the delight in pictorial detail, and the cavalier arrangement of figures for the sake of dramatic confrontation become characteristic features of English art.

King Canute commissioned the Liber Vitae in 1020 for the Minster at Winchester. On the dedication page, the king and queen, patrons of the abbey, place a cross on its altar while Benedictine monks observe the scene from an arcade below [7.22]. As in King Edgar's charter, Christ, the Virgin, and St. Peter bless the donation; however, the rulers now flank the altar and receive crowns from Heaven-sent angels. The charter becomes a political document symbolizing the blessing of the monarchy by the Church. The frontispiece also shows the first signs of a stylistic transformation that was to take place in Anglo-Saxon art about the middle of the eleventh century. The symmetrical, architectonic composition, and the quiet figures drawn with relatively firm, regular lines herald the coming Romanesque style.

When Canute's sons could not hold the new empire together, the Anglo-Saxons and then the Normans took over England, leaving Scandinavia to go its own way. In spite of political conflicts, the lands ringing the North Sea became an integrated cultural province. As a result, art historians sometimes cannot determine where a style or a work of art originated. Indeed, English and Scandinavian

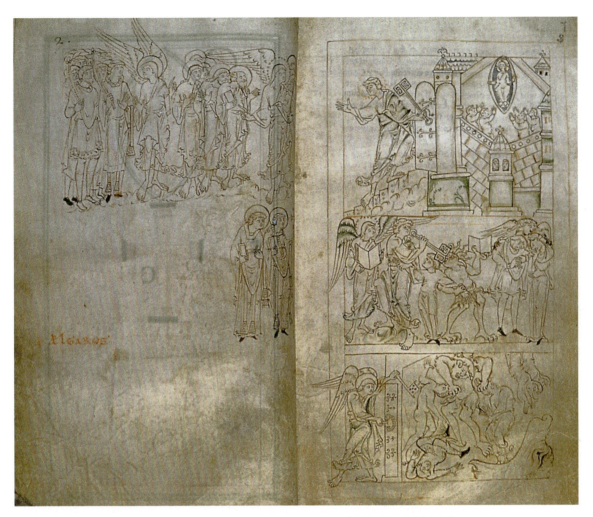

7.21 Heaven and Hell, Liber Vitae of New Minister, Winchester, 1020. The British Library.

art in this period reflects the constant presence of one people on another's soil.

North Sea art and architecture demonstrate again that pattern of religious and artistic confrontation, which so often occurred as Christianity supplanted pagan belief. At first, only the content of art changed. Just as Christ once appeared in the guise of the Good Shepherd, so Christians in the North might identify the Savior with the Great Beast. The eventual appropriation of Christian iconography, with its didactic narratives acted out by human figures in architectural or landscape settings, forced artists to abandon the animal style that had held sway in the North since prehistory.

Yet these artists never ceased to communicate the sheer energy of the forces of nature, for they continued to express their ideas through intricate patterns and abstractions rather than through personifications or literal representations. The result was a revitalized northern Christian art.

THE ART OF THE OTTONIAN EMPIRE

At the beginning of the tenth century, in 919, the German dukes assembled according to ancient custom and elected one of their number, Henry the Fowler, duke of Saxony, to be their leader, the king. Henry's son, grandson, and great grandson—all

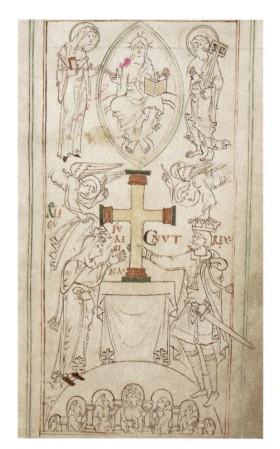

7.22 Patrons of the minister, Liber Vitae of New Minister, 1020. The British Library.

other side without extraordinary help. Otto, like Charlemagne, turned to his family and to the church for support. He filled important posts with his relatives; for example, his younger brother Bruno (d. 965) served as his chancellor, as the archbishop of Cologne, and as the duke of Lorraine. Other relatives held the archbishoprics of Trier and Mainz, and women in the family ruled as powerful abbesses. Nevertheless, Otto had to fight dissident family members in southern Germany, Vikings in the North, and the Magyars in the East. Magdeburg, founded as a monastery in 937, which Otto made an archbishopric in 968, became an important outpost on Otto's eastern front. In an ivory carving, Otto presents the Cathedral of Magdeburg to Christ and St. Peter [7.23]. He is supported by St. Maurice, whose relics he brought to Magdeburg from Burgundy in 960. Eventually the Magyars settled along the Danube in today's Hungary, and by 1000 they adopted Christianity under King Stephen and Queen Gisela, Otto's granddaughter.

Ever the politician, Otto the Great looked with interest at the wealth and prestige of Byzantium. The Byzantine court continued to set the standard for pomp and luxury among Western rulers, and Byzantine gold, enamel, ivory, and textiles served as models of taste and craftsmanship. Twice Otto sent an ambassador to the Byzantine court, but the missions met with little success, for the Germans and the Byzantines despised each other. Nevertheless, Byzantine luxury goods must have appealed to the Germans, for Ambassador Luitprand was caught trying to smuggle silk fabrics back to the West. Eventually Otto the Great arranged a marriage between a Byzantine princess and his son. In 972 Princess Theophanu arrived at the German court with works of art in her dowry and artists in her retinue. Although she had been an insignificant person at home, she became a powerful force in Ottonian politics and art.

The year after Otto and Theophanu married, Otto the Great died, and the young couple ruled the empire (973–983). When Otto II died in 983, he was buried in the atrium of the Church of St. Peter in Rome and the three-year-old Otto III was

named Otto—ruled for the rest of the century (936–1002). Consequently, the historical period and its art and architecture are known as "Ottonian."

Otto I, "the Great," chose to be crowned at Aachen, and so proclaimed himself the heir of Charlemagne. Like Charlemagne he turned his attention south, to Italy. He added northern Italy to his kingdom by marrying the widowed Lombard Queen Adelaide. Then, at the invitation of the Pope, he moved on to Rome as defender of papal lands. In 962 Otto the Great achieved his dream of reestablishing Charlemagne's Christian Roman Empire when Pope John XII crowned him emperor in Rome.

The addition of Italian territories to the Saxon kingdom presented a problem. In this age of personal rule, a king could not reside on one side of the Alps and expect to control his subjects on the

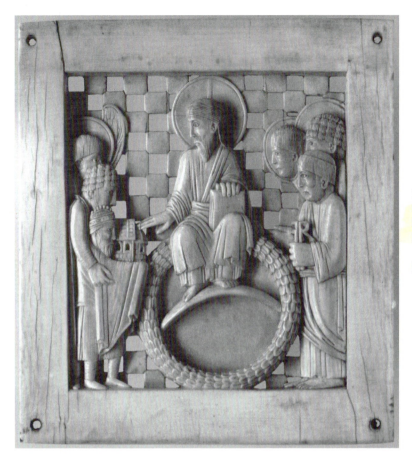

7.23
Otto I Presenting Magdeburg Cathedral to Christ, the Magdeburg Ivories, c. 962-73. Ivory, 5 x 4 1/2in. (12.7 x 11.4cm). The Metropolitan Museum of Art.

crowned king of the Germans. Otto's grandmother and mother—the Lombard Adelaide and the Byzantine Theophanu—governed as regents. Otto III (983–1002) began his personal rule in 996 at the age of 16, when he was crowned emperor in Rome [see 7.1]. Italy absorbed his attention, and in this he was encouraged by his tutor, Gerbert of Aurillac. In 999 Gerbert became Pope, taking Sylvester as his papal name, thereby identifying himself with the Pope who had baptized Constantine. Always conscious of the importance of symbolism, in the year 1000 Otto opened Charlemagne's tomb in Aachen. While venerating the imperial relics, he removed Charlemagne's pectoral cross and Gospels (The Coronation Gospels) for his own use.

Ottonian artists created a new imperial style by combining and reinterpreting elements of Roman, Germanic, Byzantine, and Carolingian art. According to their well-traveled patrons' demands, artists copied ancient monuments, whether pagan (the column of Trajan in Rome), Jewish (the menorah as they knew it from the Arch of Titus), or Christian (the stories of Christ and the saints that they saw on the walls of early Christian churches). Noting that Roman artists had depicted both historical events and allegories with human actors in a spatial environment, they, too, developed a powerful narrative and symbolic art using human figures. At the same time the artists' preference for schematization of natural forms and the intensity of their expression derives from their northern heritage. The patrons' love of gold and jewels and the artisans' great skill in every kind of metal and lapidary work are also part of this Germanic tradition. A love of opulence is as Byzantine as it is Germanic, and contemporary Byzantine art also profoundly influenced Ottonian artists. The presence of a Byzantine princess, Byzantine art objects, and perhaps even Byzantine artists in the Ottonian court

7.24 Christ in Glory, Lorsch Gospels, Aachen (Carolingian palace school), early 9th century. Vellum, 14 1/2 x 10 1/2in. (36.8 x 26.7cm). Bathyaneum, Alba Julia, Romania.

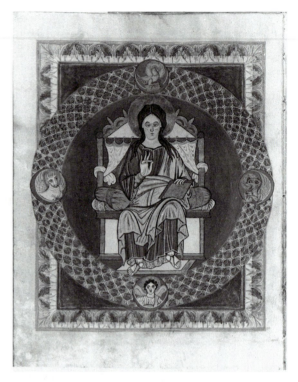

7.25 Christ in Glory, Gero Codex, Cologne or Reichenau, 965-970. Vellum, approximately 11 3/4 x 8 3/4in. (29.8 x 22.2 cm). Hessischelandesbibliothek, Darmstadt.

had an impact on the style. Byzantine art must have provided models for imperial and religious iconography, for systems of drawing the human figure, for the depiction of space, and even for details of costume and ornament. Finally, Carolingian art often acted as an imaginative filter for the Byzantine style.

The tragic destruction of works of art by fires and wars complicates the study of Ottonian art. Fortunately, illuminated manuscripts—splendid books adorned with gold, gems, and ivory—and other church treasures have survived to provide visual evidence of Ottonian art. Both secular and ecclesiastical courts were centers of patronage, and regional styles appeared in Cologne, Trier, Reichenau, Hildesheim, and Regensburg.

Two images of Christ—one from the Carolingian Lorsch Gospels [7.24] and one from the Ottonian Gero Gospels [7.25]—provide an excellent introduction to Ottonian painting. The one is

clearly a copy of the other. A comparison of the paintings of Christ in Majesty illustrates both the debt and the originality of the Ottonian artist. The painter simplified and clarified the image and focused attention on a broader and more massive figure of Christ by eliminating the angels, inscriptions, and outer frames and by simplifying the ornamental motifs. All the elements—the repeated rectangles of frame and throne interlocked with the circles of the mandorla, halo, medallions, and even Christ's round face and enlarged eyes—focus attention on Christ's blessing hand. The compact and concentrated image seems pressed into a series of thin overlapping planes in which the lingering illusionism of the Carolingian model is abandoned. This urge to clarify and control the forms extends into the drawing itself, for the calligraphic quality of Carolingian drawing has given way to clear, simplified outlines filled with bright flat colors, and the once illusionistic modeling of forms

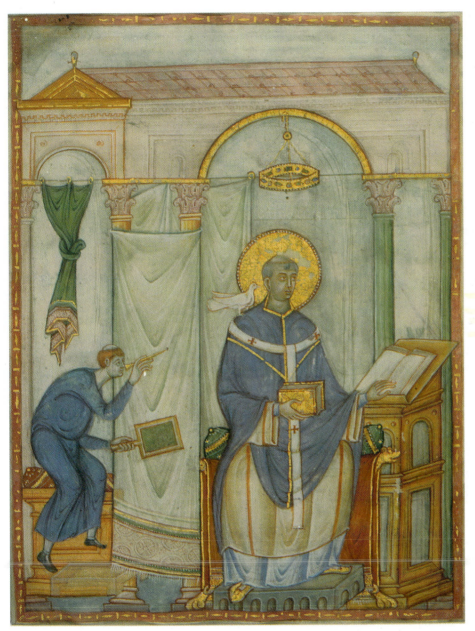

7.26
Pope Gregory the Great.
Frontispiece to Gregory's
Letters, Gregory Master,
983–984. Trier
Stadtbibliothek.

has been turned into repeated linear patterns. Ottonian artists created a style that is more severe and more ornamental than their models. (Scholars do not agree on the location of the scriptorium responsible for the Gero Codex. Some say Trier; others, Reichenau, with a date of about 965–970.)

Archbishop Egbert of Trier (977–993), who had served as Otto II's chancellor, made his abbey of St. Maximin a center of scholarship and spiritual

renewal. In 983–984, he gave his cathedral a copy of the letters of St. Gregory (the *Registrum Gregorii*) illustrated by one of the most brilliant painters in the early Ottonian period [7.26]. This anonymous artist is known as the Gregory Master (active 972–c. 1000). In the cosmopolitan atmosphere of the bishop's court, he evidently had access to Early Christian as well as Carolingian and Byzantine models, for he developed a sophisti-

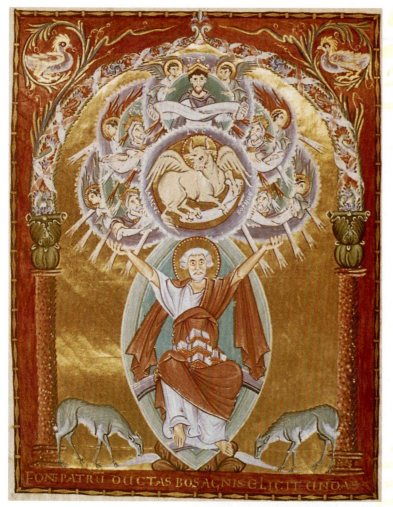

7.27 St. Luke, Gospels of Otto III, Reichenau?, c. 1000. Vellum, 13 1/8 x 11 1/8in. (33.3 x 28.3cm). Bayerische Staatsbibliothek, Munich.

page, columns, bases, throne, footstool, feet, and drapery are all worked into a carefully calculated, two-dimensional, rectilinear pattern. The Gregory Master has turned perspective systems to nonsense in a dramatic denial of the material world. The unreal, floating quality becomes particularly apparent in the secretary, who neither sits, stands, nor crouches but hovers over his bench. Yet the Gregory Master remains the most classicizing of Ottonian painters. In the sensitive treatment of idealized faces and the delicate, subtly modeled flesh and drapery, luminous colors and refined drawing, the Gregory Master found the possibility for personal expression even within the hieratic forms of Ottonian painting.

A very different mood suffuses the manuscripts made for Otto III [7.1]. The religious reforms stimulated by the Benedictine monks of the Abbey of Gorze inspired an art in which a sense of barely suppressed inner turbulence bursts forth in dramatic gestures and often a wild-eyed frenzy. The author portraits in the Gospels of Otto III (998–1001) display a striking originality [7.27]. Instead of depicting an evangelist intent on his writing, the artist represented a man in ecstasy to whom the full mystery of his religion is revealed by heavenly messengers. St. Luke sits on a rainbow enclosed by a mandorla, the writings of the prophets in his lap and his inspiration suggested by circles of heavenly fire, from which emerge King David and the Old Testament prophets, the symbolic ox, and six angels. St. Luke flings out his arms, supporting the vision above him and drawing its power into himself. At his feet flows the River of Life, nourishing the lambs—that is, the Christian community. The inscription across the lower edge of the frame reads, "From the fount of the [Old Testament] fathers the ox brings forth water for the lambs." A festooned arch supported on porphyry columns frames the page, but its architectural quality is denied by flickering brushwork and an imaginative combination of

cated, classicizing style. In a portrait of St. Gregory, he represents the learned Pope at work, inspired by the Dove of the Holy Spirit, who whispers in his ear. St. Gregory towers over his secretary who spies on him through the curtains. Gregory sits on a golden throne under a votive crown, like the Visigothic crown of Recceswinth. In contrast, the curious secretary has become a comic figure, as knotty and twisted as the curtain above him.

In the Pope's study the painter has reduced the architectural forms to a series of thin, superimposed layers. In simultaneous yet shifting views, we see the interior and exterior of the building and its gable as well as its side wall. At the bottom of the

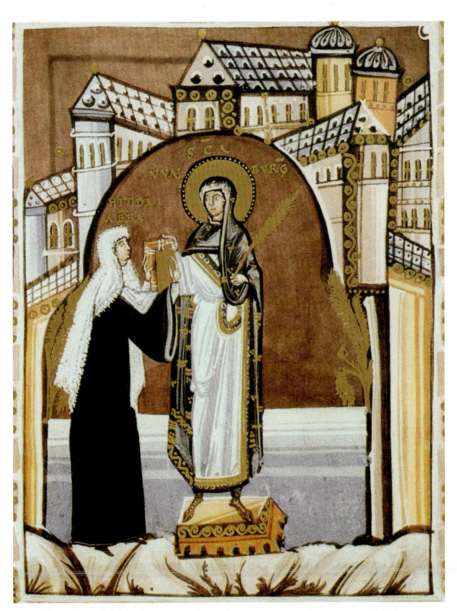

7.28
Presentation page with Abbess Hitda and Saint Walpurga Hitda Gospels. Early 11th century. Ink and colors of vellum, 11 3/8 x 5 5/8in. (29 x 14.2cm). Hessische Landesund-HochschulBibliothek, Darmstadt, Germany.

plants, birds, and ribbons. The painter has eliminated the lingering classicism of the Gregory Master, as a comparison of the heads of St. Luke and Pope Gregory shows. St. Luke nearly explodes in the emotion of the moment, but the artist seems to remain aloof, drawing clear, hard, and controlled outlines and filling them with brilliant and unnatural colors.

The charged emotional content and sumptuous painting in the Gospels of Otto III continues in the justly famous early eleventh-century Gospels of Abbess Hitda (d. 1042). The abbess, wearing a long white veil, presents the book to St. Walburga, patron saint of the convent in Meschede, near Cologne [7.28]. Her power as abbess is indicated by her size; she equals the height of St. Walburga. Buildings that in the hands of the painter become a stack of architectural details framing the figures indicate the convent she rules. The Abbess, too, is a symbol of her position, not a portrait. The book is filled with unusual paintings that suggest it was intended for private devotions.

7.29
Gero Crucifix, Cologne Cathedral, Germany, c. 970. Painted and gilded wood, height of figure 6ft. 2in. (1.87 m).

OTTONIAN CHURCH TREASURES

Intense emotional content as well as monumentality and formal clarity characterized sculpture in Cologne. An over-life-sized, polychrome wood sculpture of the crucified Christ, presented to Cologne Cathedral about 975 by Archbishop Gero (969–976), exemplifies these qualities [7.29]. Functioning as both sculpture and reliquary, the figure held the Host in a cavity in the head; thus the wooden image, in the minds of the devout Christians, literally held the body of Christ. Not a symbolic sacrificial Lamb of God, not a Byzantine emperor alive and crowned in front of a cross, not even a young hero, as in some Early Christian or Carolingian images, but a tortured martyr hangs in front of the worshipper. Archbishop Gero had traveled to Constantinople to escort Theophanu

back to the Ottonian court, so he had seen Byzantine art first hand and must have known the new theme of the suffering Christ. To the solemnity and grandeur of the image, Gero's sculptor has added a new emotional intensity, inducing in the worshipper feelings of pity as well as awe. The humility and sacrifice of Christ on the cross rather than the triumph of the Resurrection suffuses this huge, gaunt figure—invoking a pain and sorrow that the abstraction of the musculature and the geometry of the golden drapery cannot dispel.

If religious fervor distinguished earlier Ottonian art, learned sophistication, material splendor, and technical refinement characterize later work, especially in Regensburg, a city that rose to importance at the beginning of the eleventh century, during the reign (1002–1024) of Henry II and Queen Kunigunde. Otto III left no heir at his early death in 1002, and the empire passed by election to his cousin Henry, Duke of Bavaria. Henry and Kunigunde abandoned the grandiose schemes of the Ottos and devoted themselves to Germany. They enriched churches, patronized the arts, supported monastic reform, and became such efficient and pious rulers that both were canonized—Henry in 1146 and Kunigunde in 1200. They were buried in Bamberg, in the cathedral they had endowed.

Regensburg artists had important Carolingian models available to them. The Abbey of St. Emmeram housed the imperial regalia of the Carolingian house, including reliquaries and manuscripts. Goldsmiths worked beside painters and scribes to create an art that joined refinement and material splendor to surround the Word of God. When Henry II ordered a book of pericopes for Bamberg Cathedral, before his coronation as emperor in 1012, he must have given the goldsmiths items from his imperial treasury to incorporate into the cover [see 5.16]. The artist literally combined rather than reproduced elements from different sources: a Carolingian ivory from Metz, surrounded by Byzantine and Ottonian enamels. The round-headed Byzantine cloisonné enamels of prophets and apostles alternate with large rectangular stones surrounded by smaller gems and pearls. The jewels are set on a gold ground on arcades of pearled wire to raise them from the ground in order that the light will enhance their luster. Enamel roundels with the four evangelists, perhaps made locally in Regensburg or imported from Trier, fill the corners, and a niello inscription on the inner frame names Henry II as the donor. Just as in painting, strict frames within frames visually bind and control the heterogeneous elements. Each part is exquisite—the whole is magnificent.

Although the incorporation of ancient and exotic treasures into a new work associated it with older empires and thus gave it added context, Ottonian jewelers had no need to borrow Carolingian ivories. Skillful carvers worked in their shops. An artist of unusual imagination and skill carved the image of the Doubting Thomas [7.30]. The inscription carved on the ivory comes from the Gospel of John (20:27) when Christ commands Thomas to touch the wound in his side and to believe. Only in this way can Thomas trust his eyes and believe in the bodily Resurrection. With remarkable sensitivity, the sculptor abandoned Ottonian hieratic scale and literally elevated the risen Christ on an octagonal pedestal. Capturing an unusual moment, the sculpture shows St. Thomas from the back, looking upward at Christ, his head dramatically and accurately foreshortened. The intensity of the gaze establishes a psychological as well as physical interdependence, as the heavy muscular figures with their enormous hands and feet seem to interlock. The juxtaposition of the hands—the searching finger and clutching fist of St. Thomas and the passive grace of Christ—capture the spirit of the whole in a detail. Yet for all the psychological potency of the moment, the artist also escapes into an Ottonian love of ornamental display. Christ and St. Thomas both wear patterned cloaks, perhaps the rich Eastern silks so admired by the Ottonian courtiers. The contrast between the monumental figures and this decoration reinforces the tension between surface and form, solid and space, created by the compression of huge figures into a shallow round-headed niche and wide acanthus-filled frame. Scholars disagree on the place and date of this and other ivories of

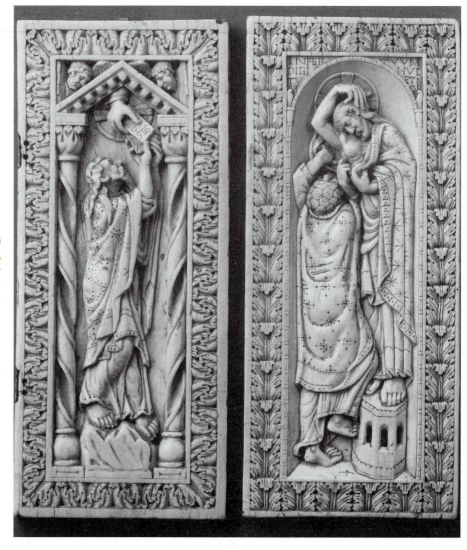

7.30
Diptych with Moses
and Thomas, c. 990 or
Echternach, c. 1050.
Staatliche Museum, Berlin.

the group—Trier or Echternach, sometime be-tween the end of the tenth and mid-eleventh centuries—but no one denies the power of the artist's imagination.

OTTONIAN ARCHITECTURE AND BRONZE SCULPTURE

Fortresses crumble; cities grow or die; secular build-ings disappear, victims of fragile materials. Reli-gious architecture is likely to survive—it is well built and it may be preserved, either because of genuine piety or because of conservative religious tradition. Nevertheless, Ottonian churches seem

particularly prone to disaster. The Cathedral of Mainz burned to the ground on the day of its con-secration in 1009. Otto the Great's Cathedral at Magdeburg burned in 1008; rebuilt in 1049, it burned again in 1208. Trier, a center of Ottonian imperial art, saw its great Benedictine Church of St. Maximin destroyed in 1674; Hersfeld, the major Ottonian Cluniac monastery, burned in 1761 and was never rebuilt. The churches of Cologne and Hildesheim were rebuilt in the twelfth and thir-teenth centuries, only to be destroyed in World War II and rebuilt yet again. Still, we must study Ottonian architecture, even in reconstruction, for it provides a link between the architecture of the

7.31 Convent of the Holy Trinity, Essen, mid-11th century; seven-branched candlestick, Hildesheim?, c. 1000.

Carolingian Empire and the Romanesque buildings of the eleventh and twelfth centuries.

When Ottonian rulers ordered their architects to create buildings that would recall the splendors of past empires, naturally, they looked to Carolingian buildings as models. The Palace Chapel at Aachen inspired the design of several chapels and sanctuaries. For example, Abbess Theophano (1039–1058), granddaughter of Empress Theophanu, added a chapel dedicated to St. Peter at the west end of her convent church in Essen [7.31]. Viewed from the nave, the structure resembles Charlemagne's chapel, but actually the central half-hexagon, ambulatory, gallery, stair turrets, and lateral bays are intricately interrelated forms unlike the relatively straightforward Car-

olingian structure. Furthermore, a tower rose two stories above the semidome of the chapel and, together with flanking stair towers, it forms a triple-towered westwork. This westwork probably retained its Carolingian imperial associations although it had many uses. Choirs may have sung from the galleries; certainly in the later Middle Ages it was used as a stage for a Passion play.

A magnificent candlestick given by the founder, Abbess Matilda (974–1011), a granddaughter of Otto the Great, copies the menorah from the Temple in Jerusalem, as represented on the Arch of Titus in Rome [see 1.4]. That the Ottonian emperors held court in Rome meant that the aristocratic patrons' admiration for ancient Rome was supplemented by first-hand knowledge of Roman imperial monuments. The Abbess's candlestick suggests the care with which Ottonian architects and artists selected, studied, and then reinterpreted their models as they sought to create a monumental imperial style for the German court.

The abbey church of St. Michael at Hildesheim (1001–1033) illustrates the Ottonian adaptation of Carolingian basilicas [7.32]. Archbishop Bernward (993–1022) consecrated the crypt in 1015. (The church suffered damaging fires and was rebuilt in the eleventh, twelfth, seventeenth, and twentieth centuries.) The Carolingian preference for balancing the east and west ends of the building, seen at Fulda and St. Riquier, inspired the Ottonian builders [7.33]. Massive crossing towers, transepts, and stair turrets at the ends of the transepts created double vertical accents [7.34]. The building depends on severe geometric masses for its exterior effect. Lombard-Catalan masons working north of the Alps influenced the simple architectonic decoration of arched corbel tables and strip buttresses.

The building's design is based on a system of square units (cubical units of space or bays) established by the crossing, which is a square bay defined by polychrome masonry arches opening into

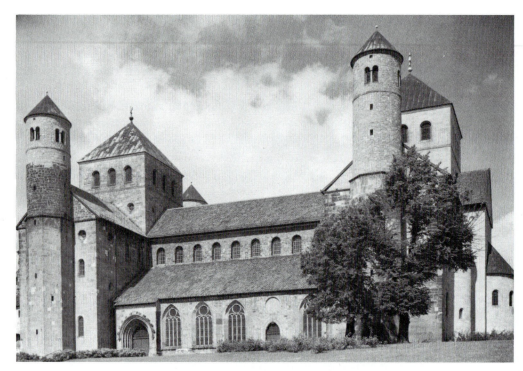

7.32 Monastery Church of St. Michael, Hildesheim, Germany, 1001–1033 (restored, 1958).

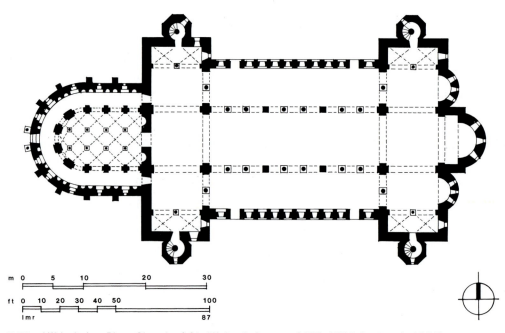

7.33 Hildesheim, Plan, Church of St. Michael, Saxony, 1001-1033 (restored, 1958).

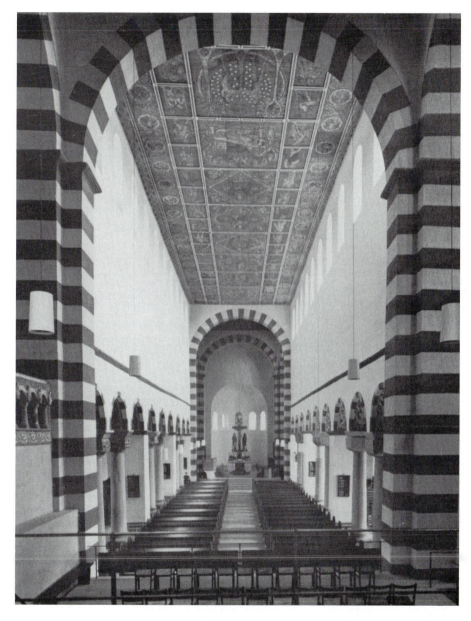

7.34
Nave and aisles, Church of
St. Michael, Hildesheim,
Saxony, 1001–1033.

the transept arms, the nave, and the sanctuary. This module is then repeated throughout the building with one unit for each transept arm and three units for the nave. Piers and columns form a rhythmic alternation of heavy and light supports, and rectangular and round forms. This contrasting horizontal and vertical movement characterizes the new architectural aesthetic and sets the Ottonian basilicas apart from their Early Christian and Carolingian prototypes.

The cloister monks and the public entered St. Michael's through side doors so that the aisles functioned as entrance halls. The nave ends in transepts and sanctuaries at both the east and the west, giving the church a divided focus. The increasing complexity of the liturgy required double choirs, for which the transept galleries, their floors connected by polygonal stair towers, offered ample accommodation. Decoration was reduced to the clear, cubical forms of architectural sculp-

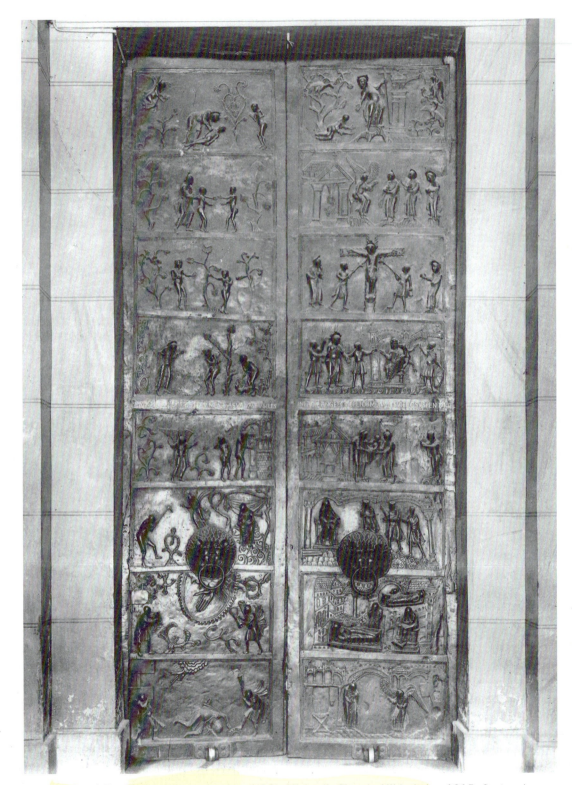

7.35 Old and New Testament scenes, doors of St. Michael's Church, Hildesheim, 1015. Cast and chased bronze. Height 16ft. 6in. (5m). Cathedral of Hildesheim.

Bronze Casting

A remarkable achievement in bronze casting for any age, the doors, each wing of which was cast in one piece, are a near miracle in the eleventh century. Earlier bronze doors had been constructed of small panels nailed to a wooden frame. At Hildesheim, the artisans used the lost-wax process, which they reintroduced to the Continent from Anglo-Saxon England (where the technology, used on a small scale, had never been lost). In the lost-wax process the artist modeled his sculpture in wax over a core. Then the casters made a mold with vents top and bottom so that, as they poured in the molten metal, the wax melted and ran out at the bottom. When they broke away the mold, if they were successful, the metal had the same form as the original wax sculpture. The process is more difficult in practice than its description implies, and the Hildesheim bronze foundry made a significant contribution to the history of technology as well as the history of art.

ture, which established a precedent for the severe and restrained style of the later eleventh and twelfth centuries.

Sculpture in bronze enriched the churches. More than the ivory or wood carver, the metalsmith had always been an important figure in the North. Ottonian smiths, with their roots deep in local tradition, were daring and innovative in the technical perfection of their work in precious metals and daring in the size of their bronzes. They rapidly developed the technical means to fulfill the most demanding patrons.

Bishop Bernward had seen carved doors and commemorative columns when he accompanied Otto III to Rome for the coronation. On his return to Germany in 1001, he ordered his artists to cast a set of bronze doors covered with scenes from the Old and New Testaments [7.35]. The doors were ready for the consecration of St. Michael's in 1015. The bronze casters of Hildesheim represent an unusually popular and dramatic narrative art. They created the first large-scale bronze sculpture in the North—a door 16 1/2 feet (5m) high and a column 12 1/2 feet (3.8m) high—for the Church of St. Michael (now in the Cathedral of Hildesheim). Surely the bishop looked back to the monuments of imperial Rome as he challenged his artists to do as well for the new Christian empire.

The intellectual content of the doors matches the audacity of their physical creation. Bishop Bernward probably designed the iconographical program himself, for only a scholar thoroughly familiar with both art and theology would have conceived of combining this clear narrative history with such subtle interrelationships. The chronological history of the fall of humanity and salvation through Christ is so arranged that paired scenes from Old and New Testaments become a mutually interdependent explication and justification of each other. The left-door wing has eight scenes from Genesis, beginning at the top with the creation of Adam, moving downward, and ending with the murder of Abel. The right wing, beginning at the bottom of the door and running upward, illustrates the New Testament from the Annunciation to the post-resurrection scene of Christ and Mary Magdalen (Noli me tangere). A wide frame with a dedicatory inscription divides the narrative sequence into groups of four scenes. On the Old Testament side, events in Paradise ending with the discovery of Adam and Eve lie above the inscription, and events in the world beginning with the expulsion lie below. On the New Testament side, the first four scenes depict the life of Mary and the childhood of Christ; the upper four, the Passion, beginning with the trial before Pilate.

That a scholar designed the program for an educated, theologically sophisticated audience is apparent in the typological comparisons established by each horizontal pair of scenes. Here the theological and moral significance of events is amplified by comparison between the Old and New Testaments. The theme of the two Eves, a theme that became widespread in medieval art, runs through several scenes: Eve, who caused the Fall and Expul-

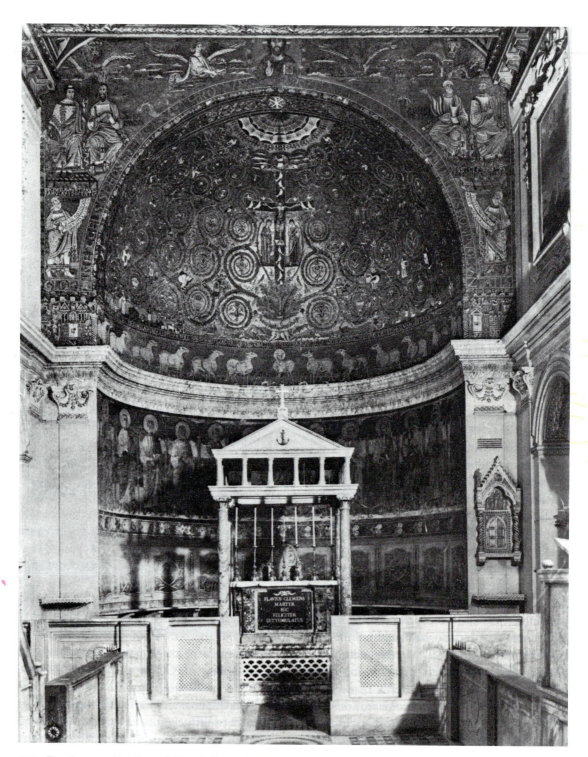

8.7 The Cross as the Tree of Life, 12ᵗʰ century. Mosaic, S. Clemente, Rome.

Pisa, Ghibelline. Florence under the Countess Matilda (1046–1115) had a prosperous and enlightened citizenry, and Matilda herself was an educated woman, a patron of the arts, and a friend of Pope Gregory VII. The cities also became commercial rivals. Competition extended into the arts, and splendid Romanesque churches rose in both cities. The typical Tuscan church remained basilican in form following Roman tradition, but, unlike the Early Christian basilicas, both the exterior and the interior were richly decorated with marble sheathing—white and green geometric and architectural patterns at S. Miniato in Florence [8.8], and blind and false arcades at Pisa [8.9].

The cathedral complex at Pisa was begun in 1063 immediately after a Pisan naval victory over the Muslims. It is a tribute to civic pride and Pisan commercial success as well as to the Virgin, to whom it was dedicated. The cathedral is part of a complex that retains the Early Christian separation of functions in different buildings. Besides the cathedral, the Pisans built a separate baptistery, bell tower, and cemetery. The most distinctive feature of the buildings is their exterior encrustation with a veneer of pale marble enriched with pilasters and tiers of arcades. The famous "leaning tower of Pisa" was

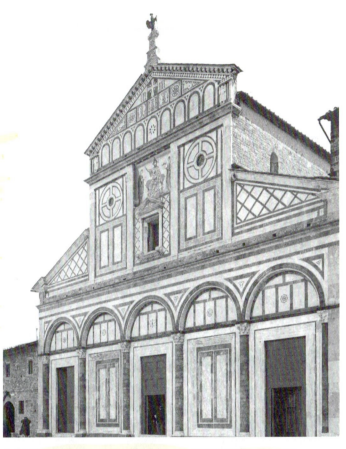

8.8 San Miniato al Monte, Façade. 1062–1150. Florence.

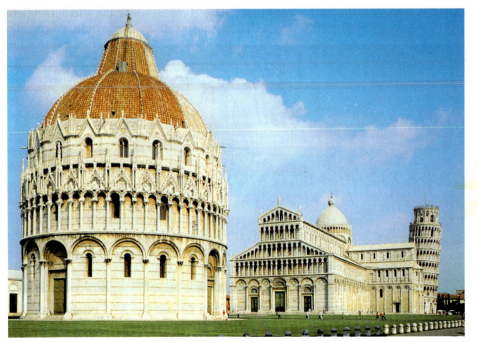

8.9
Baptistry 1153; Cathedral begun 1063; Campanile 1174. View from the west. Pisa.

8.24 Interior, Cluny III, 1088–1130.

were brought to Autun from Marseilles in 1079. (The church is now a cathedral.) Construction of the present building began about 1120; the church was consecrated in 1130, and again in 1146. The masons refined the architecture of Cluny by using such details as fluted pilasters, historiated capitals, and nearly classical moldings. The proportions used in the blind arcade and the clerestory might have been inspired by Roman gates to the city. Above this elegant wall, transverse ribs divided the pointed barrel vault into bays uniting pilasters, arches, and vault into a coherent whole.

Gislebertus, a uniquely gifted sculptor, directed the shop at Autun. (The name Gislebertus

emphasized the height of the building. (The church at Paray-le-Monial, c. 1100, replicates Cluny III on a much smaller scale.) The pointed arch is a Muslim feature, and other Muslim elements such as polylobed arches and pearled moldings also appear in Cluniac decoration.

Just as the House of God was the center of the spiritual life of the community, the cloister was the center of domestic activity. The plan established in the Carolingian period evolved into a masterful arrangement of large, well-built halls housing the scriptorium, dormitory, the chapter house, parlor, refectory, kitchen and bakery [compare 8.23 and 5.6]. At Cluny, the west range contained the abbot's palace and the wine cellar. The guest house and stables also lay to the west. A novitiate and a huge hospital were added to the south and east of the central core of church and cloister buildings.

Cluny III served as an inspiration for artists and patrons. Some builders, such as those working in Autun, copied Cluny's elegant proportions and classical details [8.25]. At Autun, the church was dedicated to St. Lazarus, whose relics

8.25 Nave, Autun, 1120–1130.

is carved directly under the feet of Christ in the center of the western tympanum. It has been suggested that Gislebertus could be the name of the patron, not the sculptor.) The master carved, or directed the carving, of interior capitals and the north and west portal sculptures at the cathedral. In the design of capitals the Corinthian capital remains a constant reference point, but the form has been reinterpreted as a closely knit, two-dimensional linear composition [8.26]. Foliage curls upward into volutes, establishing an architectural frame for narrative scenes in which the figures and the foliage become a decorative symmetrical composition. In depicting the suicide of Judas, the sculptor captured the horror of Judas' death in the grimacing face and limp, dangling figure. The demons' scrawny limbs, flaming hair, contorted faces, and gnashing teeth make them convincingly energetic embodiments of evil, who defy even the architectonic requirements imposed on the sculptor.

On the central portal of the west façade, serene in the center of the swirling activity, Christ renders judgment [8.27]. The inscription reads, "May this terror frighten those who are bound by worldly error. It will be true just as the horror of these images indicates." Among the resurrected, human touches abound. Two men carry wallets bearing the cross and scallop-shell badges of the pilgrim—

8.26 Gislebertus, Suicide of Judas, nave capital, Autun Cathedral, c. 1125.

the cross for Jerusalem and a shell for Santiago. An angel juggles the scales and another boosts a soul through the floor of the Heavenly Jerusalem. Gigantic hands snatch one fellow away to Hell. Gislebertus contrasts the drama of the Last Judgment theme with the regularity of the tympanum's

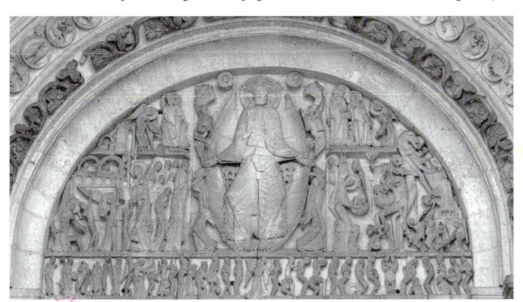

8.27
Gislebertus, Last Judgment Tympanum West porch of Autun Cathedral, c. 1140.

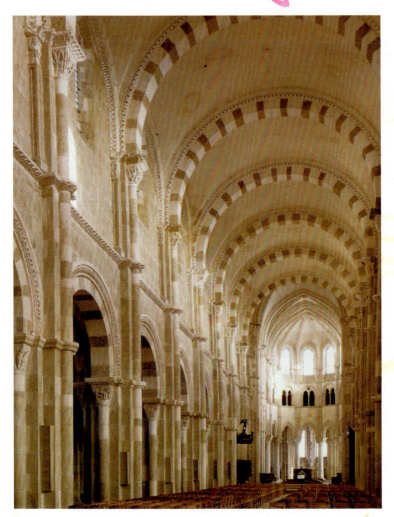

8.28 Church of the Madeleine, Vézelay, the nave, c. 1120–1132.

imental architects who built churches such as St. Philibert in Tournus. In 1050, when Pope Leo IX confirmed the existence of the relics of St. Mary Magdalen at Vézelay, pilgrimages to the shrine began. After a fire in 1120 the monks rebuilt in stone and consecrated a new church in 1132 [8.28]. The nave was finished 1135–1140 (the choir was rebuilt in an early Gothic style in the second half of the twelfth century). Vézelay was the site of dramatic events: St. Bernard preached the Second Crusade there in 1146, and a generation later Philip Augustus and Richard the Lion-Hearted met at Vézelay to leave for the Third Crusade. The church was a worthy site for twelfth-century spectacle, for its builders had been fearless in their innovations.

To create a light, open effect, the builders of Vézelay used widely spaced compound piers, eliminated the triforium, and inserted large clerestory windows. In order to build a stable masonry vault they erected a slightly flattened groin vault reinforced with concealed iron rods. Pilaster-backed engaged columns support transverse arches with alternating reddish-brown and white voussoirs, a decorative feature characteristic of Islamic architecture (as seen for example in the mosque at Córdoba, [see 6.20]). These arches dramatize the division of the space and give the building an exotic flavor.

Roman Corinthian capitals inspired the design of capitals with spiky acanthus leaves curling into volutes around an inverted bell shape. Against this, grand vigorous figures act out narratives and allegories. St. Paul turning the mystic mill of the Lord, grinding exceeding fine, can be seen in the aisle at the left [8.29]. Graceful poses animate clinging sheaths of drapery often ending in wind-tossed folds. Eyes with drilled pupils sparkle in round, doll-like faces, and large hands gesture expressively. The sculptors achieved a remarkable crispness, clarity, and linearity by undercutting forms so that edges are sharpened by shadows. The capitals seem related to the cloister crafts of manuscript illumination, ivory carving, and

composition. A symmetrical frontal figure of Christ presides over events depicted in horizontal registers. Furthermore, although actually in high relief, the elongated and interlocking figures produce a two-dimensional effect. A delicate pattern of fine parallel lines covers sheath-like, overlapping, sharply pressed drapery folds. The clinging drapery covers slender bodies and twig-like limbs and flutters freely around ankles and at edges of cloaks. Gislebertus' monumental tympanum survived modernization under a layer of plaster (undecorated voussoirs replace the original carving).

South of Atun The builders of the abbey church at Vézelay seem to be heirs of the energetic, exper-

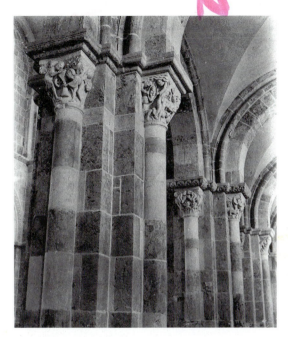

8.29 Detail of piers and aisle capitals, Church of the Madeleine, Vézelay (first capital: St. Paul grinding grain, the Mill of the Lord), 1120–1132.

goldsmithing, an effect undoubtedly enhanced by painting.

In Vézelay, about 1135–1140, the master created a dramatic tympanum [8.30]. The sculptural program covers three portals set within a narthex building. In the central tympanum he represented Pentecost or Christ's mission to the apostles. The small doors at the right and the left present the Incarnation and the Ascension. Recently it has been suggested that the portals depict the triumph of Christian peace. Either subject would have been unique in Romanesque art and singularly appropriate for a church that was both a center of pilgrimage and a staging point for crusades. The style, too, is energetic: dynamic angular forms fill the tympanum, and figures seem to writhe with energy. Christ becomes both the motivating force and a figure caught up in his own unearthly power as he twists into a compressed zigzag position, a pose enhanced by the spiral patterns of drapery at hip and knee joints. As though conscious of the need to exert an architectonic control, the sculptor has surrounded the tympanum with heavy archivolts: the inner archivolts have signs of the zodiac and the outer moldings are covered with luxuriant foliage. That will become the hallmark of later Burgundian art.

In a way unusual in Romanesque art, the sculpture at Vézelay impinges on the spectators' space and draws them into the drama. Curving backgrounds and high relief create a dramatic play between the linear surface composition and three-dimensional forms. The mandorla surrounding Christ is a saucer-like plaque, and the rippling clouds above Christ and the undulating molding between lintel and tympanum cast shadows that make the background plane appear to move. The haloes of the apostles tip and slant, creating more shifting planes within the shallow stage provided by the architecture. In later Burgundian sculpture, this dynamic linear movement becomes mere restlessness. The study of the effects of light and shade turned into a fascination with surfaces, and delight in ornament led to a near obsession with detail, already hinted at in the Vézelay sculptor's masterpiece.

So beautiful is the stone that sometimes it is difficult to remember that most medieval sculpture was painted. A few mural paintings survive to give us an idea of the true medieval color sense. At Berze-la-Ville, a grange of Cluny only seven miles from the abbey, a regal Christ giving the law to St. Peter fills the apse, and scenes of martyrdom cover the walls [8.31]. The painting may even copy the apsidal decoration of Cluny III. The rich colors—a dark blue ground with rust brown and olive green—were applied in fresco secco (paint over remoistened plaster). Forms are built up in superimposed layers of color and finished with a fine linear net of highlights derived from the Byzantine practice of indicating folds of drapery with sprays of white or gold highlights. The free drawing, the loose yet dense composition in which figures seem to jostle for position, and even the multilinear drapery style are akin to the sculptured tympanum at Vézelay. With their painted walls and sculpture, Romanesque buildings must have dazzled the viewer.

The many currents in Romanesque art come together outside Burgundy in the sculpture of the

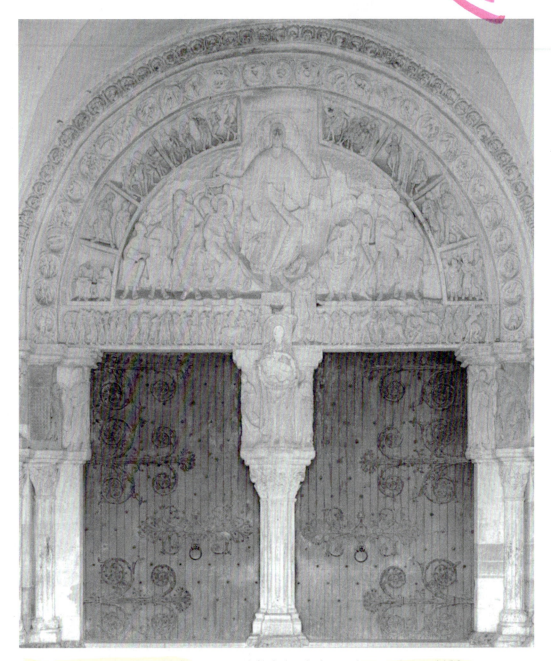

8.30 Vézelay, tympanum with Pentecost and Christ's mission to the apostles, c. 1130s.

Church of St. Peter at Moissac, a Cluniac abbey on the road to Santiago. Ruled by Abbot Durandus, who came from Cluny in 1047 and later became the bishop of Toulouse, Moissac stood second in importance to Cluny [8.32]. Abbot Durandus built a new church, dedicated in 1065, and when he died in 1072, he was buried in the cloister. There on a pier relief is his memorial portrait, a sculpture of uncompromising frontality and symmetry. The figure completely fills the arched panel; the vestments repeat both the arch of the frame and the rectangle of the pier. Crisp and delicate carving turns three-dimensional forms into flat patterns. Sheaths of drapery with edges marked by

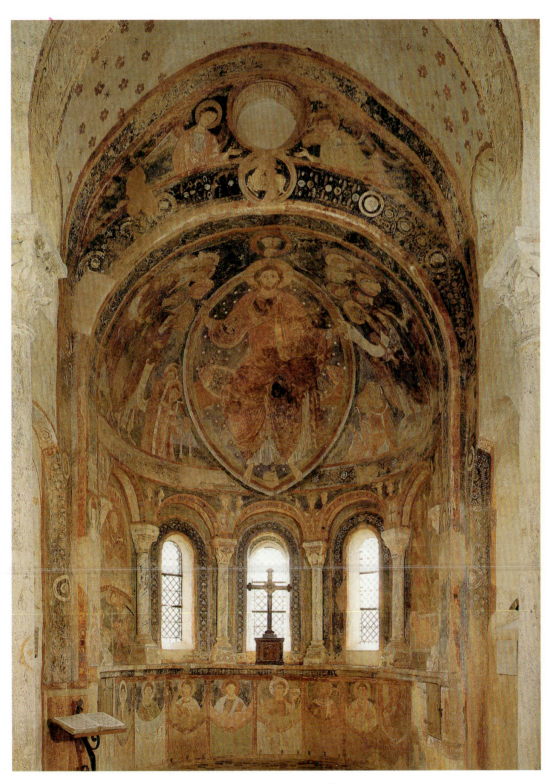

8.31 Berze-la-Ville, chapel, apse, Christ in Majesty, early 12th century, painting.

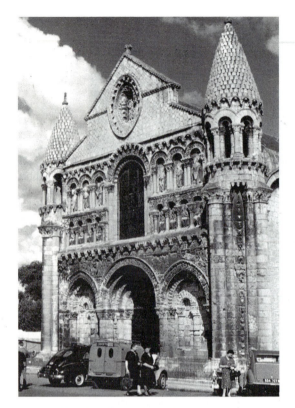

8.40 Church of Notre-Dame-la-Grande, west façade, Poitiers, 12th century.

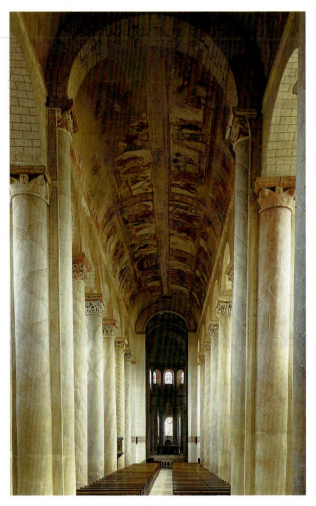

8.41 Abbey Church of St. Savin-sur-Gartempe, painting in vault, 1100–1115.

ings form a didactic program aimed at instructing the viewer as well as decorating the building. Scenes from the Old Testament fill the barrel-vaulted nave; the infancy of Christ is depicted in the transept; the Passion, in the gallery over the porch; scenes from the lives of the saints, in the chapels and crypt; and finally the Apocalypse and the second coming of Christ cover the walls and vault of the entrance porch.

The nave vault was built between 1095 and 1115. The paintings must date from the same time, for they would have been executed while the masons' scaffolding was still in place. Scenes from the Old Testament unfold in continuous registers. The paintings were expected to do more than provide an effective decoration. Since the Carolingian period, art had been justified for its educational value. The painters of the nave vault, therefore, intended that their painting would be intelligible from a distance. They worked on a large scale, emphasized outlines and broad color areas, and simplified inter-

nal modeling of figures. A harmony of earth tones—ocher, sienna, white, and green—produces a warm, light tone throughout the building.

NORMANDY AND ENGLAND

The Duchy of Normandy and the Kingdom of England were united politically as well as culturally in the eleventh century, and artists and masons had traveled between the Norman and Anglo-Saxon courts. Duke William of Normandy (William the Conqueror) conquered England in 1066. In their capital at Caen about 1061, William the Conqueror and his wife Matilda established two monastic communities: one for men with its church ded-

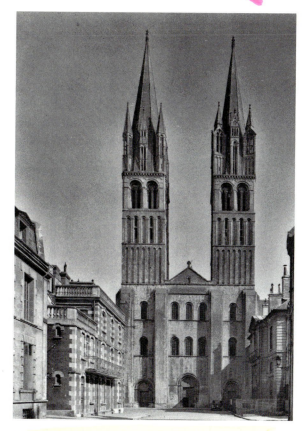

8.42 Abbey Church of St. Étienne, West façade, Caen, 1064–1087.

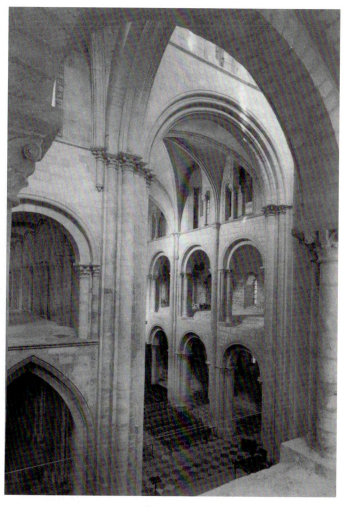

8.43 Abbey Church of St. Étienne, Nave, Caen; vaulted c. 1120.

icated to St. Étienne (St. Stephen) and one for women with the Church of the Trinity. Through their extensive military and commercial contacts, the Normans had firsthand knowledge of art and architecture throughout Europe. Now the Norman builders combined structural innovation with a desire for soaring height and good illumination. The Church of St. Étienne was begun in 1064 and finished by 1087, in time for William the Conqueror's funeral. The façade was completed by the end of the eleventh century [8.42]. (The timber roof of the nave was replaced with a vault c. 1120, and the choir was rebuilt and spires added to the towers in 1202.) Massive compound piers with column shafts running the full height of the three-story elevation divided the nave into bays and emphasized the vertical lines of the interior. The addition of pilasters on alternate piers created a subtle rhythmic movement down the nave [8.43]. In the clerestory,

between an arcade facing the nave and the outer windows, a passage within the thickness of the wall provided access to the upper areas.

In spite of the actual thickness of the walls, the Norman builders conceived of the interior as a skeletal framework of piers and arches which permitted wide openings in arcades, a tall gallery, and large clerestory windows. To lighten the masonry visually, the arches of the arcades were molded to correspond to the profiles of the piers. The result produces a contrast of vertical shafts and horizontal arcades. On the façade this ideal grid continues with enormous buttresses running unbroken the entire height of the façade to divide the wall into three vertical sections, while smaller string courses

tory demonstrate the artist's acute awareness of human life.

English scribes also played a role in the twelfth-century revival of the figurative arts. Carolingian, Anglo-Saxon, and Ottonian manuscripts were available to them in monastic scriptoria. Important as book production was in England, embroidery remains the quintessential English art. Closely related to the manuscripts, these fine embroidered textiles may have been designed by artists from the scriptoria. They probably drew the ornamental patterns and narrative scenes for the needle workers. The most famous English embroidery is the so-called Bayeux Tapestry [see 8.1 and 8.3]. Ordered by William's half brother Odo, bishop of Bayeux, and probably made in Canterbury about 1070, it records William's conquest of England. The "tapestry" is actually colored wool embroidery, worked in a difficult laid and couched stitch on linen. As a political document, the work justifies William's claims to the kingdom and recounts the preparation for the invasion, the course of the battle leading to the death of Harold, and the establishment of the new Norman dynasty.

No detail escaped the attention of the artist. In the siege of Dinan, the conformation of the land, the burning of the palisades, and the surrender as the keys are passed out from lance to lance are depicted in an energetic style which is closer to late Anglo-Saxon drawing than to the new Romanesque style. Accuracy in reporting is prized over calculated composition, specific details over idealized views, energy over elegance. The Bayeux Tapestry provides a fascinating source of visual information, not only of an important historical event but of daily life in the eleventh century.

In the eleventh and twelfth centuries, Romanesque art developed as a style with marked regional variations, reflecting the diversity in the religious, political, and social organization of western Europe. Yet certain elements are consistent. Romanesque builders defined the functions and spaces of the church with simple geometric shapes as they emphasized the symbolic content of the buildings. Towers, standing like city gates as symbols of authority and temporal power, dramatize both castles and church façades, while sculptured portals of the church emphasize the sanctity and the importance the House of the Lord. A lantern tower or a cupola could give additional distinction to the crossing of the nave and transept and also serve as a reminder that every church was a martyrium. A complex choir provided space for the participating clergy and chapels to house the relics of saints. The impression given by the buildings is of solid, massive, uncompromising strength—the architectural expression of an essentially hierarchical and military society.

Architecture dominated the arts of the eleventh and twelfth centuries. The wall established the limits of the relief, and the architectural element, the frame. In painting, too, the illusion of three-dimensional space was reduced or eliminated through the use of strong outlines and brilliant colors. Manuscript illustrations and mural decorations alike had a geometric clarity and monumentality. The exquisite refinement of the decorative arts imported from the Byzantine and Muslim East reinforced the desire for superior craftsmanship. Artists looked again at the antique tradition of realism/humanism as distilled by Byzantine artists.

Painters and sculptors had an additional impetus to seek formal clarity, for their work had a didactic as well as a decorative purpose. The strong suspicion that images led to idolatry induced a feeling that art should be justified as educational. St. Bernard's concern over the ostentatious decoration of churches expressed a common Christian fear of graven images and a puritanical disapproval of the expense of art. St. Bernard considered the decoration of cloisters a distraction, but even he admitted the usefulness of narrative and symbolic art for instruction in parish churches. The visual arts became a system of signs and symbols often enhanced by explanatory inscriptions, but still difficult to unravel today when the common language of belief and folklore has been forgotten. This selection and combination of elements, as well as the submission to an architectural discipline, gave Romanesque art its distinctive character.

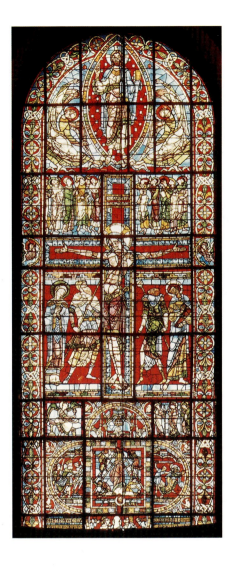

9.1
Poitiers, Cathedral, Crucifixion Window,
given by Henry II and Queen Eleanor.
Stained glass, 12th century.

<div align="right">CHAPTER 9</div>

ORIGINS OF GOTHIC ART
The "Year 1200" Style

Hailed as "King of the Aquitainians, of the
Bretons, of the Danes [Normans], of the
Goths, of the Spaniards and Gascons, and
of the Gauls," and elected because he posed little
threat to the great nobles who actually held these
lands, Hugh Capet, Count of Paris, became king
of France in 987, and the Capetian dynasty
began its 340-year rule. The archbishop of Reims
crowned and consecrated Hugh Capet and so es-
tablished the moral authority of the Capetian
house. The new king's political authority was de-
pendent on his own personal holdings around
Paris—the Île-de-France—and such loyalty as he
could exact or inspire. In theory, the king defended

the realm and dispensed justice. In fact, at the time
of Hugh's succession, the title of king carried with
it powers of moral suasion and very little else.

The Capetians, blessed with long lives and
competent heirs, gradually turned a loose system
of allegiances into a powerful, centralized monar-
chy. Remarkably enough, from the days of Hugh
Capet until 1316, there was always a son of age to
inherit the throne. Hugh Capet, Robert the Pious,
Henry I, Philip I, Louis VI (the Fat), and Louis
VII succeeded each other—only six kings in
nearly 200 years. The prestige and wealth of the
monarchy had grown slowly and steadily. The arts
reflected this situation, and the regional styles of

| 227

9.9 Cathedral of Sens, Nave, begun before 1142. Height of vault about 81ft. (24.7m).

of Cluny and Autun. Massive compound piers formed by engaged columns running through two stories carried the transverse and diagonal ribs of the vaults. Paired cylindrical piers—a new form, invented by the Sens Master and used again in Canterbury Cathedral [see 9.27]—supported the intermediate arches.

"Symbolic geometry," as it is called today, continued to be an essential element in building design. At Sens, the master evidently used the equilateral triangle to establish key points in the elevation and cross section, abandoning the Anglo-Norman galleries and clerestory passages and using a narrow triforium and thin clerestory wall. When the windows were enlarged in 1230, this single

plane of stone and glass had to be supported with flying buttresses [see box]. The compact plan, the union of the three-part nave elevation with six-part ribbed vaults, and the alternation of piers and columns at Sens established a new model for builders.

STAINED GLASS

Abbot Suger saw the church as the Heavenly Jerusalem, as did other people of his time, and he wrote of it in metaphors of dazzling light and colored jewels—especially rubies and sapphires. The architecture became a mere skeleton to support stained-glass windows. These windows were walls of glowing color that, with the movement of the sun and clouds in the sky, changed the interior of a building into shifting waves of red, blue, and purple light.

Abbot Suger took special care to describe the stained-glass windows in the new choir at St. Denis. He tells of bringing masters to do the work, and he arranged for a specialist to care for the windows. The windows were to him the epitome of art used in the service of religion, for they led the worshipper to God, "urging us onward from the material to the immaterial in an anagogical fashion." One window, for example, began with an allegory in which the Old Testament prophets carried sacks of grain to be ground into flour by St. Paul, the New Testament (as we have seen at Vézelay [see 8.29]). Twelfth-century scholars studied and explained the images, using typological analysis to give depth and meaning to human action through perceived relationships with the Old Testament.

The St. Denis windows have been badly damaged or destroyed, but fragments of glass can be studied in museums and in the restored panels in the church. At Chartres and Bourges Cathedrals, however, twelfth-century windows are still in

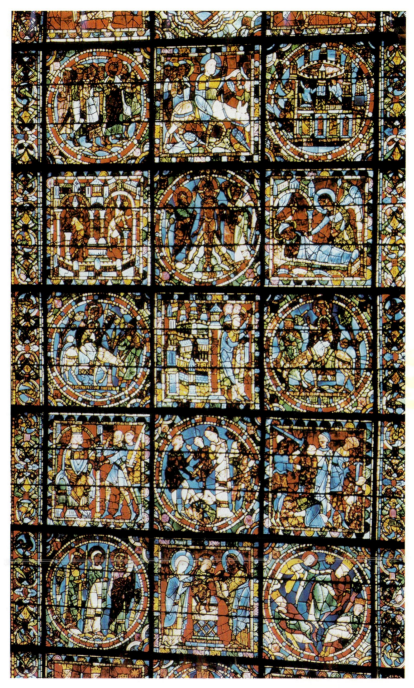

9.10
Chartres Cathedral, West façade, Stained-glass windows. Scene from the Life of Christ. c. 1150–1170.

place. Above the portal in the western wall at Chartres, three great lancet windows represent the Tree of Jesse, the life of Christ [9.10], and his Passion. In the Life of Christ window, the designers organized the narratives in a series of alternating circular or square frames and also alternated the background colors between red and blue. (This simple color pattern was also used to heighten the carrying power of designs in heraldry and is referred to as heraldic alternation.) The elegant, painted figures recall the sculpture on the portal below [see 9.13, 9.14, and 9.15], while the wide

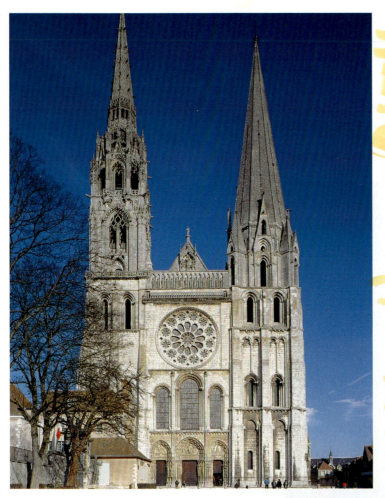

9.12 Chartres Cathedral, the Cathedral of Notre-Dame, West façade, Chartres, France, c. 1134–1220; south tower c. 1160; north tower 1507–1513.

pollution [9.12]. After a fire in 1134, rebuilding of the west façade began at once with the towers. The sculptured portals between the towers must have been carved between 1140 and 1150 [9.13]. When, in 1194, lightning struck the wooden roofed eleventh-century building, which burned to the ground, the Royal Portal survived, protected by its masonry vault and flanking towers.

Sculpture does not spread over the façade as it does in some Romanesque buildings in Queen Eleanor's Aquitaine. Certain architectural members seemed most appropriate for sculptural enrichment—door jambs, lintels, tympana, and archivolts. The sculpture is not compressed or controlled by the architecture, as it had been in the Romanesque style, but instead conforms naturally to the shape of the architectural element and visually reinforces the architecture. The figures carved around the doors, for example, become columns themselves, in contrast to the lively jamb figures at Vézelay or Moissac. Vertical elements dominate the composition; consequently, in the voussoirs, figures follow the line of the arches, rather than radiating out from a center, the better to harmonize with the vertical lines of the statue columns. Lintels might be filled

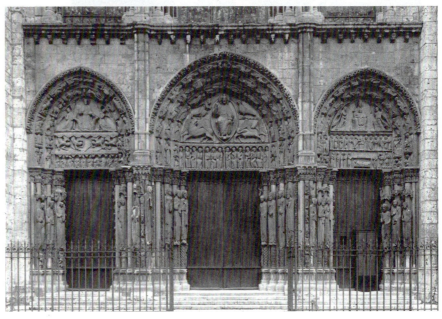

9.13 Chartres Cathedral, Royal Portal, west façade, c. 1140–1150.

with standing figures under an arcade—the arcade reinforces the horizontal lines of the lintel and the figures establish a pattern of verticals within the horizontal block. Within the lunette of the tympanum, through the continued use of hieratic scale, the central figure of Christ naturally rises to fill the apex while apocalyptic beasts fit gracefully into the remaining triangular sections. The number of figures is reduced and their relationship to each other and to the architecture is clarified so that the tympana of Chartres are composed of self-contained and balanced units, in contrast to the intricate interlocking Romanesque forms.

With the exception of some ornamental patterns on subsidiary colonnettes and moldings, the portal sculpture conveys a message. The idea that the Old Testament supported the New is clearly stated in the actual physical relationship of jambs and archivolts. The Old Testament kings and queens of Judea lead to the New Testament with Christ and the Virgin. Furthermore, as jamb figures flanking the portals, the kings and queens literally draw the worshipper into the House of God. The columns support sculptured capitals, which become a continuous arcaded frieze with scenes from the life of Christ. In the tympana, Christ is glorified, as is His mother; he appears in the past, present, and future at the end of time.

The right-hand portal depicts Mary, the Christ Child, and scenes from the early life of Christ [9.14]. In the Nativity, on the lowest lintel, the Virgin reclines on a bed, which at the same time forms an altar on which the Christ Child lies. Next, in the Presentation in the Temple, Christ stands on the altar, again in the center of the composition. In the tympanum, Christ and Mary assume the position of the traditional "Throne of Wisdom" statues. (The baldachino over their heads is lost, but the bases of the columns that supported it are visible at each side of the throne, and the line of the gable roof and arch can still be traced.) Since the narrative progresses logically from left to right and bottom to top, the adjustment of the three representations of Christ (lying, standing, and then sitting in the center of the composition) had to be carefully calculated. In each case, he appears not as a living child but enshrined

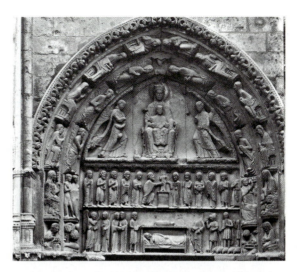

9.14 Chartres Cathedral, Virgin Portal, west façade, right bay, mid-12th century.

as a cult object. In the voussoirs, perhaps in recognition of the cathedral school of Chartres, studious ancient philosophers and the personifications of the liberal arts surround Mary, their patron. The dedication of an entire portal on the principal façade of a cathedral to Mary has been seen as a significant change in her status (and through her, perhaps that of other women) in the twelfth century.

On the left-hand side of the portal, Christ ascends heavenward in a cloud, adored and supported by angels. In the voussoirs, signs of the zodiac and works of the months symbolize earthly time, which comes to an end in the glory of the Second Coming. The final vision of glory fills the central tympanum. Christ as the Pantokrator of the Apocalypse, with the four beasts and 24 elders and choirs of angels, rises over the 12 apostles. The Chartrain theologians have organized all of Christian history on the façade of their cathedral, and the master sculptor, known today as the Head Master, has created a logical and convincing architectural composition in fulfillment of their wishes. Later masters had only to expand or condense the themes of the Royal Portal. Indeed, elaborate portals added to the transepts of Chartres in the thirteenth century provide extended Old Testament themes on the north side and the Last Judgment and the saints on the south.

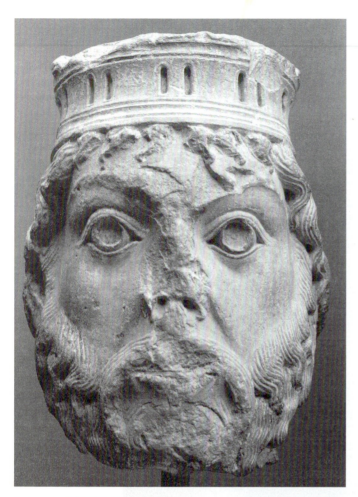

9.23 King David, Ste. Anne Portal, west façade, Cathedral of Notre-Dame, Paris, 1165–1170. The Metropolitan Museum of Art.

domed-up form recalls the shape of earlier Romanesque domes. In the Cathedral of St. Pierre, built about 1162–1180, slender piers support ribbed vaults over three aisles of nearly equal height. The vaults buttress each other, and the outer walls became sheaths around a cubical space. English architects soon adopted this form for chapels—for example, in the Cathedral of Salisbury [see 10.33] and Germans often used it, for example at St. Elizabeth's, Marburg [see 10.37]. It was very popular in secular architecture, for markets and palace halls. The light, open rectangular building did not suit the taste of Île-de-France builders, however, and not until the fourteenth century was the hall church form widely used there.

Two great works of art with the crucifixion as their theme, one in stained glass and one in champlevé enamel, remind us of the continuation of the rich artistic tradition of southwestern France and the great centers of Poitiers, Limoges, and Bordeaux. At the end of the nave of the Cathedral of Poitiers the great Crucifixion Window seems to float about the altar [see 9.1]. On a smaller scale but still essentially an art of colored glass and an adornment of the altar is the cross in champlevé enamel. The technique is called Limoges, but these enamels were produced in several workshops in

9.24
Cathedral of Poitiers, Nave, St. Pierre, begun 1162.

9.25 Grandmont Altar, Christ on the Cross, Limoges, c. 1189. Champlevé enamel. The Cleveland Museum of Art.

southern France and northern Spain. The cross is probably the work of the Master of the Grandmont Altar and can be dated about 1189–1190 [9.25].

The Limoges cross recalls the precious jeweled "True Cross" that was venerated in Jerusalem. The cross within the cross stands on Golgotha, literally identified as "the place of the skull" by Adam's skull resting on the ground beneath Christ's feet. Christ is stretched on the cross; however, the slight sway of his body and the droop of his head, as in Byzantine art, suggest a sacrificial rather than a triumphant figure. Of course, the cool stylization of anatomy is based on artistic convention, not observation, although the contrast of the pale pink face with the white flesh of the torso hints at the artist's awakening concern for natural appearances. The cross is a special object, and the Grandmont Master gave his work an extraordinarily delicate finish by stippling the metal walls that hold the enamel

pastes with tiny punch marks and then gilding these contour lines. As the cross is moved, the contours catch the light, and the image appears to be a golden drawing on a field of glowing color.

ENGLISH GOTHIC ART

Across the channel in England, Henry II had as dynamic, powerful, and loyal a second in command in Thomas Becket as the French kings had in Abbot Suger. When Becket became archbishop of Canterbury, however, he defended the Church against the king. His murder in the cathedral in 1170 gave England a new martyr and, in 1173, a saint. His shrine in Canterbury became the focus of a great pilgrimage, immortalized by Geoffrey Chaucer in *The Canterbury Tales*.

On the night of September 5, 1174, a fire destroyed the choir of the Canterbury cathedral. Gervase of Canterbury described the fire and the rebuilding of the cathedral in an invaluable firsthand account of medieval building practice. Reconstruction began almost at once under the direction of William of Sens. The architect was responsible for the overall design, and for relations with the patrons (the cathedral chapter), for the organization of the masons, for acquiring material (William imported fine building stone from Caen), and for direct supervision of the work. William salvaged the surviving crypt and some of the outer walls of the building, so this Norman structure gave the new church its curiously pinched plan and diagonally placed chapels [9.26]. The six-part vault, the molded ribs, the foliate capitals, and the three-part elevation of the new work all reflect the builders' knowledge of modern French architecture [9.27]. The passage in the thick clerestory wall, the detached colonnettes on the piers, and the increasing elaboration of the design, especially the addition of Purbeck marble shafts, whose dark brown and black color contrast dramatically with the white Caen stone, reflect English preferences and building traditions. Gervase tells us that William of Sens fell from a scaffold in 1178 and returned to France. His place was taken by William the Englishman, who finished the building of the choir and the eastern chapel in

9.26
Canterbury Cathedral,
Plan, 12th–15th
centuries.

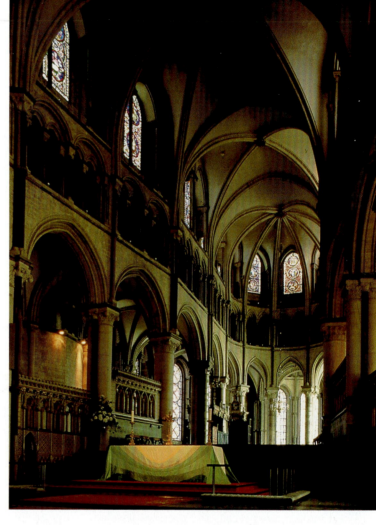

9.27
Canterbury Cathedral, choir,
William of Sens, after 1174.

1184. The personal quality of Gervase's narrative provides us with some of the useful and homely detail we miss in Abbot Suger's description of building of his abbey. These two accounts could serve as an introduction to the Gothic age, but, as Gervase wrote, "All may be more clearly and pleasantly seen by the eyes than taught in writing."

Winchester, where so many great Anglo-Saxon manuscripts had been made, continued to be the site of a major scriptorium. A Bible, now known as the Winchester Bible, was created by several artists over a period of about 50 years. Their different styles have been related to such widely scattered works as murals from Sigena in Spain, mosaics in Palermo [see 6.30], and the other cloister crafts of

the second half of the twelfth century. The Winchester Bible is a veritable repertory of painting styles.

Among the most impressive artists working in Winchester was the Master of the Morgan Leaf, so called from a detached page now in the Pierpont Morgan Library in New York [9.28]. The painter depicts the story of David: David slaying Goliath, playing the harp for Saul, anointed by Samuel, and finally mourning Absalom. Well-proportioned figures enhanced by flowing form-revealing draperies act out the drama within a shallow stage-space. This interest in the representation of three-dimensional forms in a limited spatial environment suggests a renewed contact with Roman and Byzan-

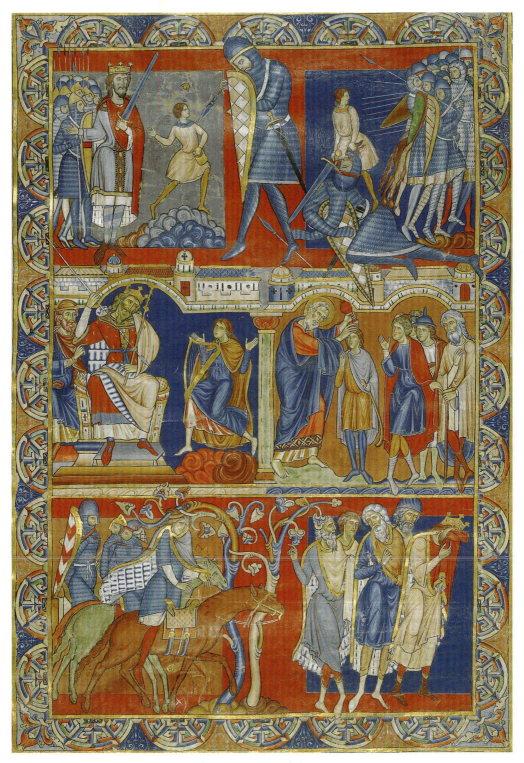

9.28 Morgan leaf, scenes from the life of David, Winchester (possibly Winchester Bible), third quarter of the 12th century. 22 5/8 x 15 1/4in. (57.5 x 38.7cm). The Pierpont Morgan Library.

THE SPREAD OF EARLY GOTHIC ART

Although many sculptors and architects working in the last decades of the twelfth century were inspired by St. Denis and Senlis, sculptors in many places remained conservatively tied to the Romanesque aesthetic. The portal of the Church of St. Trophime in Arles copies the iconography and composition of the central portal at Chartres. However, the Romanesque conception of sculpture as a low relief decorating a flat wall surface and the strict architectonic organization and control of all the elements remain in force [9.36]. The monuments of classical antiquity in the region also influenced the portals. The sculptors skillfully adapted such classical architectural decoration as fluted pilasters, Corinthian capitals, and acanthus relief panels. These antique forms appear beside ferocious Romanesque lions gnaw-

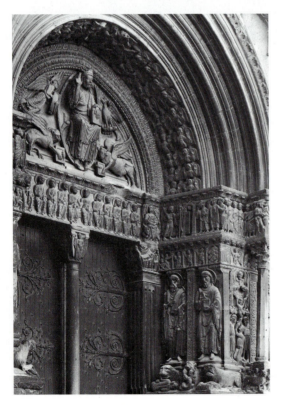

9.36 Church of St. Trophime, Portal, west façade, second half of the 12th century, Arles.

ing people and animals. The standing figures of saints lack the sense of inner life seen in the Gothic sculpture of the north. They remain flat relief panels inserted between pilasters. Even at the end of the century, sculptors who had seen the Early Gothic innovations continued to work in the rich and beautiful but essentially conservative Provençal Romanesque style.

In contrast, in far-off Santiago de Compostela, the Portico de la Gloria of the Cathedral provides another version of the transition from the late Romanesque to the early Gothic style [9.37]. Linked to St. Denis in iconography and Senlis in its humanism, this magnificent narthex was constructed by Master Matthew, who inscribed his name and the date 1188 on the lintel. The document in which the king commissioned the work in 1168 also survives. Master Matthew's vision of the Apocalypse, combined with a Last Judgment as it was at St. Denis, included apostles and prophets in the door jambs, angels trumpeting from the vaults, and the 24 elders playing harps and viols. On the trumeau, above a representation of the Tree of Jesse and a capital with sculpture of the Trinity, St. James sits on a lion throne holding his pilgrim's staff. The adjustment of the seated figure to the pier is but one example of Master Matthew's acute observation and technical skill. In the apostles, prophets, and angels, he even captured fleeting smiles and spontaneous gestures. Yet he and others of his shop used ornament with Romanesque profusion: folded and crinkled hems, engraved borders imitating jeweled embroideries, and corkscrew curls. Master Matthew, more than many artists of his generation, blended accurate observation with decorative abstraction. The musical instruments of the 24 elders, for example, are represented with such fidelity that they have been successfully reproduced and played by modern students of medieval music.

Master Matthew was only one of many masters who began to adopt elements of Gothic technique, style, and sensibility. Benedetto Antelami in Parma as early as 1178, the date of his Deposition relief,

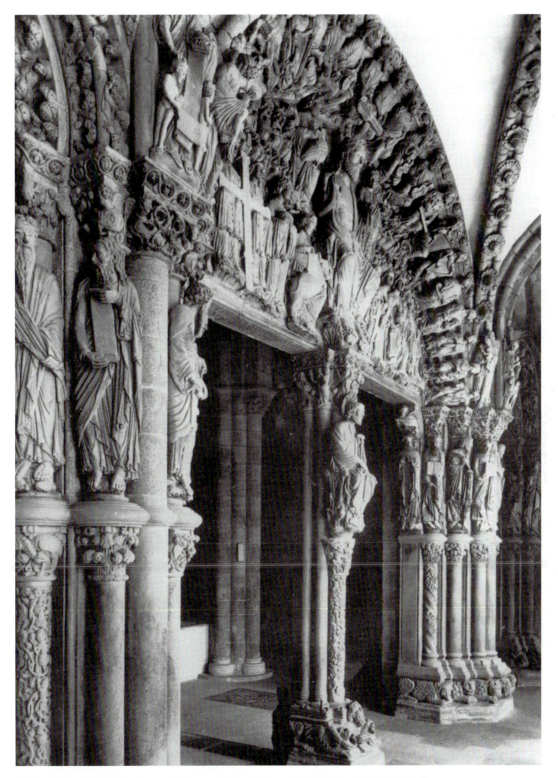

9.37 Cathedral of Santiago de Compostela, Portico de la Gloria, c. 1168–1188.

and after 1196 in the Parma baptistery, and the masters of Bamberg Cathedral in Germany introduced the new Gothic humanism into the local milieu.

During the twelfth century, artists began to think of the human figure as an independent and majestic form worthy of representation in art. They could justify their art because man had been given the outer appearance adopted by God while on earth. The Father and Son, and even the ranks of angels, had to be represented in human form. However, the human figure continued to be treated in a religious or educational context and not as beautiful in itself. Here a distinction can be drawn between Western and Byzantine art. Whereas in Byzantium images of Christ and the saints became icons to be venerated, in the West figures usually had a didactic role. Whereas Romanesque artists had merely borrowed figure conventions and compositions, early Gothic artists assimilated the Byzantine lessons and then looked at the world afresh when they had to create actors in the sacred drama. Both Romanesque art and Gothic art still make a powerful impact on the mind and the emotions of the viewer. However, the final impression created by Romanesque art is one of naked power, that of the Early Gothic of humanized force. The Romanesque artist seemed to expect the Apocalypse; Gothic artists hoped for salvation and the joys and splendor of Paradise.

10.1
Page with Louis IX and Queen Blanche of Castile, Moralized Bible, Paris. 1226–1234. Ink, tempera, and gold leaf on vellum, 15 x 10 1/2in. (38 x 26.6cm). The Pierpont Morgan Library.

CHAPTER 10

MATURE GOTHIC ART

In the Moralized Bible, the Queen Mother, Blanche of Castile, and her son, St. Louis, preside over the scriptorium where a scholar and illuminator work on a manuscript [10.1]. "And even as the scribe that hath made his book illumineth it with gold and blue, so did the said King illumine his realm with the fair abbeys," wrote John, Lord of Joinville, about St. Louis as a patron of the arts (Book 2, ch. CXLVI). The reign of King Louis IX of France (1226–1270) coincided with the mature phase of the Gothic style in France. Louis IX owed the peace and resources that enabled him to patronize the arts to the skillful politics of his grandfather, King Philip Augustus. The wars between Philip Augustus and King John of

England ended in 1204 with Philip's victory. Ten years later a French-Hohenstaufen coalition defeated the English-Welf alliance at the battle of Bouvines, assuring French political, economic, and cultural independence. During the thirteenth century the French kings (and queens, like Blanche of Castile, who ruled as regent from 1226 to 1234) established a strong centralized government with a staff of civil servants dependent on royal favor. From their court in Paris the rulers defended their realm with professional mercenary troops hired with the income they received from their towns.

The kings granted privileges to old towns and founded new ones, and this new city wealth made them independent of nobles and feudal armies.

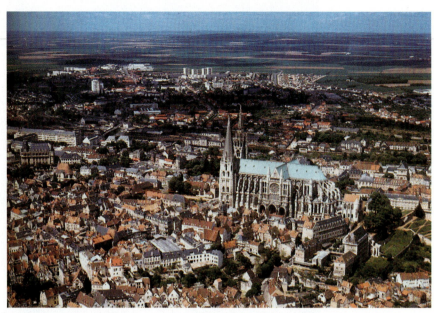

Meanwhile, townspeople had a stake in the success of monarchs because they needed the peace, which a strong central government could ensure, in order to operate their business ventures successfully [10.2]. With the growth of commerce and industry, artisans and merchants organized guilds to control the production and prices of goods and to ensure that their members maintained high standards of quality. They kept careful watch on the education and welfare of members. Women, too, became guild members when, as widows, they carried on the family's business. Guild members had their confraternities and their patron saints, whose chapels they maintained, but this growing urban middle class needed more spiritual guidance and help than the parishes and rural monastic communities provided. New religious orders, the Franciscan and Dominican friars (from the Latin *frater,* brother), worked in the cities, caring for those in need. The friars had a special interest in education, first of all to combat heresy, and some friars also became outstanding scholars and teachers. Many taught at the University of Paris, which was founded in 1200 and officially recognized in 1215.

The Crusades to take Jerusalem and other Christian holy sites from the Muslims had begun at the end of the eleventh century and continued throughout the thirteenth century. The later crusaders often had unacknowledged economic as well as religious goals. During the Fourth Crusade at the beginning of the century, Venetian merchants and French knights turned the campaign into raids against Christian cities, and in 1204 they sacked and looted Constantinople itself. They installed one of their number as emperor and ruled the sadly reduced Byzantine Empire until they were driven out by a new Byzantine dynasty in 1261. King Louis of France led a crusade in 1244–1254, and he died while crusading in 1270. (The Church recognized his efforts and piety by making him a saint in 1297.)

The association of western European crusaders with the Byzantine and Muslim East had a profound impact on Europe. Scholars gained access to Muslim science: astronomy, astrology, mathematics (including Arabic numerals and the concept of zero), and the rudiments of biology and medicine. They also learned about such practical devices as chimneys, clocks, and windmills. With travel, knowledge of geography improved and so did mapmaking and navigation. Trade fairs became clearing houses for imported as well as native products as markets and a money economy expanded. New products appeared in Europe: rice, lemons, melons, apricots, sugar, sesame, cloves, incense and sandalwood, cotton and damask, carpets, and jewels.

THE CATHEDRAL OF CHARTRES

Of first importance to the builders and patrons of Gothic art was the quality of the stained-glass windows and the colored light they created [10.3]. Today, when buildings have lost most of their medieval glass and are without the color that once infused the space, the churches may seem emotionally cold and austere in a way never intended by their creators.

Fortunately Chartres is an exception, and here the full effect of color in an interior can still be appreciated. Not only are the walls rich, luminous sheaths but the space itself is animated by beams of colored light slanting through the air. The beams shift and move, and the quality of light and color changes depending on the time of day and the movement of clouds across the sun. Thus nature—sunlight and weather—unite with artistry to create an awe-inspiring work of art.

In the Cathedral of Chartres, superb twelfth-century glass survives in the west façade windows [see 9.10 and 9.11]. Between 1215 and 1240, most of the other windows were glazed, and the entire program was finished for the consecration of the building in 1260. The simple lancets in the aisles and chapels, which were low enough to be easily seen, had complex narratives from Christian history. Many small scenes were arranged in geometric panels, whose frames of iron formed a black pattern across the rich colors of the glass. These vivid windows emerge as glowing panels in the dark mass of the wall. In the choir, the guild of furriers donated a window with scenes from the story of Charlemagne, who had been the original Western owner of the Virgin's tunic, Chartres's most important relic [10.4]. The exploits of Charlemagne and his knights are depicted in an elaborate interlocking composition. The artists demonstrate a remarkable skill in adjusting the narrative to the armature of the window. The Christian hero Roland charges against the Moorish champion, whose lance breaks in the violence of combat. Color clarifies and emphasizes the scene—the red of Roland's tunic and the glittering yellow of his helmet against the blue

ground are picked up again in the red disc of the Moor's shield. Above in a circular medallion, Roland finally blows his horn to summon help from Charlemagne's army. Fluid brush strokes in enamel on the colored glass render the essential details of the armor, drapery, and horses' heads.

The high clerestory windows have single figures of saints, prophets, and apostles. There the designers have used larger figures, simple drawing, and brilliant color so that the images can be seen at a distance. In the north transept, lancets and a huge rose window (over 42 feet (12.8m) in diameter) are filled with deep-blue and ruby-red glass and emblazoned with the heraldic golden lilies of France and the castles of Queen Blanche of Castile, who may have been the royal patron [10.5]. In the heart of

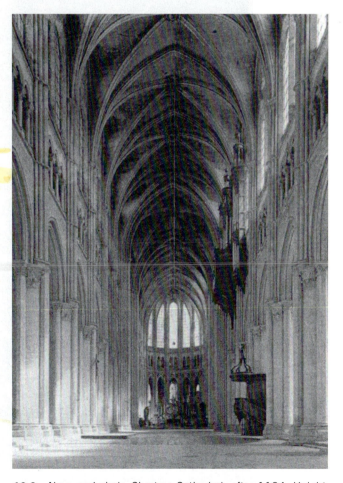

10.3 Nave and choir, Chartres Cathedral, after 1194. Height of vault approximately 122ft. (37.2m).

the rose, the Virgin and Child are surrounded by four doves (the Gospels) and eight angels. Old Testament kings and prophets, the ancestors of Christ, sit in the circle of lozenges, and around the rim of the rose, medallions bearing prophets float in a red-and-blue diapered (checkered) ground. St. Anne holds the infant Mary in the center lancet above the royal coat of arms.

Artists and patrons gave St. Anne a place of honor in the iconographical program of the north transept because the Count of Blois had presented the precious relic of her skull, acquired in Byzantium, to the cathedral when he returned from the Fourth Crusade in 1204. Both the portal sculpture and the stained-glass windows glorify St. Anne. In the lancets, St. Anne and Mary are flanked by Old Testament figures: Melchizedek, David, Solomon, and Aaron. Melchizedek and Aaron prefigure the priesthood of Christ, and David and Solomon are his royal ancestors. Melchizedek and Solomon triumph over the idolatry of Nebuchadnezzar and Jeroboam, represented in panels below their feet, while David stands above the suicide of Saul, and Aaron (Moses' brother) watches the destruction of Pharaoh in the Red Sea. Outside on the triple entrance into the north transept, St. Anne has the position of honor on the trumeau of the central portal [see 10.18]. Scenes from the life of Mary fill the lintel and tympanum, and Old Testament kings and prophets stand in the jambs.

THE ARCHITECTURE OF CATHEDRALS

At the beginning of the thirteenth century, builders, sculptors, and painters achieved a synthesis of form and meaning that seems to summarize the aspirations of Western Christendom. Earlier artists had experimented with structural and decorative features—ribbed vaults supported by a variety of wall and buttress systems, complex interior elevations with galleries and clerestories, regularized iconographical and compositional programs in sculpture and stained glass. Now thirteenth-century masters resolved the technical and aesthetic problems posed by their twelfth-century predecessors, and in so doing they created a style characterized by

order, harmony, and balance. The builders of the thirteenth-century Gothic cathedrals expressed Western Christian ideals just as seven centuries earlier the architects Anthemius and Isidorus and the Emperor Justinian had made the Church of Hagia Sophia a visible symbol of Byzantine culture and belief.

The Chartres Cathedral [10.6] still stands in a small city surrounded by rich agricultural land—land that provided the wealth that made building possible at the beginning of the thirteenth century [see 10.2]. The structure became a model for builders throughout northern France: Its design was challenged at Bourges and both emulated and perfected in the Cathedrals of Reims and Amiens. Built on the foundations of the church destroyed by fire June 10, 1194, in a remarkably short time this new cathedral rose on the site behind the surviving Royal Portal. The massive western towers of the old church had protected the precious twelfth-century sculpture and stained glass. The new nave may have been finished about 1210 and the east end (apse, ambulatory, and radiating chapels composing the chevet) by 1220, when the first dedication took place [10.7]. The clergy tried to convince the nobles and the townspeople to pour their resources into the rebuilding campaign, but they were not always successful.

The master builders of Chartres Cathedral simplified, clarified, and regularized elements introduced in the twelfth century [10.8a]. They combined the long nave, aisled transept, and multiple towers of Laon Cathedral with the compact double ambulatory and radiating chapels of St. Denis and Paris. In the elevation, they adopted the three-part scheme of Sens [see 9.9] in preference to the four-part elevations of Paris and Laon [see 9.18]. Alternating cylindrical and polygonal compound piers articulated by contrasting shafts divide the nave into vertical bays. Ribbed, four-part vaults cover both the rectangular bays in the nave vault and the square aisle bays. Pointed arches permit the keystones of transverse and diagonal ribs to be set at the same height in order to produce the level vault and continuous space leading to the sanctuary. In contrast to this horizontal forward movement, the verticality

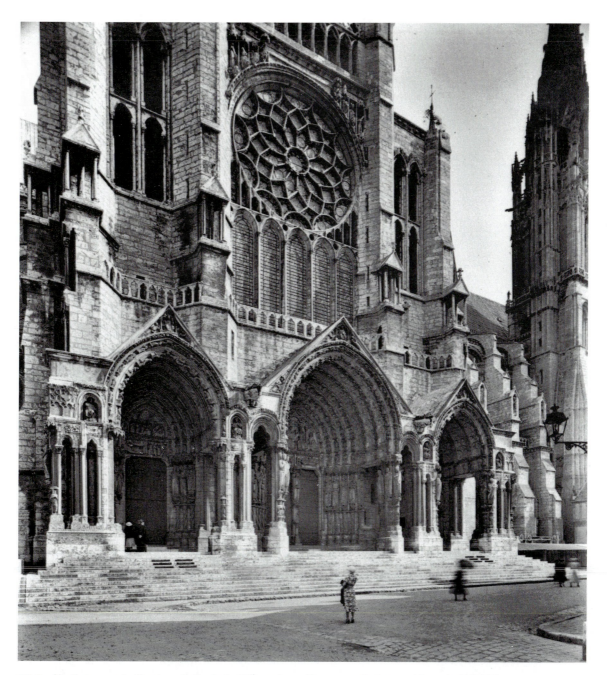

10.6 North transept, Chartres Cathedral, 13th century. (See rose window and lancets [10.5].)

of the tall arcade and clerestory and the linear thrust of compound piers and clustered wall shafts of diminishing diameter carry the eye into the high ribbed vault [10.9a]. Structurally the piers, vaulting ribs, and the exterior flying buttresses form an independent architectural skeleton. Unlike earlier buildings, the wall is not a series of discrete units but a continuous, subdivided, arched frame for stained glass. By balancing a nave arcade and a clerestory of equal height divided by an arcaded triforium passage, the designer created an impression of balance and harmony in the interior.

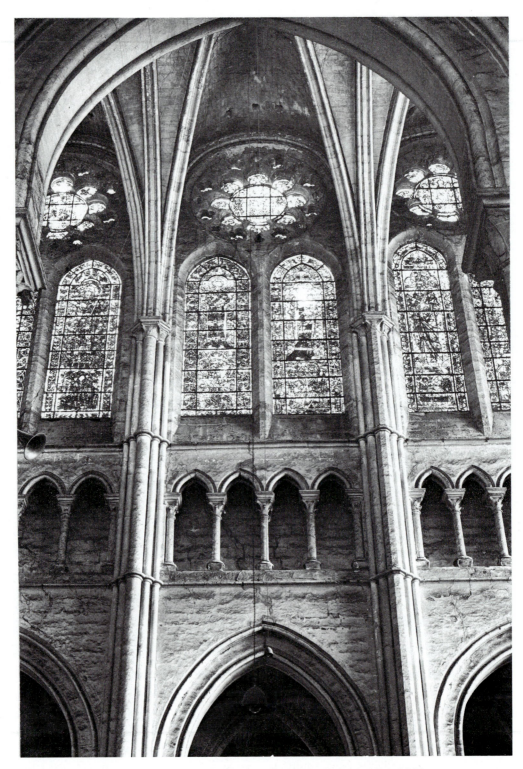

10.7 Upper wall of nave, Chartres Cathedral, 13th century, glazed before 1260.

The upper wall reads as a plane, not as masonry mass [10.7]. In each bay, two lancets and a rose pierce the wall to form clerestory windows 45 feet (13.7m) tall. Inside, the wall holds sheets of glowing color; outside, it is shimmering gray. Flying buttresses make this enlargement of the windows possible. Double arches joined by arcades of round arches on short columns divide the double struts that carry the weight of the vault over the aisle roofs to buttresses so massive that even today one senses the architect's determination to build for the ages.

In the choir the architect subtly modified the elevation. The triforium continues around the hemicycle with paired arches, while in the clerestory, a single lancet window fills each bay [see 10.3]. In the high vault, ribs radiate out from a central keystone, and their lines are continued in lower trapezoidal ambulatory bays and polygonal chapels. Double flying buttresses support the hemicycle and carry the thrust of the vault to massive buttresses set wall-like between the chapels. St. Denis's continuous ring of chapels with stained-glass walls must have inspired the builders of Chartres; however, at Chartres, the builders had to incorporate the foundations of the original crypt, with its three strongly projecting chapels into the plan. They used three different designs for the seven chapels of the chevet. Three strongly projecting and separately vaulted chapels over the earlier foundations (the second, fourth, and sixth chapels) alternate with shallow chapels vaulted together with the outer ambulatory bays, as at St. Denis. The third and fifth copy St. Denis's double lights and vaulting system exactly, but in the first and sixth the Chartres Master increased the number of windows from two to three so that a window stands on the axis of the chapel, enhanc-

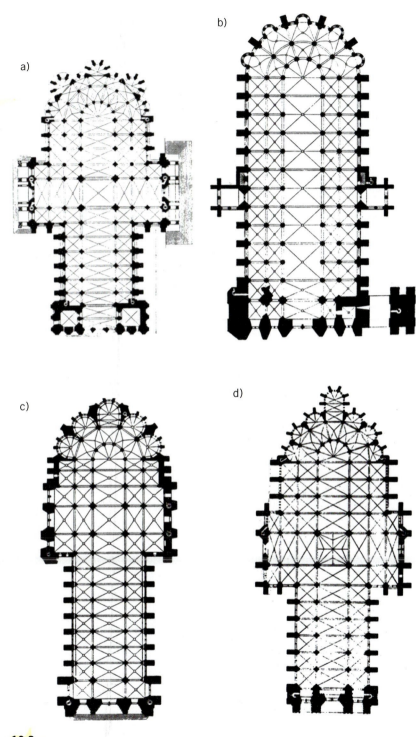

10.8
a) Plan, Chartres Cathedral, begun 1194.
b) Plan, Bourges Cathedral, begun 1195.
c) Plan, Reims Cathedral, begun 1211.
d) Plan, Amiens Cathedral, begun 1218.

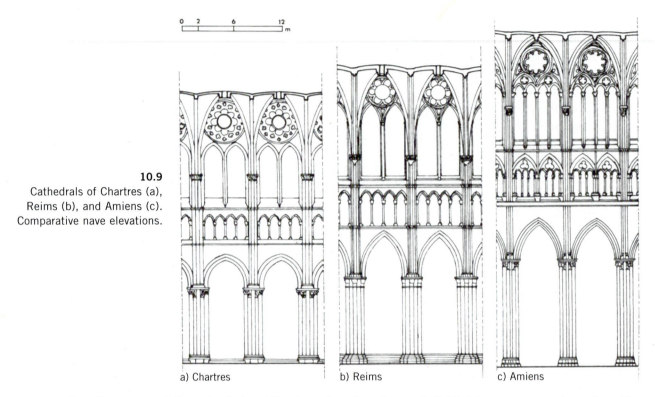

10.9
Cathedrals of Chartres (a),
Reims (b), and Amiens (c).
Comparative nave elevations.

a) Chartres b) Reims c) Amiens

ing the effectiveness of the stained glass. The ring of chapels formed an aureole of colored light around the high altar.

Contemporary with the Chartres Cathedral but inspired by different models, a cathedral dedicated to St. Étienne (Stephen) was built between 1195 and c. 1225 in Bourges, 140 miles south of Paris [10.10]. Here the architect created a building whose spatial complexity and lateral extension established an alternative to Chartrain architecture. The compact plan with double aisles and ambulatory, and six-part vaults over double bays [see 10.8b], has been compared to Notre-Dame, Paris [see 9.19 and 9.20]; however, the builders emphasized space and light rather than mass, and line rather than surface. At the Cathedral of Bourges, in spite of the divisive effect of the six-part vault, the eye moves rapidly down a nave and choir uninterrupted by a transept. Contrarily, attention may be distracted laterally into the double aisles. Relatively light piers in the nave arcade articulate the space, their slender verticality enhanced by eight thin column shafts. The triforium and clerestory, squeezed between this tall arcade and the vault,

have bays subdivided into narrow units—the triforium into six arches under a relieving arch and the clerestory into triplet windows. So high are the flanking aisles (59 feet (18m)) that they, too, have triforia and clerestories. The arcades open into yet lower side aisles lit by lancet windows. Thus three ranges of windows, alternating with two triforia, form bands of stained glass and shallow arcading. As they seem to rise and approach each other, they create diagonal sight lines contradicting the primary focus on the sanctuary. This remarkable outward expansion of the interior space contrasts with the balanced verticality of Chartres. The Bourges design inspired builders in such far-flung places as Tours and Le Mans in France and Burgos and Toledo in Spain.

Chartres, instead of Bourges, provided a model for the architects and patrons in Reims and Amiens, cathedral cities, north and east of Paris. A Roman and then a Merovingian stronghold, Reims was the site of the baptism of the Frankish king Clovis in 496. Reims came to be identified with the monarchy as the coronation church as well as the seat of the archbishop. The archbishop claimed

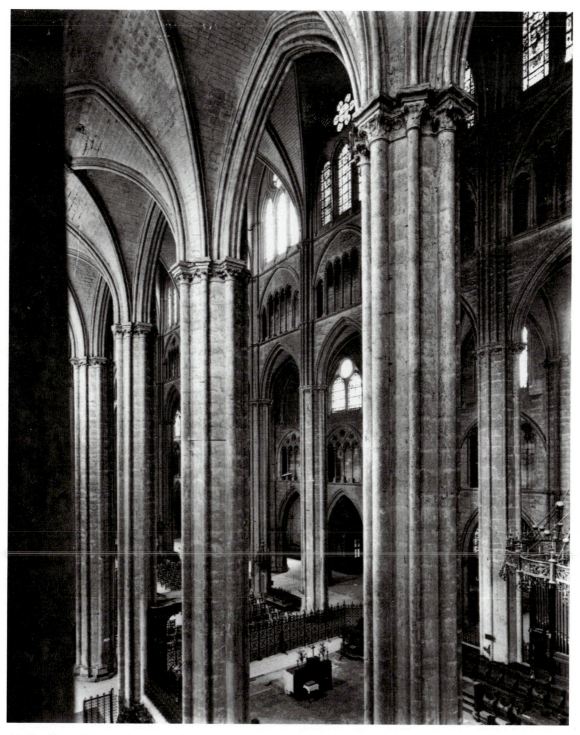

10.10 Nave, Bourges Cathedral, from south choir aisle triforium, begun 1195.

precedence although both the abbot of St. Denis (where the crown and other regalia were kept) and the archbishop of Sens also challenged Reims's primacy. Many buildings had stood on the site of Reims Cathedral: Roman baths, then a fourth-century Roman palace, a baptistry, Archbishop Ebbo's Carolingian cathedral with its westwork and transepts, and finally Archbishop Samson's mid-twelfth-century addition of a two-tower western façade and a new sanctuary. After a fire destroyed the city in 1210, masons, probably led by the architect Jean d'Orbais, laid the first stones of the building we see today [10.11].

Work on the cathedral continued for over a hundred years, from 1211 until it was left unfinished in the fourteenth century. At times the church officials and the citizens did not enjoy good relations, and money for building became scarce. Nevertheless in the course of the thirteenth century, five architects directed the work. A labyrinth laid in the pavement of the nave (destroyed in 1776) recorded four of their names and some cryptic comments about their tenure and accomplishments. (Architectural historians do not agree on the interpretation of the inscriptions.) The most likely sequence of builders and their work follows: Jean d'Orbais established the plan and elevation and oversaw work on the choir between 1211 and 1220 [10.9b]. He was followed by Jean le Loup, who was master for 16 years, according to the labyrinth's inscription. Jean must have overseen the construction of the transepts. Then Gaucher de Reims became master for eight years, during which time the chevet, transepts, and three bays of the nave were finished. Gaucher may have also begun the west façade. Bernard de Soissons, master for 35 years from 1254 to 1289, built the western bays of the nave and the west façade. The rose window was finished in 1287.

Construction had proceeded rapidly at first, but the oppression by the archbishops as they collected money for the building led to urban uprisings in the 1230s. Archbishop Henri de Braine (1227–1240) was particularly ruthless. Fighting broke out, and for a few years the canons even had to abandon their residence on the north side of the cathedral. In 1241 the canons were reinstalled in the liturgical choir located in the eastern bays of the nave. The chronology of work on the west façade and especially the sculpture of its portals has been vigorously debated. Some sculpture was being carved in the 1230s; work was in progress in the 1250s and 1260s and continued as late as 1285, when the cathedral prepared for the coronation of King Philip on January 6, 1286. Stained glass in the western rose and gallery dates from the end of the thirteenth and beginning of the fourteenth century. Robert de Coucy, who was not included in the commemorative labyrinth but who worked at Reims from 1290 until his death in 1311, finished the façade and roofed the building with lead but never completed the proposed towers and spires. The towers as we see them today were built in the fifteenth century.

The masters of Reims altered the Chartrain scheme by lengthening the nave, shortening the transept, and improving the geometric regularity of the choir by turning the ambulatory and radiating chapels into regular wedge-shaped sections [10.8c]. This compact yet spacious plan at the east end of the building gives the effect of a centralized structure attached to the nave. It becomes a martyrium for the first bishops [10.12 and 10.13]. The rippling pattern of windows and radiating flying buttresses enhances the circular movement of the ambulatory and chapels. Even the sculptured angels in the buttresses ringing the choir seem appropriate to a martyrium church.

The builders of Reims Cathedral achieved for the Western Roman Catholic Church a solution to the Christian architectural dilemma—that is, they combined the central plan and vertical movement of the martyrium (the tomb of Christ and the martyrs) with the horizontal axis of the basilican hall in a single building and so satisfied both liturgical and congregational requirements of the church [10.13]. The worshippers' gaze might rise upward into vaults, or to the heights of towers outside, but their attention was also directed forward to the sanctuary. The builders maintained the dramatic focus on the altar found in the Early Christian basilica and added a light-filled rotunda surrounded by a ring of subsidiary chapels to create a

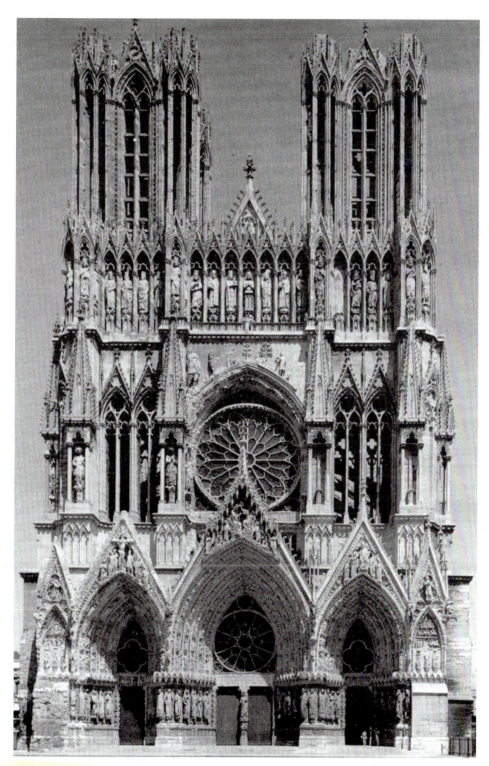

10.11 Reims Cathedral, west façade, Cathedral of Notre-Dame, Reims, France.
Rebuilding begun c. 1211 after fire in 1210; façade 1230s to level of rose by 1260;
towers left unfinished in 1311; additional work 1406–1428.

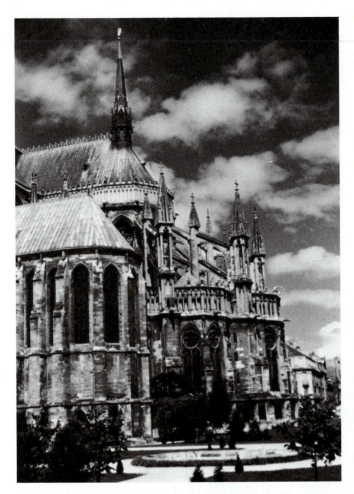

10.12 Chevet exterior, Reims Cathedral, 1211–1260.

jecting wall shafts and sharply pointed arches [10.9a,b,c] . Identical compound piers at Reims replace the cylindrical and polygonal piers of the Chartres arcade [10.14]. Capitals, which are doubled on all four attached column shafts, wrap the piers with broad bands of foliage. The capitals interrupt the upward surge of the compound piers and wall shafts, their bands of foliage creating a horizontal element in the nave elevation. Meanwhile the triforium loses its horizontal continuity, for it lies behind the projecting wall shafts. Furthermore, the slight thickening of the central column in the triforium arcade suggests a relationship with the double lancets of the clerestory above and even hints at the merger of these two elements.

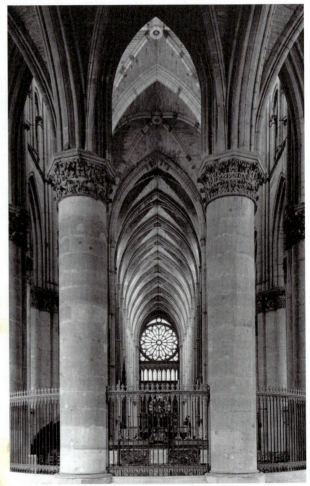

10.13 Interior, choir looking west, Reims Cathedral. Height of nave vault 125ft. (38.1m).

sanctuary that had connotations of the Dome of Heaven. Not content with the Byzantine glitter of reflected light from gold mosaics, the Western artists turned the entire church interior into colored light by replacing masonry walls with colored glass. The Virgin Mary with Jesus and the Crucified Christ, as well as all the archbishops, look down from the choir windows on the celebrations at the high altar below.

The logic and clarity inherent in Gothic architecture become even more apparent in the nave at Reims. The ideal of soaring height is achieved through actual height (125 feet (38.1m) to the crown of the vault), through proportion (Reims's 2.8 to 1 as compared to Chartres's 2.2 to 1), and through an emphasis on the vertical lines of pro-

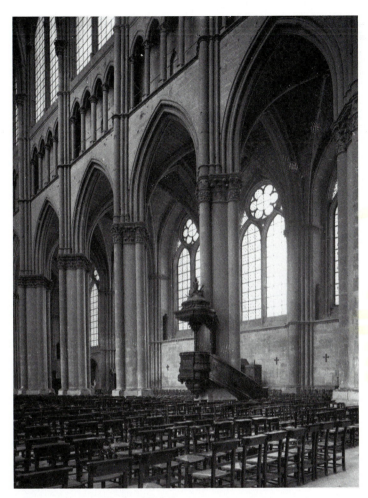

10.14 Nave, Reims Cathedral.

The masons' increasingly skillful use of flying buttresses made the enlarged windows possible. Profiting from generations of experience, they calculated thrusts and loads and stabilized the vaults and roofs with slender struts and arches attached to massive, tower-like buttresses (see Chapter 9, Box: *Flying Buttresses*). At Reims every buttress terminates in a pinnacle-weighted tabernacle housing a sculptured angel. Had the full complement of seven towers and spires been completed, the cathedral would have seemed to soar into the clouds, the House of the Lord guarded by flights of angels.

The architects of the Cathedral of Amiens—Robert de Luzarches and Thomas de Cormont—refined the solutions reached by builders at Chartres and Reims [10.16]. The city of Amiens in the thirteenth century was a rich textile manufacturing and trading center. A Romanesque cathedral and a church dedicated to St. Firmin, the first bishop of Amiens, stood on the site of the present cathedral. The cathedral burned in 1218; and Bishop Evrard de Fouilloy, the cathedral chapter, and the wealthy townspeople seized the opportunity to rebuild their cathedral on a scale they deemed appropriate to the importance of their city. Recent studies of the building show that the masons may have begun building at the east end of the nave and worked in both directions—down the nave, first in the north aisle and then the south, and eastward to the transept and choir [see 10.8d]. The crossing is located near the center of the building (with five choir bays and seven nave bays). A few other events provide guidance for the building's chronology; for example, bells were hung in the south transept in 1243. Robert was working on the west façade between 1220 and 1236, and work was finished by 1247. For a time, money was scarce, but building began again under Thomas de Cormont in the 1250s. After an outburst of civil unrest in 1258, in which people tried to burn down the cathedral,

In the clerestory and aisles, the Reims masters revolutionized window design with the invention of bar tracery. Earlier windows simply pierced the walls in a technique known as plate tracery, but at Reims the builders enlarged the open area, divided it with tracery, and filled it with glass. In each bay of the aisle and clerestory, mullions rise into pointed arches to form a pair of lancets supporting a rose. The repeated design links the upper and lower stories of the building since the aisle windows can be seen through the arches of the nave arcade, and these bands of colored light seem to be both joined and divided by a dark triforium. The invention of bar tracery and the expansion of the fields of glass at the Cathedral of Reims had a profound impact on the glazers' art.

The Seven-Spire Church

The nineteenth-century French architect and conservationist Viollet-le-Duc was also an excellent draftsman. He detailed his conception of the completed Gothic church, with its seven towers, in an elegant and persuasive drawing. The architect's intention for the complete cathedral is difficult to imagine today, even while we admire the rich sculpture of the deep porches and contrast the pure lines of the soaring Gothic towers. The Cathedral of Chartres is one of the few with a thirteenth-century spire (on the southwest tower). The northwest spire is a delicate web of flamboyant tracery, built in the sixteenth century. Patrons and masons planned seven towers for Laon and as many as nine towers for Chartres: a pair for each façade—west, north, and south—another pair at the beginning of the choir and a great tower over the crossing; consequently, nine spires should have pierced the heavens above the church of the Virgin. These spires, and the ingenious plan of the chevet with its circular and rising forms, create a Gothic equivalent of the symbolic Dome of Heaven encountered in Early Christian and Byzantine art.

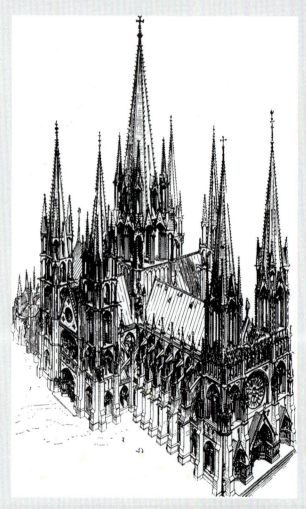

10.15 E. Viollet-le-duc, Seven Spire Church. *The Ideal Cathedral*, E. Viollet-le-Duc, *Dictionnaire raisonné de l'architecture française du XI au XVI siècle*, vol. II, Paris, 1859.

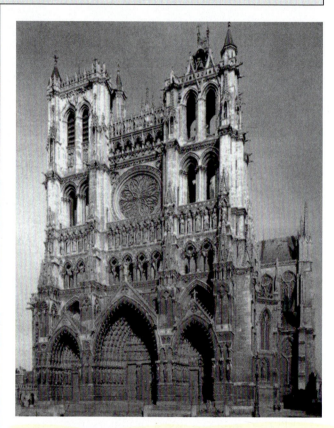

10.16 Amiens Cathedral, west façade, c. 1220-1236. Work continued through the 15th century.

Thomas's son Regnault de Cormont was able to build the upper stories of the choir, finishing about 1269. Regnault worked in the elegant, luminous Rayonnant style preferred by Parisian court circles (see 10.45). At the end of the century and in the fourteenth century, chapels were added between

the buttresses of the nave, and the belfry towers of the façade were built. The rose window tracery dates from 1500, and the arcade between the towers is a nineteenth-century addition.

The Amiens builders' passion for height and light should have been satisfied [10.17]. The Amiens nave is higher than that of Reims (144 feet (43.9m) in comparison with Reims's 125 feet (38.1m)), but the width remains about the same (about 48 feet (14.6m)) [see 10.9]. These proportions, as well as the increased vertical subdivision of the elevation and the steeply pointed arches of the vault, give an appearance of height that matches the real space. Furthermore, the extraordinary 60-foot-high (18.3m) nave arcade and aisles dwarf the spectator.

The addition of chapels between the outer wall buttresses in the fourteenth century changed this effect. Today the impression of lateral extension in the nave approaches that of Bourges. Uniform compound piers line the nave, and, as in Chartres, the shafts that support the transverse arches run the full height of the elevation. Stringcourses link the shafts and the wall, but the primary shafts are uninterrupted by capitals. With exquisite logic, the elements in the shaft bundle increase in number and diminish in size at each stage—that is, above the major capital, two shafts lead to the diagonal ribs of the vault; at the triforium level and running through the clerestory two additional shafts lead to the lateral wall arches.

"Creation by division" characterizes the design of the triforium and clerestory. The triforium arcade is composed of two large arches enclosing triple arcades and trefoils; in the clerestory, pairs of lancets and roses are subdivided into identical repeating motifs. The mullions of the clerestory extend down to form wall shafts in the triforium, uniting the upper two registers into a single unit and dividing each bay into narrow segments. One horizontal element intrudes into this essentially vertical composition. At the base of the triforium, a continuous band of idealized curling foliage completely encircles the main vessel of the church. This decorative molding emphasizes the horizontal continuity of the triforium and provides an enrichment comparable to the capitals at Reims. The sculptors introduce the world of nature into the logic and precision of the architecture with foliage carving.

In the choir at Amiens, the Cormonts introduced a new architectural mode, one that developed into the light, elegant Rayonnant style. By placing windows in the triforium, they eliminated the last horizontal band of darkness in the elevation. The choir suggests a two-story building: a spacious ambulatory leading to chapels as the first level with a united triforium and clerestory above. The sanctuary becomes a luminous space captured by delicate vertical lines and the open spiky forms of tracery that now spreads over the walls as well as the windows.

ARCHITECTURAL SCULPTURE

Just as architecture served as a frame and support for stained-glass windows whose effect is appreciated inside the building, so too the masonry provided the underlying structure and material for sculpture outside. The sculptures at Chartres, Amiens, Reims, and elsewhere demonstrate the all-encompassing nature of the iconographical program devised by the churchmen. Only scholars could have devised a vision of the world that included all medieval knowledge. As the French scholar Émile Mâle wrote nearly a hundred years ago, the sculpture of a cathedral resembles an encyclopedia in stone, the Speculum of Vincent of Beauvais.

At the Chartres Cathedral, where the west façade already illustrated history as it was then known from the Incarnation to the Apocalypse, the north and south transept portals seemed to expand and comment on the earlier program. The north transept portal sculpture—like the stained-glass windows above—displayed the precursors of Christ and the Life of the Virgin, in short, the Old Testament world before Christ's ministry [see 10.6]. The triple portal culminates in the coronation of the Virgin. St. Anne supports the scenes in the tympanum as the trumeau, and the Old Testament ancestors of Christ stand in the door jambs. St. Anne's sweeping, almost metallic drapery encompasses both her elongated rounded form and the functional architectural post, the trumeau [10.18]. A twist of drapery at St. Anne's feet stabi-

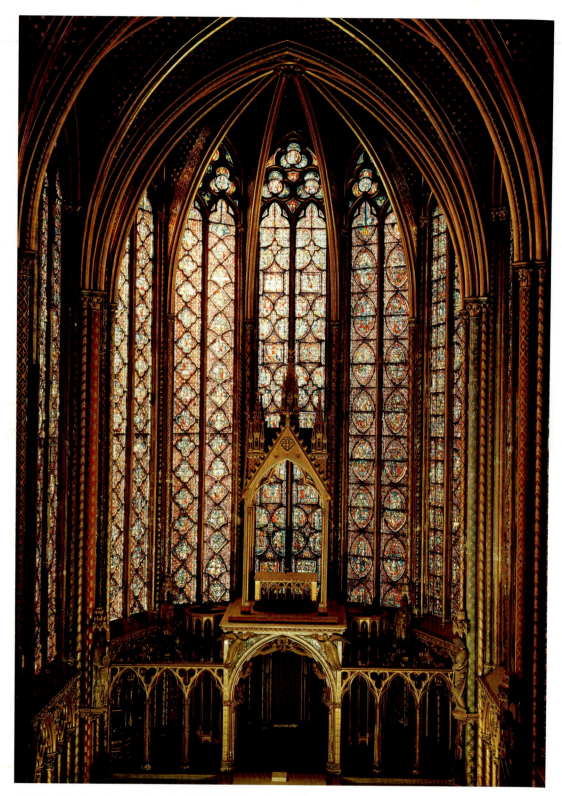

10.45 Interior of upper chapel, 1243–1248. Sainte-Chapelle, Paris.

Sculptured figures of the twelve apostles on the piers link the painted and gilded lower wall to the stained-glass windows above. The windows are glazed with deep red and blue glass so that sunlight fills the interior space with violet light. Small scenes set in repeated medallions against diapered backgrounds are framed with heraldic devices, such as the castles of Castile for the Queen Mother, Blanche. Although the rapid construction of the windows encouraged repetition of motifs and scenes, as a composition in colored light and as a sensual experience, the Ste. Chapelle is an unqualified success.

On the exterior of the chapel [see 10.43], wall buttresses terminating in pinnacles mark each bay of the tall, narrow structure. Each window is framed by an arch that rises up into the gable, which in turn breaks through the roof line. This interpenetrating pattern of gables and arches became a popular decorative framing device in all the arts. The original rose window of radiating fields of tracery can be seen in the miniature painting. Popularized by the French court, the Rayonnant Style soon spread throughout western Europe.

Parisian workshops produced splendid illustrated books for secular patrons as well as the church, and noble and royal bibliophiles assembled great private libraries. Commercial workshops sprang up in Paris, and buyers no longer depended on monastic scriptoria. In order to supply the increased demand for fine books, masters hired many scribes and painters who became specialists within the shop, able to answer the demands for more and more books. The masters, unlike the anonymous monks of earlier scriptoria, were secular artists whose careers can be traced in the legal and business records of Paris and the French court—tax rolls, contracts, sales, and inventories.

In the Psalter made for St. Louis [10.46], architectural motifs from the exterior of the Ste. Chapelle—interpenetrating arches and gables, large rose windows—frame the narratives. Events occur on a narrow stage, acted out by slender but well-modeled figures. Like other Gothic artists, the manuscript illuminators worked within architectural constraints; figures lie as clearly within the frame

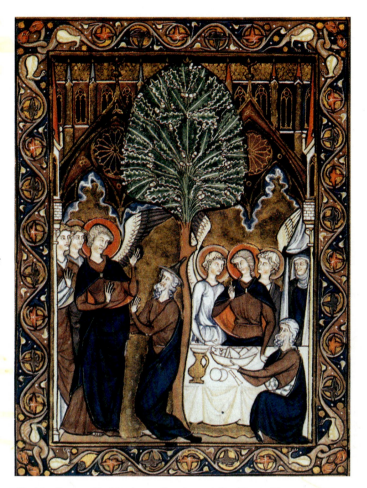

10.46 Page with Abraham, Sarah, and the Three Strangers, Psalter of St. Louis, Paris. 1253–1270. Ink, tempera, and gold leaf on vellum, 5 x 3 1/2in. (136. x 8.7cm). Bibliothèque nationale, Paris.

and on the plane of the vellum folio as do jamb figures in the architecture of the portal. They may move and gesture gracefully within a setting established by miniature landscape and architectural elements. The hint of realism in the oak of Mamre with its distinctive leaves and acorns, like the foliage sculpture of Amiens and Reims, is a realism of detail not of overall form or underlying essence.

The Rayonnant Style triumphs in the west front of the Cathedral of Reims (c. 1230/1254–1287). The façade at Reims as we see it today, like the choir at Amiens, introduces the new sensibility [see 10.11]. Deep porches lavishly decorated with sculpture emphasize the entrance and provide a

stable base for the intricate spatial composition above. Stained glass, with its impressive interior effect, supplants sculptured tympana; and inside the nave the west wall becomes a giant trellis of niches filled with sculptured figures punctuated by the rose windows. Sculpture unites the portals and porches on the exterior as well. Porches with magnificent sculptured gables disguise wall buttresses; and tracery and relief sculpture cover the buttresses of the outer walls. At the level of the rose, the buttresses become spired tabernacles, and the semitransparent towers are pierced with open traceried lancets through which the diagonal lines of the flying buttresses of the nave can be seen. The façade becomes a reaffirmation of Gothic delight in complex linear articulation of space and interpenetrating spaces and forms. The rose window seems to float above and behind the central gable, where under a filigree of turrets, Christ himself crowns his mother. The kings' gallery above the rose masks the gable of the nave and also ties the towers into the composition by providing a dense, horizontal element. Had spires been completed over the tall open towers, the verticality and apparent weightlessness of the design would have made the stabilizing breadth of the sculptured portals essential to the harmony of the composition.

On the reverse façade, the life of the Virgin (left) and the story of St. John the Baptist (right) flank a portal where a rose window replaces the tympanum sculpture [10.47]. In ascending order, history and prophecy reinforce each other, alternating with bands of almost realistic foliage. Narratives are reduced to single or paired figures dressed in contemporary costume. They move with ritualized gestures: Melchizedek celebrates the Mass; Herod and Herodias strike arrogant poses, Herodias, the embodiment of evil. Proud and defiant, she confronts John the Baptist, and in this world she emerges the victor—for she will be presented with his head.

APPROACHES TO GOTHIC ART

Writers have defined and redefined the Gothic style. Inspired by Johann Wolfgang von Goethe's praise of Strasbourg Cathedral, in the nineteenth century, Romantics saw in the Gothic cathedral an architecture whose vertical proportions, accented by pointed arches, slender piers, and intricate tracery, created a soaring space and engendered in human beings intuitions of the sublime. Nationalists found in the Gothic style a Northern Germanic aesthetic, a will-to-form inspired by the vast Northern forests. In contrast, architects and engineers such as Eugène Viollet-le-Duc looked at the masonry of the buildings and saw the pointed arches and ribbed vaults stabilized by flying buttresses weighted by pinnacles as the epitome of rationality.

In the twentieth century, Henri Focillon and Jean Bony wrote of skeletal structures created to mold space, and Paul Frankl, in a brilliant reversal of Focillon's definition of the Romanesque "additive" aesthetic, suggested that the Gothic style was one of "creation by division." The Gothic cathedral was seen as a complete statement of Christian history and belief: For Émile Mâle it was a *Summa Theologica* and a *Speculum* in stone and glass; for Hans Sedlmayr, the House of God and the New Jerusalem; for Erwin Panofsky, the demonstration of Scholastic principles and methodology in tangible form. Otto von Simson found in its geometric proportions and luminosity the expression of Augustinian mysticism. Louis Grodecki found that light as form and symbol, transfiguring space, remained essential to the definition of Gothic.

Today while archaeologists excavate foundations and engineers calculate thrusts and the force of wind, historians search archives to document financial and workshop organization and the careers of patrons and builders. The liturgy and the music of the church inspire as much interest as the light of stained-glass windows; and church furniture, vessels, and reliquaries are given the attention once reserved for architecture and architectural sculpture. All the arts of the thirteenth century, but especially stained glass, ivory carving, enamels, and manuscript painting, are studied as assiduously as the monumental arts. And secular art and building and even the ephemeral arts of the garden, spectacle and pageant, and household arts of daily life have inspired scholarly attention.

10.47 Interior, nave looking to the west, finished by 1286–1287, Reims Cathedral.

and modified the *opus francigenum* with unabashed enthusiasm. Using local materials and building techniques, they created new regional styles. In an age that ended with the disastrous Black Death, beginning in 1347, men and women found the courage, resources, and faith to build magnificent churches, chapels, and palaces and to fill them with treasures.

THE LATER RAYONNANT STYLE

The Court Style of Paris spread through France and neighboring countries in the later years of the thirteenth century. Private commissions of chapels and parish churches, rather than huge cathedrals, and luxury arts, rather than monumental sculpture and painting, dominate the arts. Figures made of precious materials like ivory and intended to be used for private devotions became popular. An early (1260–1280) example is the elegant Virgin and Child, once in the treasury of St. Denis [11.1]. A new theme appears; now Mary is a youthful mother admiring her baby rather than a regal Queen of Heaven. This Gothic princess, with her oval face, high forehead, small sharp features, and almond eyes, could be a beauty from the Parisian court. The sculptor exaggerated the formula of swaying stance, smiling tilted head, and billowing drapery, and enhanced the S-curve of the figure with such broad sweeping folds that the drapery alone seems to support the Child. Made of rare luxury material and delicately tinted, gilded, and bejeweled (she has lost her medieval jeweled crown and brooch), the sculpture reminds us that in the thirteenth and fourteenth centuries Paris was the center of the production of luxury items for both secular and ecclesiastical courts in western Europe.

The new Rayonnant Style soon spread from the Île-de-France through Europe. As an architectural style, the Rayonnant period has two phases: the first, associated with the Parisian court of St. Louis, and the second, exemplified by the Church of St. Urbain at Troyes in eastern France [11.2]. In Troyes Pope Urban IV (1261–1264) founded a church on the site of his birthplace (his father's cobbler's shop) and dedicated it to his patron saint, St. Urbain. The architect, Jean Langlois (John the Englishman?), inaugurated a new phase of the Rayonnant Style characterized by a fanciful use of Gothic architectural forms produced by crisp precise stone cutting that gives an almost metallic effect. The interior of the church is brilliantly illuminated by huge windows filled with pale stained glass [11.3]. For the Church of St. Urbain, built between 1262 and 1270, John Langlois designed a simple three-aisled building with a square transept and a choir of two bays ending in a polygonal apse flanked by polygonal chapels [11.4]. Two bands of windows enclose the apse: The first story is a traceried passageway with a glazed outer wall; the second is a huge clerestory. Continuous repeated tracery patterns flowing over masonry walls and glazed openings alike unite the two stories. Engaged shafts turn piers into clusters of rippling moldings; their insignificant capitals allow the channeled shafts to flow unbroken into the ribs of the vault. Light streaming in through pale glass illuminates the tracery, moldings, and interior sculpture. Like the Ste. Chapelle, the choir of St. Urbain is a glass cage, but the color and quality of the light now has changed from a mysterious royal purple to the silvery light of day.

At St. Urbain the glass may have been begun at the same time as the building and may have been finished by 1277. The expectation of patrons and the skills of artists in combining grisaille and col-

11.2 Church of St. Urbain, Troyes, 1262–1270, rebuilt after 1266.

11.3 Interior, Church of St. Urbain, Troyes.

ored glass produced dramatically different interior effects. Grisaille glass—clear glass painted with geometric patterns or foliage in black or dark brown—had been used when windows had to be glazed rapidly and economically. Abbot Suger's artists at St. Denis worked in grisaille as well as color, and this glass was even approved of by St. Bernard and the Cistercians. Some of the finest is to be seen in the fourteenth-century windows in the Church of St. Ouen in Rouen [11.5]. In the later years of the thirteenth century, artists and patrons chose grisaille glass to complement interiors enriched with intricate tracery and painted sculpture. Artists also combined the traditional techniques of glazing by inserting stained-glass panels of figures into grisaille windows to form horizontal bands of color. The colored panels, surrounded by delicately patterned grisaille, satisfied the desire for rich color and narrative at the same time the grisaille allowed an increased amount of light in the interior.

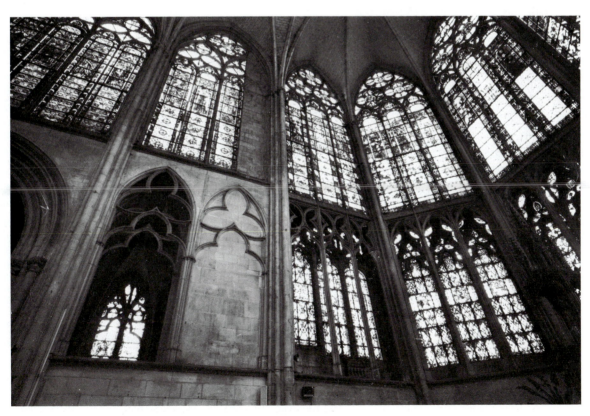

11.4 Interior, Church of St. Urbain, windows c. 1270 and later.

The discovery that silver oxide could produce a wide variety of shades of yellow from pale lemon to rich browns had added to the aesthetic possibilities available to the glaziers [11.6]. Artists painted on larger panels of glass and so reduced the amount of leading; consequently fewer dark lines broke up the surface of the window. Flashed glass, in which one color was coated with another to lighten, darken, or change the original color, had made more variations possible, but now even brighter colors could be made easily—pinks by coating clear glass with ruby red, or brilliant greens from blue glass flashed with yellow. Pale silvery whites and lemony golds replaced the deep colors of the twelfth and thirteenth centuries. The spacious, well-lit, and richly decorated interiors of the Rayonnant buildings in the later thirteenth and the fourteenth centuries provided a new impetus for independent sculpture and painting.

In the fourteenth century, Paris remained the center of luxury arts, gold and enamel work, fine

11.5 Stained-glass window, with grisaille decoration. c. 1325. Pot-metal and colorless glass, with silver stain and vitreous paint: 10ft. 7 1/2 x 35 1/2in. (323.9 x 90.2cm). Abbey Church of St. Ouen, Rouen. The Metropolitan Museum of Art, The Cloisters Collection.

11.6 The Annunciation and Visitation c. 1330, Abbey Church of St. Ouen, Rouen.

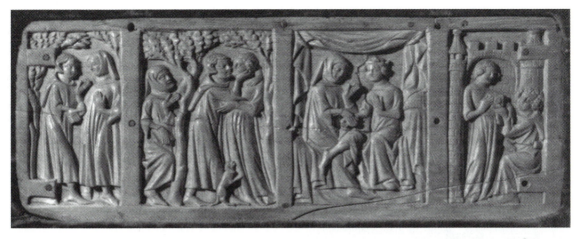

11.7 La Châtelaine de Vergi, first half of the 14th century. Ivory, 3 1/2 x 9 1/2in. (8.9 x 24.1cm). Spencer Museum of Art.

manuscripts, jewelry, and clothing. The elegance and small scale of work in precious materials—gold, silver, enamel, ivory—appealed to aristocratic private patrons, who ordered objects for secular use, such as pendants, belts, clasps, goblets, ewers, basins, and knives as well as prayer books and shrines for private worship. Ivory carvers produced mirror backs, combs, and jewel boxes as well as devotional images like the St. Denis Virgin and Child. Often these deluxe objects were carved with scenes from the new vernacular literature. The literate upper class enjoyed tales of intrigue and romance, such as the story of Tristan and Iseult in the *Roman de la Rosa* (*Romance of the Rose*). [See Box: *Roman de la Rosa.*]

The tragic love of the Châtelaine de Vergi [11.7] provides the subject for an ivory box. The meeting of the Châtelaine (or lady of the manor) and her knight is witnessed by the duke of Burgundy, and in the third scene the jealous duchess pries the secret from the duke. She sends the Châtelaine an invitation to a dance, where all will be revealed, leading to the lovers' suicide. In the ivory carver's shorthand, the representation of a few trees indicates a forest or orchard, and a swag of drapery the private apartments of the duchess. Such condensed narratives were possible, for these were well-known tales and the artist was a skilled story-teller.

The gilded silver reliquary statue of the Virgin and Child, dated 1339 and presented to the Abbey of St. Denis by Queen Jeanne d'Evreux, the widow

Guillaume de Machaut

Guillaume de Machaut (c. 1300–1377) is generally regarded as the leading French composer of the fourteenth century. A poet as well as a musician, he wrote both lyrics and music, composing about 420 lyric poems as well as eight long narrative poems, twenty three motets, many shorter works, and the earliest surviving polyphonic Mass written by one composer. He wrote in both Latin and French.

Guillaume took care with the preservation and visual presentation of his works as well as their musical performance. He evidently personally oversaw the preparation of the manuscripts containing individual and collected works, organizing them chronologically. The manuscripts are beautifully illuminated. The illustrations include portraits of the author, sometimes at work and often assisted by personifications of Nature, the Virtues, and the Arts. In the most famous, Madam Nature presents her daughters to Guillaume.

of Charles IV, illustrates the fine craftsmanship and conservative style of royal goldsmiths [11.8]. Again Mary appears as a loving human mother as well as the majestic Queen of Heaven. Her delicate features shine with timeless beauty, yet their melancholy cast suggests that she contemplates her son's fate on earth, even as Jesus reaches up to caress her

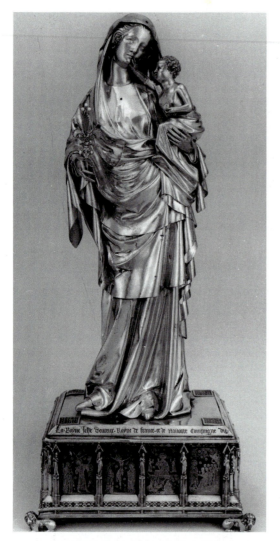

11.8 The Virgin of Jeanne d'Evreux, 1339. Silver gilt with basse-taille enamel. The Louvre, Paris.

decorated with tiny figures under gables divide the sides of the base into 14 rectangular panels enameled with scenes representing the Life and Passion of Christ. The familiar story begins on the right side with the Annunciation, continues on the back and left side, and finally on the front it concludes with Christ carrying the Cross, the Crucifixion, Resurrection, and Descent into Limbo. Delicate figures, whose appearance owes much to the painter Jean Pucelle [11.9], act out the sacred drama against a ground of translucent blue and green enamel enriched with golden flowers with opaque red centers. The artist achieves an effect allied to grisaille paintings by reserving the figures, engraving them, encrusting them with enamel, and then gilding them to create the appearance of drawing in color on gold. A new technique, known as *basse-taille* (very low relief) enamel, became popular in the fourteenth century. Translucent enamel is applied over the modeled surface of the plate and appears deeper in color where it collects in the recesses and consequently shades to a deep color. The technique produces an effect that is both delicate and rich, subtle yet brilliant.

Charles IV ruled for only a short time (1322–1328), but he did commission a masterpiece of fourteenth-century painting, the Book of Hours by Jean Pucelle (1325–1388) that he gave to his wife [11.9]. The book can be dated between 1325, when Jeanne d'Evreux and Charles married, and 1328, when Charles died (Jeanne lived on until 1371). Jean Pucelle was mentioned in the queen's will. Jeanne's Book of Hours is personalized by the inclusion of the Hours of St. Louis. Only 40 years after his canonization, the king had become a popular saint with the ladies of the French court.

Jean Pucelle, in making this luxurious prayer book, having 25 full-page paintings and many historiated initials and line endings, revitalized Parisian book illustration. He worked in a modified grisaille technique, using ink washes but adding flesh tones and light background colors and picking out a few details in red, blue, or pink. He painted

face. Mother and son seem isolated by the enveloping folds of the mantle and veil, an effect of enclosure perhaps felt less when Mary still wore her golden crown adorned with sapphires, garnets, and pearls. She still carries a rock-crystal, jeweled *fleur-de-lis*—the symbol of the French monarchy as well as a sign of Mary's purity—which serves as a reliquary container for strands of the Virgin's hair.

The rectangular base of the reliquary rests on four crouching lions and bears a dedicatory inscription and the royal arms. Miniature buttresses

11.9 Annunciation, Betrayal, in the *Book of Hours of Jeanne d'Evreux,* Paris, 1325–1328. Painted by Jean Pucelle. Miniature on vellum. The Metropolitan Museum of Art, The Cloisters Collection.

both folios of an opening, juxtaposing scenes from the Life of the Virgin and the Passion of Christ. This foreshadowing of torture and death in even the most joyous scenes creates a somber atmosphere consonant with Pucelle's choice of the grisaille technique. In one opening, the paired images of the Annunciation and the Arrest of Christ introduce the prayer for matins. The Virgin receives the angel Gabriel in her home as the dove of the Holy Ghost flutters through an opening in the paneled ceiling and angels rejoice from the upper windows. In the initial the queen kneels with her book, guarded from unwanted visitors by a youth with a club, or, in another interpretation, a man with a candle. Both the guarded door and the lighted way would be appropriate for a queen praying to the Virgin Annunciate. The letter "D" sprouts foliage and supports a musician and a monkey. In the lower

margin, known as the *bas-de-page,* the energy of the angels seems to spread to the children playing Froggy in the Middle, a game that in the Middle Ages symbolized the mocking of Christ. This lower scene relates to the opposite page, where Judas and the Roman soldiers crowd around Christ. One fellow helps Judas identify Christ by holding a lantern up over Christ's head. Judas embraces Christ and Peter cuts off Malchus' ear. In the border image below, figures riding goats mock knightly jousts.

Pucelle borrowed widely but selectively, and by assimilating ideas from England, Italy, and his own French predecessors, he created a distinctive, harmonious personal style. The mixture of religious narrative with secular allegory, the fantasy of the grotesque and foliate borders, and the supplementary *bas-de-page* reflect English painting. The new spaciousness, especially the architectural interior

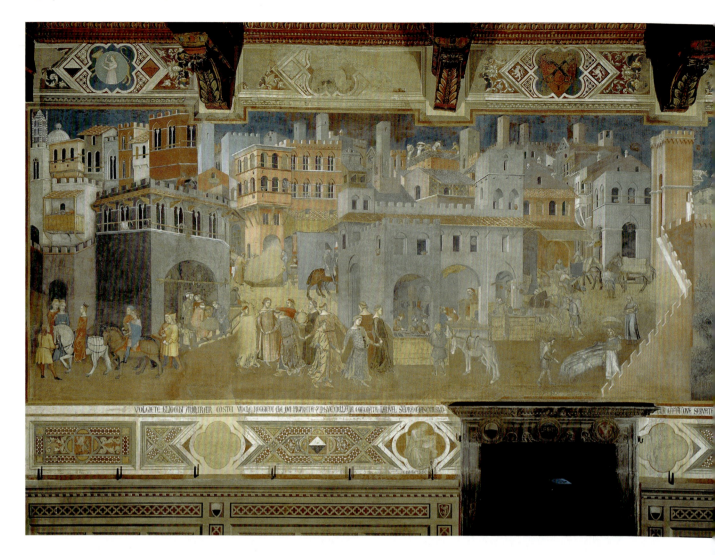

VOLGETE GLIOCCHI ARIMIRAR COSTEI VOGE DEGGIETE CHE ONI HONRATA 7 PSVE GRLLEOR COMPLTA IAUREL SEVRACHIASEVI SVO

the drapery of the central figure and establishes a functional space. The sky is filled with torches and poles—their unruly positions reflecting the spirit of the faceless mob. Giotto balances the decorative effect of the chapel as a whole with the intellectual and emotional impact of the individual scenes to produce a narrative art unsurpassed in any age.

In Siena, Duccio di Buoninsegna (active 1278–1318/1319) became the principal painter. His masterpiece, the altarpiece of the Virgin in Majesty, is known simply as the *Maestà*—Majesty. So admired was the work in its own day that when the altarpiece was finished in 1311, the people formed a festive procession to carry it through the city streets from the workshop to the cathedral.

The huge altarpiece is made up of many smaller panels: On the front, Mary is enthroned as Queen of Heaven; scenes from her life fill the predella; and the Life and Passion of Christ are found at the back. (The altar piece has been disassembled and moved several times. The major part is now in the Cathedral Museum. Some of the smaller panels are now in other museums.)

Duccio combined elements of Italo-Byzantine and courtly French art to form his own unique style. Like a Byzantine icon painter, he represents the Nativity in a cave with the Virgin lying on a mattress [11.38]. The scene takes place in a stylized mountain landscape against a golden sky. In contrast to these Byzantine elements, the delicate,

11.39
Allegory of Good Government in the City and *Allegory of Good Government in the Country,* frescoes in the room of peace, meeting place of the city's magistrates, the Nine. 1338–1339. Approximately 46ft. long (14m). Ambrogio Lorenzetti. Siena.

graceful figures and miniature architectural setting recall Parisian art. The decorative quality of the light, intense colors, especially the pinks and blues, the meticulously rendered details, and the calligraphic quality of the line all suggest the art of manuscript illumination. In spite of his tentative use of linear perspective, the architecture never quite establishes a spatial environment. Nevertheless, through his sensitivity to gesture and feeling, to nuances of color and subtle modeling of drapery and figures, Duccio achieves a convincing interrelationship of figures. The grace, even the gentleness, of his art and its lingering courtly elegance contrast with Giotto's severe monumentality. While Giotto inspired artists like Ferrer Bassa in

Catalonia, Duccio influenced Jean Pucelle and the painters of France and Flanders.

Just before the Black Death struck Europe in 1347, killing millions of people and eliminating an entire generation of artists, two brothers, Pietro and Ambrogio Lorenzetti (active 1319–1348), became the leading painters in Siena. In 1338, the City Council commissioned Ambrogio to paint murals in the City Hall having as their theme the effects of good and bad government. Ambrogio recorded the appearance of Siena and a rather idealized view of the activities of its citizens [11.39]. Merchants come and go; masons finish a tall building; shops are open; and a circle of young women dance to the rhythm of a tambourine. This is the good life as it

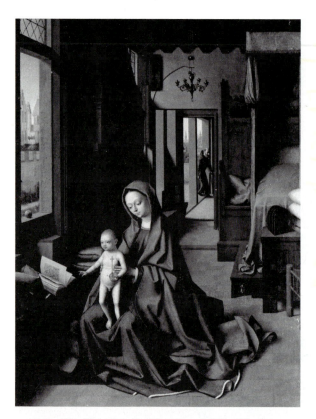

12.3 The Holy Family, Flanders, 1472. Oil on wood panel, 27 3/8 x 20in (69.5 x 50.8cm). Petrus Christus (c. 1415–1472/1473), The Nelson-Atkins Museum of Art.

forts available to a skilled artisan like St. Joseph [12.3]. Petrus Christus (active 1444–1473) placed the Holy Family in a room with glazed and shuttered windows opening onto a walled garden. He surrounded them with fine furniture, including a curtain-hung bed, benches piled with pillows, and an elaborate brass chandelier. Although the apple in the window may refer to the Fall in the Garden of Eden and Mary as the new Eve, the brass chandelier with its ropes and pulley, the stacked red and green cushions, the chamber pot, and the three-legged stool surely hold no subtle iconographical messages. Such genre details establish a mundane setting for the activities of the Holy Family and so bring the religious figures into association with the daily life of the painting's owners.

Artists and architects produced imaginative buildings and filled them with sumptuous arts.

Carpenters rivaled stone masons in their use of sophisticated techniques and subtle decorations. In England the Perpendicular style and in Germany the Parler style dominate late Gothic architecture with their technical and aesthetic innovations. The Perpendicular style became the "national style" of England. The repetitive linear quality of the towers added to Wells Cathedral [see 10.29] suggests the emergence of a new aesthetic, based on the forms of carpentry and perhaps also influenced by the French Rayonnant. The new style appeared in monuments closely related to the royal court like the tomb of Edward II [see 11.15], but it soon spread throughout the country. Rectangular tracery patterns, distinctive "linen fold" paneling, the translation of carpentry patterns into stone, and an emphasis on family pride in the decorative use of heraldry characterize the style.

At the Abbey of St. Peter at Gloucester (elevated to cathedral status and rededicated to the Trinity after the Reformation), the dean and chapter decided to modernize their Norman Romanesque building in the 1330s. The masons preserved the stonework of the Norman choir behind a screen of perpendicular tracery, and they added a new clerestory, east window, and vault in the Perpendicular style [12.4]. Old and new work, walls and windows are united by tracery in repeated rectangular panels formed by mullions and transoms in the windows and extended as a blind tracery over wall surfaces. Curvilinear tracery in the head of each rectangular frame relieves the austerity of slender mullions. The linear quality of the design continues into the vault, where a pointed barrel vault is disguised by decorative net-like ribbing. The vault seems to float weightlessly above the piers and windows.

At Gloucester, the east window (c. 1350–1360) is an enormous tripartite wall of glass measuring 72 by 38 feet (21.9 x 11.6m), enlarged by setting the side walls at an angle to accommodate even more glass [12.5]. The great window rises like a glowing altarpiece dedicated to the Virgin and Child. Around these central figures are elegant angels, apostles, saints, and deceased members of the community, each swathed in voluminous draperies. A

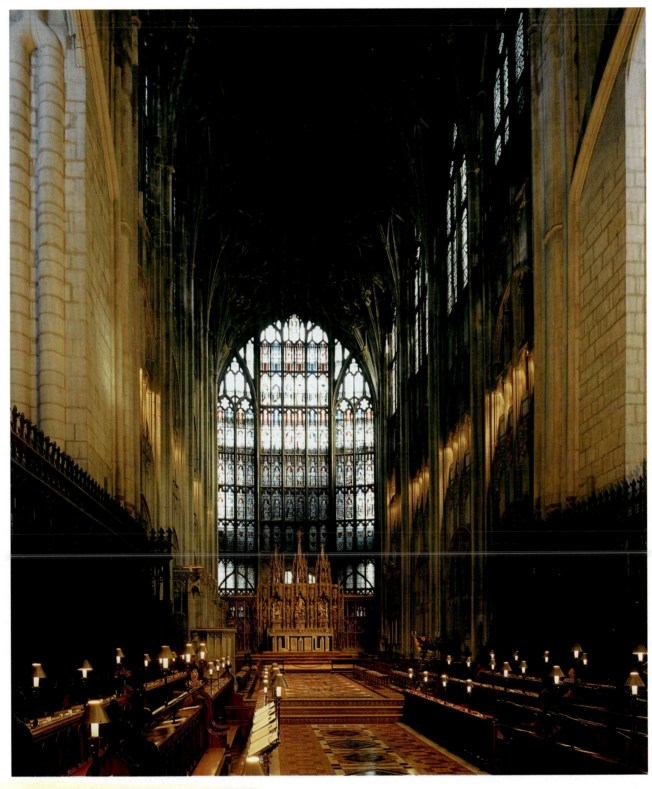

12.4 Interior, Gloucester Cathedral, choir, 1330s.

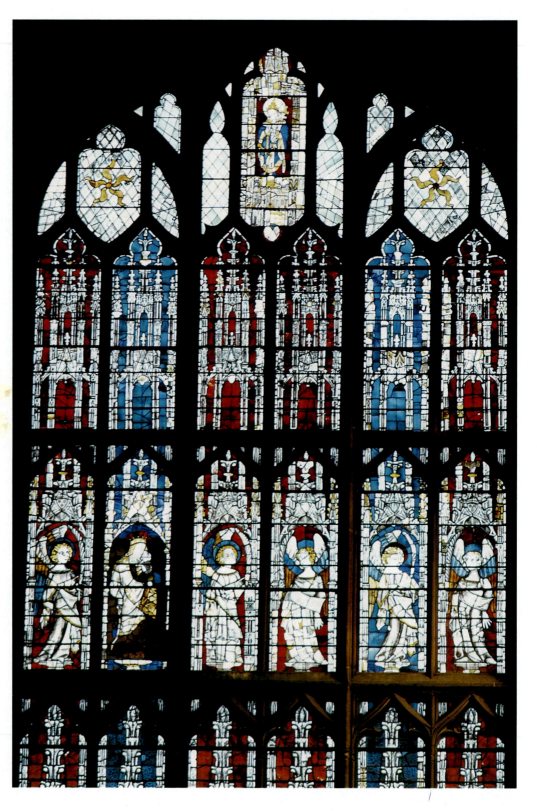

12.5
East window,
stained glass,
Gloucester Cathedral,
c. 1350–1360.

single figure stands in each light of the window under a canopy that becomes an extension of the stone tracery. The grisaille figures and architecture are silhouetted against colored glass backgrounds so that at a distance the window seems to be composed of alternating bands of red, blue, and gray, reinforcing the lines of the mullions and transoms. It has been suggested that the window might be a memorial to those who fought in the Hundred Years War.

In the fourteenth century, English masons created yet another variation on the rib vault, known as the fan vault. One of the earliest fan vaults was built in the cloister at Gloucester Cathedral between 1351 and 1377; the entire cloister was finished by 1412 [12.6]. The structural principle of the fan vault is simple: Curving, cone-shaped corbels laid up in horizontal courses support a series of flat panels along the crown of the vault. In other words, the masons replaced the skeletal structure of Gothic architecture with massive walls and vaults. The false ribs, each with the same curvature and the same length, seem to spring from each pier; however, they are not structural but instead are merely tracery carved out of the corbels. The handsome form of the fan vault with its rich ornamental pattern of moldings is heightened by the silvery light from large windows. The new architectural aesthetic plays on the contrast of walls and windows, but at the same time bonds opposing masses and voids behind a delicate screen of rectilinear tracery.

By the time many cathedral chapters were ready to finish their buildings taste had changed; consequently, many churches are graced with towers in the later style. At Wells Cathedral [see 10.29], for example, beautifully proportioned towers designed by William of Wynford and built between 1365 and 1440 provide a severe but handsome foil to the vivid color and texture of the thirteenth-century façade. Perpendicular architecture embodies the characteristics of clarity and balance, juxtaposition of horizontal and vertical, mass and void. The architects stated and restated the verticality of the

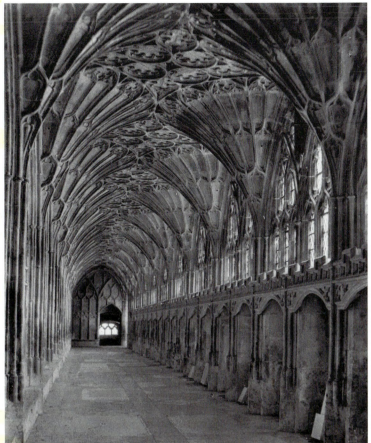

12.6 Gloucester Cathedral, cloister, south range, 1351–1412.

towers but tempered the severity of the structure with delicate vertical moldings, cusped headings, and narrow gables.

One of the most characteristic building complexes, and one for which the Perpendicular style proved to be especially satisfactory, was the university. The oldest colleges of Oxford and Cambridge provide excellent examples of the secular and religious architecture of the later Middle Ages (and are often copied in American collegiate architecture). Cloister-like quadrangles surrounded by living quarters, assembly rooms, refectories and kitchens, and of course the library and chapel, illustrate the essentially functional character and the adaptability of the style. One of the most beautiful of these collegiate buildings is King's College Chapel at Cambridge, built by Regionald

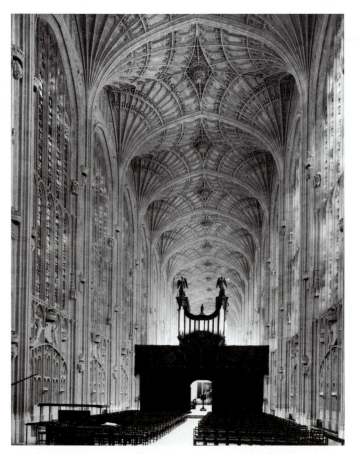

12.7 Interior, King's College Chapel, Cambridge, 1446–1515.

Ely and John Wastell between 1446 and 1515 [12.7]. The chapel is a large, rectangular hall lighted by enormous windows filled with sixteenth-century Flemish stained glass and covered by a fan vault. Massive walls are enriched on the interior by the Tudor emblems of roses and portcullises in high-relief sculpture. This heraldic decoration also surrounds the entrances. The opposition of horizontal and vertical lines, which gave the style its popular name, Perpendicular, produces a building that heralds the classical Renaissance style in its regularity, its horizontal lines, and its sheer wall surfaces. When Tudor monarchs introduced classical art of the Italian Renaissance into the British Isles, builders did not have to rethink the form and structure of their buildings; they simply changed the decoration from Gothic to classical ornament.

English medieval styles lingered on in the Tudor period. At Westminster Abbey, Henry VII, the founder of the dynasty, ordered a new Lady Chapel which would also function as a mausoleum and a chantry chapel for himself (a chantry is an endowment for perpetual Masses for the soul of the founder). Between 1503 and 1519, William Vertue built an exquisite chapel, incorporating yet another variation on the theme of the rib vault, known as the pendant fan vault [12.8]. The underlying structure of the vault consists of enormous transverse arches, but these arches nearly disappear under a filigree of stonework. About a third of the way around the arches, Vertue elongated the voussoirs into pendants 8 feet (2.4m) long, from which fan vaults spring. These pendant fans are actually openwork, and transverse arches are visible through the tracery. To enliven the rich surface of the vault still further, additional pendant fans drop from the flat panels along the crown. The building is a master mason's tour de force. The wall is reduced to octagonal piers, which on the exterior become turret-like bases for heraldic beasts carrying gilded weather vanes. Inside, the walls and windows are bound together by a trellis of rectangular paneling and a broad band of sculpture beneath the windows. The stalls and banners of the Knights of the Bath, whose chapel this has become, now add the final touch of fantasy to a building as sumptuous and extravagant as late medieval chivalry itself.

In Spain in the fifteenth century two national styles appeared: Mudejar, inspired by Moorish craftsmen and design [see Box: *Mozarabic Art and Mudejar Art*], and Isabellan Gothic. The Isabellan style can be seen at its most ornate in the Church of San Juan de los Reyes (St. John of the Kings) in Toledo, founded in 1477 by Isabella and Ferdinand and designed by Juan Guas [12.9]. Parish and monastic churches built during the reign of Ferdinand and Isabella were usually of modest size, but they are often richly decorated. This new Isabellan church type has a single nave flanked by unconnected lateral chapels between the buttresses, a raised choir over the western entrance bay, raised pulpits at the crossing, and a low lantern tower. This compact and efficient design

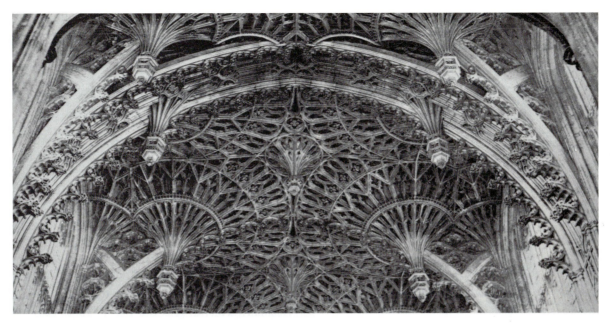

12.8 Westminster Abbey, Henry VII Chapel, London, 1503–1519.

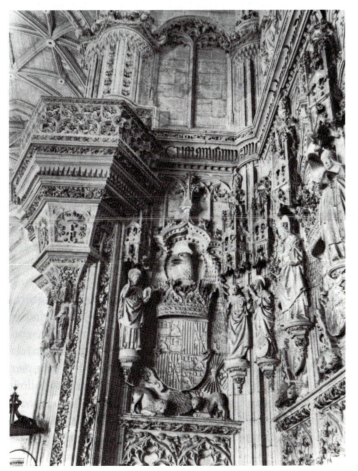

12.9
Church of S. Juan de los Reyes, Toledo, Spain, begun 1477. Juan Guas (active 1459–1496),

allowed ample space for altars, pulpits, and tombs (if the church was intended as a burial chapel), a nave free for the congregation, and wall space suitable for an educational or propagandistic decorative program [12.10]. The Isabellan church became the Spanish "mission" type built in the Americas by the *conquistadores*.

Lavish interior decoration at San Juan honored the Catholic sovereigns. Heraldry became a principal decorative feature (as it was in Tudor England), and the royal coats of arms are as prominent as the assembly of saints. In friezes of tracery and foliage, the artists' attention to the accurate representation of visual details rivals the painters' realism. Carved insects, birds, and animals appear to climb in vines that sometimes seem entirely independent of the buildings. Other prominent features such as stalactite corbels and inscriptions in continuous friezes were inspired by Moorish art. Years

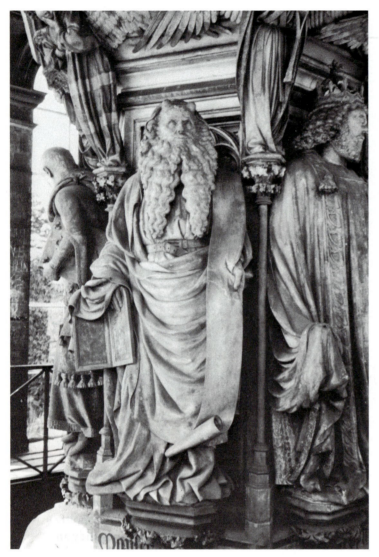

12.17 The Well of Moses, cloister, Carthusian monastery of Champmol, Dijon, 1395–1406. Claus Sluter, Height of figures 5ft. 8in. (1.7m).

Christ must die to save mankind. Sluter could have seen the play, and the theatrical quality of his sculpture may not be simply a product of our imagination.

In sculpture at once monumental and human, Sluter combined realistic portraiture with massive figures enveloped in voluminous, sweeping draperies. He created such life-like images that the spectator feels that he or she is standing in their presence. To create his effects, Sluter combined intense surface realism and dynamic movement with a carefully calculated light and shade pattern. Sluter observed the world so acutely and carved so deftly that he could capture the essence of his subjects without the scientific anatomical study that had begun to captivate his Italian contemporaries.

Moses is justly considered the masterpiece of the group. His sad old eyes blaze out from a memorable face entirely covered by a fine filigree of wrinkles. A mane of curling hair and huge beard cascade over his heavy figure, and an enormous cloak envelops him in deep horizontal folds. Jean Malouel's painting and gilding of the sculpture (traces of which remain) must have enhanced its impact. Sluter's mastery of dramatic representation and volumetric breadth completely transformed the contemporary ideal of sculpture. Under Sluterian influence, realism, bordering at times on caricature, took the place of the sophisticated and often superficial elegance of the court schools and the International style.

Sculptors and painters still reflected the deep piety of the Middle Ages. They and their patrons sought an underlying significance and symbolic meaning in natural objects and everyday activities. They explored the visual and symbolic possibilities of an art based on the observation of nature. In their desire for ever greater and finer detail in the rendering of the surfaces of objects, the painters developed a new painting technique, using oil as a medium for the pigments, building up colors in a series of semi-transparent glazes that had a greater intensity and luminosity than tempera paints. The technique had been used earlier where

base of Sluter's Well of Moses (1395–1406) still stands in the cloister. From the bottom of the well rose a pier bearing a complex sculptured group consisting of Old Testament prophets supporting a crucifix (only a fragment of the crucifix survives). The prophecies painted on the prophets' scrolls were taken from a contemporary mystery play, *The Judgment of Jesus*. In the play Mary pleaded the cause of her Son before the great men of the Old Testament, and each replied that

d........quired—for example, be exposed to theded and popu........

Rog........00–1464) anders such as Jan van Eyck and Petrus Christus (c. 1420–c.73) popularized the technique. Rogier typifies the new age in art. Instead of working for the aristocracy, he was the official painter for the city of Brussels. His straightforward, appealing paintings made him the most copied of all Flemish masters [see 12.1]. Rogier seems to have taken delight in every detail of *St. George and the Dragon,* from the brocades of the princess's gown to the scales of the dragon, from the swirling lines of St. George's trailing red sleeves to the glittering highlights of his armor. The landscape rises in a series of flat, sharply defined planes from the narrow foreground stage, on which the confrontation of saint and dragon takes place, to the fantastic rock formations and a high horizon line. In his painting of the distant city, however, Rogier achieved an effect of sweeping landscape. The reason for Rogier's popularity is apparent: He is an excellent storyteller, a superb draftsman and colorist, and his people have about them a quality of idealized nobility—making him unsurpassed as a portrait painter as well as a painter of religious themes.

During the fifteenth century, the Flemish style and painting technique spread throughout Europe as local artists adopted the luminous colors and careful realism of Flemish painting. The style extended into other mediums as well as painting. In Strasbourg, for example, about 1477 Peter Hemmel organized the stained-glass painters into an extended workshop to supply windows for the new or remodeled buildings. Carefully modeled grisaille figures seem to float in front of or emerge from elaborate curling foliage and deep red or blue damask-like backgrounds [12.18]. Peter's

12.18 Hemmel family. The Mater Dolorosa. German (Swabia), about 1480. Pot-metal glass and vitreous paint, 19 5/8 x 16 3/8in. (49.8 x 41.6cm). Cathedral of Constance. The Metropolitan Museum of Art. The Cloisters Collection.

son (or perhaps son-in-law) painted the sorrowing Virgin for the chapterhouse and former library of the Cathedral of Constance. True to the requirements of their medium, the glass painters retained some of the two-dimensional elements of the local late Gothic art in their adaptation of the Flemish style.

Influenced by German mystics who advocated the renunciation of reason and the dependence on subjective personal feelings to unite the soul with God, the artists were concerned with the emotional impact of their work and aimed for perfect harmony by using simple compositions and limiting colors to the primary hues. They emphasized expressive lines and abstract colors rather than realistic images and coherent spatial relationships. In

ciborium A baldacchino. A vessel for the consecrated host.

cinquefoil A five-petal shape.

Cistercians Reformed Benedictines; an austere order founded in 1098 by St. Robert of Molesme at Cîteaux in Burgundy. Its most famous member was St. Bernard of Clairvaux.

clerestory Literally a "clear story;" the upper story of basilica pierced by windows.

cloisonné See **enamel.**

cloister A monastery or convent; an open courtyard surrounded by covered passageways connecting the church with the other monastic buildings.

cloister vault A cupola rising in curved segments from a square or octagonal base; also known as a **domical vault.**

Cluny, the congregation of Cluny Reformed Benedictines who emphasized strict adherence to the founder's rule and a life focused on the Divine Office; famed for their use of the arts to enhance the splendor of the church services. Founded in 910 by William I at Cluny in Burgundy, eastern France. The entire international congregation was ruled by a single abbot at Cluny.

codex (pl. **codices**) A manuscript in book form rather than a scroll.

collects Short prayers said or sung during the Mass.

collegiate church A church which has a chapter or college of canons, but is not a cathedral.

colobium The long robe worn by Christ in Byzantine and Byzantine-inspired art.

colonnette A small column.

colophon Information about the production of a manuscript, placed at its end (comparable to the title page in a modern book).

column A cylindrical, vertical element supporting a lintel or arch and usually consisting of a base, shaft, and capital. A column may stand alone (as a monument), or as one of a series (a colonnade), or may be attached to a wall (engaged column).

column-figure or **statue-column** A human figure carved as part of a column.

compound pier A pier with attached columns, pilasters, or shafts, which may support arches or ribs in an arcade or vault.

conch Shell-like in shape. A half-dome covering a semicircular structure such as an apse or exedra.

confessio An underground chamber, near the altar, containing a relic.

confessor saints Christians who have demonstrated extraordinary service to the Church through their exemplary lives, especially as scholars and interpreters of scripture, but who did not suffer martyrdom.

cope A cape worn by a bishop.

corbel An architectural support; a bracket.

corbel table A row of brackets, supporting a molding.

cornice Uppermost element of the entablature; crowning element in a building.

corpus Christi Latin: the body of Christ. The figure of Christ on a crucifix; the consecrated bread (the host) in the Eucharist; the feast commemorating the institution of the Eucharist (Thursday after Trinity Sunday).

Cosmati work Marble inlay and mosaic used as pavement and on church furniture, originating in Italy.

couching An embroidery technique in which threads laid on the face of the material are tacked down by threads carried on the back.

crenelated battlements, crenelation A technique of fortification in which the upper wall has alternating crenels (notches) and merlons (raised sections) forming permanent shields for the defenders.

crocket Stylized leaves used as decoration along angles of spires, pinnacles, gables, and around capitals.

crosier, crozier The staff carried by bishops, abbots, and abbesses; in the West having a spiral termination or the form of a shepherd's crook, and in the East, a cross and serpent.

cross Roman instrument of execution; the cross on which Christ was crucified became the principal Christian symbol.

ankh Egyptian looped cross, a symbol of eternity.

Constantinian cross Combined with the monogram of Christ.

cross-standard A long-handled cross with a flag, a symbol of triumph.

crucifix The cross with the figure of Christ.

Greek cross Cross with four equal arms.

Latin cross Cross with three short and one long arm.

St. Andrew's cross Diagonal, X-shaped cross.

tau cross T-shaped, or three-armed cross.

wheel cross Celtic form in which the arms are joined by circular bracing.

crossing In church architecture, the intersection of nave and transepts.

crucks Pairs of timbers in which the shape of the natural tree trunk and branches forms the posts and rafters of a timber-framed building.

crypt A vaulted chamber usually beneath the apse and choir, housing tombs or a chapel.

cubiculum (pl. **cubicula**) Chamber in a catacomb.

curtain wall Outer wall of a castle.

cusp The pointed projection where two curves (foils) meet. See also **foil.**

dalmatic Knee-length tunic worn by deacons and occasionally by bishops at High Mass. See also **vestments.**

damp-fold Clinging draperies, represented as if wet.

deacon Greek: servant, minister. A cleric who assists a priest, acts as reader, leads prayers, distributes communion, receives offerings, and distributes alms. An archdeacon is the principal administrative officer in a diocese.

Deësis Greek: supplication. Christ enthroned between the Virgin Mary and St. John the Baptist, who act as intercessors for mankind at the Last Judgment.

diaconicon In Early Christian and Byzantine architecture, a chamber beside the sanctuary where the deacons kept vestments, books, and liturgical vessels.

diaper All-over decoration of repeated lozenges or squarees.

diaphragm arch A transverse arch carrying an upper wall supporting the roof and dividing the longitudinal space into bays.

diocese The district and churches under the jurisdiction of a bishop.

diptych Two-leaved, hinged plaques containing painting, carving, or wax on which to write. In the early church, they were used to record the names of donors and others for whom special prayers were to be offered. Later they were used as portable altarpieces. See also **triptych.**

Divine Office Daily public prayer. Monastic communities celebrated seven day hours (Laudes, Prime, Terce, Sext, None, Vespers, and Compline) and one nigh hour (Matins) as fixed by St. Benedict, who called it *opus Dei,* the work of God. In cathedrals and parish churches a simple office consisted of morning and evening prayers. See also **hours.**

dogtooth molding Architectural ornament consisting of square, four-pointed, pyramidal stars.

dome A hemispherical vault; to erect a dome over a square or octagonal structure, the area between the walls and base of the dome is filled with pendentives or squinches. See also **pendentive, squinch, vault.**

Dominicans A preaching and teaching Order founded at Toulouse in 1206–16 by the Spaniard Domenico Guzmán (ca. 1170–ca. 1221, canonized 1234); also known as the Black Friars from the black claok worn over a white habit. The great scholar St. Thomas Aquinas (1225?–1274), author of the *Summa Theologica,* was a Dominican friar. See also **friars.**

domus Latin: house. *Domus Ecclesiae:* House church. *Domus Dei:* House of the Lord, the Church.

donjon The keep or principal tower stronghold of a castle.

dorte Dormitory.

double-shell octagon A church plan in which a central octagon is surrounded by an ambulatory and gallery.

dowel A pin used to hold two pieces of material together.

drôleries French: jokes. Marginal decorations in Gothic manuscripts.

drum The cylindrical or polygonal wall supporting a dome.

ecumenical council (also **oecumenical**) A world-wide council of bishops, called by the Pope, to decide doctrinal matters to be confirmed by the Pope and thenceforth binding on the Church.

elevation The side view of a building. The raising of the host and chalice during the Mass.

enamel Powdered colored glass fused to a metal surface and then polished.

> **champlevé enamel** French: raised ground. The area to be enameled is cut away from the plate.

> **cloisonné** French: partition. The cells or compartments for enamel are formed by strips of metal fused to the surface.

enceinte The outer fortified castle wall or the space enclosed by the wall.

entablature The horizontal structure carried by columns or piers; in Classical architecture, it consists of the architrave, frieze, and cornice.

epigraphy The study of inscriptions; compare **paleography,** the study of ancient written documents.

Epiphany The manifestation of Christ to the Gentiles, first through the Magi, the wise men from the East, who

brought gifts to the newborn King of the Jews (Matthew 2:1–12). The gifts of the Magi were gold (royalty), frankincense (divinity), and myrrh (suffering and death). The Feast of the Epiphany is January 6.

Epistles Apostolic letters; 21 books of the New Testament, 14 of which are attributed to St. Paul.

Eucharist Greek: thanksgiving. The central act of Christian worship; the commemoration of Christ's sacrifice on the cross by the consecration and taking of bread and wine, signifying the body and blood of Christ (the actual nature long debated by the Church). See also **Host.**

evangeliary A liturgical book containing selections from the Gospels to be read by the deacon during the Mass.

evangelists The traditional authors of the four Gospels, St. Matthew, St. Mark, St. Luke, and St. John. The evangelists' symbols are the winged creatures from Ezekiel's vision (Ezek. 1:5–14, Rev. 4:6–8): the winged man or angel for St. Matthew, the lion for St. Mark, the bull or ox for St. Luke, and the eagle for St. John.

exarchate A province of the Byzantine Empire, as for example Ravenna.

exedra (pl. **exedrae**) A semicircular recess, apse, or niche covered by a conch.

façade The face of a building, usually the front but also applied to the transepts of a church.

fald-stool Folding seat, like a modern camp stool; as a throne it may be claw-footed and lion-headed and covered with drapery and a large cushion.

fan vault A Late Gothic form in which solid, semicones, nearly meeting at the apex of the vault and supporting flat panels, are decorated with patterns of ribs and tracery paneling to give the appearance of an ornamental rib vault.

Fathers of the Church Scholars and teachers of the early Church.

> **The Latin Fathers** St. Jerome, St. Ambrose, St. Augustine, St. Gregory.

> **The Greek Fathers** St. John Chrysostom, St. Basil, St. Athanasius, St. Gregory Nazianzus.

feast A religious festival commemorating an event or honoring the Deity or a saint. The Feasts of the Church are of three types: (1) Sundays—weekly commemoration of the Resurrection, declared a general holiday by Constantine in 321; (2) Movable Feasts—Easter and Pentecost (seventh Sunday after Easter), the annual commemoration of the Resurrection and the Descent of the Holy Ghost; (3) Immovable Feasts—Christmas, Epiphany, and the anniversaries of martyrs (saints' days). **The Twelve Great Feasts,** in the order of the liturgical calendar, are: Epiphany (Jan. 6), Presentation of Christ in the Temple (Feb. 2), Annunciation to Mary (March 25), Palm Sunday, Ascension Day, Pentecost, Transfiguration (Aug. 6), Death and Assumption (Dormition) of the Virgin (Aug. 15), Nativity of the Virgin (Sept. 8), Holy Cross (Sept. 14), Presentation of Mary in the Temple (Nov. 21), and Christmas (Dec. 25). Easter, as the Feast of Feasts, is in a class alone and is not counted as one of the twelve.

fibula Metal fastener, on the principle of the safety pin, with ornamented foot and head plates and spring fastener.

filigree Intricate ornament made from fine, twisted wire, hence any delicate fanciful decoration.

finial Ornamental terminal, especially at the peak of a gable or spire.

flèche A tall slender spire.

fleur-de-lis French: lily flower. Stylized flower of the iris. In heraldry a three-petal form; the royal arms of France.

foil The lobe formed by cusps making a leaf-like design. The prefix designates the number of foils, hence the shape of the figures, as trefoil, quatrefoil, cinquefoil; a thin sheet of metal, used as backing for translucent enamel or garnets.

font A receptacle for baptismal water.

Franciscans A mendicant Order founded in 1209 at Assisi by St. Francis (Giovanni di Bernardone, ca. 1182–1226, canonized 1230); also known as Grey Friars from the color of their robes (later, habits were brown and tied with knotted cord).

fresco Mural painting in which pigments in water are applied to wet plaster which absorbs the colors. In *fresco secco* the dry plaster is remoistened so that the pigments adhere to the wall surface.

friar A member of a mendicant Order, such as the Dominicans or Franciscans.

frieze The middle element in the entablature; a horizontal band of carvings or paintings.

frontal See **altar frontal.**

Galilee In architecture, a large entrance porch or vestibule; a narthex.

gargoyle A waterspout often carved as a monster or animal.

garth The open space within a cloister.

gesso Plaster of Paris used as a ground for painting or gilding.

gisant The effigy of the deceased on a tomb.

glory The light emanating from a figure indicating sancity; a **halo** or **nimbus** surrounds the head; a **mandorla** surrounds the entire figure.

gloss Commentary on a text.

Golgotha Aramaic: skull. "The place of the skull;" the site of the Crucifixion outside Jerusalem, also called Calvary from the Latin for skull.

Gospels Old English: Godspel, "good news." The term came to be used for the first four books of the New Testament in which the evangelists record the life of Christ. Since the "good news" (the "glad tidings of redemption") is the same in all the Gospels, the proper form is "The Gospel according to Matthew," etc.

gradual Choir book; antiphons from the Psalms.

Greek cross See **cross**.

grisaille Monochromatic painting or stained glass.

groin The edge of two intersecting vaults. See also **vault**.

guilloche Interlacing bands forming a braid; used as a decorative form of molding.

habit Monastic dress.

hall church From German, *Hallenkirche.* A church with nave and aisles of equal height.

hammerbeam A horizontal beam projecting at right angles from the top of a wall, carrying arched braces and posts and thus reducing the span of a timber roof.

Harrowing of Hell or **Descent into Limbo** According to the Apocryphal Gospel of Nicodemus, between Christ's Entombment and Resurrection He descended into Limbo where souls waited to be admitted into Heaven. Christ is often represented rescuing Adam, Eve, and other souls from Hell (a misunderstanding of Limbo).

haunch In an arch or vault the point of maximum outward thrust.

hemicycle A semicircular structure.

heresy A belief contrary to established doctrine. See **Adoptionism, Arianism, Monophysitism, Nestorianism.**

Hetoimasia The throne prepared for the second coming of Christ, as foretold in Revelations.

hieratic Sacerdotal, hence conventionalized art governed by priestly tradition; formal; stylized.

hieratic scale A convention in which the size of a figure indicates its relative importance.

historiated Decorated with a narrative subject, as historiated capitals or historiated initials.

Hodegetria Greek: showing the way. The Virgin holding and gesturing toward the Infant Christ.

Holy Ghost Third Person of the Trinity. **Gifts of the Holy Ghost:** Wisdom, Understanding, Counsel, Fortitude, Knowledge, Piety, Fear of the Lord (Isaiah 11:2); often represented as seven doves.

homily A lecture or sermon.

hood molding A projecting molding over a window or door to throw off rain. Also called a label or dripstone.

horseshoe arch An arch of horseshoe shape which, however, can be pointed as well as round.

hospice Lodging for guests.

Host Latin: *Hostia.* The sacrificial victim; thus the consecrated bread in the Eucharist; the body of Christ.

hours Cycle of daily prayers: Lauds (morning prayer, on rising), Prime (6 AM), Terce (9 AM), Sext (noon), None (3 PM), Vespers (originally variable but before sunset, now about 4:30 PM), Compline (variable, said just before retiring), and Matins (2:30 AM). The hours varied with the season, depending on time of sunrise and sunset. The liturgical day was composed of nine services, that is, the eight hours and Mass which was said between Terce and Sext.

icon An image of Christ, the Virgin Mary, or saint venerated in the Eastern (Orthodox) Church.

iconography The study of the meaning of images.

iconostasis A screen separating chancel and nave in a Byzantine church; by the fourteenth century a wall covered with icons and pierced by three doors leading to the altar, the diaconicon, and the prothesis.

impost The element below the springing of an arch; the blocks on which the arch rests.

impost block A downward tapering block, like a second capital, above the capital of a column.

inhabited initial or scroll Entwined foliage and small figures.

Instruments of the Passion See **Passion**.

intaglio Designs cut into a surface.

jamb The side of a door or window; often splayed and decorated with column-figures.

8.3 Mayeux Tapestry, Surrender of Dinan: © Centre Guillaume le Conquérant, Bayeux, by permission of the city of Bayeux

8.4 St. Barthélémy Church, Liège, Baptismal font: © Paul M.R. Maeyaert

8.5 Sant' Angelo in Formis, Desiderius Offering of the Church to Christ: © Scala / Art Resource, NY

8.6 Church of San Clemente, interior: © Archivi Alinari, Firenze

8.7 Church of San Clemente, mosaic: © Alinari / Art Resource, NY

8.8 San Miniato al Monte, Florence, façade: © Marvin Trachtenberg Archives, courtesy of the Photographic Archives, National Gallery of Art, Washington, D.C.

8.9 Cathedral and Campanile, Pisa, Bapistry: © Scala / Art Resource, NY

8.10 Cathedral, Modena, west façade: © Alinari / Art Resource, NY

8.11 Cathedral, Modena, relief, Death of Cain: © Alinari / Art Resource, NY

8.12 Church of San Ambrogio, exterior: © Marilyn Stokstad

8.13 Church of San Ambrogio, interior: © Archivi Alinari, Firenze

8.14 Church of San Clemente, painting in apse, Christ in Glory: © Museu Nacional D'Art de Catalunya, Barcelona, photo: Archivo Mas

8.15 Santo Domingo, Silos, Christ on the Way to Emmaus: © Paul M.R. Maeyaert

8.16 Santiago de Compostela, cathedral: © Kenneth J. Conant

8.17 Santiago de Compostela, plan: © after Dehio

8.18 Santiago de Compostela, south transept: © Archivo Mas

8.19 Santiago de Compostela and Cluny III, alternative structural forms, cross sections: © Kenneth J. Conant

8.20 Santiago de Compostela, Puerta de las Platerias: © Marilyn Stokstad

8.21 Church of St. Sernin, Toulouse, Christ in Glory: © Bildarchiv Foto Marburg

8.22 Church of St. Sernin, Toulouse, Miégeville door: © Bildarchive Foto Marburg

8.23 Cluny III, plan: © Kenneth J. Conant

8.24 Cluny III, as reconstructed by Kenneth J. Conant, drawn by Turpin Bannister: © Bildarchiv Foto Marburg

8.25 Autun Cathedral, nave: © Paul M.R. Maeyaert

8.26 Autun Cathedral, capital, Suicide of Judas: © Musée Lapidaire

8.27 Autun Cathedral, tympanum, Last Judgement: © Paul M.R. Maeyaert

8.28 Church of the Madeleine, Vézelay, nave: © Zodiaque, St. Leger Vauban

8.29 Church of the Madeleine, Vézelay, detail of piers and aisle capitals: © Clarence Ward Archive, courtesy of the Photographic Archives, National Gallery of Art, Washington, D.C.

8.30 Church of the Madeleine, Vézelay, tympanum: © Paul M.R. Maeyaert

8.31 Berze-la-ville, painting in apse: © Paul M.R. Maeyaert

8.32 Durandus, Moissac, cloister pier: © Bildarchiv Foto Marburg

8.33 Church of St. Peter, Moissac, tympanum, detail: © Marilyn Stokstad

8.34 Church of St. Peter, Moissac, tympanum: © Marilyn Stokstad

8.35 Church of St. Peter, Moissac, trumeau: © Marilyn Stokstad

8.36 Abbey Church, Fontenay, plan: © Bildarchiv Foto Marburg

8.37 Abbey Chruch, Fontenay, nave: © Robert G. Calkins

8.38 Cistercian Manuscript, Tree of Jesse: © Collection Bibliothèque municipale de Dijon. Ms. 129 – f° 4v 5, cliché (François Perrodin)

8.39 Abbey Church, Fontervault, nave: © Johnson

8.40 Church of Notre-Dame-la-Grande, Poitiers, west façade: © Johnson

8.41 Saint-Savin-sur-Gartempe, nave: © Achim Bednorz, Cologne

8.42 Abbey Church of St. Etienne, Caen, west façade: © Clarence Ward Archive, courtesy of the Photographic Archives, National Gallery of Art, Washington, D.C.

8.43 Abbey Church of St. Etienne, Caen, nave: © Clarence Ward Archive, courtesy of the Photographic Archives, National Gallery of Art, Washington, D.C.

8.44 Cathedral of Durham, nave: © Clarence Ward Archive, courtesy of the Photographic Archives, National Gallery of Art, Washington, D.C.

8.45 Cathedral of Durham, plan: © after Dehio

8.46 Gloucester candlestick: © By courtesy of the Board of Trustees, the Victoria and Albert Museum, London

CHAPTER 9

9.1 Cathedral, Poiters, The Crucifixion and the Ascension: © Bridgeman Giraudon

9.2 Chateau Gaillard: © Johnson

9.3 House of Cluny, façade: © Marilyn Stokstad

9.4 Merchant's house, Cluny, plan: © drawing by Leland M. Roth

9.5 Abbey Church of St. Denis, west façade: © Bildarchiv Foto Marburg

9.6 Church of St. Denis, plan: © drawing by Leland M. Roth

9.7 Church of St. Denis, head of king: © The Walters Art Museum, Baltimore

9.8 Abbey Church of St. Denis, interior of choir: © Clarence Ward Archive, courtesy of the Photographic Archives, National Gallery of Art, Washington, D.C.

9.9 Cathedral of Sens, nave: © Clarence Ward Archive, courtesy of the Photographic Archives, National Gallery of Art, Washington, D.C.

9.10 Chartres Cathedral, west façade, Scenes from the Life of Christ: © Wim Swaan

9.11 Chartres Cathedral, west façade, Tree of Jesse: © Jacques Nestigen, Éditions Flammarion

9.12 Chartres Cathedral, entire west façade: © Centre des monuments nationaux, Paris

9.13 Chartres Cathedral, west façade, Royal Portal: © Bildarchiv Foto Marburg / Art Resource, NY

9.14 Chartres Cathedral, west façade, Virgin Portal: © Pierre Devinoy

9.15 Chartes Cathedral, west façade, Ancestors of Christ: © Pierre Devinoy

9.16 Cathedral of Laon, exterior: © Jean Roubier, Paris

9.17 Cathedral of Laon, nave: © Clarence Ward Archive, courtesy of the Photographic Archives, National Gallery of Art, Washington, D.C.

9.18 Comparison of nave elevations, Laon and Paris: © after Grodecki

9.19 Cathedral of Notre-Dame, Paris, nave: © Clarence Ward Archive, courtesy of the Photographic Archives, National Gallery of Art, Washington, D.C.

9.20 Cathedral of Notre-Dame, Paris, plan: © after Dehio

9.21 Notre-Dame de Amiens, cross section through the nave: © drawing by Leland M. Roth

9.22 Cathedral of Notre-Dame, Paris, west façade: © Marilyn Stokstad

9.23 Cathedral of Notre-Dame, Paris, Head of David: © The Metropolitan Museum of Art, Harris Brisbane Dick Fund, 1938. Photograph © The Metropolitan Museum of Art, NY

9.24 Cathedral of St. Pierre, Poitiers, nave: © Johnson

9.25 Grandmont Alter, Limoges, Christ on the Cross: © The Cleveland Art Museum, gift from J.H. Wade

9.26 Canterbury Cathedral, plan: © after Dehio

9.27 Canterbury Cathedral, choir interior: © Anthony Scibilia / Art Resource, NY

9.28 Winchester Bible, Morgan Leaf, Scenes from the Life of David: © The Pierpont Morgan Library, New York. MS M.619 verso.

9.29 Flying Fish of Tyre: © The Pierpont Morgan Library, New York. MS M.81 f. 69.

9.30 Liber Scivias, Hildegard's Vision: © Brepols Publishers, Turnhout, Belgium

9.31 Hortus Deliciarum after Rosalie Green et. al., Herrad von Landsberg: © Warburg Institute, London, 1976.

9.32 Ingeborg Psalter, Pentecost: © Musée Condé, Chantilly, France

9.33 Cathedral of Senlis, west portal, detail of tympanum and lintel: © Bildarchiv Foto Marburg

9.34 Nicolas of Verdun, alterpiece: © Stiftsmuseum Klosterneuberg

9.35 Nicolas of Verdun, Crucifixion: © Stiftsmuseum Klosterneuberg

9.36 Church of San Trophime, Arles, portal, west façade: © Helmut Hell

9.37 Santiago de Compostela, Portico de la Gloria: © Institut Amatller D'Art Hispànic, Barcelona

CHAPTER 10

10.1 Moralized Bible, page with Louis IX and Queen Blanche of Castile: © The Pierpont Morgan Library, New York. MS M.240 f. 8.

10.2 Chartres Cathedral, air view with town: © Bernard Beaujard, Martiguargues, France

10.3 Chartres Cathedral, nave and choir: © Bildarchiv Foto Marburg

10.4 Chartres Cathedral, Charlemagne Window: © Wim Swaan

10.5 Chartres Cathedral, north transept, rose and lancets: © Angelo Hornak, London

10.6 Chartres Cathedral, north transept: © Clarence Ward Archive, courtesy of the Photographic Archives, National Gallery of Art, Washington, D.C.

10.7 Chartres Cathedral, upper wall of nave: © Pierre Devinoy

10.8 Plans of French cathedrals: Chartres, Bourges, Reims, Amiens: © after Dehio

10.9 Elevations: Chartres, Reims, Amiens: © Rizzoli International Publications

10.10 Reims Cathedral, west façade: © H. Lewandowsko © Reunion des Musees Nationaux, Paris

10.11 Bourges Cathedral, interior: © Clarence Ward Archive, courtesy of the Photographic Archives, National Gallery of Art, Washington, D.C.

10.12 Reims Cathedral, chevet exterior: © Marilyn Stokstad

10.13 Reims Cathedral, interior, choir looking west: © Bildarchiv Foto Marburg

10.14 Reims Cathedral, nave: © Clarence Ward Archive, courtesy of the Photographic Archives, National Gallery of Art, Washington, D.C.

10.15 Ideal seven-towered cathedral: © after Viollet-le-duc

10.16 Amiens Cathedral, west façade: © Clarence Ward Archive, courtesy of the Photographic Archives, National Gallery of Art, Washington, D.C.

10.17 Amiens Cathedral, interior nave: © Clarence Ward Archive, courtesy of the Photographic Archives, National Gallery of Art, Washington, D.C.

10.18 Chartres cathedral, north transept, Ste. Anne: © Hirmer Fotoarchiv

10.19 Chartres Cathedral, south transept, St. Theodore: © Pierre Devinoy

10.20 Amiens Cathedral, west portal: © Hirmer Fotoarchiv

10.21 Amiens Cathedral, central portal, west façade: © Bildarchiv Foto Marburg

10.22 Notre-Dame, Paris, west portal, Last Judgement: © Hirmer Fotoarchiv

10.23 Bourges Cathdral, Portada del Sarmental: © Bildarchiv Foto Marburg

10.24 Reims Cathedral, west portal, Coronation of the Virgin: © Hirmer Fotoarchiv

10.25 Villard de Honnecourt, drawing of figures: © Cliché Bibliothèque nationale de France, Paris

10.26 Reims Cathedral, west portal, Annunciation and Visitation: © Hirmer Fotoarchiv

10.27 Reims Cathedral, west portal, Presentation in the Temple, with Joseph: © Hirmer Fotoarchiv

10.28 Winchester Hall, interior: © Robert G. Calkins

10.29 Wells Cathedral, west façade: © Marilyn Stokstad

10.30 Wells Cathedral, nave and crossing: © Bildarchiv Foto Marburg

10.31 Wells Cathedral, capitals in south transept, Man with a Toothache: © F.H. Crossley

10.32 Salisbury Cathedral, exterior: © Foto Marburg / Art Resource, NY

10.33 Salisbury Cathedral and Wells Cathedral, plans: © after Dehio

10.34 Salisbury Cathedral, Lady Chapel: © The Gramstorff Collection, courtesy of the Photographic Archives, National Gallery of Art, Washington, D.C.

10.35 Salisbury Cathedral, nave: © Stephen Addiss

10.36 Last Judgement, William de Brailes: © Fitzwilliam Museum, Cambridge (MS 330 fol.3)

10.37 Church of St. Michael, Hildesheim, ceiling painting: © Michael Jeiter, Morschenich, Germany

10.38 Church of St. Elizabeth, Marburg, nave: © Bildarchiv Foto Marburg

10.39 Church of St. Elizabeth, Marburg, exterior: © Foto Marburg / Art Resource, NY

10.40 Naumburg Cathedral, choir screen with the Crucifixion: © Deutscher Kunstverlag, München

10.41 Naumburg Cathedral, west chapel sanctuary, figures of Uta and Ekkhard: © Erich Lessing

10.42 Church of St. Francis, Assisi, transverse section: © Scala / Art Resource, NY

10.43 Royal Palace with Ste. Chapelle, Tres Riches Heures: © Bridgeman Giraudon

10.44 Abbey Church of St. Denis, nave: © Archives Photographiques, Paris

10.45 Sainte-Chapelle, Paris, interior: © Erich Lessing / Art Resource, NY

10.46 Psalter of St. Louis, Abraham and the Angels: © Cliché Bibliotheque nationale de France, Paris

10.47 Reims Cathedral, inner west façade: © Bridgeman Art Library, NY

CHAPTER 11

11.1 Abbey Church of St. Denis, Virgin and Child: © The Taft Museum, Cincinnati

11.2 The Church of St. Urbain, Troyes, exterior: © Clarence Ward Archive, courtesy of the Photographic Archives, National Gallery of Art, Washington, D.C.

11.3 The Church of St. Urbain, Troyes, interior: © Bildarchiv Foto Marburg

11.4 The Church of St. Urbain, Troyes, interior of choir: © Marvin Trachtenberg Archives, courtesy of the Photographic